SPLENDORS
OF ISLAM

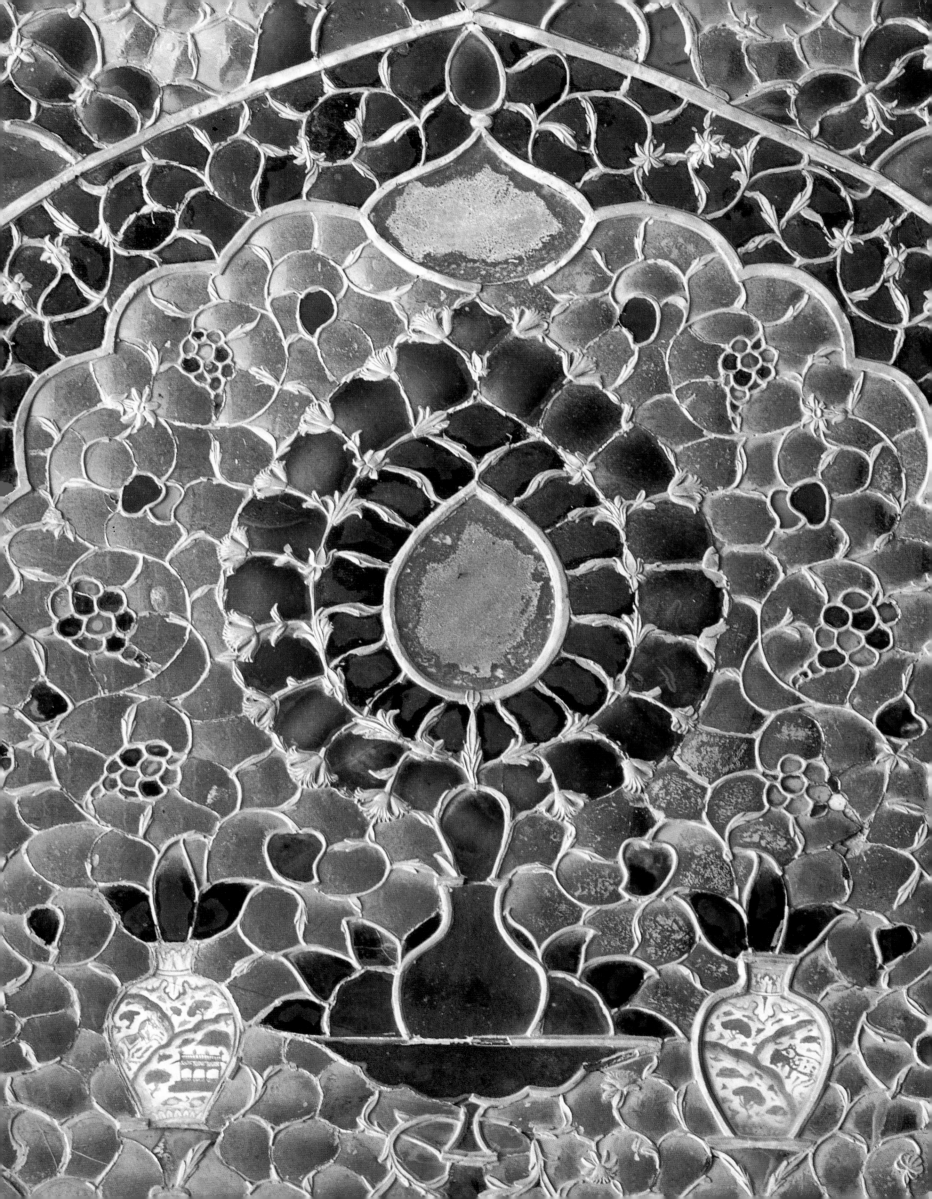

SPLENDORS OF ISLAM

ARCHITECTURE, DECORATION AND DESIGN

Dominique Clévenot
Photographs by Gérard Degeorge

THE VENDOME PRESS
NEW YORK

Translated from the French *Décors d'Islam* by Jean Davis

Frontispiece: Detail of the decoration of the Shish Mahal
(Palace of Mirrors), built by Shah Jahan in 1631. Lahore Fort, Pakistan.

All the photographs in the book are by Gérard Degeorge, except:
3, 26–31 (Werner Neumeister); 15, 17–21 (G. Dagli Orti); 98 (Scala);
123 (Monique Kervran); 178, 293 (Jean Mazenod); 203 (RMN);
218 (Dominique Clévenot).

This edition first published in the United States in 2000 by
The Vendome Press, 1370 Avenue of the Americas, Suite 2003
New York, NY 10019

Distributed in the USA and Canada
by Rizzoli International Publications
through St. Martin's Press
175 Fifth Avenue
New York, NY 10010

Library of Congress Cataloging-in-Publication Data

Clevenot, Dominique.
 [Decor et architecture de l'Islam. English]
 Splendors of Islam: architecture, decoration, and design / by Dominique Clevenot;
 photographs by Gerald de George.
 p. cm.
 Includes bibliographical references.
 ISBN 0-86565-214-7
 1. Architecture, Islamic. 2. Art, Islamic. 3. Islamic art and symbolism. 4. Decoration
and ornament, Islamic. 5. Decoration and ornament, Architectural. I. George, Gerald de.
II. Title.

NA380 .C5713 2000
729'.0917'671--dc21
 00-038147

Printed and bound in Spain

Contents

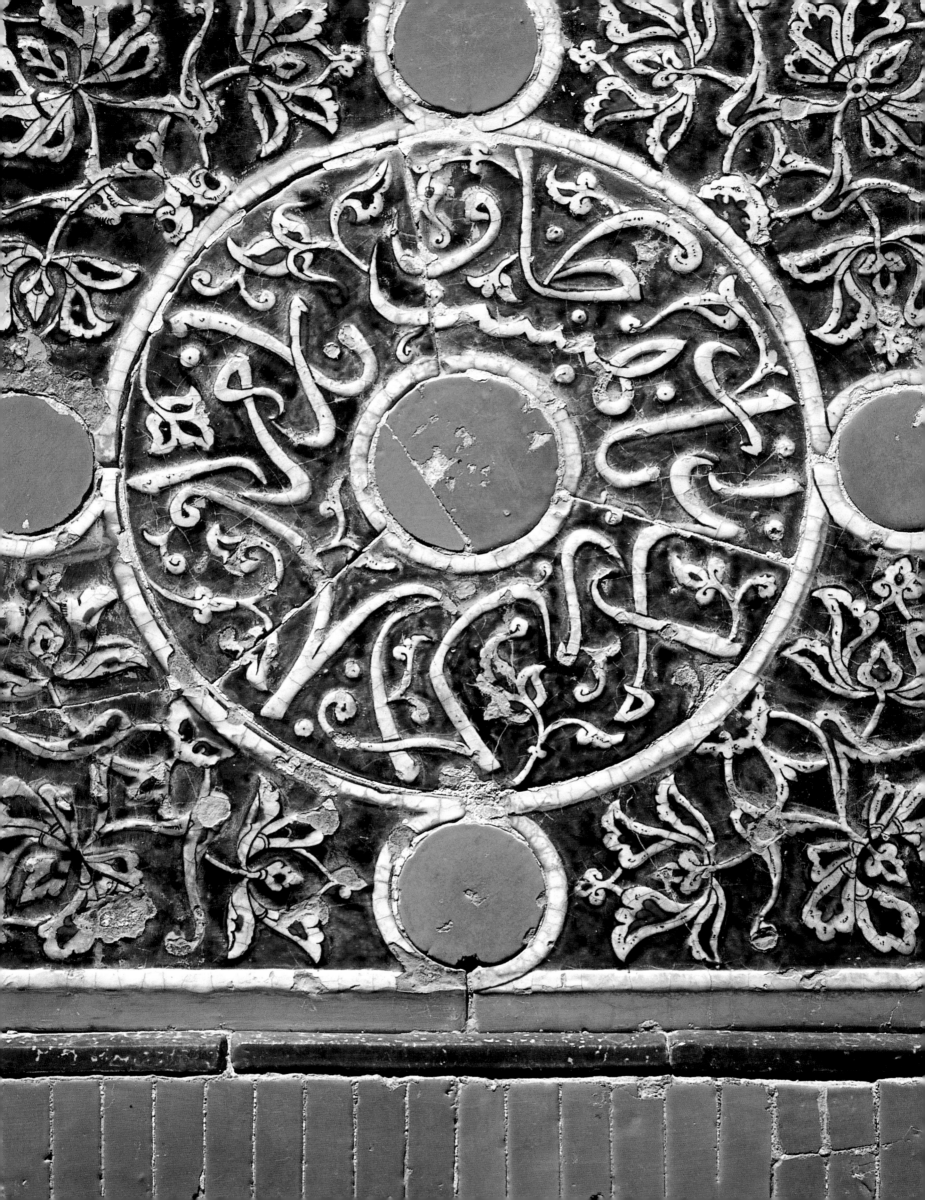

Introduction

After its sudden appearance in the 7th century on the margins of the great Middle Eastern civilizations, Islam expanded within a few centuries to encompass an area stretching from the Atlantic to the Indian Ocean. Despite modest beginnings as a local religious movement, Islam became the cement of an empire, radically altering the political map of a large part of the world. However, because it integrated the cultural heritage of the territories conquered with the religious and social values transmitted by Qur'anic revelation, Islamic civilization, though always fundamentally recognizable, displayed considerable variety.

Architecture is the most immediate visual testimony of this civilization. Although Islamic architecture has experimented with various stylistic orientations in different regions during its history, it has always preserved those characteristics which distinguish it from other architectural traditions. Among various recurring traits, the fundamental role given to surface decoration is undoubtedly the most important. It is this ornamental dimension of Islamic architecture which will be explored here.

Rather than limiting itself to an exclusively historical perspective, the current work presents four successive approaches to Islamic architectural ornamentation. The first part offers an overview of Islamic architecture, discussing the great diversity it contains. Dealing exclusively with techniques, the second part considers the materials most often used as well as the expertise of the builders and Muslim decorative artists. The third part explores themes in Islamic ornamentation. The fourth part discusses aesthetics and studies the relationship between the buildings – the structures or their architectonic components – and their ornamental coverings.

So as to provide an uncluttered view of a multifaceted subject, each of the four parts is composed of a general introduction followed by four studies of detailed aspects. There is an addendum attached to each of these four parts in the form of a documentary notebook with complementary information, which being essentially visual, permits a full examination of the material.

A glazed and engraved ceramic panel which decorates the mausoleum of Shad-i Mulk Aqa in the Shah-i Zinda necropolis in Samarqand (1371–83).

One night, while meditating in a cave not far from Mecca, Muhammad received a visitation from the archangel Gabriel who commanded him to preach: *Iqra!* This decisive event is known as the Night of Destiny. It was not, however, the moment chosen as the beginning of the Muslim calendar. In fact the Muslim era began when the young community, hounded by the inhabitants of Mecca, found refuge three hundred kilometres to the north in an oasis which was to become *Madinat al-Nabi*, the City of the Prophet: Medina. The fact that Islam chose this exile – *al-hijra*, the hijra (AD 622) – as the starting point of its history bears witness to its dual nature. Islam is not only a religion but also a political system. One of the first acts resulting from the installation of the Muslims in Medina was the building of a house to shelter the Prophet and his family and to serve as a meeting hall and place of prayer for the whole community.

At first, the house of the Prophet was no more than a square courtyard fifty metres long, bounded by a dry brick wall. Three doors gave access to the building from the south, the east and the west. On the northern wall was a simple portico made of palm leaves and cob, supported by palm trunks. On the eastern wall were added several rooms occupied by the Prophet's wives. Such a rudimentary construction cannot be regarded as a true architectural work. However, it was indeed the first example of Islamic architecture and the basic traits of the spatial concept seen in later mosques follow this pattern.

Medina, the seat of power during the lifetime of Muhammad (d. 632) and the reigns of the first four caliphs, that is from 632 to 661, was the starting point for the initial expansion of Islam. It spread over the peninsula and reached north into Palestine and Syria, to Mesopotamia and Iran in the east, and to Egypt, Cyrenaica and Tripolitania in the west. When the

Preceding pages

Detail of the one of marble bas-reliefs decorating the Taj Mahal (1631–43).

2 One of the first important Muslim settlements of the Near East, the city of Anjar, located in the Beka'a valley, goes back to the Umayyad caliph al-Walid I (714–15). Its layout recalls a Roman camp with its two principal intersecting arteries. The construction techniques are Roman, particularly the use of alternating layers of stone and brick.

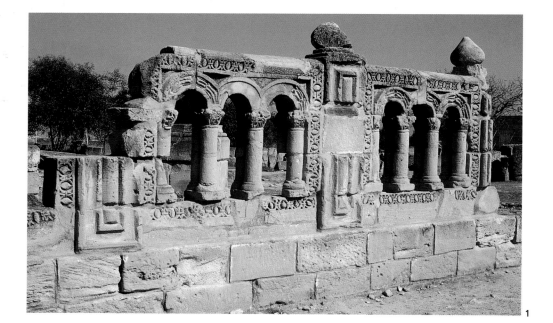

1 The palace complex of Khirbat al-Mafjar (739–44) near Jericho contains a palace, a mosque, reception halls and thermal baths. It is attributed to the Umayyad caliph al-Walid II. In its architectural forms, its stucco and sculpted stone and pavement mosaics, this imposing building harmoniously combines Roman, Byzantine and Sasanian elements.

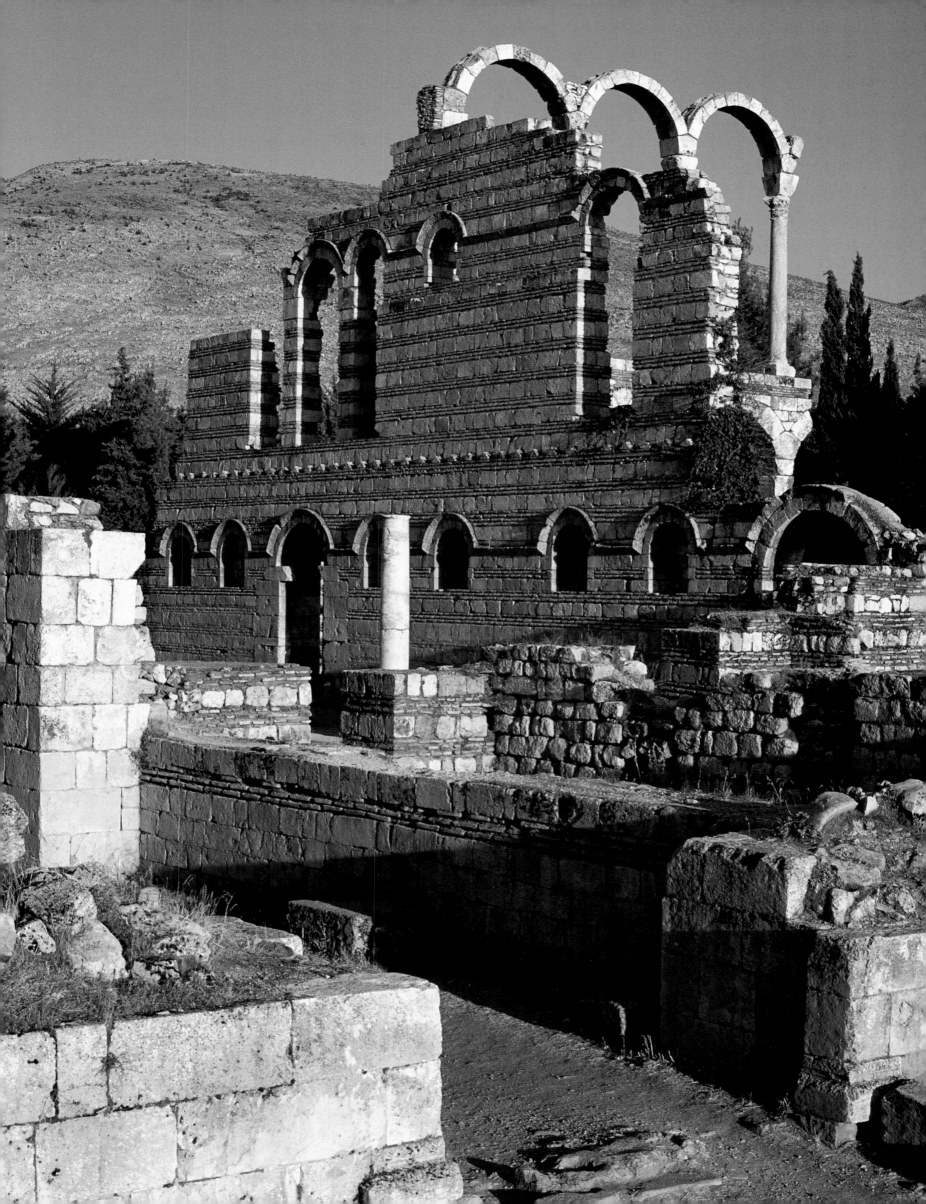

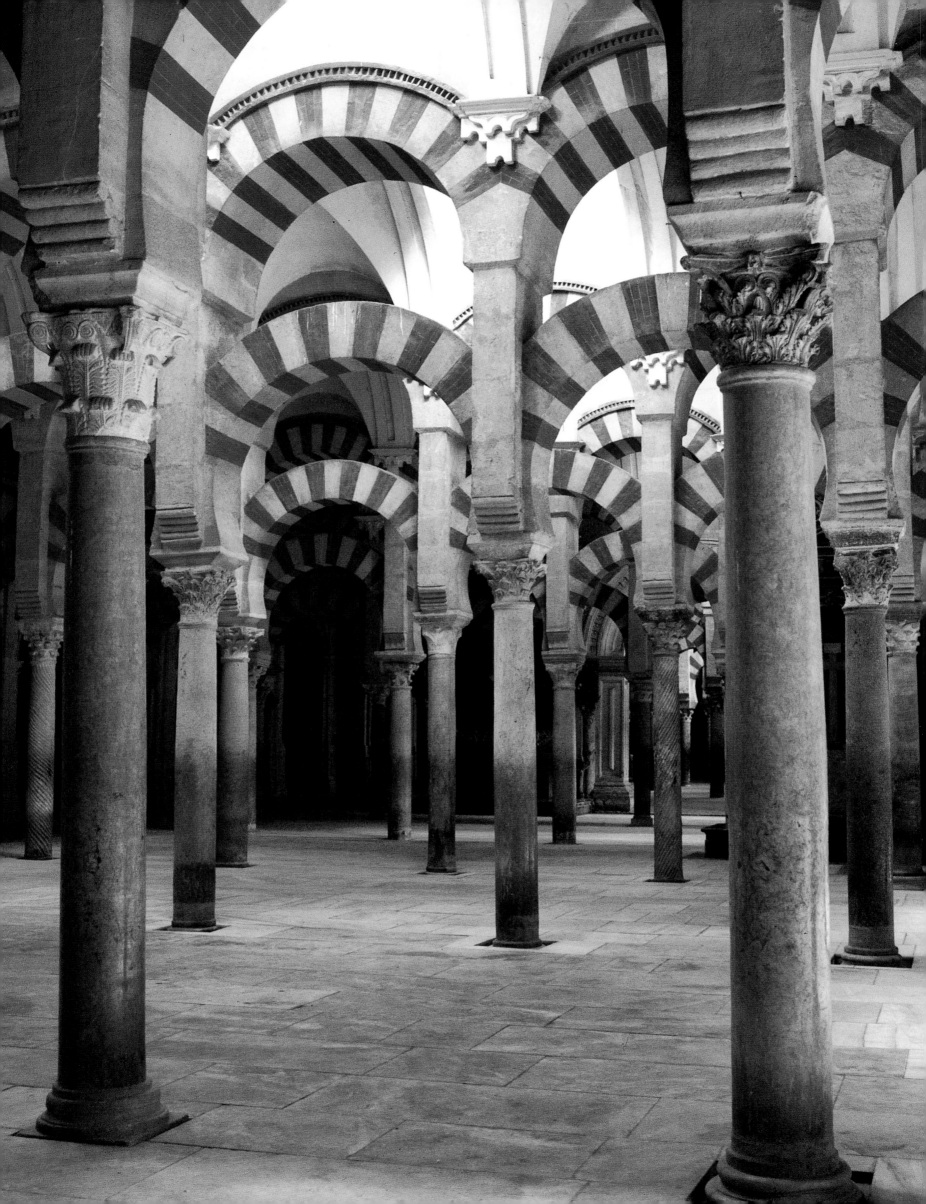

3 The Great Mosque of Cordoba, built between 786 and 787 by 'Abd al-Rahman I and enlarged three times by his successors, displays an original architectural system: the roof is supported by a series of columns, mainly Visigothic in origin, and by arches running along two levels, imitating the Roman aqueduct at Merida. This system gave birth to an utterly new and seemingly unlimited concept of space.

governor of Syria, Mu'awiya, took power in 661 and made Damascus the capital of the Umayyad caliphs, a second expansion began. In 732, only a hundred years after the death of Muhammad, Muslim forces were at the gates of Poitiers in western France. During that time they had also become firmly established on the borders of China and on the banks of the Indus.

For the first decades of Muslim expansion the new masters were content simply to take possession of conquered cities or set up military camps. But after the establishment of the Umayyad dynasty, the caliphs began to erect monuments designed to enhance the prestige of both the new religion and the new political power. These monuments were also a symbolic expression of Islam's appropriation of the conquered territories. The first expression of an Islamic architecture was the Dome of the Rock (*Ill. 16*), an exceptional monument in many ways. It was erected in Jerusalem between 688 and 691 by the caliph 'Abd al-Malik on the site of the Temple of Solomon. Several years later, between 706 and 715, the Great Mosque of Damascus (*Ill. 97*) was built on the site of the Church of John the Baptist. As for secular architecture, a series of palaces, which can still be seen, were constructed by the Umayyad caliphs on the edges of the Syrian desert. These include Khirbat al-Mafjar, a complex comparable to the great establishments of Antiquity.

Umayyad architecture owes much to local traditions for its construction techniques and formal language as well as its ornamental systems. The dominant local tradition was Byzantine, but those of late Near Eastern Antiquity and of Sasanian Persia were also used. This latter influence was to assume an even greater importance after the 'Abbasid dynasty seized power in 750 and established their capital at Baghdad. Hitherto, the hierarchization of architectural volumes inherited from Roman and Byzantine traditions had been highly visible in such Umayyad monuments as the Dome of the Rock and the Great Mosque of Damascus. Now they were to give way under the 'Abbasids to a different set of

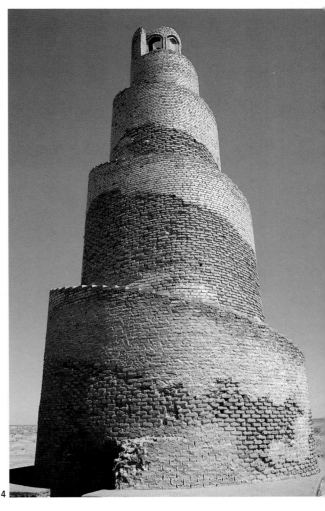

4 Built by the 'Abbasid caliph al-Mutawakkil from 859 to 861 in Samarra, north of Baghdad, the mosque of Abu Dulaf has a minaret similar to that of the Great Mosque of Samarra which was built ten years earlier. Its spiral shape, exceptional in Islamic religious architecture, recalls the form of Mesopotamian ziggurats.

3

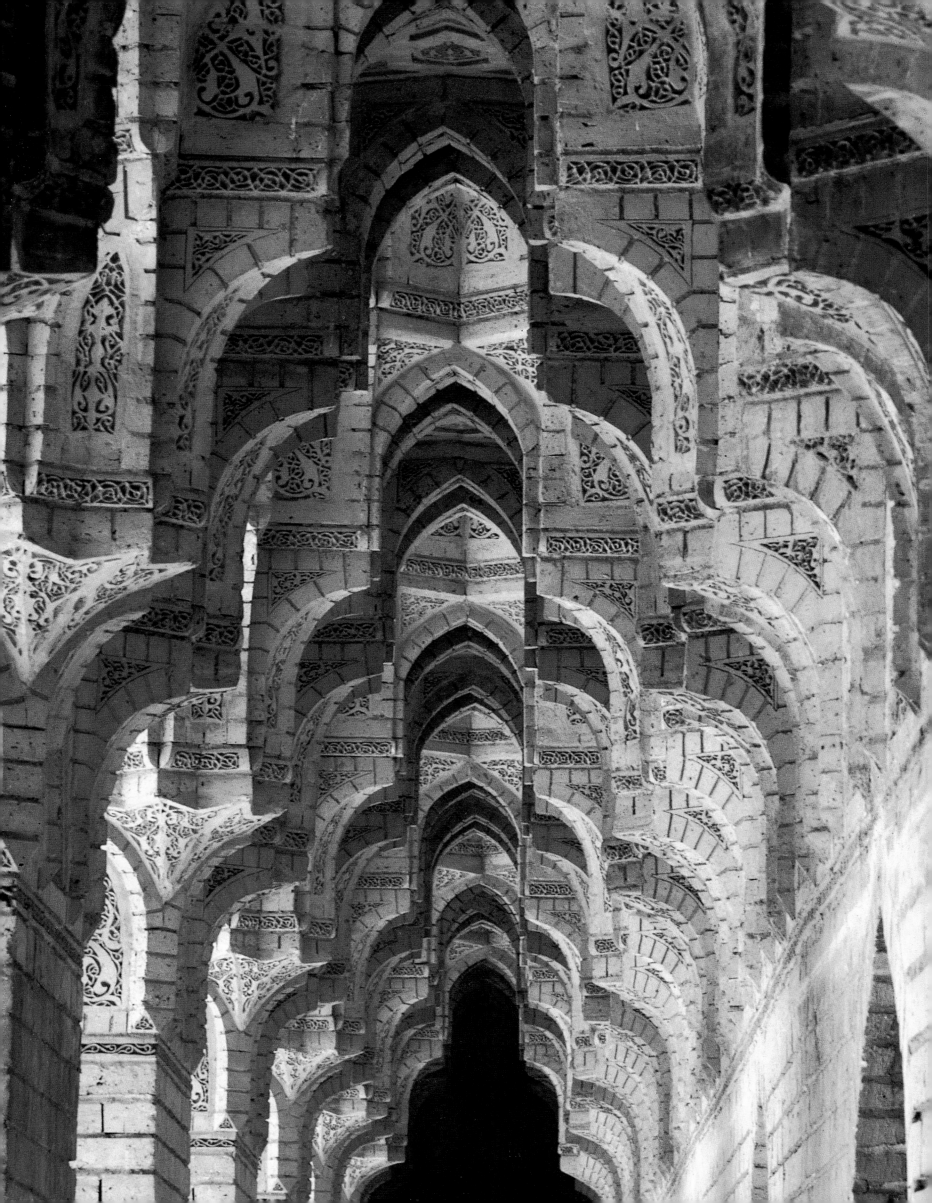

5 Almost nothing remains today of the Qal'a *madrasa* in Baghdad (mid-13th century), except for a square courtyard. It is surrounded by a two-tiered gallery formed by a succession of deep *muqarnas* vaults made of delicately sculpted brick.

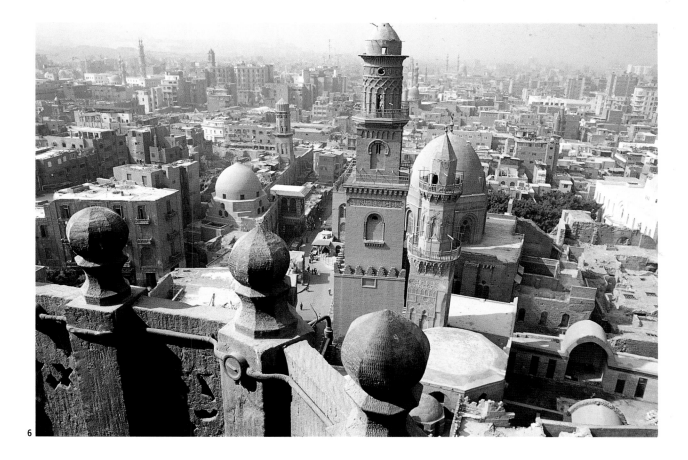

6 Mamluk Cairo: the dome and minaret of the mausoleum of Sultan Qala'un (1283–85) seen from the top of the minaret of the *madrasa*-mosque of Sultan Barquq (1384–86). In the foreground the minaret of the *madrasa* of Muhammad ibn Qala'un.

aesthetics, inclined to the serial disposition of identical elements, as can be seen in the Great Mosque of Samarra (848–52). At the same time, in the techniques used both for construction and ornamentation, materials like rock, marble or glass mosaic were, generally speaking, to be replaced by more fragile but more adaptable materials such as stucco and brick. These two main architectural traditions, the Byzantine and the Sasanian, which can be regarded as respectively Western and Eastern, formed the basis upon which Islamic architecture first developed.

Furthermore, with the Islamization of conquered cities and the progressive transformation of military encampments into veritable urban centres, a repertoire of architectural types began to develop which served religious requirements and political and administrative functions as well as the daily life of the community: the Great Mosque, able to accommodate the entire male population of the city for Friday prayers, the neighbourhood mosque for daily prayers, the palace as the seat of power, the *hammam* or public bath, the caravanserai or *funduq*, which grouped together shops and workshops, and the *kasbah* or *qasr*, a citadel usually located outside but adjacent to the city ramparts, etc.

Although the empire which stretched from the Atlantic to Turkestan was relatively unified during the first centuries of Islam under the authority of the Umayyad, then later the 'Abbasid central power, it started to fragment as early as the 9th century. At its western extremity was Spain with its

prestigious capital at Cordoba. This was the domain of the Spanish Umayyads (756–1031), descended from a surviving member of the dynasty, most of whom were massacred in 750 by the 'Abbasids. The Fatimid dynasty (909–1171), which developed from a heterodox religious movement, conquered Egypt in 969, claimed the title of Caliph and made Cairo into a cultural and artistic capital that rivalled Baghdad.

To the east, local dynasties appeared which were progressively able to free themselves from the authority of Baghdad. The Samanids (874–999), based in Bukhara and Samarqand, reigned over Transoxiana, Afghanistan and eastern Iran. The Buyids (932–1055) occupied western Iran and part of Iraq, the Ghaznavids (977–1186) set out from their base in southern Afghanistan to conquer India, and the Saljuqs (1038–1194), originally from Central Asia, spread their power over Iran, Iraq and parts of Syria and began moving into Anatolia. In these eastern non-Arab dynasties can be seen the rebirth of Iranian cultural and artistic traditions as well as new contributions, mainly from Central Asia. It was under the Saljuqs, for example, that an architectural structure appeared which was to have great success in Iran: the Persian mosque with four façades facing onto the courtyard, each pierced by a monumental arch or *iwan*.

Another event, however, radically shook the internal cultural frontiers of the Muslim world: the Mongol invasions in the middle of the 13th century. In two major waves, the armies of Genghis Khan and later his grandson, Hulegu, subdued all of Persia and then overthrew the 'Abbasid caliphate. Only the

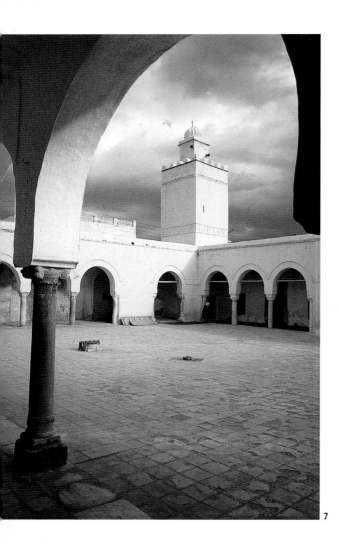

7 The Zaituna mosque in Qairawan.

8 The mosque of Ibn Tulun, built between 876 and 879 in Fustat, an earlier name for Cairo, draws its inspiration directly from the Great Mosque of Samarra. It uses the same construction technique, brick, and also has a spiral minaret.

9 The Great Mosque of Jibla, south of San'a'. The brick minaret is decorated with patterns traced in lime which emphasize the structure. This practice is common to the vernacular architecture of Yemen. The body of the mosque, on the other hand, is completely whitewashed. Its only ornamentation consists of a frieze of cut-out patterns encircling the base of the dome, a distant reminder of crenellated military architecture.

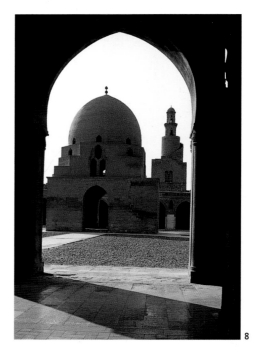

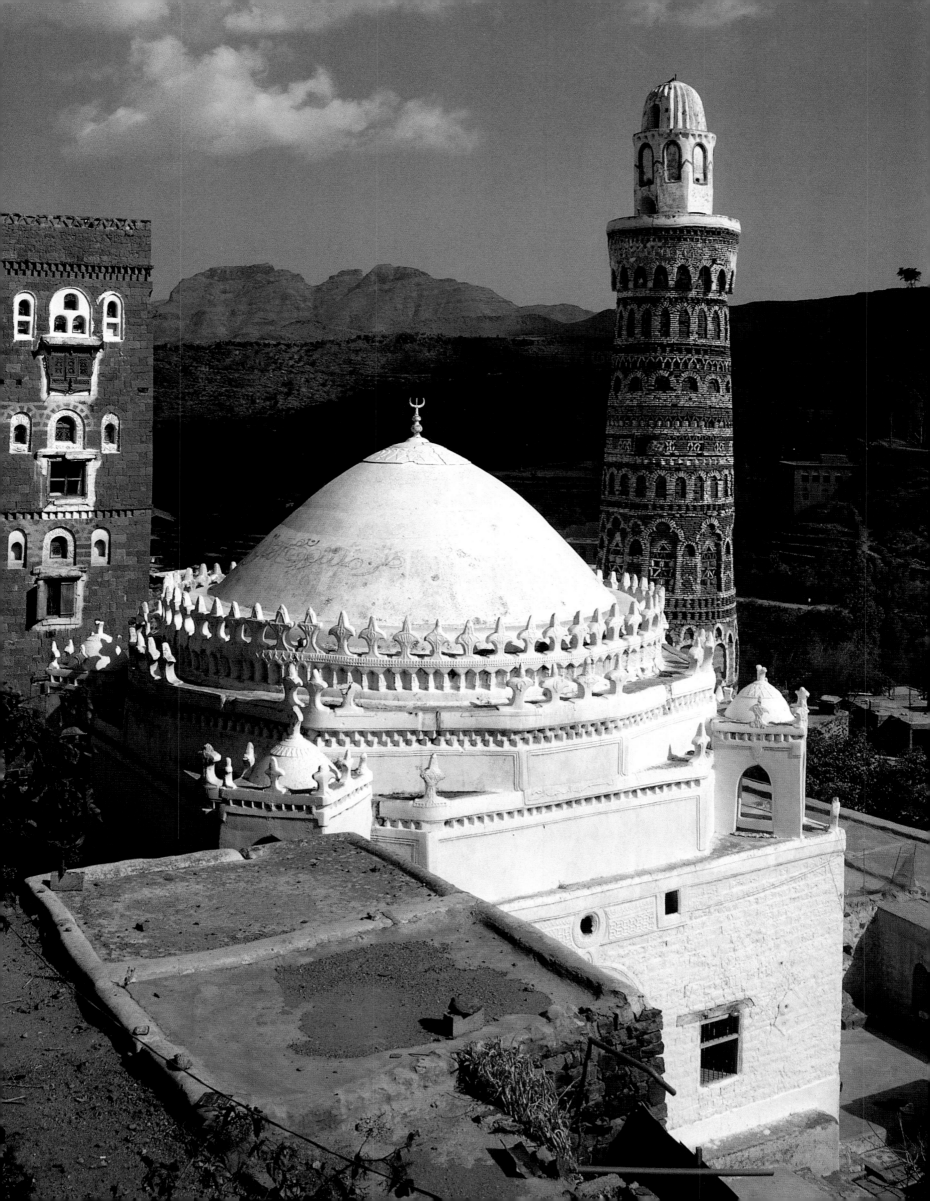

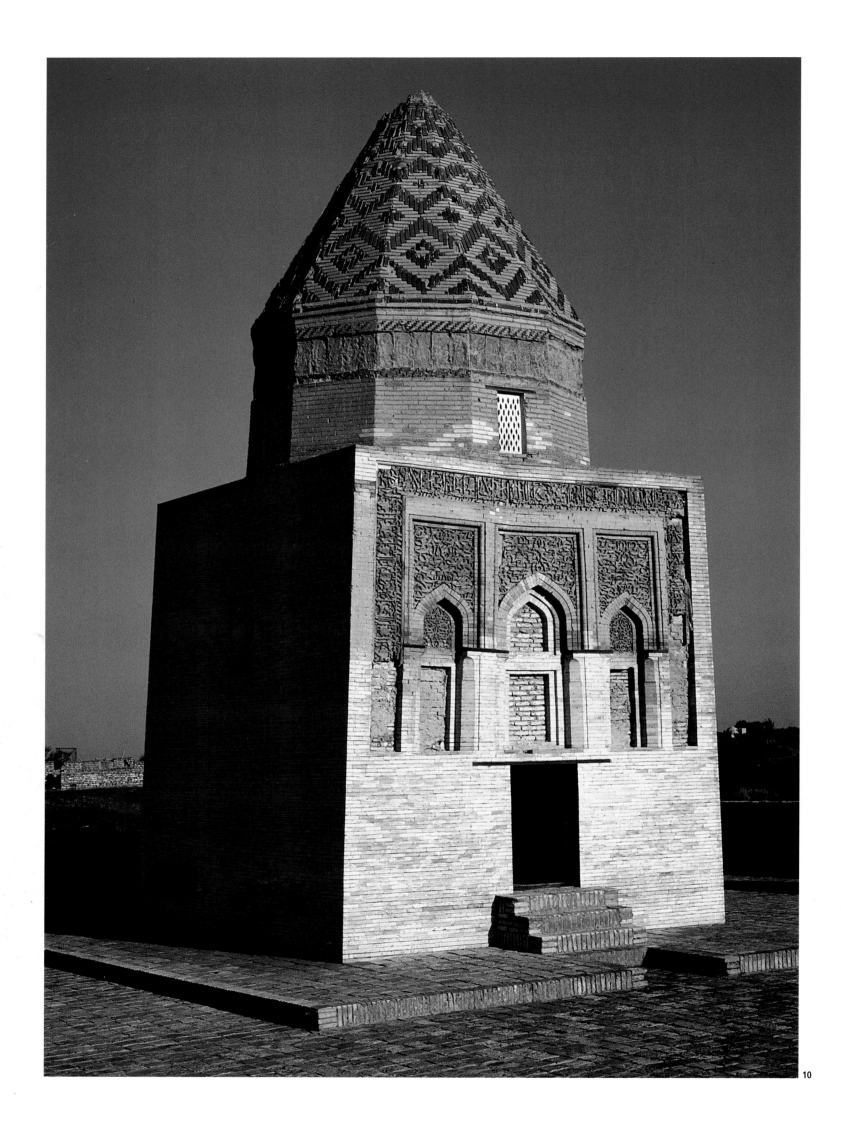

recently established Mamluk dynasty in Egypt was able to halt the onslaught. This geopolitical upheaval divided the Middle East into two blocs: to the west of Mesopotamia the Mamluks developed Arab culture, whereas to the east were the Mongol invaders, known as the Ilkhans, 'subordinate khans'. They eventually settled on Tabriz as their capital, converted to Islam within forty years of the first invasion under Genghis Khan and became, by a spectacular turnaround, patrons of Iranian culture.

To these two cultural blocs formed by the Arab and Iranian worlds must be added the Turkish and Indian identities. The former established itself in Asia Minor. Eastern Anatolia, formerly a Byzantine border territory, was conquered in the late 11th century by a cadet branch of the Saljuq clan. With the progressive rise to power of the Osmanlis, or Ottomans, during the 14th century, the Anatolian Turks assumed ever greater political importance. In 1453 they captured Constantinople, and, in the reign of Suleyman the Magnificent in the 16th century, their empire spread into Hungary and covered most of the Arab world.

India, which had been invaded in the 11th century by the Ghaznavids, and had experienced prosperity under the Delhi Sultanate (1206–1526), was to become the seat of the Mughal Empire from the 16th century

11 Situated in the official quarters of Fatehpur Sikri, the imperial city constructed by the Mughal emperor Akbar in the years around 1570, the *diwan-i khass*, or private audience hall, is an elegant two-storey pavilion, with arches opening onto the four cardinal points and surmounted by four small domed kiosks characteristic of Mughal architecture. The emperor sat in the centre of this pavilion.

10 The mausoleum of Il Arslan in Kunya Urgench is typical of the brick architecture of Central Asia. Built between 1156 and 1172, it has preserved some of its sculpted brick ornamentation.

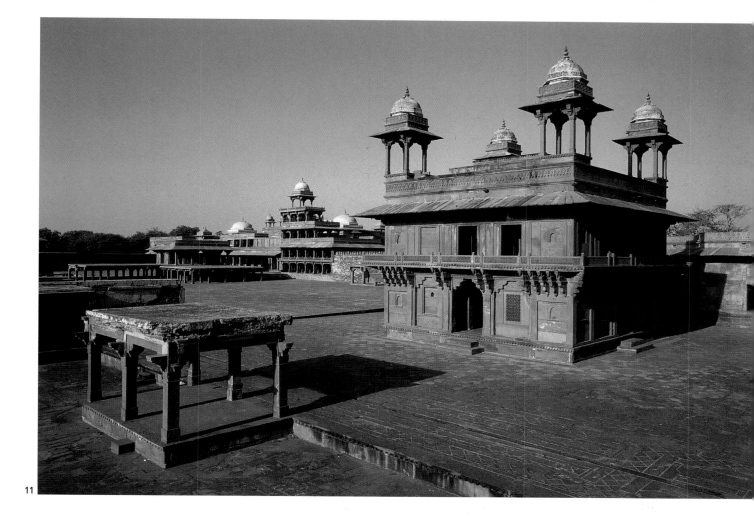

11

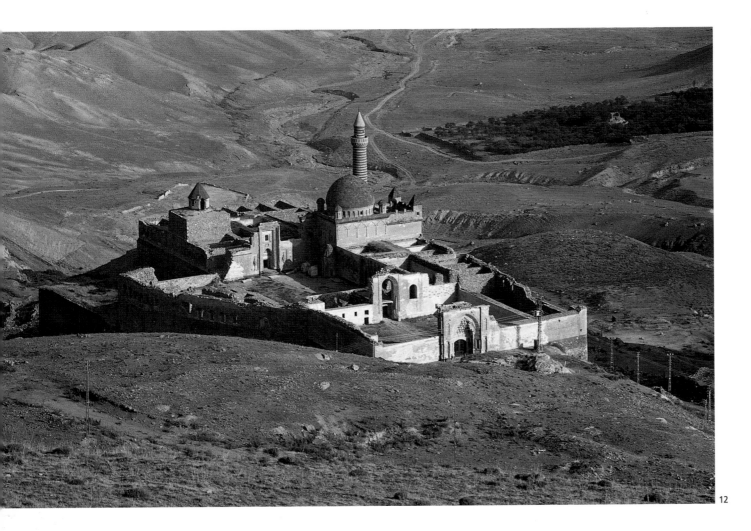

12

onwards. Its artistic and political apogee was reached during the reigns of the Great Mughals: Akbar, who built the imperial city of Fatehpur Sikri some forty kilometres from Agra (founded in 1569); Jahangir, who constructed several royal mausoleums; and Shah Jahan, who erected the Taj Mahal (1631–43) in memory of his wife, generally known by her title, Mumtaz Mahal.

Since it was produced by a multitude of peoples over a period of about a millennium, Islamic architecture, so called, is inevitably diverse. The differences between the Great Mosque of Cordoba, the Shah Mosque in Isfahan and the Süleymaniye Mosque in Istanbul are considerable indeed. Each one declares its specificity in global structure, construction techniques and ornamental methods. Distinctly different styles can be distinguished, habitually designated by either regional or ethnic appellations, such as Arab, Hispano-Moorish, Persian, Turkish, etc., or by dynastic appellations such as Umayyad, 'Abbasid, Safavid, Ottoman, etc.

Nonetheless, the architectural production of the Muslim world cannot be considered as a mere aggregate of local traditions or dynastic schools. Beyond the historic and regional differences there is a relative unity which is due to the recurrence of techniques, themes, principles of design and

common aesthetic choices. These recurrent traits can be explained by an intermingling of cultures resulting from exchanges experienced throughout the Muslim world. For instance, it is known that the builders and artisans employed on construction sites could offer their skills to many different patrons, thus carrying their knowledge from one region to another. Thus it is sometimes possible to follow the path of a construction technique or a particular architectural form over vast areas, as is the case for example with the *muqarnas*, or stalactite vaults. These became widely popular around the 11th century and are found, with slightly varying forms, from Iran to the Maghrib.

This diffusionist explanation is, however, incomplete. If certain forms or techniques spread through different provinces of the Muslim world, it was also because they reflected the values proper to Islam, this term being taken in its broadest sense to designate not only a religion but also a model of society, a way of thinking and even a philosophical system. Thus, though the particularities of a given region must be acknowledged, it is quite legitimate to speak of Islamic architectural aesthetics.

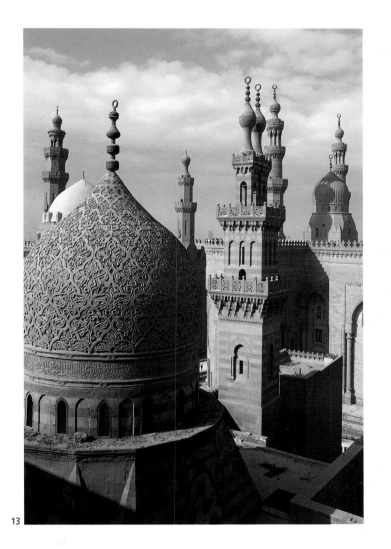

13

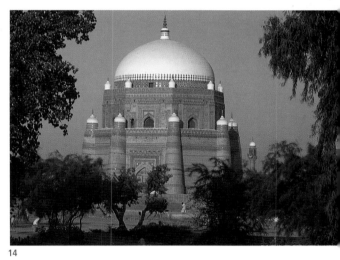

14

13 Mamluk Egypt: behind the cupola and the minaret of the mosque of Amir Akhur (1503) can be seen the minarets of the *madrasa*–mosque of Sultan Hasan (1356–63) and those of the much later al-Rifa'i mosque.

14 Built in the 13th century to shelter the remains of a holy man, the mausoleum of Shah Rukn-i 'Alam in Multan constitutes the apogee of a long tradition of funerary architecture in the Indus valley.

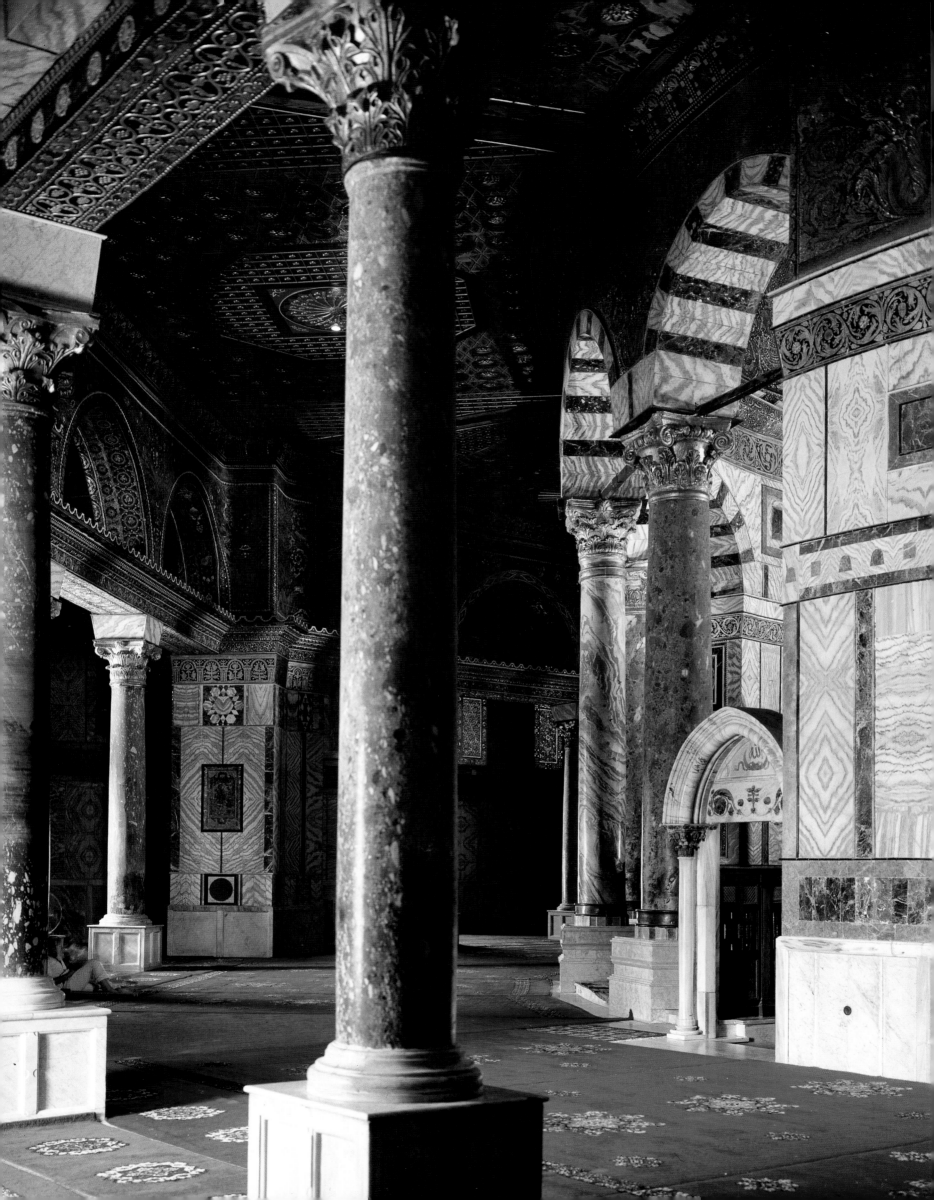

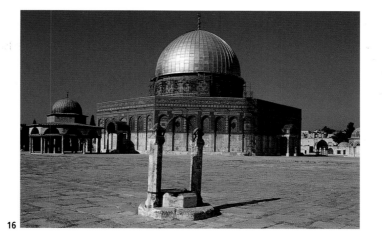

The Dome of the Rock

The emblematic monument of Jerusalem, the Dome of the Rock, is the oldest Islamic edifice to be preserved in its architectural integrity. Erected on the orders of the Umayyad caliph 'Abd al-Malik between 688 and 691, it is also the first Islamic building created with the manifest intention of accomplishing a major artistic feat. Although its original function has not been determined with certainty, the Dome of the Rock has, nonetheless, an extraordinarily intense symbolic value on both religious and political levels.

Unlike numerous other Islamic buildings which hide themselves from public view, the Dome of the Rock was conceived to be seen from afar and its imposing form is a focal point of the surrounding landscape. It is composed of simple geometric volumes which present an identical and immediately recognizable profile from every angle. Its

visual impact is also due to its location. It stands in the great courtyard which covers the summit of Mount Moriah.

This artificial esplanade, called the *Haram al-Sharif*, or 'Noble Sanctuary', and considered the third most holy site in Islam after Mecca and Medina, is also the site of the Temple of Jerusalem, constructed by Herod the Great between approximately 15 and 7 BC and destroyed by the emperor Titus in AD 70. Herod's temple occupied the site of the Temple of Solomon destroyed by Nebuchadnezzar in 586 BC. Today the *Haram al-Sharif* takes the shape of a roughly rectangular terrace covering some 140,000 square metres. At the southern extremity of this quadrilateral stands the al-Aqsa mosque, built by al-Walid the successor of 'Abd al-Malik. More or less at the centre of the esplanade, a trapezoidal platform reached by eight monumental stairways

constitutes the foundation of the Dome of the Rock. This platform corresponds to the summit of Mount Moriah, at the spot where a rock was once visible and is now covered over by the Dome.

Throughout history many religious beliefs have been associated with this irregularly formed mass of rock. According to a Christian pilgrim who visited Jerusalem in 333, the Jews had the custom of visiting the site each year and lamenting as they anointed the sacred rock with oil. They regarded the rock as the *omphalos*, the centre of the world, the site where Adam had been created and where he was buried and also where Abraham had prepared to sacrifice his son.

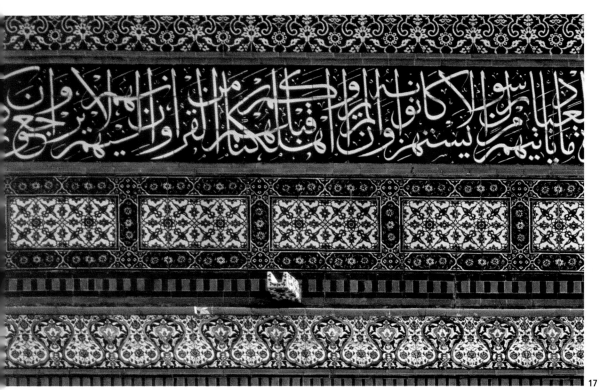

17

17 Ceramic facing with floral and epigraphic patterns decorating the upper part of the façade of the Dome. Largely dating back only forty years, these tiles with dominant blue and white colours are exact copies of the ones given by the Ottoman sultan Suleyman the Magnificent in the 16th century.

The function or the true significance of the Dome of the Rock, set in a place of such symbolic importance, is a complex question. It has exercised all historians of Islamic architecture but no definitive answer has been found. Therefore, before addressing the various hypotheses, we shall look at the building itself, its constituent parts, structure and ornamental scheme.

From the outside, the Dome of the Rock appears as a relatively low octagonal space, approximately fifty-four metres in diameter and twelve in height. From this emerges a cupola reaching up to thirty-four metres in height and supported by a cylindrical drum pierced by sixteen windows. A general impression is given of imbricated forms which, although they are solidly set upon the floor, focus attention upon the vertical axis. The eight façades of the octagon each contain seven identical flat-backed niches. However, four of the façades, those facing the four cardinal points, have a door cut into their centre before which is a vaulted porch. The equal value given to the four doors, as well as their placement, dictated by the cardinal points, help accentuate the static character of the edifice. But although the architectural concept of the Dome of the Rock is dominated by the notion of the centre, it is difficult to say whether it should be perceived as a deployment of shapes expanding out from a central point or as an arrangement directing attention in towards the centre. It is probably the tension created by these two possible interpretations that explains the magnetism of the Dome of the Rock.

The commitment to geometrical clarity is apparent in all its rigour when the architectonic structure of the building and the mathematical schema by which it is determined is fully analysed. The principal architectonic element supporting the dome consists of the circular arcade surrounding the rock. This arcade is composed of sixteen arches set upon four piers and twelve columns. Around the central circle, the lower-level octagon, which counterbalances the thrust, is divided into two concentric alleys, or a double ambulatory, separated by an octagonal arcade composed of eight piers and sixteen columns. The form and the placement of these different architectonic elements – the circular arcade, the octagonal arcade and the

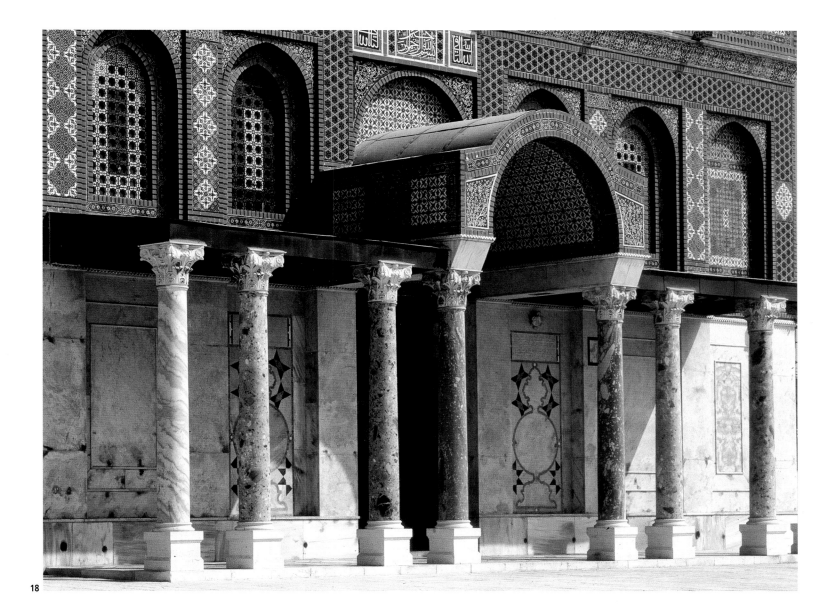

18

octagonal enclosure – are determined by
a layout which is both simple and subtle.
All the points of the plan derive from
a geometrical figure to which Muslim
ornamentalists would later give the name
Solomon's seal (*khatem Sulaiman*). This
consists of a circle in which are drawn
two squares, intersecting each other
at forty-five degrees. The system of
proportions generated by this pattern
also regulates the building's elevation,
determining the height of the enclosure
wall, the drum and the cupola.

The formal perfection of the Dome
of the Rock clearly comes from this
rigorous application of geometry. The
principle of geometrical harmony, which
was to be the focus of considerable
development in the Islamic world, both
architecturally and in ornamentation,
originated in Byzantine tradition, itself

heir to Rome and Greece. The architect
Michel Ecochard has demonstrated the
congruence of the Dome of the Rock's
mathematical schema not only with
those of numerous Near Eastern
Christian monuments, including the
Church of the Holy Sepulchre, the
Church of the Ascension and the Church
of the Tomb of the Virgin in Jerusalem
and Saint Simeon's in northern Syria, but
also with the mathematical schema of
buildings located in more distant regions
where Byzantine art can be found, such
as the church of San Vitale in Ravenna
or the chapel of Aachen. However, if
the Dome of the Rock applies Byzantine
architectural principles, it uses them
with a sense of formal abstraction
hitherto unknown. In the words of
Oleg Grabar, this monument is 'a
pure exercise of rational geometry'.

18 The door opening to the south,
that is, towards the *qibla* and the
al-Aqsa mosque, is endowed, as
are the three other entrances,
with a vaulted porch. It is framed
by a small portico. Between the
reused antique columns which
support it are panels of marble
marquetry.

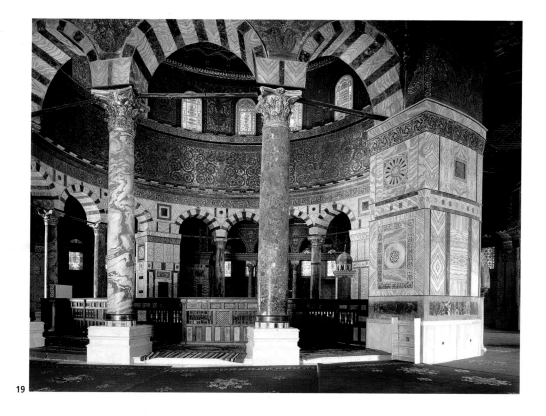

19

19 The central circular arcade
bearing the weight of the drum
and the cupola is made of four
massive pillars and a dozen
columns. Behind these runs
a wooden balustrade from
which the rock can be seen.

20 The octagonal arcade of
the ambulatory has an original
structure with alternating pillars
and columns grouped in twos.
Between these supports and
the semicircular arches there is
a thick, horizontal beam which
serves as a tie beam and adds
to the stability of the whole
structure.

The Dome of the Rock is also characterized, however, by the richness of its ornamentation, which not only transmutes what is perceived but may also serve to clarify its meaning.

The treatment of the external surfaces is a perfect example of the way in which the solid nature of a construction can be visually transcended. Even though the original mosaic coverings were replaced in the 16th century by a facing of glazed tiles, the distribution of the different types of ornamentation has remained the same. The lower part of the façade is sheathed in white marble embellished with geometrical motifs, whereas the upper part is covered with tiles – a chromatic zone with a dominant shade of blue, which continues beyond the break marked by the parapet onto the outer face of the drum. Higher up, the cupola, once covered by copper but recently plated with gold, thanks to a donation from the King of Jordan, reflects the rays of the sun. This partition into three chromatic ranges – white, blue, gold – which does not coincide exactly with the architectural division of volumes, achieves the visual effect of liberating the monument from the laws

of gravity. The lower part of the wall is in chromatic continuity with the paving of the esplanade and the blue zone above mirrors the sky. This partition gives the impression that a kind of architectural horizon traverses the edifice, making it one with the surrounding scenery. This visual phenomenon can also take on a symbolic meaning if we consider the partition to be a cosmological representation which articulates three levels: the earth, the sky and the Divine Sphere.

However, it is the ornamentation inside the building which attracts the most attention, displaying a remarkable richness and bringing together many different techniques: marble facing and marquetry, stone and wood sculpture, bronze and copper plaques, ceramics, mosaics, etc. Among all these ornamental elements it is the mosaics which take pride of place.

The mosaics in the Dome of the Rock employ a Byzantine technique consisting of an assemblage of small coloured or gold-leafed glass cubes among which can be found slices of mother-of-pearl or gems. The zones covered by mosaics correspond to the arches and the spandrels of each of the faces of the two arcades – the octagonal arcade which separates the ambulatory into two alleys (*Ill. 19*) and the circular arcade which surrounds the rock – as well as the internal face of the drum. The motifs and the technique come principally from Byzantine art, but with the distinct feature that no human or animal figures are present. There are vegetal motifs – more or less realistic or stylized trees, such as the palm or the Tree of Life, wreaths, scrolls, foliated patterns, vase-shaped cornucopias, etc. – but also motifs borrowed from jewellery – necklaces, pins, pendants, diadems, brooches, etc. – such as were worn by the ruling class in Byzantium. In this Byzantine repertoire, certain Sasanian motifs can also be detected, such as

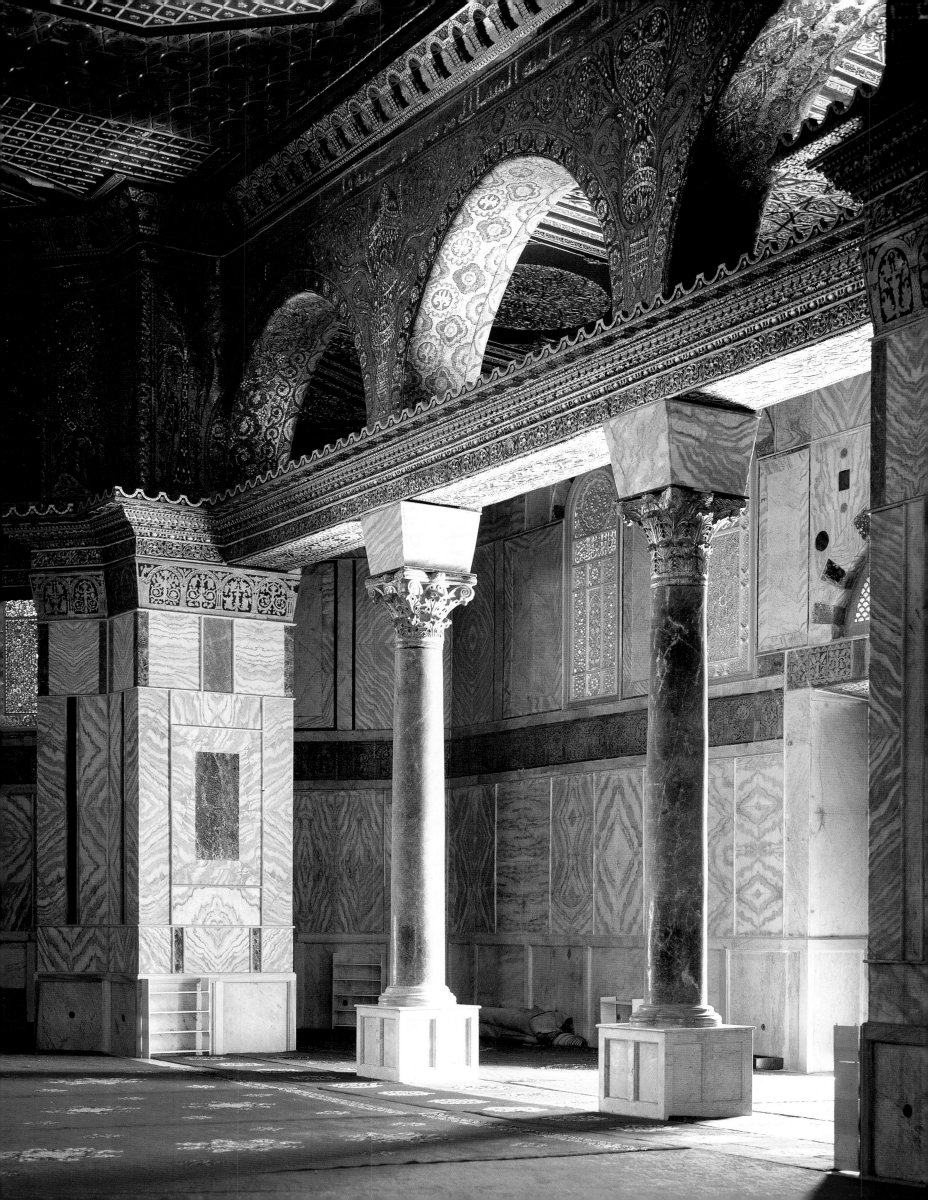

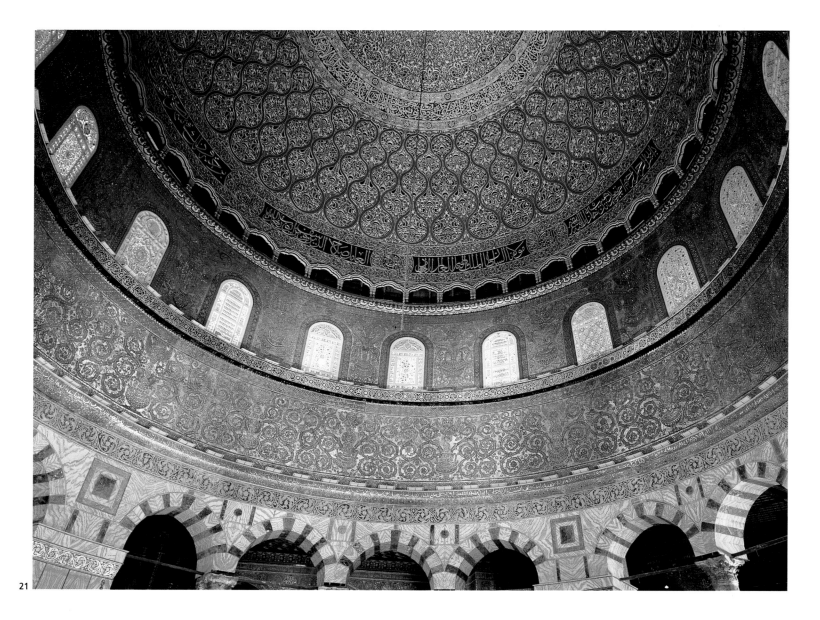

21

heart-shaped leaf compositions or symmetrical pairs of wings, an ancient emblem of Iranian royalty. Thus, with regard to these mosaics, one might speak of a Sasanian influence on a Byzantine background. However, what is most notable in this fusion of styles is a new aesthetic which ignores the usual distinctions between reality and fantasy, between representation and ornamentation, an aesthetic which gave birth to strange, hybrid compositions where the animate and the inanimate come together.

The true significance of the Dome of the Rock, the determining factor behind this masterly work of over-abundant ornamentation, is not to be found in sources contemporary with the building of the monument. Furthermore, the architectural structure of the Dome

of the Rock does not belong to any clear category of Islamic building. Although it has sometimes been designated as "Umar's Mosque", it does not share any of the spatial characteristics of mosques which, apart from anything else, are clearly oriented towards Mecca. On the contrary, its principal characteristic is to obey a centralized plan which does nothing whatsoever to direct the spectator's attention elsewhere. Indeed, it is precisely this aspect which has been used to support various hypotheses concerning its function.

The first hypothesis explains the construction of the Dome of the Rock as the result of particular historical circumstances. Between 680 and 692, an opponent of the Umayyad dynasty, 'Abd Allah ibn al-Zubair, proclaimed himself Commander of the Faithful in Mecca

and, as a consequence, the pilgrimage to the holy sites (*hajj*) became impossible for the subjects of the Umayyad caliph. The caliph 'Abd al-Malik is said to have decided to make Jerusalem the focus of the pilgrimage. So he constructed an edifice there designed to be the equivalent of the Ka'ba in Mecca and the conception of the Dome of the Rock could plausibly respond to certain liturgical requirements of the *hajj*. However, even if one can imagine the double ambulatory surrounding the rock as the zone reserved for circumambulation, it is difficult to explain how such an upheaval in the tradition of the *hajj*, one of the Pillars of Islam, left no trace in the chronicles.

The second hypothesis, following a current Muslim tradition, claims that the Dome of the Rock commemorated the *Mi'raj*, a miraculous episode in the life of the Prophet. Following similar lines to Jewish legends which consider the rock on Mount Moriah to be the *omphalos* of the world, the Muslims made it the place of Muhammad's mystical ascension to heaven. According to one interpretation of the Qur'anic verse, 'Glory to him who did take his servant for a journey by night from the Sacred Mosque to the Farthest Mosque whose precincts we did bless', the Prophet was said to have been miraculously transported from Mecca to Jerusalem, then carried by Buraq, a human-headed winged steed, up into the presence of God. The Dome of the Rock, since it neatly recapitulates the structural characteristics of commemorative Christian edifices, the *martyria*, is capable of fulfilling the function of a memorial to a miraculous event. However, there is no proof that the legend of the *Mi'raj* was current when the Dome of the Rock was built, and no allusion is made to this episode in the inscriptions found on the monument.

The most likely explanation is the one proposed by Oleg Grabar. The construction of the Dome of the Rock was probably an act of religious or political propaganda by 'Abd al-Malik designed to endow the new religion, which had previously contented itself with rudimentary places of worship, with an exemplary monument capable of competing with Christian monuments in Jerusalem such as the Holy Sepulchre or the Church of the Ascension. Indeed, what better way to combat the prestige of Christian sacred structures than to use their own architectural vocabulary? In addition, by choosing an important site of Jewish tradition, the Caliph was clearly presenting Islam as the true successor to earlier revelations.

Architecturally, the Dome of the Rock is what Umberto Eco has called an 'open text', i.e., a work capable of containing a variety meanings. This would explain why it was later associated with the tradition of the *Mi'raj* or why today it is given fresh political significance.

22 At the summit of the façades runs a long calligraphic band of white cursive characters on a dark blue background, dating from the 16th century when Suleyman the Magnificent carried out restoration work on the external ornamentation.

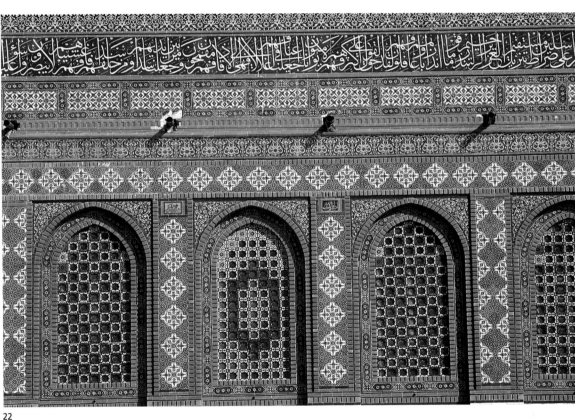

22

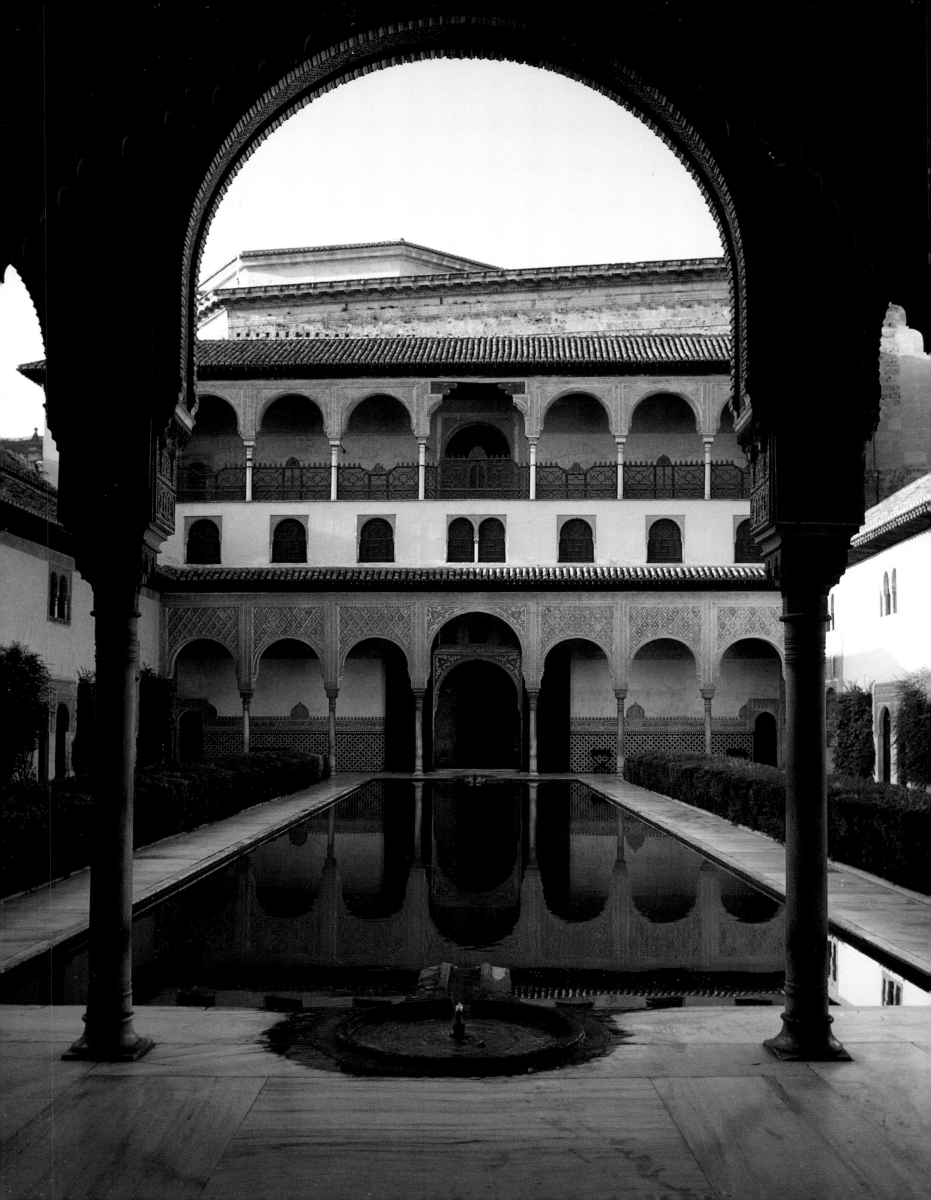

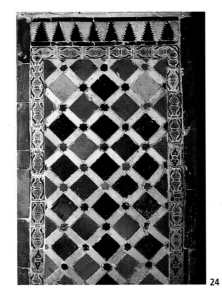

24

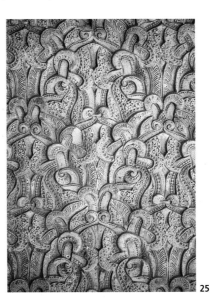

25

24, 25 *Zellij*, a ceramic tile facing cut into forms of varied complexity, and stucco, a sculpted plaster coating, are the two techniques most often used in the ornamentation of the Alhambra. *Zellij* is used for dados and stucco is used to embellish the upper parts of the walls as well as the ceilings.

The Alhambra

23 The Court of the Myrtles constitutes the centre of the administrative apartments. Its proportions are oblong and it contains a pool whose position indicates the principal axis. At either extremity is a hall formed of seven arches carved in stucco and resting on slender columns.

If the Dome of the Rock is the inaugural monument of Islamic architecture, the Alhambra is the crowning achievement of Hispano-Islamic traditions of architecture developed over a period of eight centuries in al-Andalus, the westernmost province of the Islamic world. Residence of the Nasrid kings, the last Muslim sovereigns to rule over any part of Spain, the Alhambra is an administrative, military and residential complex overlooking the urban centre of Granada.

On 2 January 1492 – the year in which Columbus discovered a new continent – the Kingdom of Granada was occupied by Isabella of Castile and Ferdinand of Aragon. Its last Muslim occupant, Muhammad XII, known in the West as Boabdil, was forced into exile and sought refuge in North Africa.

The Muslim presence in the Iberian peninsula dates from 711, when Tariq ibn Ziyad led an army of some seven thousand Berbers and Arabs across the Straits of Gibraltar, which, like the neighbouring promontory, have since been named after him, *Jabal al-Tariq*, 'Tariq's mountain'. However, al-Andalus owes its brilliant history to repercussions from the bloody overthrow of the Umayyads. The only survivor of the massacre, the young 'Abd al-Rahman, sought refuge in this distant province and proclaimed himself Amir in 756. This was the start of a flourishing period when the Spanish Umayyads made Cordoba a cultural capital rivalling both Baghdad and Cairo. The power of the Umayyads collapsed, however, at the beginning of the 11th century and they were replaced by a multitude of constantly warring principalities, the *taifas*. This political fragmentation was of great advantage to the Reconquista which, thereafter, inexorably gained

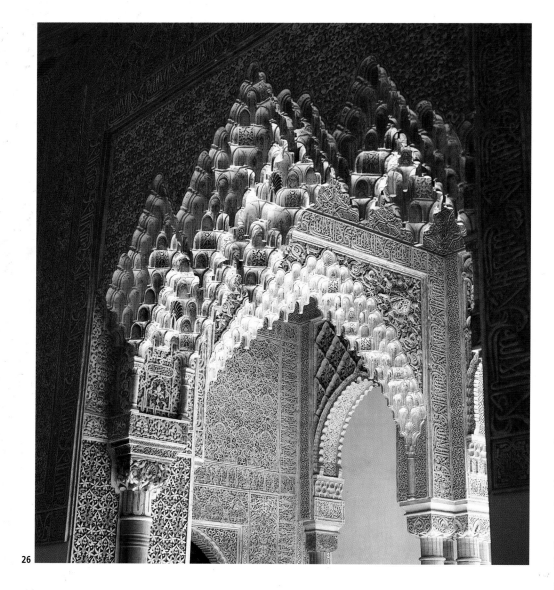

26

years until 1492. Probably already conscious at its birth of its inevitable demise, the Kingdom reached its artistic apogee in the 14th century in the reigns of Yusuf I and Muhammad V. It was these rulers who created those major constructions of the Alhambra which have survived.

The name Alhambra probably comes from the Arabic word *al-hamra'* meaning 'the red', a toponym already present at the end of the 9th century in the form *al-qal'at al-hamra'*, 'the red castle', which at that period was the name of a modest fort situated at the western extremity of the rocky spur known as Sabika, 'the ingot'. This presses up against the abutment of the Sierra Nevada and dominates the confluence of the Darro and the Genil rivers as well as the city of Granada.

Immediately after his installation in Granada, Muhammad I began the construction of a new fort on the site with a belt of ramparts punctuated by massive towers. He then had an aqueduct built to bring water to the fort from the upper reaches of the Darro. Thus the Sabika became the perfect site for the construction of a royal complex overlooking the city. Although the plans were undoubtedly the work of Muhammad I himself, this palace–city was only gradually built in the reigns of his son and grandson, Muhammad II and Muhammad III, at the turn of the 13th and 14th centuries. It was not until the last two-thirds of the 14th century that the works were carried out under Yusuf I and Muhammad V which gave the Alhambra its distinctive profile.

According to reconstructions, the royal city was composed of three principal sectors within the limits of its ramparts: the Alcazaba or military fortress, the palaces which were the seat of power as well as the residence of the rulers with the mosque nearby, and finally, the city itself which housed an entire population of artisans, merchants

26 The art of stucco is at its most spectacular in the Court of the Lions. In the two small pavilions which stand at either end of the court, the masters of stucco-work appear to have revelled in transforming the architectonic elements into veritable draperies of plaster.

27 A masterpiece of elegance, the Court of the Lions with its countless slender columns, its scalloped arches displaying carved openwork in stucco and its canals fed by small jets of water situated at ground level, is quite different from the simplicity of the Court of the Myrtles. Here the visitor enters the private palace whose cruciform structure symbolizes paradise.

ground. The Almoravids and later the Almohads came north from Morocco, establishing their domination over Muslim territories; but they were not able to stop the Christian advance. Eventually the only Muslim power left facing the Christians was the Nasrid kingdom of Granada.

In 1232, when the Almohad empire was falling apart, Muhammad ibn Yusuf ibn Nasr (Muhammad I) established the beginnings of Nasrid rule. In 1237 he installed his court in Granada, which became the capital of the last Muslim kingdom in Spain and Muslim territory was now limited to a coastal region stretching roughly from Tarifa to Almeria. However, the Nasrids recognized the suzerainty of Ferdinand III and, because of this astute political alliance, were able to hold onto the last portion of al-Andalus for a further 255

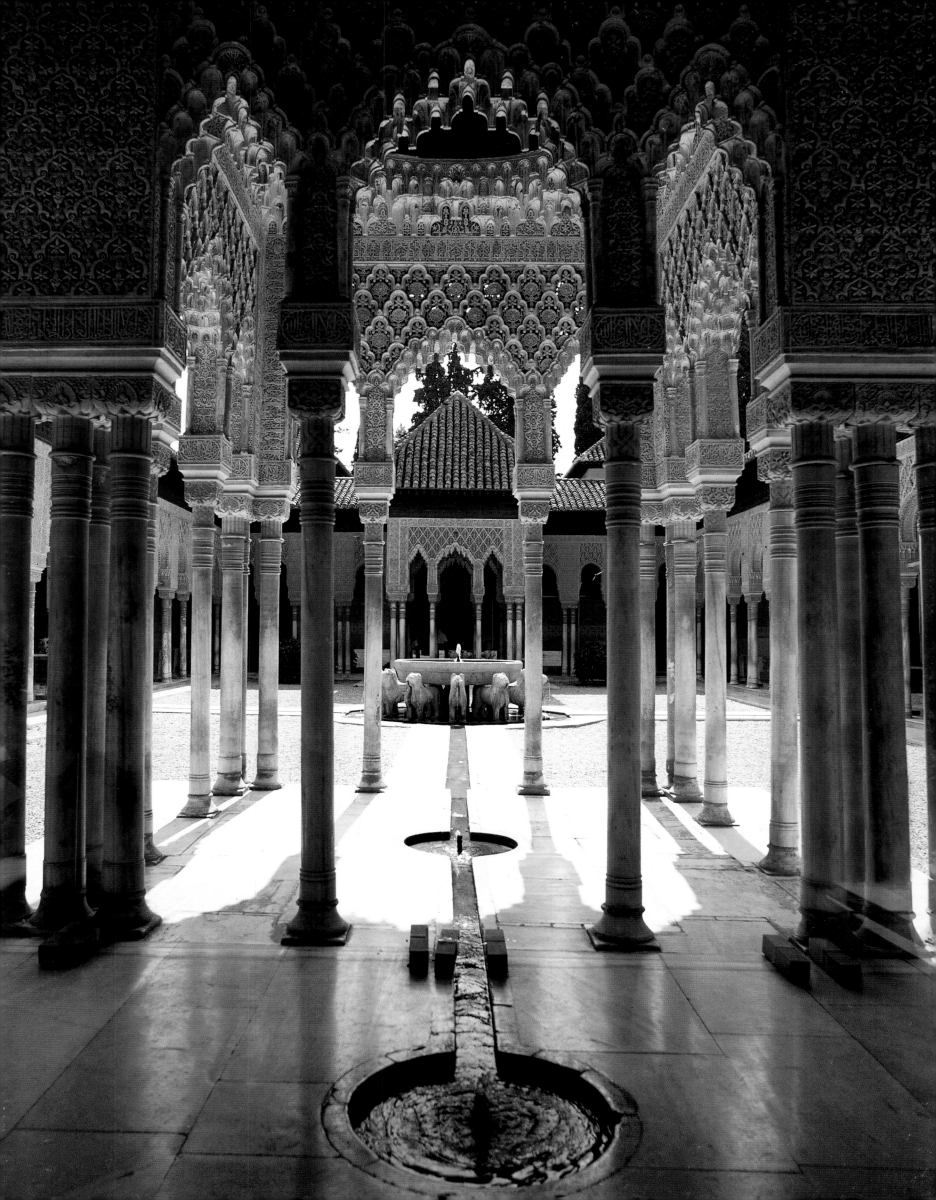

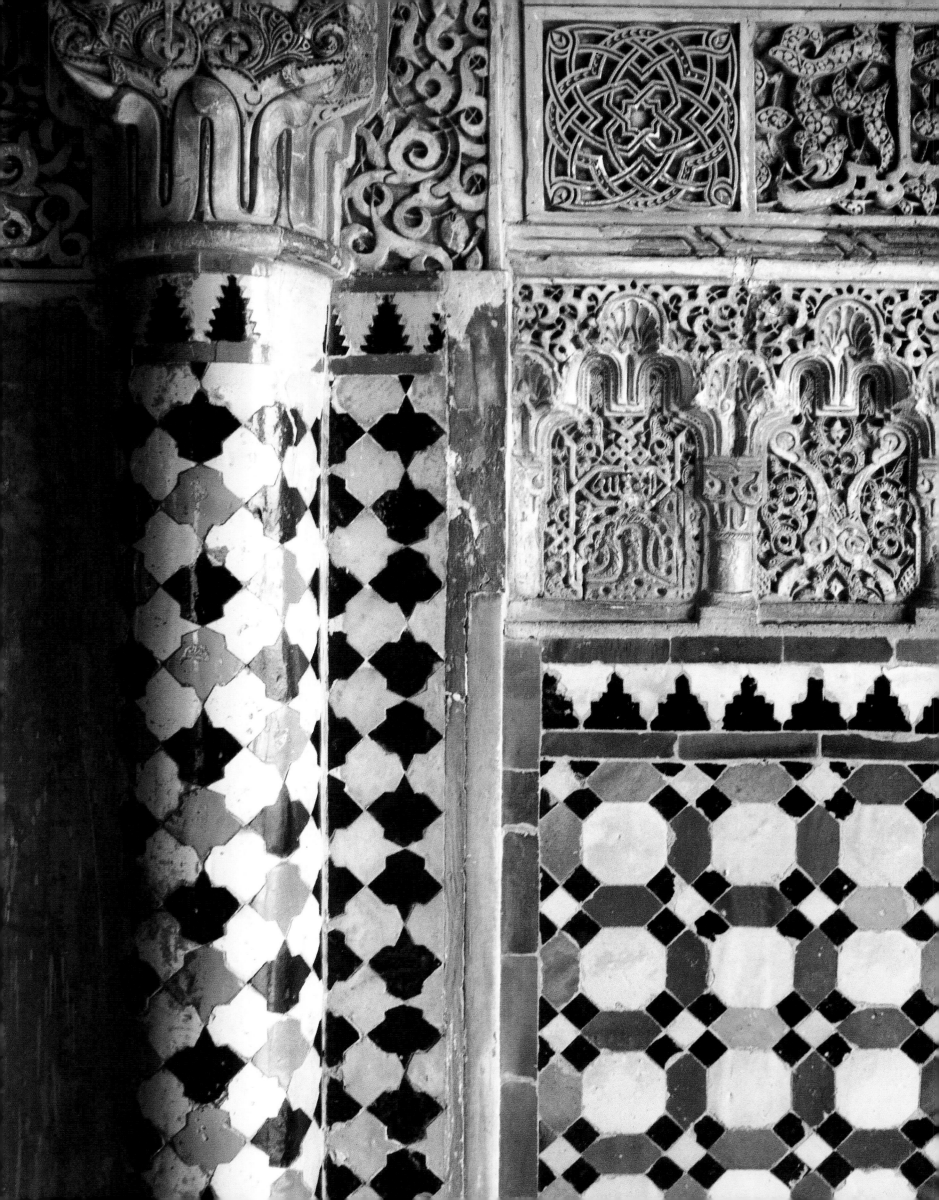

and civil servants attached to the court. Of this ensemble only the Alcazaba and the various palaces and residences installed in towers dominating the ramparts have survived. The mosque was destroyed in the middle of the 16th century and replaced by the church of Santa Maria. All the vernacular constructions have long since disappeared. The Generalife, a summer pavilion surrounded by orchards and gardens, must be considered along with the palaces since, although it was constructed outside the royal enclosure, it was in fact an essential part of Nasrid courtly life.

The Comares Palace and the Palace of the Lions, built in the 14th century at the perimeter of the northern ramparts, are the best preserved buildings in the Alhambra. What characterizes them initially is the absence of an external façade, making it impossible to perceive the edifices as monuments one might be able to walk around or even be able view in their entirety. Unlike classical Western architecture, which tends to use the outer walls of a building to reflect the power or wealth of its occupants, Nasrid palace architecture is totally introverted and can only be seen from within.

This enhancement of the interior, common in Islamic architecture, bestows on the court, or patio, a structural role of prime importance. Thus, the palaces of the Alhambra appear to be three successive interlocked interior spaces, each one turned towards a courtyard: the Mexuar, the Court of the Myrtles and the Court of the Lions. The arrangement of these three spaces corresponds, in conformity with court ceremonial, to a progress from the public into the private domain. The first stage of this progression, the Mexuar, was devoted to judicial and administrative functions. On the north side of the courtyard, the room called the Cuarto Dorado, preceded by an elegant, triple-arched portico, provided a prestigious setting for the

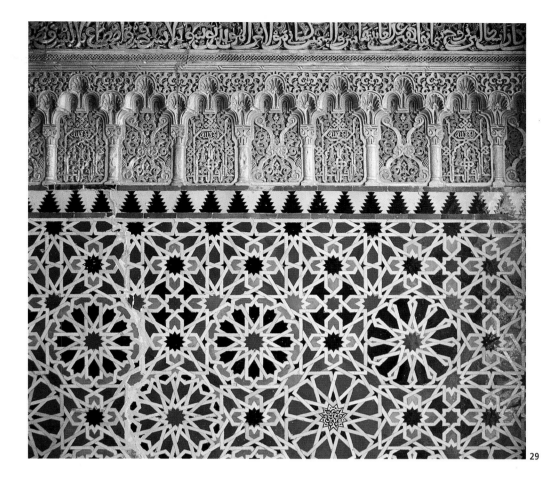

29

tribunal presided over by a *qadi* (judge) or by the sovereign himself. However, it is the south wall of the courtyard which displays the most refined ornamentation, the lower portion and the frames of the doors being covered with glazed tile mosaic, panels of finely chiselled stucco, cornices with *muqarnas*, etc. The reason for such lavish embellishment is that this wall was the threshold of the public ceremonial palace, the Comares Palace, whose centre is occupied by the Court of the Myrtles.

The Court of the Myrtles takes the form of a long rectangle. Its axis is emphasized by a pool and its northern and southern extremities are decorated with porticos, although the lateral walls are virtually devoid of ornamentation (*Ill. 23*). The disposition which favours the longitudinal axis of the court directs one's attention toward the imposing Comares tower whose ground floor houses the Hall of the Ambassadors. This is a large square room, decorated with polychromatic tile mosaic (*Ills. 28, 29*) and covered by a wooden *artesonado*

28, 29 Details of the decor in the Hall of the Ambassadors. Combining vegetal patterns and geometrical figures, the polychromy of ceramics and the interplay of light and shadow on sculpted stucco, Andalusian ornamentation was at its most refined in the Alhambra.

cupola, which was used as a throne room where the Nasrid ruler received official delegations and granted audiences.

The third space, which can be reached by going through a door in the east wall of the Court of the Myrtles, is arranged around the magnificent Court of the Lions. Unlike the previous courtyard which has a longitudinal axis designed to focus attention on the image of power, the Court of the Lions is built on a cruciform plan, marked out by four canals linking the central structure, a fountain supported by twelve stone lions, to four small pools situated at ground

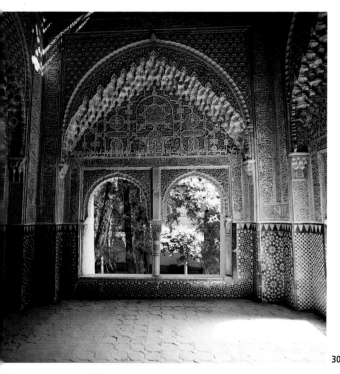

level (Ill. 27). Two of these pools, to the east and west, are surmounted by pavilions of a rare elegance (Ill. 26), and the other two are set at the centre of two magnificent halls, the Hall of the Abencerrajes and the Hall of the Two Sisters (Ill. 31), adjoining the courtyard to the south and the north. This cruciform schema clearly has a symbolic value since it follows an Iranian structure known as *chahar bagh*, 'four gardens', which is an image of paradise.

Nevertheless, even more than its spatial conception, the ornamentation of the Alhambra has played a determining role in establishing its fame. Indeed, the Alhambra can be seen as a veritable encyclopaedia of Islamic ornament. Among the techniques used, stucco, a coating mixture of plaster and marble powder which can be carved while it is still drying, predominates. The patterns thus produced give the surface of a wall a lace-like quality, usually combining geometrical and vegetal forms. When used in the decoration of vaults, as in the Hall of the Abencerrajes and the Hall of the Two Sisters, the stucco creates honeycomb compositions, *muqarnas*, of infinite complexity. The polychromatic tile mosaics, *zellij*, are reserved for the dados. Another important technique is *artesonado*, which consists of an assemblage of lengths of moulding and small wooden panels. Used in the fabrication of ceilings, it creates star-shaped patterns which can, as in the throne room, be endowed with cosmological significance.

All this ornamental profusion conceals the material reality of the edifice and produces an image of the unreal, as if the palace were meant to be no more than pure decoration, an ethereal dream far removed from the outside world. Yet among the inscriptions engraved in stucco praising the palace the motto of the kings of Granada was a premonition, perhaps, of their coming defeat: '*Wa la ghalib illa 'llah*', 'Only God is victorious.'

30 The Mirador de la Daraxa adjoining the Hall of the Two Sisters, is a pavilion with particularly delicate stucco decor. During the Nasrid period, and before Charles V constructed the imperial apartments, it had a clear view of the valley.

31 The cupola of the Hall of the Two Sisters, entirely covered with *muqarnas* in stucco, is astonishingly complex. As if suspended above a series of sixteen high windows, the cascade of alveoli which covers the room seems to defy all architectural laws. A verse of the court poet, Ibn Zamrak, reproduced on the walls of the Hall of the Two Sisters praises this masterpiece: 'The splendour of this cupola surpasses the splendour of the heavenly canopy.'

30

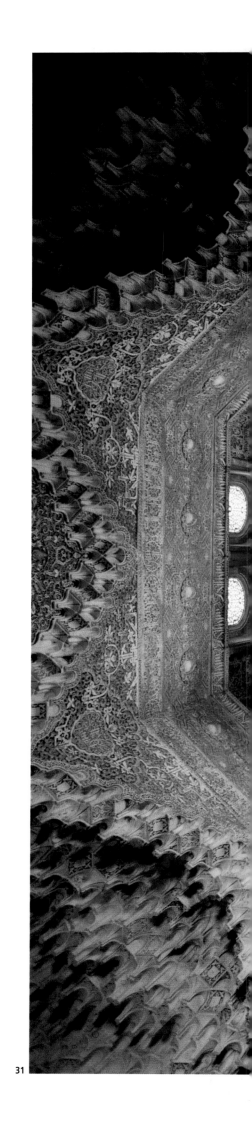

31

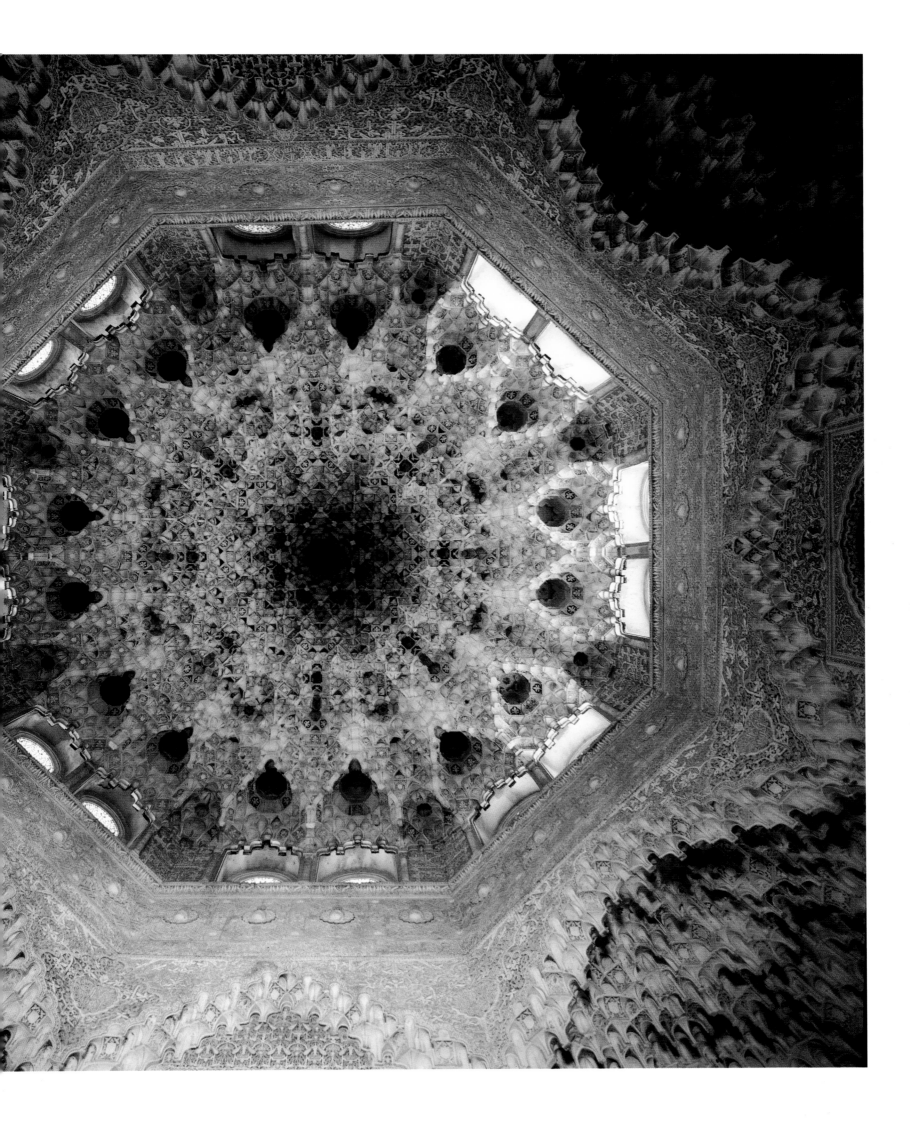

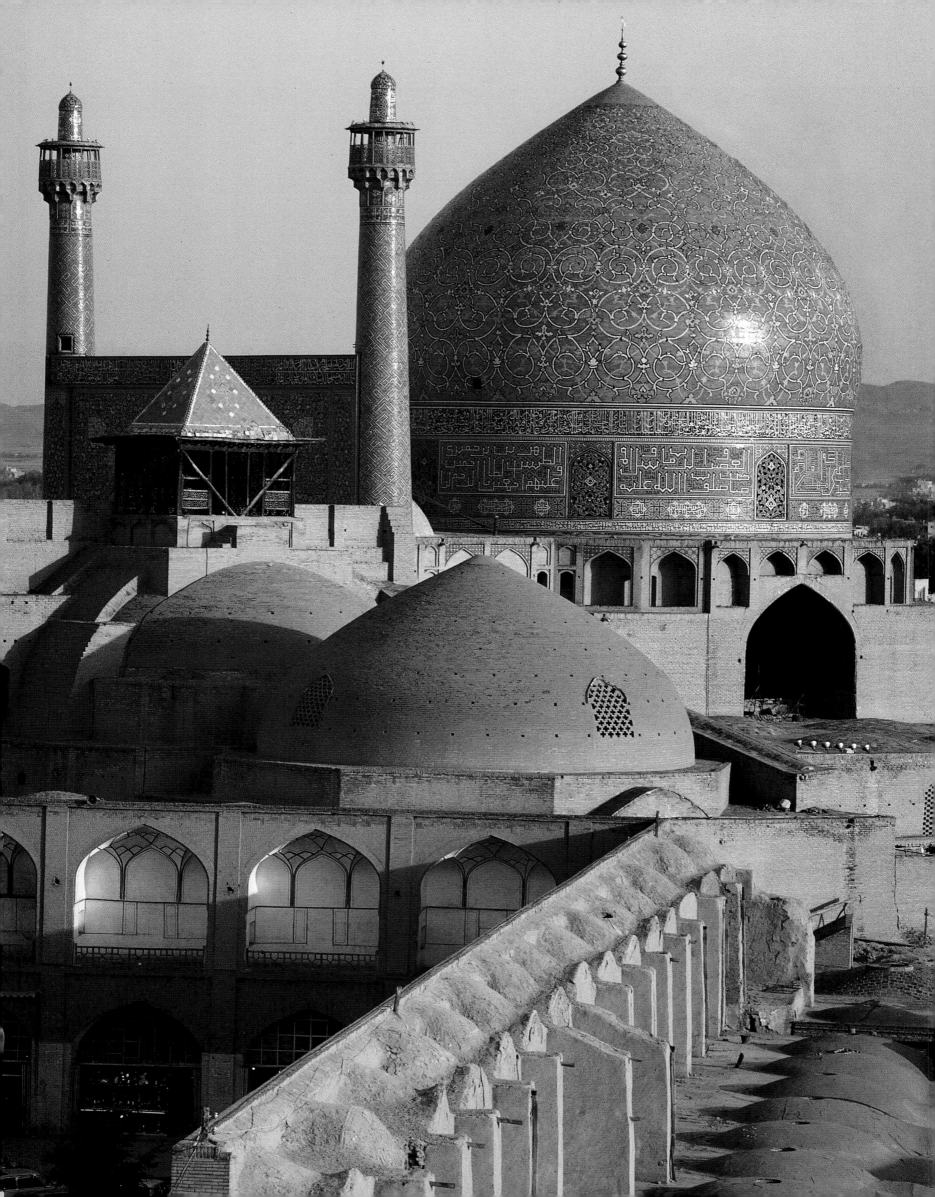

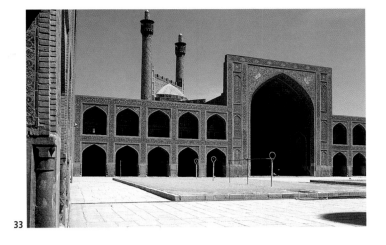

The Shah Mosque

32 As seen from the terrace of the 'Ali
Qapu, the Shah Mosque appears to be
a complex ensemble of walls, arches,
vaults and cupolas, from which emerge
twin minarets and a dome covered with
glazed tiles in a dominant blue. Its difficult
legibility can be explained by the fact
that the building was not conceived
to be apprehended from the exterior,
only revealing itself in all its formal
rigour from inside.

Overleaf

34 Working almost exclusively with brick,
Iranian builders created magnificent vaults.
The lines of force which structure the half-
dome covering the northwest *iwan* of the
Shah Mosque stem from a layout based
on two squares intersecting each other
at 45 degrees. Out this geometrical
schema bursts the pattern of a star.
Whereas the geometrical rigour invokes
the perfect order of the celestial world,
the vegetal ornamentation realized in
glazed tile mosaic testifies to the Persian
love of gardens.

The Shah Mosque, *Masjid-i Shah*, of
Isfahan, now dedicated to the Twelfth
Imam, was built by the Safavid ruler
Shah 'Abbas from 1611 onwards in
order to endow his new capital with
a congregational mosque reflecting
the splendour of his reign. Both by its
structure and by the importance given
to ornamentation it is seen as the
classical expression of a specifically
Iranian model. This model, which
Persian builders began to develop with
greater confidence in the 11th century,
is known as the four-*iwan* mosque.

Following a rigorously logical use
of space, the plan of the building is
arranged in a cruciform design. At the
centre is a courtyard whose two axes
are emphasized by monumental arches,
called *iwan*s, each opening onto an
interior façade. The ornamentation
consists of a polychromatic ceramic
sheath, predominantly blue-green in
colour, covering most surfaces visible to
the worshipper. The formal perfection

of the Shah Mosque may seem cold
to some, but careful analysis reveals
that it is an excellent demonstration
of the symbolic meaning of the edifice.

The historical prototype of the
mosque is, as we have seen, the house
built by the Prophet Muhammad when
he installed the Muslim community in
Medina in 622. This house was described
by Arab historians as an open space,
delimited by a wall of dry brick and
provided, on the side of the *qibla* – the
direction of prayer – with a portico
supported by the trunks of palm trees.

With the expansion of Islam into the
former territories of the Byzantine and
Sasanian empires, this rustic structure
gave birth to a more elaborate type of
building composed of two basic parts:
a courtyard surrounded by porticos and,
on the side facing Mecca, a prayer hall
whose roof was supported by a forest
of columns linked together by a series
of arches. This development, which is
known as the hypostyle mosque, spread

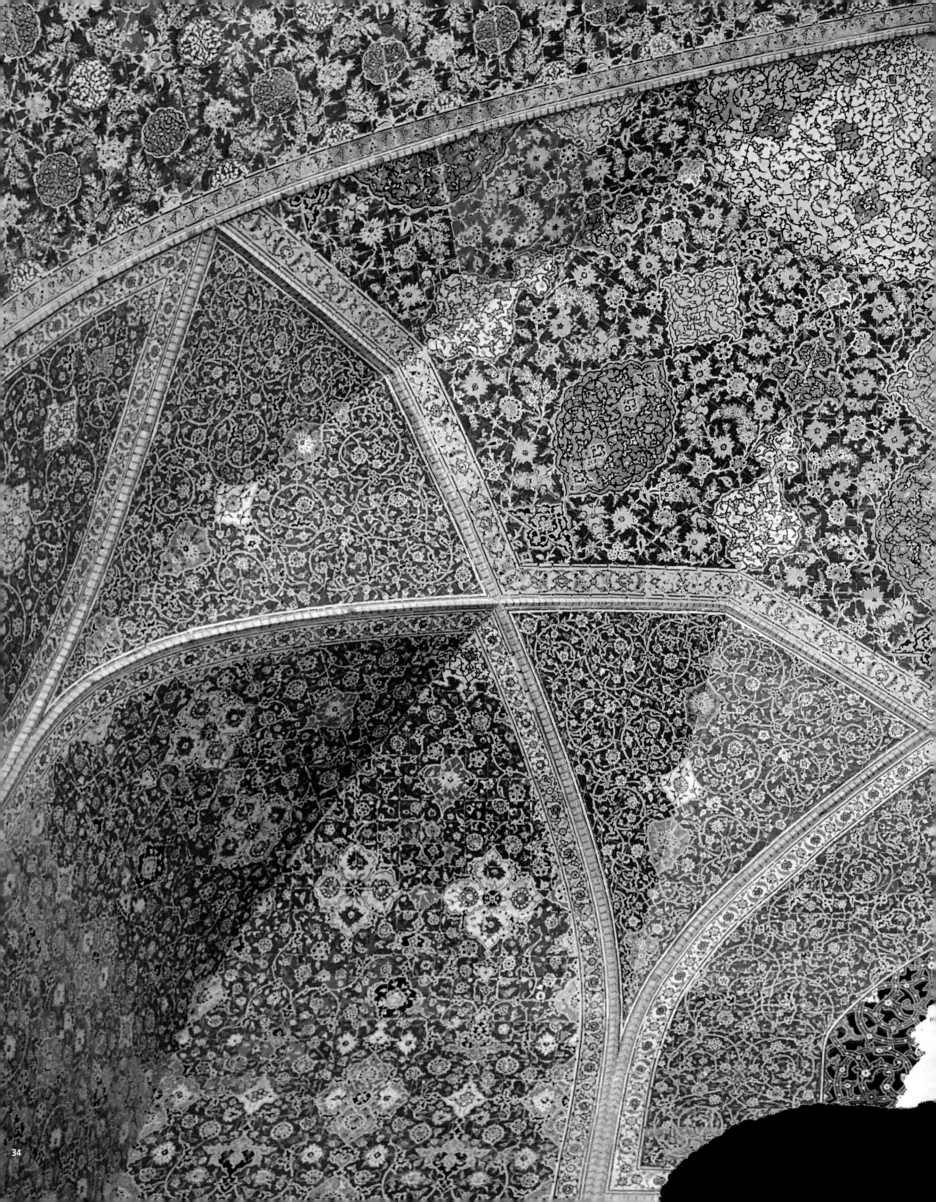

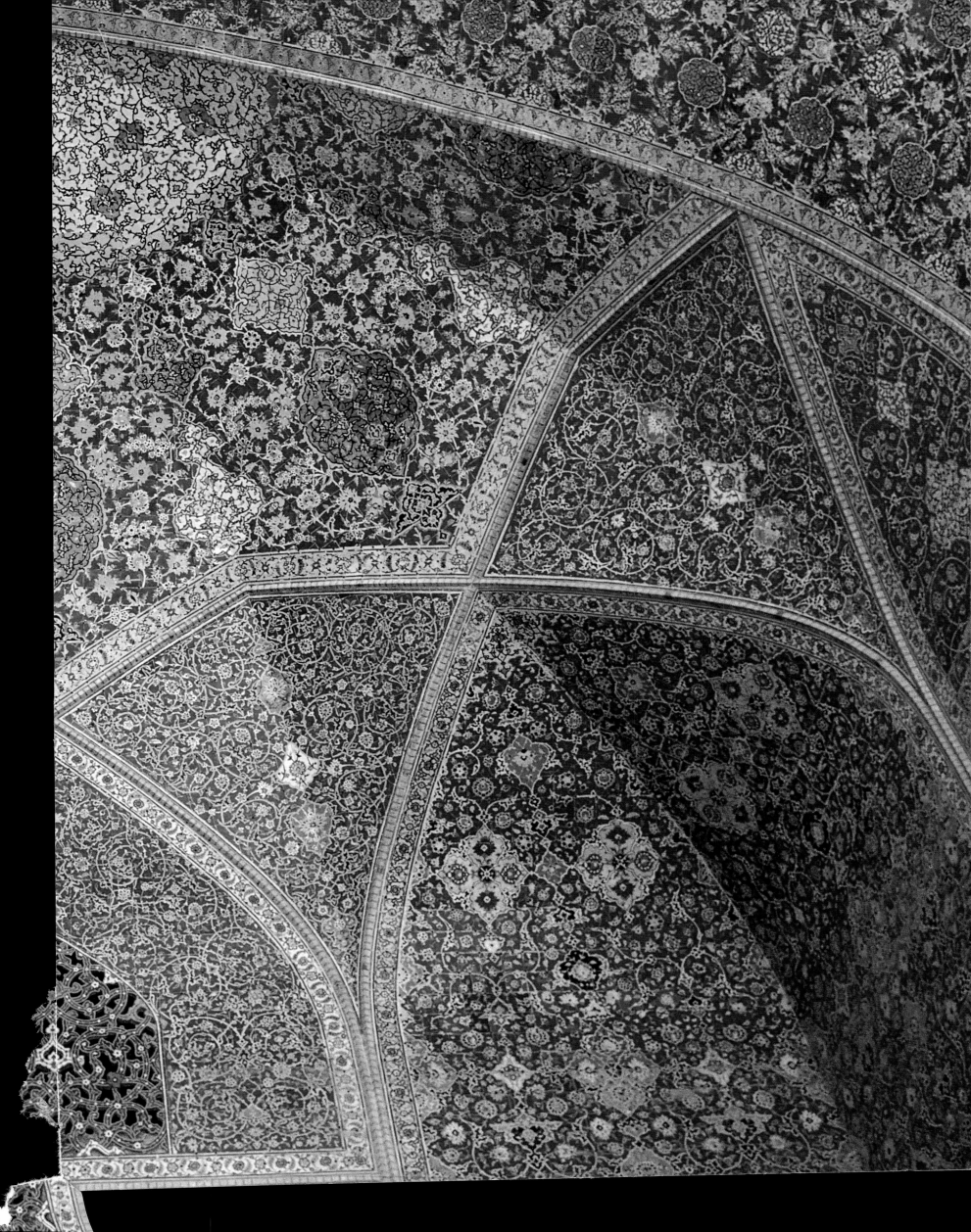

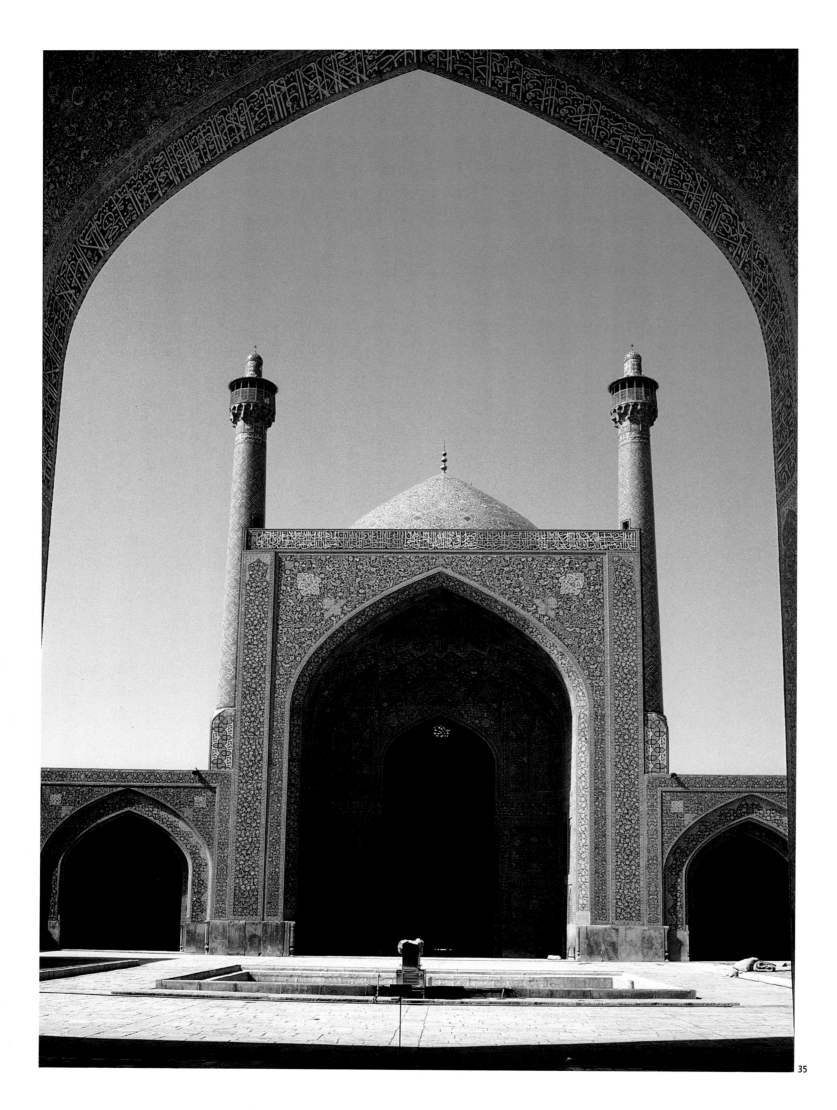

with local variations throughout the Muslim empire in the first centuries of the hijra.

Although the first mosques built in Iran followed this model, there very quickly appeared certain distinctive traits such as those which we can still see in the Friday Mosque of Na'in, north-east of Isfahan. Whereas in early Arab hypostyle mosques the arches linking the columns often developed into arcades, in the Persian variant the supports – usually pillars – are generally linked to each other crosswise, thus creating square spatial units covered by vaulted intersections. Another Persian trait connected to this is the tendency to transform the porticos looking onto the courtyard into actual rooms, imitating the example of the prayer hall. These simple differences in the spatial structuration, which can be partly explained by the Persian technique of brick construction, reveal a preference for a more static concept of space.

The most important innovations appeared, however, at the end of the 11th century and at the beginning of the 12th during the alterations carried out on the Friday Mosque of Isfahan (Ill. 64). The Friday Mosque had followed the general model of the hypostyle mosque in its initial form but, during the Saljuq period, elements borrowed from an older Iranian architectural repertoire were added. The four iwans, inherited from Sasanian palace architecture, mark the four sides of the courtyard and a cupola, derived from Zoroastrian religious architecture, indicates, beyond the principal iwan, the hall containing the mihrab. Compared to the great Arab hypostyle mosques, such as the Ibn Tulun in Cairo or those of Qairawan and Samarra, the Friday Mosque of Isfahan presents an entirely new, strongly accented, central symmetry. This new architectural model continued without any fundamental modifications into the reign of Shah 'Abbas I.

The Safavid dynasty had its origins in the north-western provinces and was the first independent indigenous dynasty to unite Iran since the Islamic conquests. Its founder, Shah Isma'il, established his rule at the beginning of the 16th century. Probably the most enduring result of the Safavid rise to power was the adoption of Twelver Shi'ism as the state religion.

Shi'ism designates the minority heterodox sects of Islam in contrast to the dominant Sunni orthodoxy. According to certain branches of Shi'ism, the time of the Prophet's revelation was followed by a period of interpretation, that is, exegesis of the hidden meaning of the Qur'an. Authority was bestowed on a series of Imams, descendants of the Prophet via his son-in-law and cousin 'Ali. Twelver Shi'ism, the most numerous branch of Shi'ism, recognises twelve Imams, hence its name.

It was during the reign of Shah 'Abbas I that the Safavid court left Qazvin, south of the Caspian sea, to

35 The main iwan, a monumental arch indicating the direction of Mecca and opening onto the prayer hall is flanked by two identical minarets. This symmetrical composition is prolonged into the smaller lateral arches.

36 The northwest iwan is distinguished by the goldasta, a small pavilion from which the imam addresses the crowd gathered in the courtyard.

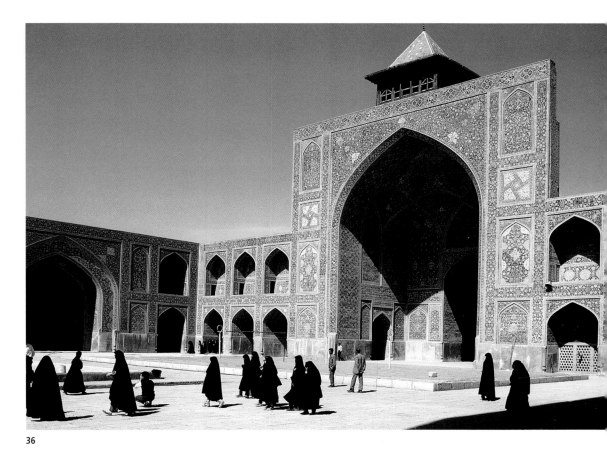

36

establish itself in Isfahan at the heart of the empire. Although the city had been embellished by powerful rulers under the Saljuqs, the works undertaken by Shah 'Abbas between 1598 and 1628 radically altered its appearance. To the old Saljuq city, centred around its Friday Mosque and the bazaar with its twisting streets, was joined a new city, planned throughout and endowed with parks set around a great avenue, the Chahar Bagh. The Safavid city aroused the admiration of various Western travellers, including Jean-Baptiste Tavernier who stayed in Isfahan in the middle of the 17th century.

The most remarkable part of this exercise was the series of official buildings, laid out in an elaboration of the four-*iwan* plan around the Royal Square (*Maidan-i Shah*), a rectangular space where military parades and polo games took place. On the north side of the square an imposing gate gave access to the old city, on the west stood the 'Ali Qapu, the entrance pavilion of the palace complex, on the east the small mosque of Shaikh Lutfallah and on the south the great Shah Mosque.

Nowadays dedicated to the twelfth, or hidden, *Imam*, the Shah Mosque when it was built was not only a place of worship but a symbol of the prestige of the sovereign. Since the mosque of Shaikh Lutfallah was too intimate to accommodate court ceremonial, Shah 'Abbas undertook the construction of this new mosque in 1611. The work, which took twenty years, was supervised by the architect Ustad Abu'l-Qasim. Despite the time it took, the mosque was built as a single concept and has remained unaltered, which explains its remarkable unity.

Given the north–south orientation of the Royal Square and the orientation of the *qibla* to the south-west, it was necessary to turn a forty-five degree angle from the entrance portal to the interior of the building. This explains the effect of asymmetry which can be observed from outside. Nevertheless, when one enters the courtyard, everything seems to be dominated by the greatest formal rigour. At the centre of the courtyard is a rectangular pool. To the right and the left, two *iwan*s of equal width stand face to face, interrupting the continuity of the double gallery of superposed arches. In front stands the main *iwan* which is larger than the others and is flanked by two minarets (*Ill. 35*). Above its façade one can see the cupola of the *mihrab* hall. All this contrives to give the viewer the sense of being at the heart of a perfectly rational structure laid out following laws as precise as those of crystallography.

A mathematical analysis of the plan confirms this sensation. Each part of the building owes its dimensions and its exact position to the application of rigorous geometrical rules. But what is most interesting to note is that this logic developed from those elements which were in principle the least architectonic, namely the vacant space of the courtyard and its central pool. The proportions of this rectangular courtyard correspond to those of Pythagoras's right-angled triangle: short side = 3, long side = 4, diagonal = 5. From this there follows a series of geometrical properties which dictate the dimensions of the central pool, then the width of the *iwan*s as well as that of the cupola overlooking the *mihrab* hall and so on, down to the dimensions of the two courtyards flanking the main courtyard. The fact that the entire edifice derives from a simple pool is undoubtedly significant. Situated at the intersection of the two axes marked by the *iwan*s, this pool appears – to the detriment of the *mihrab* hall – to be the actual structural centre of the edifice. Although Islam requires the faithful to pray in the direction of Mecca, the four-*iwan* mosque thus presents itself as a place endowed with a cosmic character and designed, as Henri Stierlin would say, 'to put the believer in direct contact with the divine'.

The Shah Mosque also owes its visual impact to the sumptuous polychrome sheathing that covers all the surfaces turned towards the court, as well as the entrance portal and the great dome. Although the technique varies according to the placement: an assemblage of enamelled brick for the cupola and the minarets, glazed tile mosaic for the *muqarnas* vaults and certain particularly refined details and polychromatic ceramic tiles – a more rapid technique known as *haft rang*, or 'seven-colour' – for large mural surfaces. As for the motifs,

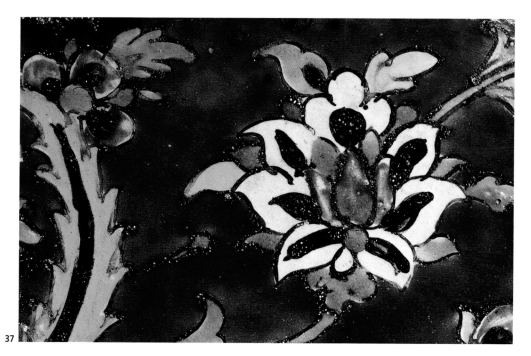

37

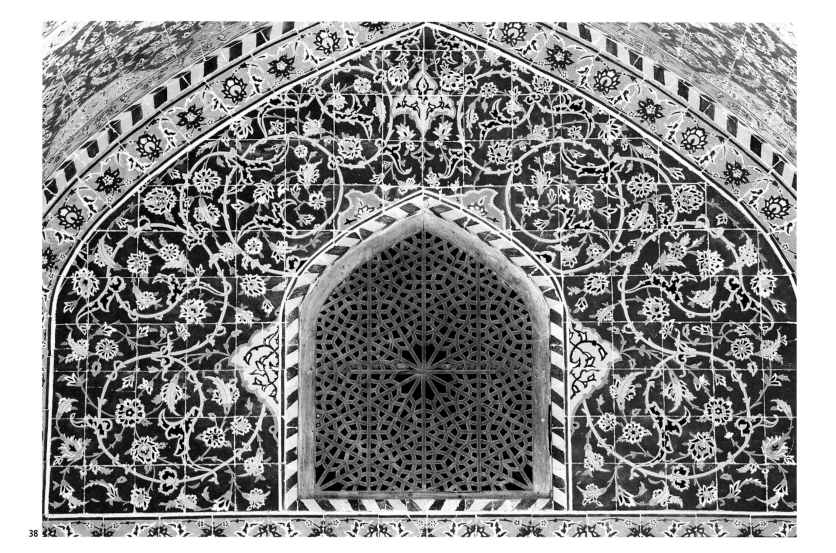

38

aside from the epigraphic bands underlining certain structural axes and the star-shaped polygons which are part of the internal logic of the *muqarnas*, the great majority are vegetal, lending themselves to decorative compositions resembling the Safavid carpets produced by the royal workshops in Isfahan.

Dressed in this ornament with its endlessly repeating pattern of flowers and which, according to the angle of the light, can become a reflecting surface, the building takes on the appearance of an objet d'art and transforms itself into pure decor. Apart from any salient forms such as cornices and pilasters, the ceramic sheath with its smooth surface and keen edges tends to reduce the building to a series of abstract planes.

This sensation of an architecture which defies the laws of gravity is also due to other details. For example, the ceramic sheathing covers the surface only above a certain height. Beneath is an uninterrupted ochre marble dado. Thus the edifice seems to float above the ground.

A final important point is the choice of colours. Although the ceramics of the Shah Mosque include white, black and a reddish ochre, it is the blues, yellows and greens which predominate, conferring on the global structure a shade of turquoise similar to that of the sky above Isfahan. The azure robing transfigures the ordinary brick and the luxuriant plant motifs offer an image of the heavenly gardens which have been promised to the devout Muslim.

37 Detail of a glazed tile facing produced using the *haft rang*, 'seven–colour', technique. Faster to make than the traditional ceramic mosaic, the procedure consists of painting the motif directly onto the clay tiles which are then fired a second time.

38 This ceramic panel, framing a small bay window fitted with a wooden grill, offers a perfect example of the Safavid vegetal arabesque. The composition is structured by a series of large symmetrical scrolls upon which are scatterings of stylized lotus flowers and peonies.

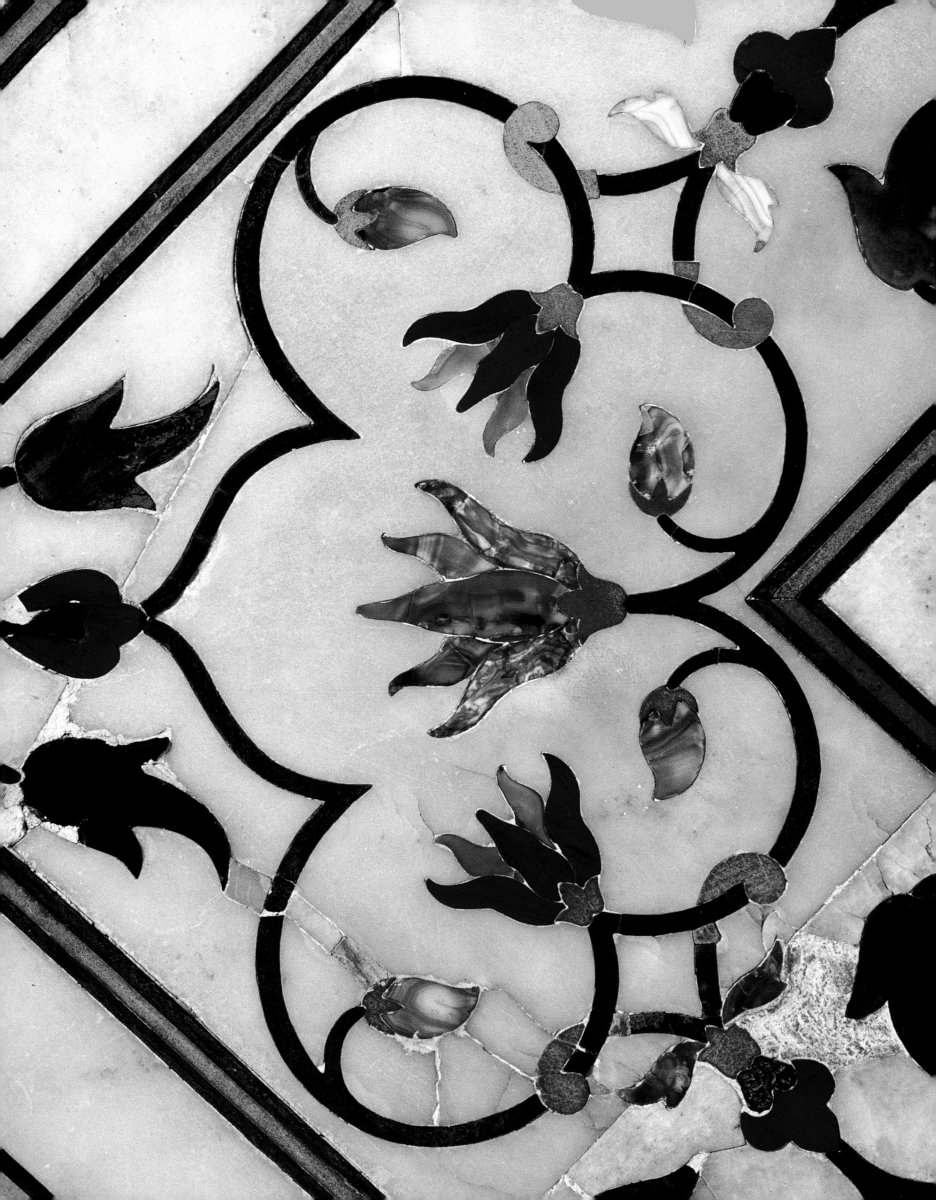

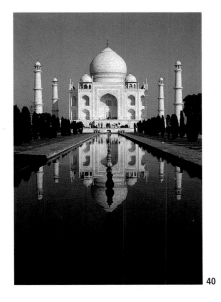
40

40 General view of the Taj Mahal with its reflection in the longitudinal canal of the garden.

41 Detail of a corner pillar covered with black and white marble facing.

41

The Taj Mahal

39 The main architectural ornament of the Taj Mahal consists of the inlay of semi-precious stones in white marble. Some historians have suggested the influence of Renaissance Italian marble marquetry. The patterns are mostly inspired by vegetation and are either treated quite realistically or, as in this detail, display marked stylization.

Overleaf

42 The Taj Mahal seen from the banks of the Yamuna river at daybreak. The mausoleum is flanked by two symmetrical buildings: a mosque on the right and a guest house on the left.

The Taj Mahal, situated on the banks of the Yamuna river at Agra some 150 kilometres south of Delhi, is the most famous mausoleum in the Islamic world. Constructed between 1631 and 1643 by the fifth Mughal ruler Shah Jahan, to house the tomb of his wife, the complex which has become known as the Taj Mahal owes its fame in part to the white marble facing which completely covers it, to its inlay of semi-precious stones and to the perfect harmony of its proportions.

Along with these formal aspects, another reason for its immense popularity is its sentimental history. Mughal historiography presents the Taj Mahal as a testament to the love of the Emperor for his second wife, Arjumand Banu Begum, whose title was Mumtaz Mahal, or 'the chosen one of the palace', and who died in 1631.

However that may be, a monument

of such magnificence served more than the commemoration of a beloved wife. It also allowed Shah Jahan to leave behind physical evidence of the sheer splendour of his reign and as such it has taken its place among the prestigious funerary monuments so characteristic of Mughal architecture.

Babur, king of Ferghana – a small Central Asian state – and a direct descendant of Tamerlane, founded the Mughal dynasty. Driven from his domain by the Uzbeks, he set out from Kabul at the beginning of the 16th century to conquer India. The Mughal Empire, which lasted over three centuries from 1526 to 1857, constitutes the most flourishing era in the history of Muslim India, notably under the rule of the Great Mughals: Akbar, Jahangir, Shah Jahan and Aurangzib. Active patrons of painting and architecture, these rulers can be seen as the originators of a

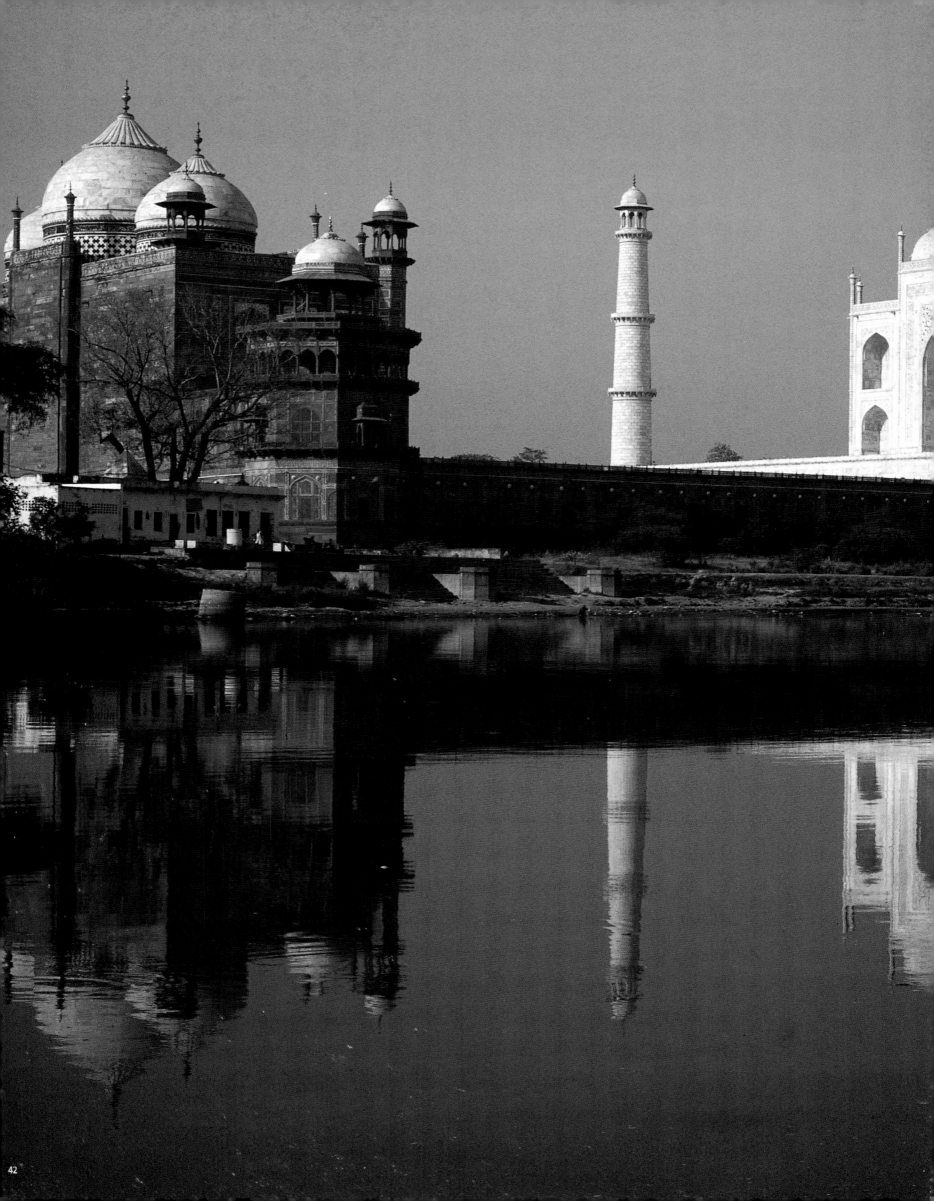

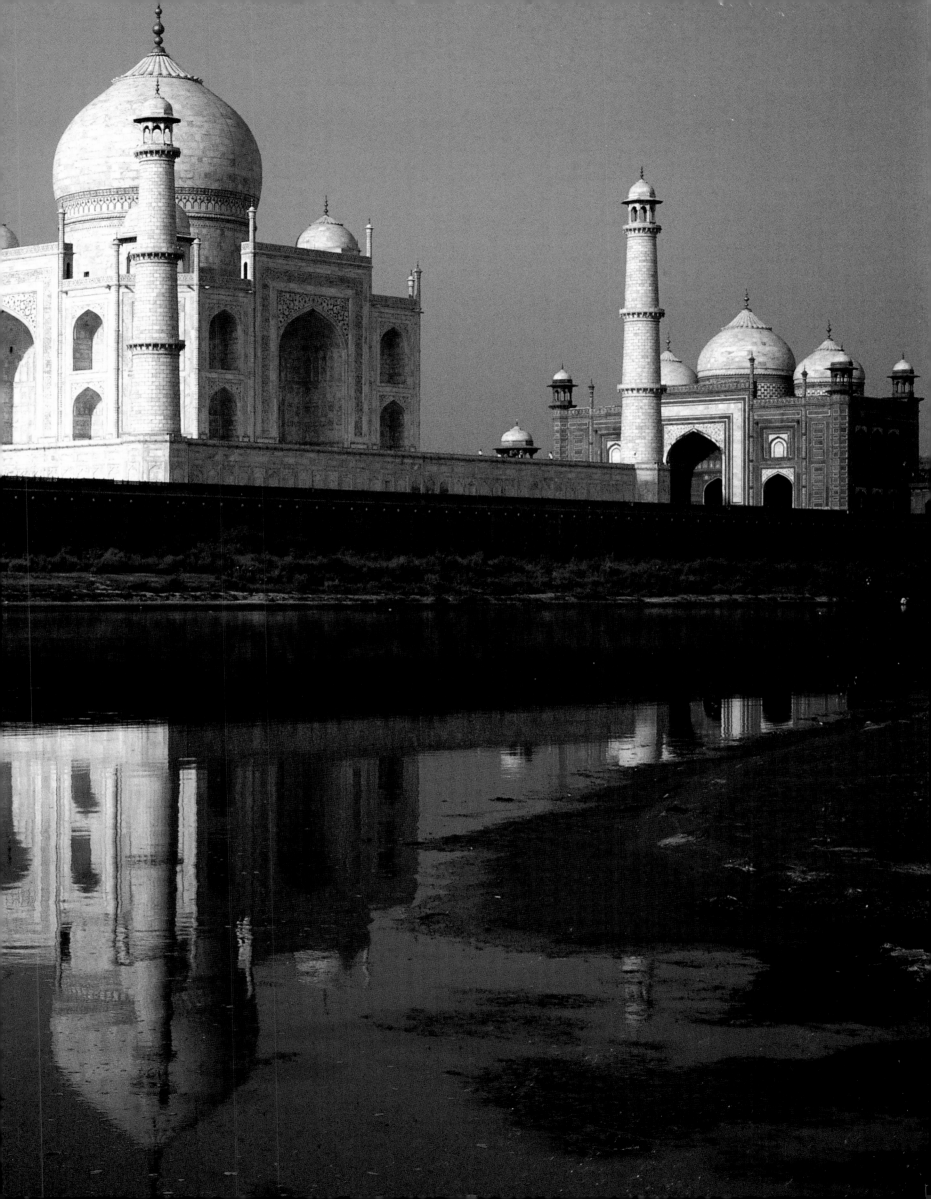

43

strongly personalized art placed at the junction of diverse stylistic traditions.

Mughal architecture in its most commonly displayed traits deftly combines Persian and Hindu traditions. From the former, it borrows elements such as the *iwan*, the pointed arches and the cylindrical minaret, from the latter, its massive architectonics with superposed entablatures and a fondness for red sandstone. Jahangir (ruled 1605–27), however, was to give a lighter touch to Mughal architectural style. Marble replaced sandstone and an inlay of gems tended to replace sculpted motifs. Indeed during the reign of Shah Jahan (1628–58), an enthusiastic builder, Mughal architecture reached its apogee. The use of white marble and semi-precious stone inlay became widespread, multifoiled arches proliferated and proportional ratios received ever more precise attention.

The numerous architectural projects of the Great Mughals include, most importantly, the imperial city of Fatehpur Sikri to the west of Agra, constructed by Akbar in the years around 1570, the Red Fort of Agra, with its palace and its mosques, built by Akbar, Jahangir and Shah Jahan, and the Great Mosque of Delhi, constructed by Shah Jahan in 1650. However, it is the mausoleum which has particular significance in Mughal architecture. The history of the Mughal dynasty is punctuated by a series of sumptuous funerary edifices: the mausoleum of Humayun (1565) in Delhi, that of Akbar (1613) in Sikandra near Agra, the mausoleum of I'timad al-Daula (1622–28) in Agra *(Ill. 78)*, and that of Jahangir (1637) near Lahore *(Ill. 160)*, etc.

Although their basic purpose was to legitimize Mughal power, these dynastic mausoleums are also architectural works of a most distinct religious symbolism. Invariably situated in gardens and laid out on a central plan dictated by a geometry associating squares, circles and octagons, these buildings contain a sense of the divine often echoed by their epigraphic ornamentation. Of the many extant examples of Mughal funerary architecture, the Taj Mahal is the most refined expression of this tradition.

As with other Mughal mausoleums, the Taj Mahal is not an isolated building. It is an edifice which has been carefully set in a complex of constructions and gardens and is located at the northern limit of an immense rectangle bordered by high walls. On either side of the Taj Mahal stand two symmetrical buildings in red sandstone. To the west is a mosque and to the east a guest house. At the other extremity of the enclosure, to the south, there is an entrance, also built of red sandstone. In front of this stand two commercial buildings, a caravanserai and a bazaar, whose revenues were used for the maintenance of the mausoleum. Between the two constructed zones are a series of gardens conceived on the Persian model of the *chahar bagh*. They

form a vast square, approximately three hundred metres in length, divided in four by canals which intersect each other at right angles. Where they intersect, a pool reflects the white mausoleum.

Thus endowed with its perspective by the disposition of the gardens, the Taj Mahal confronts the spectator in all its majesty. The central body, set upon a square terrace as if upon a pedestal, is composed of a cubic volume with bevelled edges. This is dominated by a bulb-shaped dome which towers more than seventy metres above the gardens. Set within each of the four façades, is a monumental portal flanked on two levels by smaller arches. Its dome is surrounded by four small pavilions adorned with cupolas. Four minarets, separated from this principal volume and situated at each corner of the terrace, mark the limits of the architectural composition.

To create this masterpiece, whose planning alone lasted two years, Shah Jahan is said to have summoned a series of architects. It is not known, however, who was chief among them. Could it have been Ustad Ahmad Lahori, an architect–mathematician, or perhaps Mir 'Abd al-Karim (to whom the Emperor gave the title Ma'mur Khan), or Mulla Murshid Shirazi, also known as Mukarrimat Khan? If historical documents do not designate a single architect as creator of the monument, perhaps it is because Shah Jahan himself was responsible for its conception. After all, he is known to have drawn up the plans for the Shalimar gardens in Kashmir when he was still Prince Khurram.

Whatever the identity of the man who conceived the Taj Mahal, we can see clearly from an analysis of its structure that, like earlier Mughal mausoleums, it derives in part from the architectural traditions of Persia and Central Asia and in part from Hindu principles of construction. Thus, the layout around the central space,

which is occupied by the funerary chamber, of eight contiguous octagonal rooms set on two levels, reflects the Persian model known as *basht bibisht*, or 'eight paradises'. Further, the articulation of the façades of the Taj Mahal, each with its central *iwan*, can be seen as an equivalent of the façades facing the courtyard in Iranian mosques, except that in this case they are turned outwards.

Nevertheless, if it is true that geometry is the ultimate determinant in the conception of the Taj Mahal, as it is in the constructions of Iran and Central

Asia, one significant element appears when one considers the relationship between the constructed volumes and the interior spaces. Whereas the interior spaces in the Islamic monuments of Central Asia, Iran and even the Near East are usually delimited by thin walls, here they seem to be carved out of a compact mass of masonry. This type of architectonic conception seems to be a continuation of the carved-out monolithic aspect of Hindu temples. Moreover, certain of the architectural elements of the Taj Mahal descend directly from local tradition, including

43 Spreading their leaves and flowers on either side of a central stem, as on the pages of a herbarium, the plants sculpted in white marble which flank the main entrance of the Taj Mahal at the base of the wall, demonstrate an exceptional degree of realism for Islamic art.

44

44 Window equipped with a marble grill situated at a corner of a façade of the mausoleum.

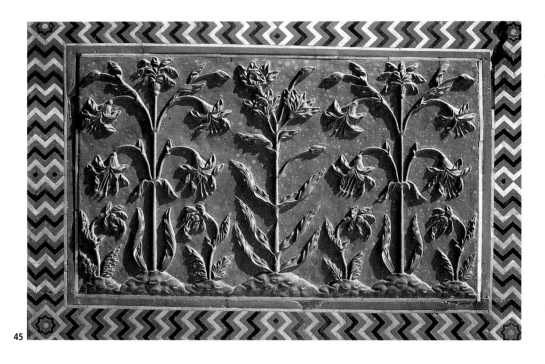

45

45 Produced with less finesse than the white marble reliefs of the Taj Mahal, the plant sculptures decorating the guest house east of the mausoleum seem to have been produced by less experienced craftsmen, or to have been made more quickly. Whatever the case, this relative rusticity is perfectly suited to the austerity of the red sandstone.

46 One of the four entrances to the mausoleum.

47 The guest house. Ornamental detail associating bas-relief sculpture and an inlay of black and white marble in the red sandstone.

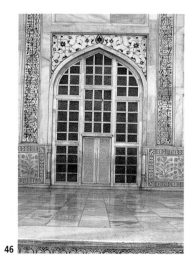

46

the four pavilions with their cupolas which surround the central dome and which are known as *chhatri*.

Although it is often said that the Taj Mahal is entirely built of white marble, it is in fact a brick building. The white marble from the Makrama quarries is simply a facing which covers the internal structure. This regal robing, whose pale shimmering colour evokes light, renders the building almost unearthly compared to the other constructions in the funerary complex; but the full transformation of the edifice achieved by its ornamentation only becomes apparent as one draws nearer.

The two main ornamental techniques used in the Taj Mahal are bas-relief sculpture displayed on the casing at the base of interior and exterior walls, and the technique known as *pietra dura* which consists of an inlay of varicoloured stones in the white marble. For the calligraphic inscriptions which underline the framework of the *iwan* on each façade, black marble was used. For the rest of the ornamentation, which displays a dominant vegetal element, a multitude of semi-precious stones of diverse origins were used: yellow amber from Burma, lapis-lazuli from

Afghanistan, nephrite from Chinese Turkestan, cornelian, agate, amethyst, jasper, green beryl, chalcedony, onyx and coral from different regions of India. This ornamental technique, although most heavily concentrated in the burial chamber, is also found in the decorative friezes on the outer walls and has contributed to the fame of the building.

The motifs chosen for this decoration were mainly floral, including lilies, narcissi, irises and tulips. Even more remarkable is the degree of realism with which the various plants are represented. They may be arranged as formal sprays in vases or stylized friezes, but they are also often shown with their bare roots or growing in little mounds of earth. By the curvature of their foliage or their petals, these plants seem to distance themselves from Persian models, suggesting instead a possible Western influence. It is thought that their inspiration came from engravings in European herbaria of the early 17th century, introduced to the Mughal court by Jesuit missionaries. As in these Western botanical plates, insects and butterflies are found alighting on the sculpted and inlaid plants of the Taj Mahal.

However, if certain aspects of this floral ornamentation drew inspiration from European models, its global sense remains Islamic. When set on the walls of a mausoleum, this luxuriant vegetation is designed to recall the gardens of paradise. It is, in fact, this paradisiacal meaning which is emphatically underlined by the inscriptions on the Taj Mahal. On the southern façade of the entrance gate can be seen the eighty-ninth *sura* of the Qur'an, 'The Dawn', inscribed in black marble, ending with these words: 'But ah! thou soul at peace! Return unto thy Lord, content in His good pleasure! Enter thou among My bondmen! Enter thou My Garden!'

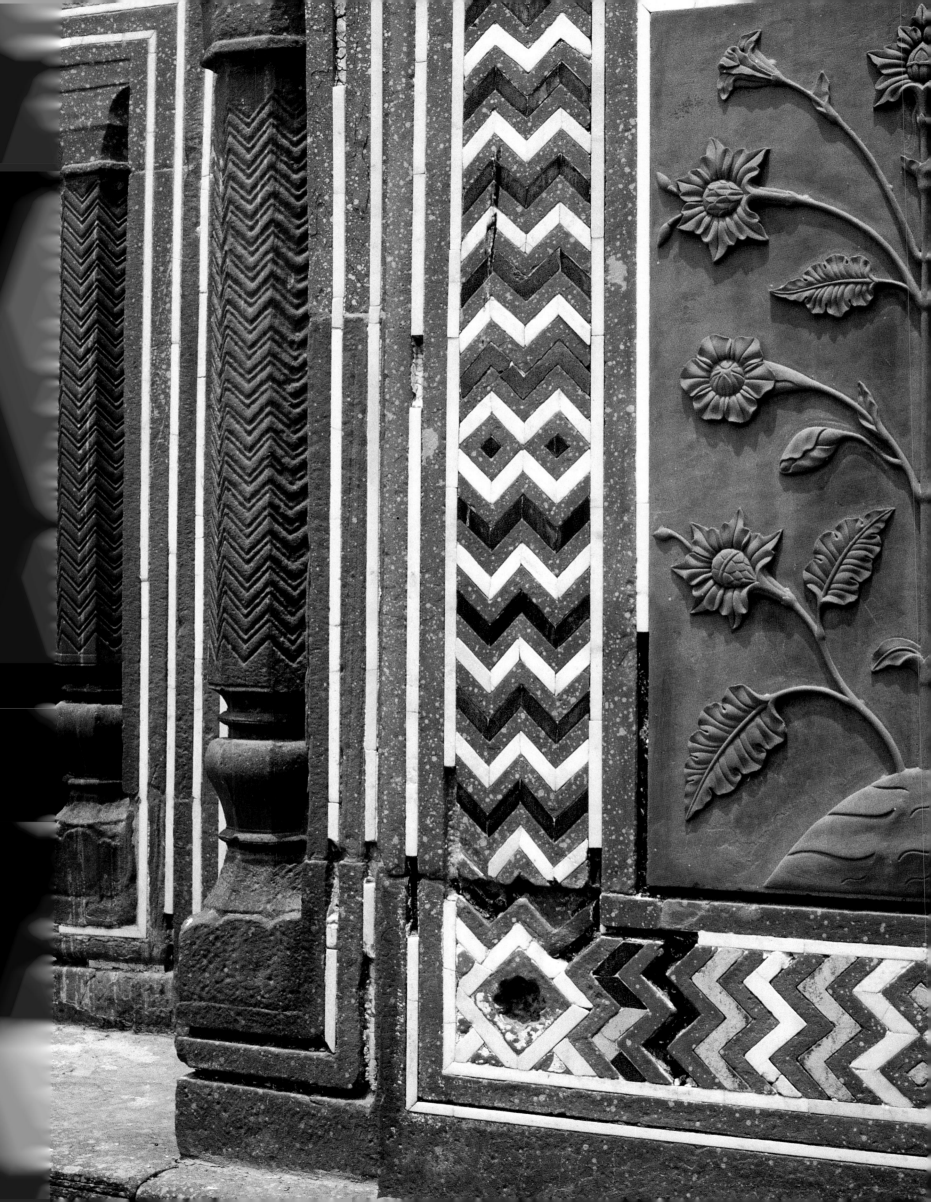

PRINCIPAL MONUMENTS

THE ARAB WORLD

48, 49 Of the many *madrasa*s built in the 14th century by the Marinid dynasty, the al-'Attarin *madrasa* in Fez, though rather small, is one of the most perfect, both in the equilibrium of its forms and the richness of its decor. Constructed between 1323 and 1325, it is disposed, as are all Marinid *madrasa*s, around a courtyard. The rooms of the theology students, located on the second floor, look out onto the courtyard. Combining carved stucco, glazed tile mosaic and sculpted wood, the ornamentation exploits a variety of textures, patterns and colours.

50 Located in the Atlas mountains of Morocco, the *kasbah* of Tlwat, a former palace–fortress of the Glawa, dates back only to the 19th century, but the richness and quality of its interior decor make it a worthy heir of Marinid art.

51 The al-Najjarin fountain in Fez, situated in front of the entrance to the al-Najjarin *funduq* (17th century).

52 Detail of the articulation between the capitals and the bases of the arches in the Great Mosque of Qairawan (836–62).

48

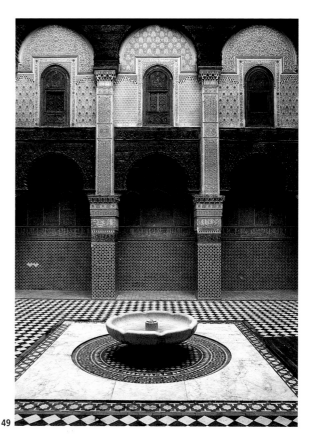

49

50

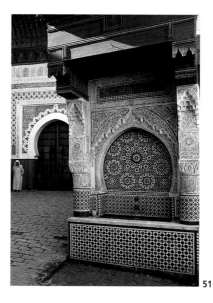

51

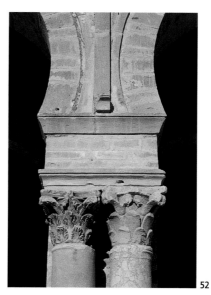

52

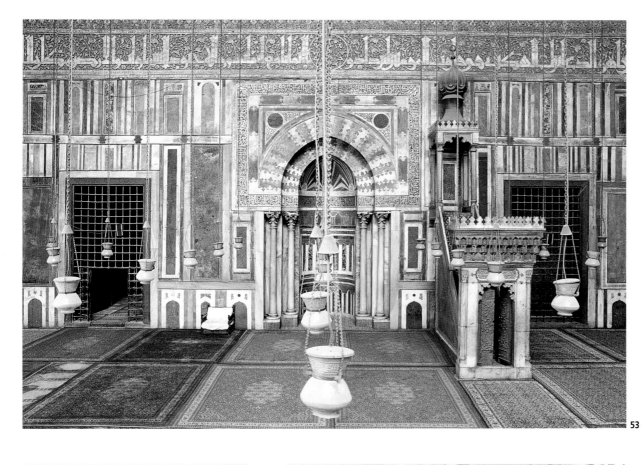

53

54

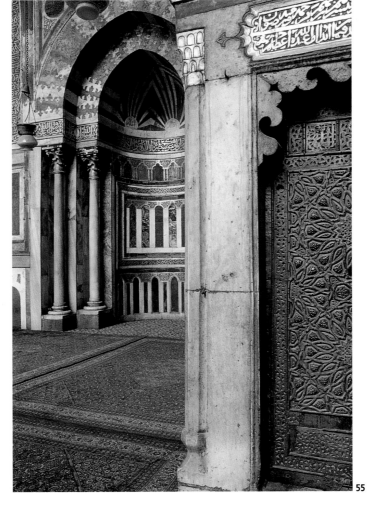

55

53–55 The most remarkable monument in Cairo, the *madrasa*-mosque of Sultan Hasan was constructed between 1356 and 1363. The wall of the *qibla* is completely covered in polychromatic marble, one of the most representative ornamental techniques of Islamic architecture in Egypt. At the centre, the *mihrab* is composed of a double arch with scalloped interlocking elements resting on twin columns. At the top of this imposing composition runs a Qur'anic inscription in monumental kufic script. The arch of the *mihrab* is framed by a thinner epigraphic band in a cursive style.

THE TURKISH WORLD

56, 57 Built in 1228 and 1229, the
Great Mosque of Divrighi, with its
use of stone and the concentration
of sculpted ornamentation on its portals,
is representative of Saljuq architecture
in Anatolia. However, the style of these
sculptures in deep relief is in violent
contrast to the vegetal patterns and
geometric forms rather than
complementing them.

58 Characteristic of the Saljuq architecture
of Anatolia, the *türbe* – like the Hatuniye
Türbesi in Erzurum (1255) – is a cylindrical,
octagonal or dodecagonal funerary
monument with a conical roof. For
some writers, this structure is a reminder
of Turco–Mongolian funerary tents though
others argue for the influence of Armenian
architectural forms.

59 Entrance to a *türbe* adjacent to the
'Ala' al-Din mosque in Konya. Erected
in the 12th century by Qilij Arslan II, it
contains eight cenotaphs of which five
belong to Saljuq sultans.

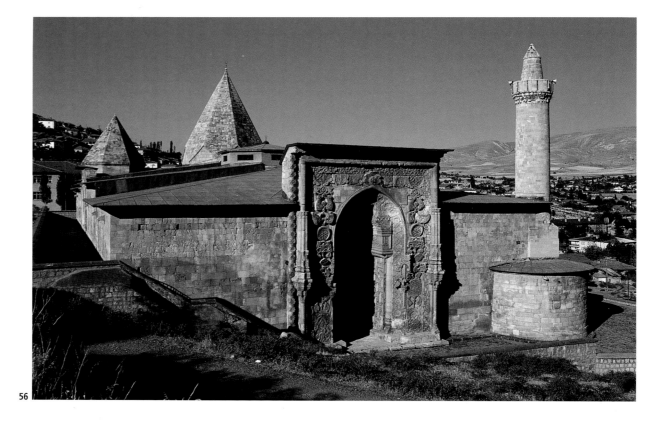

56

57

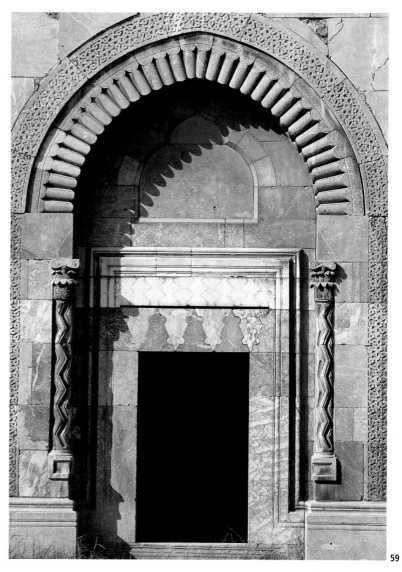

59

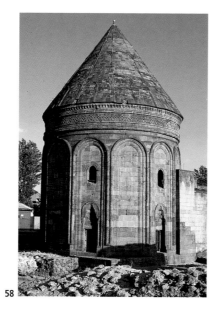

58

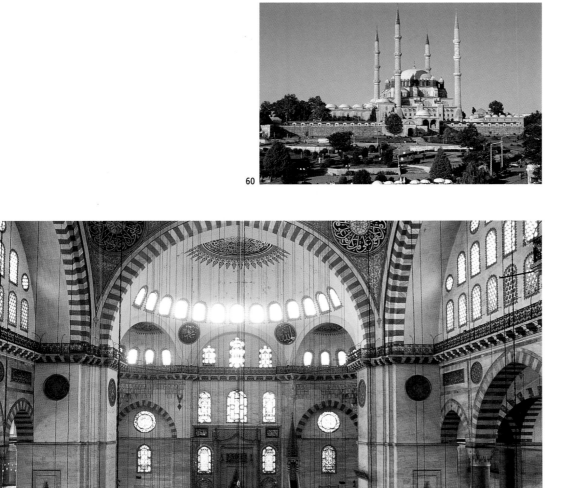

60

60, 63 Created twenty years after the Süleymaniye, for Sultan Selim II, the Selimiye mosque in Edirne (1569–74) is considered to be Sinan's crowning achievement. He chose a central plan: a principal dome resting on an octagon inscribed in a square. The four slender minarets set around it give an upward momentum to the ensemble. The continuity of the interior space, the abundance of windows and the vertical movement of the eight weight-bearing arches create a stunning impression of lightness.

61, 62 Constructed on the summit of one of the seven hills of Istanbul between 1550 and 1556 by the architect Sinan for Suleyman the Magnificent, the Süleymaniye constitutes a perfect example of the Ottoman mosque with cupolas. Taking direct inspiration from the basilica of Hagia Sophia, its structure is based on the system of two half-domes buttressed against a central dome. Thus, the interior volume has the aspect of a vast nave illuminated by numerous openings, whereas the exterior appears to be a cascade of domes.

61

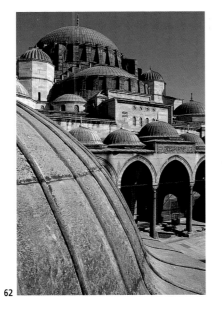

62

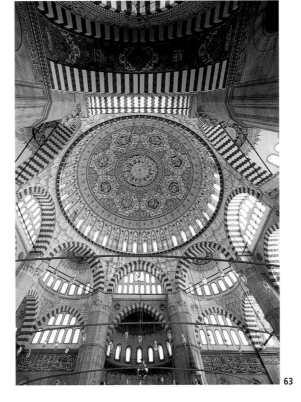

63

IRAN AND CENTRAL ASIA

64 The Friday Mosque of Isfahan, transformed several times between the 10th and the 12th centuries, is one of the first Iranian mosques to display a cruciform structure. This plan found its classic expression in the Shah Mosque. The northwest *iwan* has particularly imposing proportions and the calligraphic decor on its façade is the result of restoration work under the Safavids. On the other hand, the large alveoli or *muqarnas* which cover its vault are characteristic of the Saljuq period (12th century).

65 Detail of the *muqarnas* of the southeast *iwan* of the Friday Mosque of Isfahan.

66 Detail from the ceramic facing covering the outer portal of the mausoleum of Tamerlane in Samarqand.

67, 68 The Shah-i Zinda necropolis in Samarqand, containing some twenty-five mausoleums dating from the 14th century, is outstandingly beautiful. The tomb of Shad-i Mulk Aqa, built between 1371 and 1373, is covered with a ceramic facing in which turquoise and ultramarine blue colours dominate. These demonstrate the degree of technical perfection achieved by the Timurid ceramicists.

69 The Gunbad-i Jabaliya, a small mausoleum situated near Kirman dating from the Saljuq period.

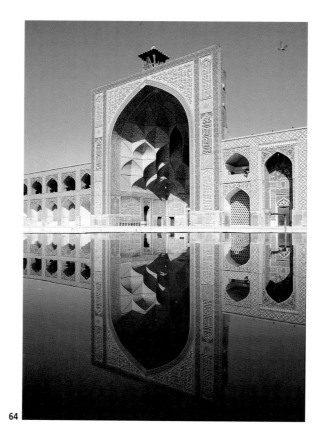

64

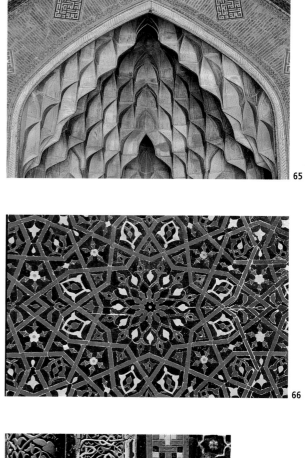

65

66

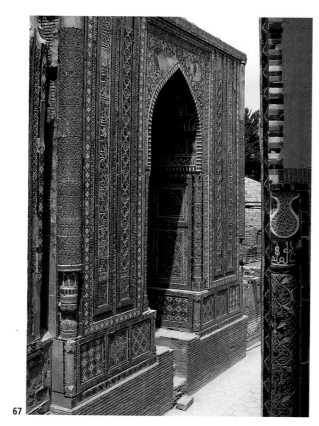

67

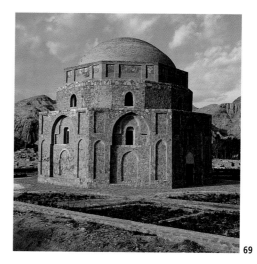

68

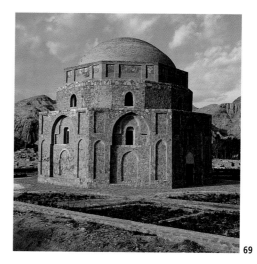

69

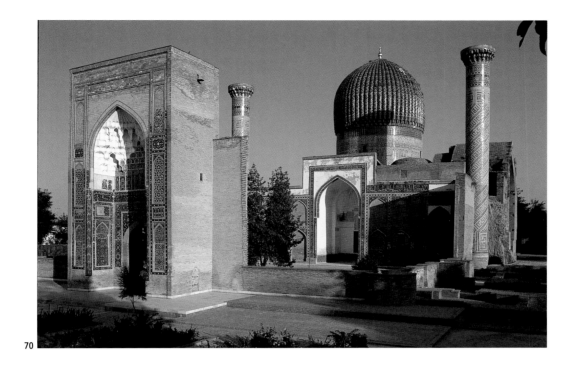

70

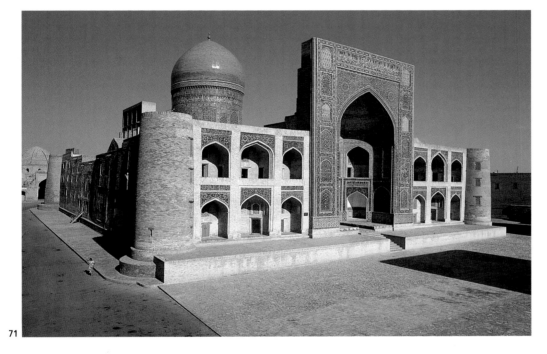

71

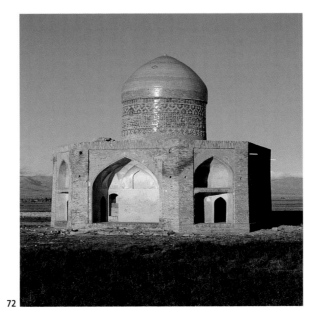

72

70 The mausoleum of Tamerlane or *Timur Lenk* (the Gur-i Mir) in Samarqand (1404) is part of an architectural ensemble which includes a mosque and a *zawiya*. Rising above these constructions, the glazed dome covering the tomb itself has a bulbous shape and high drum characteristic of the Islamic architecture of Central Asia.

71 Constructed in 1535 opposite the Kalyan mosque in Bukhara, the Mir 'Arab *madrasa* is a typical example of the classical Central Asian *madrasa*: its façade is composed of two rows of superposed arcades, punctuated by an *iwan* portal flanked by large conical minarets of which only the bases remain today. The cupola, supported by a high cylindrical drum, indicates the tomb of Shaikh Mir 'Arab.

72 The mausoleum of Mulla Hasan Shirazi in Sultaniya, between Tehran and Tabriz, dates from the beginning of the 14th century, a period when the Mongol dynasty of the Ilkhans ruled Iran. Its structure – an octagonal base from which a spherical dome emerges – recalls the Dome of the Rock.

THE INDIAN WORLD

73, 76 The Qutb Minar minaret, constructed in 1199 near the Quwwat al-Islam mosque in Delhi, is one of the oldest monuments of Muslim India. Although it was built in red sandstone, a typically Indian construction material, its formal conception can be likened to the brick funerary towers of Central Asia and to certain minarets in Afghanistan. Like these buildings, it adopts a star-shaped plan produced by the rotation of squares inscribed in a circle.

74 Window bay in the tomb of Humayun in Delhi (1565). Mughal funerary architecture exploits the repetition of the pattern of the arch set in a rectangular frame. As if suspended among the geometrical forms of an openwork marble screen, the arch has become a purely decorative element.

75 The Great Mosque of Fatehpur Sikri, a palace–city built between 1570 and 1580 near Agra, combines Persian architectural formulas, such as the monumental arch inscribed in a rectangular façade, and elements of Hindu origin, such as the small cupolas resting on slender columns called *chhatri*. The ornamental use of sandstone polychromy on the other hand is representative of the earliest Mughal architecture.

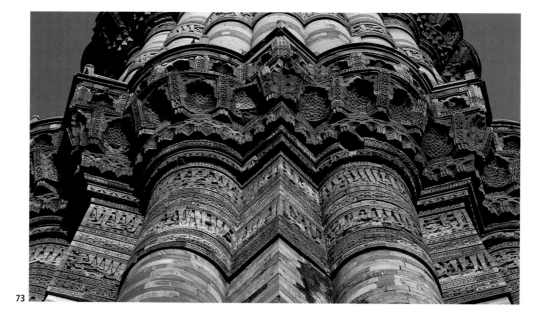
73

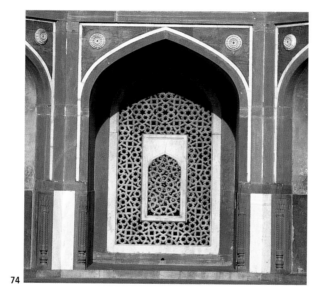
74

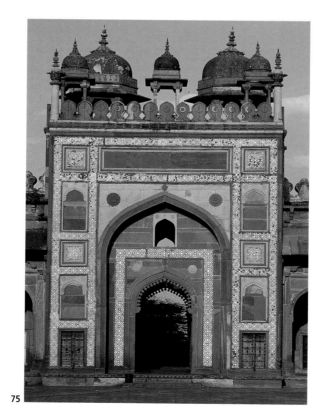
75

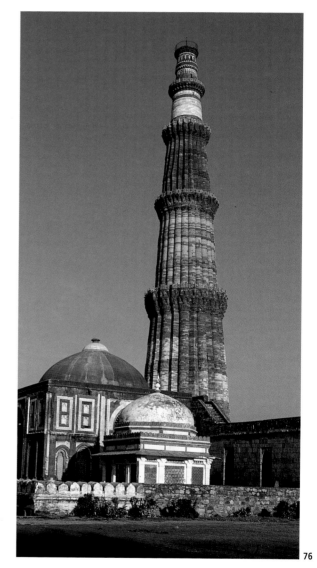
76

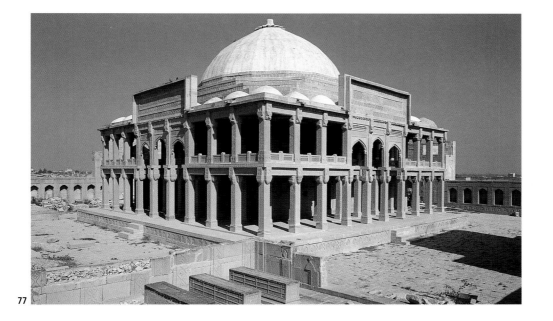

77

77 Makli Hill, not far from Thatta in Pakistan, is a vast necropolis containing a million burial sites ranging from simple tombstones to mausoleums. The most important monument is the tomb of Mirza 'Isa Khan II, a governor of Thatta who died in 1644. The sobriety of its lines indicates the influence of the style used in Fatehpur Sikri.

78 Completed in 1628, the mausoleum of I'timad al-Daula in Agra is the first Indian building to replace sandstone with white marble designed to serve as a background for the inlay of coloured stones, a technique known as *pietra dura* used with the most resounding success in the Taj Mahal.

79 The mausoleum of Bibi Jawindi, at Uch Sharif in the lower Indus valley, belongs to a rich tradition of funerary architecture. Its octagonal base, its conical corner towers and the heavy profile of its dome produce an impression of power, accentuated by the system of ornamental bands made of glazed brick.

80 Detail of the transition between the octagonal base and the spherical dome of the cupola in the mausoleum of Bibi Jawindi.

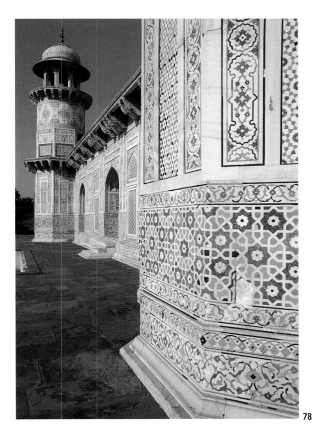

78

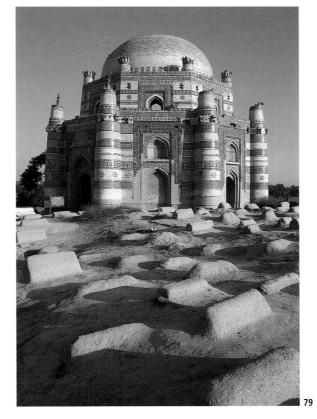

79

80

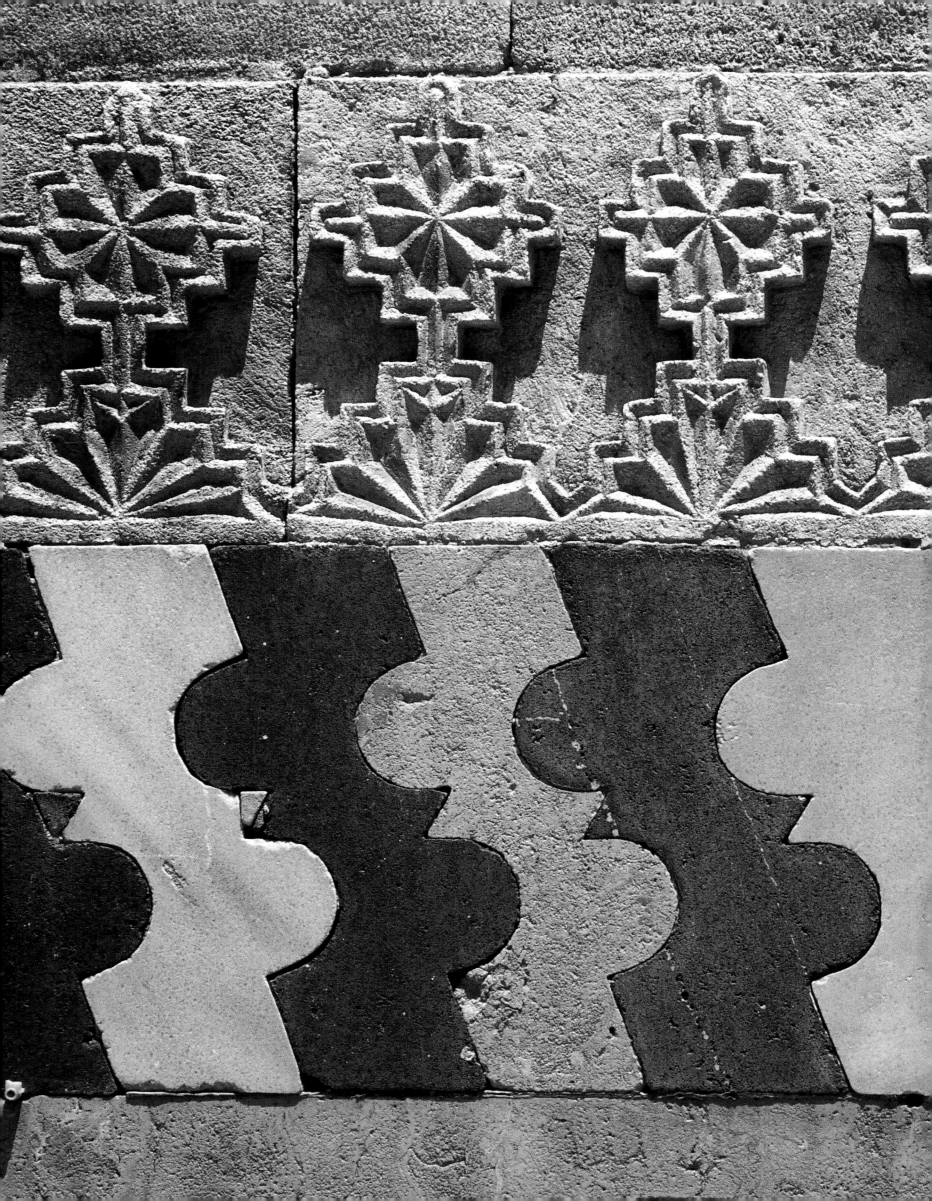

Techniques:
Knowledge and
Know-how

Mosaic
Stucco
Brick
Ceramic

Other Techniques
Bronze
Wood
Painted Wood

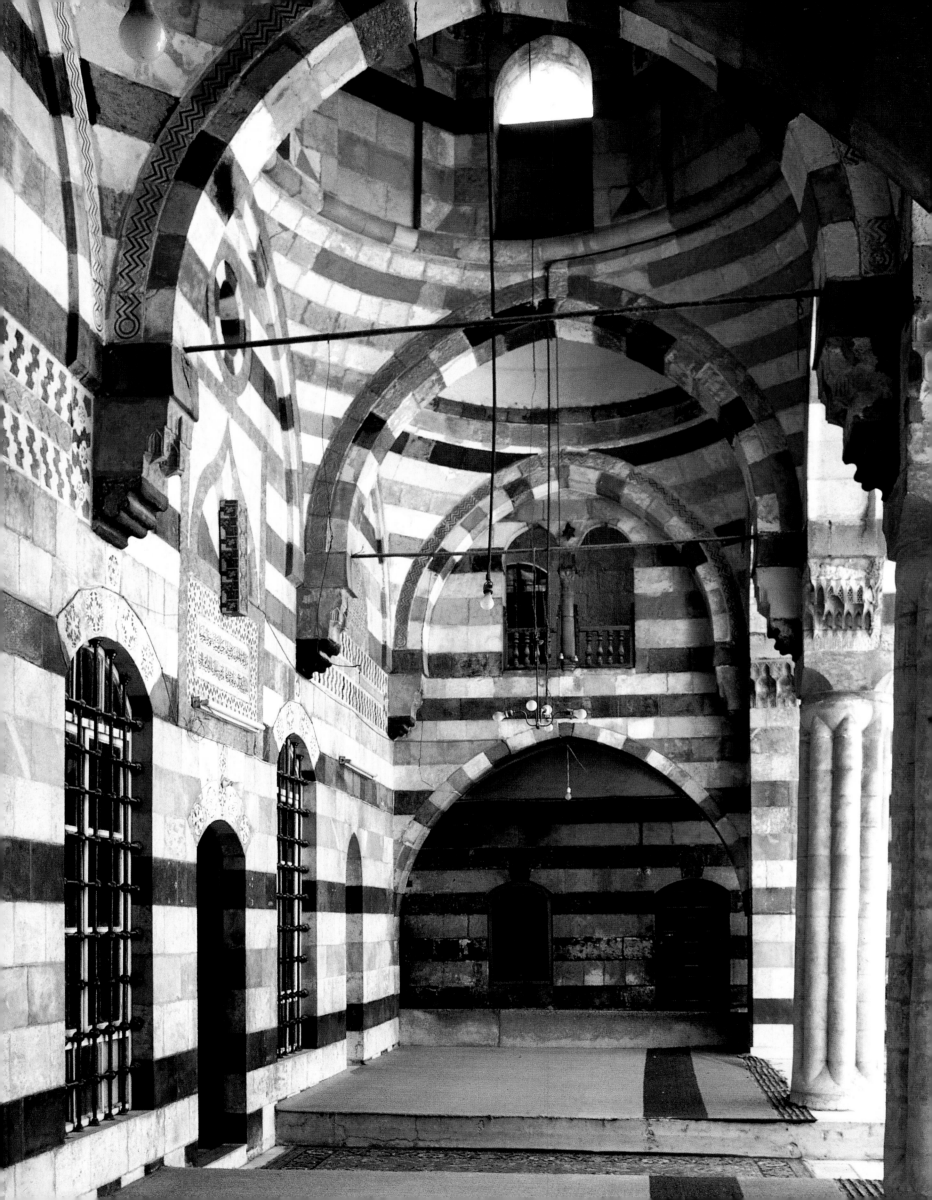

The study of major Islamic edifices demonstrates that the organization of volumes and spaces in Islamic architecture often responds to a geometric order that includes even minute ornamental details. This correspondence between the whole and the parts has led historians to speculate about the existence and the status of the individual who was responsible for the conception of the building in its totality and controlled its creation from beginning to end, in short, the architect. Limited contemporary sources for the history of Islamic architecture makes it impossible to answer this question with any certainty. What is clear, however, is that the image of the architect as creator, in the manner conceived in the West since the Renaissance, is a concept unknown in the Muslim world. Even with an edifice as famous as the Taj Mahal, the identities of its creators is a matter for conjecture. A few cases, such as that of Sinan, the architect appointed by the Ottoman sultan Suleyman the Magnificent and creator of some 318 buildings, are exceptions to the silence surrounding this profession. Although the role of the architect is unclear, it seems that he was considered more of an engineer–geometrician – such is the meaning of the term *muhandis* most often used of him – rather than an artist expressing himself with materials and space.

As for an architect's training, it was often the same as a builder's. According to various inscriptions on buildings, it seems that the role of architect, especially in the Iranian world, could be filled by professionals whose apprenticeship was in a particular technique. Thus the architect–builder (*al-muhandis al-banna'*) of the Kashana tower of Bist in Afghanistan (1301) – a certain Muhammad ibn al-Husain ibn Abi Talib – was also known as an expert in stucco technique (*jassas*). In the same way, the name of the architect can be found on other edifices followed by a qualifying term such as bricklayer, mason or carpenter. It seems then, that the architect in the Islamic world was not the product of specific professional training, as in the West, but that his knowledge was a development of technical expertise acquired on the job.

Preceding pages

The Ghazala house in Aleppo. Detail of a projecting band created by the technique of interlocking scalloped elements.

83 The al-'Azm palace in Hama occupied until 1742 by Asad Pasha al-'Azm, governor of Hama, is today a museum. It offers a simple yet refined example of polychrome stone technique.

83

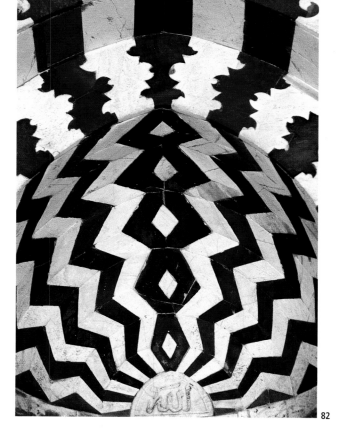

81 The construction technique using polychromatic stones, already in present in pre-Islamic Middle Eastern architecture, continued to be used. In Ottoman architecture it took on a primary ornamental function as in the Fatih mosque in Damascus (18th century).

82 Detail of the vault of the *mihrab* from the tomb of al-Ashraf Barsbay in Cairo (1425). During the Mamluk period in Egypt and Syria, the art of stone cutting and assemblage lent itself to the creation of skilful styles of vaulting in which construction and ornamental techniques were perfectly combined.

82

84 The mausoleum of Sultan
Qansuh al-Ghuri in Cairo (1504).
The door, whose leaves are
covered with bronze, is framed
by an assortment of austere
white and black stones running
horizontally over and under
a cursive calligraphic band
on a scrolled background.

The place of the craftsmen in the building professions is easier to recreate.
We know that the organization of labour in the field of construction, as
in other traditional fields of work, was dictated by a highly specialized
system. The stone craftsmen, for example, were divided into numerous
subcategories: quarrymen, rough-hewers, cutters, sculptors, assemblers, etc.
The same was true for those who dealt with plaster, brick or ceramic. Such
specialization, which limited the individual to a given set of actions, made
it possible to attain a high level of technical ability and rapid execution.
It required precise organization, which gave the master – *mu'allim* or *ustad*
– a fundamental role, but also demanded a general consensus on aesthetic
canons.

Another important characteristic of the development of Islamic
architecture is geographical mobility. In a world where former linguistic
frontiers were over-ridden by the widespread diffusion and use of Arabic,
which was the language of both religion and science, architects and
craftsmen could move with comparative ease from one site to another
and so be available to work on new construction projects initiated by
different patrons in different regions.

This mobility could also be provoked by political upheaval, either
because the craftsmen and architects were part of a population fleeing
a war or because they had been taken prisoner and transported to serve
new masters. Thus, for example, the Central Asian ruler Timur (Tamerlane)
deported Anatolian masons in the early 15th century to work on the
embellishment of his capital Samarqand. Such intermingling of peoples

85

86

85 Lintel and relieving arch with
interlocking scalloped elements
on the door of the Taghribirdi
mosque in Cairo (1440).

86 Cursive calligraphic band
on a scrolled background on the
Ben Yusuf *madrasa* in Marrakesh
(1564–65). The excised *zellij*
technique, frequently used in
Morocco, consists of chipping
at the enamelled tile surface so
as to make the pattern appear
in colour on a background
of denuded terracotta.

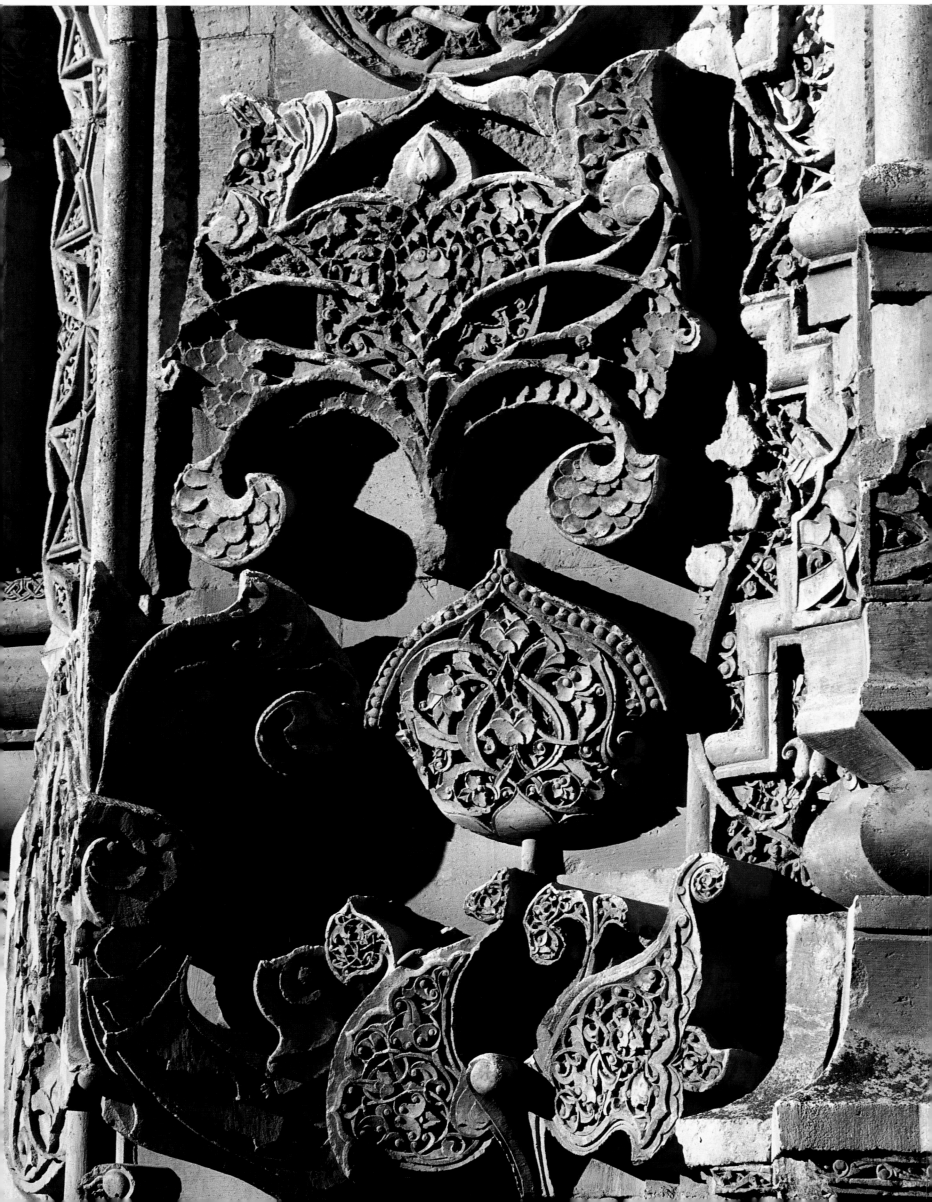

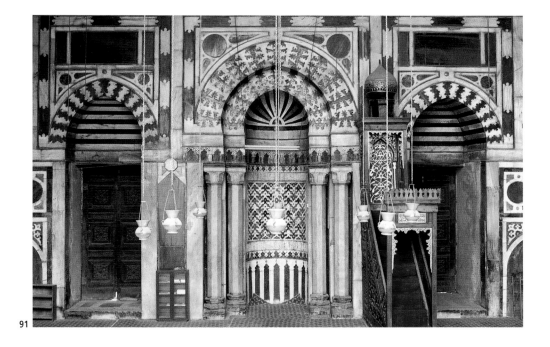

90 Sculpture from the north portal of the Great Mosque of Divrighi (1228–29). An example of exceptional quality in Islamic architecture, this sculpted ornamentation combines surfaces with finely carved arabesques and vegetal patterns which stand out in strong relief against a hollowed-out flat background.

91 The *mihrab* of the *madrasa*-mosque of Sultan Barquq in Cairo (1384–86) demonstrates the technical mastery achieved by Mamluk stonemasons in Egypt.

mausoleum at Sikandra (1605–15) or that of I'timad al-Daula at Agra (1622–28) we can see a multitude of compositions using a network theme or a theme of mathematical subdivisions of the surface, tending to make the materiality of the construction disappear completely.

Of all the techniques employed, mosaic, which was used in the Umayyad period, had only limited later influence. Created by Byzantine craftsmen, the mosaics which decorate the Dome of the Rock and the Great Mosque of Damascus are made of glass tesserae, tinted in the mass or covered with gold leaf (*Ill. 95*). Although this technique produced masterpieces, it was to play only a minor role in the following years. It was employed in the 10th century to embellish the *mihrab* of the Great Mosque of Cordoba (961–76) and the technique appears again in several buildings in Damascus in the 13th and 14th centuries.

Whereas mosaic could only be used where foreign workers were present, and was not able to establish itself as an art form, another ornamental technique, stucco, was used with considerable success all over the Islamic world. A plaster coating often used to mask rough-hewn masonry, stucco is an inexpensive material and its decorative qualities are determined principally by the fact that it is a perfect medium for carving. Inherited from Sasanian builders, stucco technique was first seen in Umayyad architecture in the decoration of Qasr al-Hair al-Gharbi (728), but it was put to full use during 'Abbasid residence at Samarra (9th century). From there it spread through Egypt, North Africa, Spain and throughout the Iranian world. How can this great success be explained? It is tempting to cite the humble nature of plaster, its flexibility rendering it adaptable to all sorts of surfaces and its ephemeral quality as an appropriate reflection of the ethical and aesthetic values of Islam which emphasize the transient nature of the world.

Brick techniques, preponderant since earliest Antiquity in a geographical zone stretching from Mesopotamia to Central Asia and the Indus Valley, constitute the second major foundation of Islamic architecture and architectural ornamentation. Because of its mechanical characteristics,

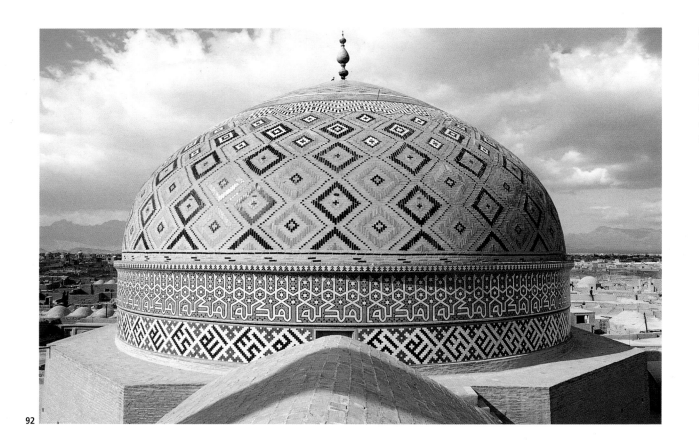

92 Dome of the Friday Mosque of Yazd. Iranian architecture owes its forms as well as its ornamental techniques to its basic material, brick. The two epigraphic bands which encircle the drum consist of a repetition of two pious formulas.

which include good resistance to compression and weak resistance to tension, brick requires an architecture dominated by the arch, the vault and the cupola. It is these forms which largely determine the stylistic kinship of most buildings constructed in the eastern Islamic lands. The method of making brick also dictates the uses to which it is put. Produced serially in moulds and so having an identical format, brick more than any other material brings the principle of repetition into play both in the process of construction and in the appearance of the building. Using these inherent qualities, ingenious bricklaying techniques were developed which staggered and alternated bricks, worked with oppositions of light and shadow, rhythms and patterns. All of these variations, based on the principle of repetition and the groundwork, display features similar to those found in the textile arts.

Finally, the art of the ceramic mural, which is a direct extension of brick technique, introduced colour into Iranian and Central Asian architecture as early as the beginning of the 12th century. At first it was limited to a few touches of turquoise blue enamel to accent the ochre of the brick, but soon this introduction of colour gave birth to a refined art of ceramic mosaic which spread until it covered all visible surfaces. Thanks to this polychromy, dominated by turquoise blue, ornamentation came to possess a symbolic value which lifted architectural reality into an image of the Divine.

93 Detail of a glazed tile mosaic panel in the Wazir Khan mosque in Lahore (1634).

94 Brick cupola of the lateral portico of the Great Mosque of Thatta erected by Shah Jahan in 1647.

93

96

96 Situated under the western gallery of the courtyard in the Great Mosque of Damascus is a vast composition which represents a landscape with majestic trees and groups of buildings set along the banks of a stream.

Mosaic

95 The mosaics of the Great Mosque of Damascus (705–15) owe their technique, which includes cubes covered with gold leaf and fragments of mother-of-pearl, to Byzantine tradition.

The first buildings constructed by the Umayyads used mosaic either as paving or wall-facing. Mosaic paving is encountered in most of the Umayyad desert castles, those luxurious retreats on the edges of the Syrio-Jordanian desert, such as Qasr al-Hair al-Gharbi, Khirbat al-Minya and Khirbat al-Mafjar. From a technical point of view these pavements resemble Roman mosaics found around the Mediterranean and are composed of small cubes of stone or tesserae, fixed in place with a lime mortar.

The most spectacular examples are to be seen in the baths of the palace complex of Khirbat al-Mafjar near Jericho. Carried out with great precision, these mosaics offer a series of variations on geometrical themes which conform harmoniously to Classical and Byzantine repertoires. One mosaic, however, situated in a small reception room attached to the baths, stands out from the others because of its use of figuration. On either side of a tree groups of animals can be seen: on one side two gazelles graze peacefully, while on the other a third gazelle is being attacked by a lion (*Ill. 98*). Some observers have seen in this a theme borrowed from royal Persian iconography – it may even be an imitation of a Sasanian carpet. Since it is located in the apse of a reception room, we can assume that this borrowed theme had become an emblem of Umayyad power.

The most famous Umayyad mosaics are those which decorate the walls of the Dome of the Rock in Jerusalem and the Great Mosque of Damascus. The technique is no longer Roman but strictly Byzantine. The mosaic displays brighter colours and has a surface that glistens because the basic material is now glass not stone.

The origin of glass mosaic technique goes back to the 5th century when in order to obtain brighter colours the Byzantines began covering stone cubes with a layer of glass. Then, towards the 6th century, they began to produce tesserae of coloured or gold-plated glass itself. To create the first kind of mosaic, sheets of glass were prepared which were tinted with metallic oxides and then cut into cubes. To obtain the golden tesserae, plain glass cubes were cut in half and then fixed together again after a sheet of gold had been sandwiched between the two layers. Fragments of mother-of-pearl or semiprecious stones were also used with these glass cubes. These elements, which were produced in specialized workshops, were set directly in place on the surface which had been first covered with a plaster coating. On this uniform surface, the contours of the motif were drawn with a sharp point which served to fix the precise spot where each cube was to be placed.

When, at the end of the 7th century, the caliph 'Abd al-Malik decided to build a monument over the rock marking the site of Solomon's Temple in Jerusalem in order to assert the supremacy of the new religion and the prestige of Umayyad power, he chose this type of ornamentation to enhance its splendour. Because the technique is relatively complex and a high degree of specialization is required to produce the glass cubes themselves, the mosaics of the Dome of the Rock must have been made by Byzantine artists or local artists trained in the Byzantine school. In fact it is likely that the mosaic cubes were produced in the imperial workshops in Constantinople. Thus, in order to compete with Byzantium, Islam appropriated Byzantine ornamental techniques and artists. But, although the mosaic technique used in Jerusalem was Byzantine, its iconography and general style display highly singular aspects. These must be explained either by the particular geographical location of the city in a Near East which was open to Iranian influence, or by the personal tastes and specific instructions of the people who ordered the work.

The primary feature of these mosaics is that they show no living creatures. Because of the restrictions imposed by the jurists, such subjects were excluded from the ornamentation of religious monuments. The mosaics demonstrate an underlying vegetal theme whose various green hues, when mixed with the golden background, produce nuances at once both fresh and mannered. In some cases this vegetation assumes a relative realism. For example, on the flank of a pillar, we can recognize a palm tree loaded with dates or a sycamore grove whose branches seem to rustle in the breeze. However, these naturalistic scenes are the exception. Everywhere else the mosaic vegetation obeys laws quite different from those of nature. The trunk

97 On the façade of the principal nave in the Great Mosque of Damascus, part of the original mosaic facing remains.

98 The lion mosaic in the Umayyad palace of Khirbat al-Mafjar at Jericho (739–44), although carried out in a Roman technique, has iconography which recalls Sasanian art.

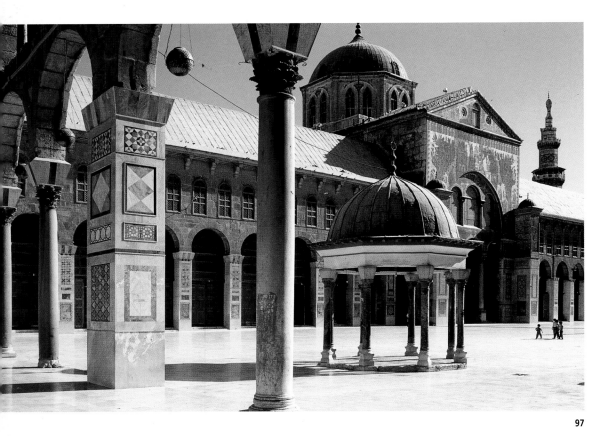

97

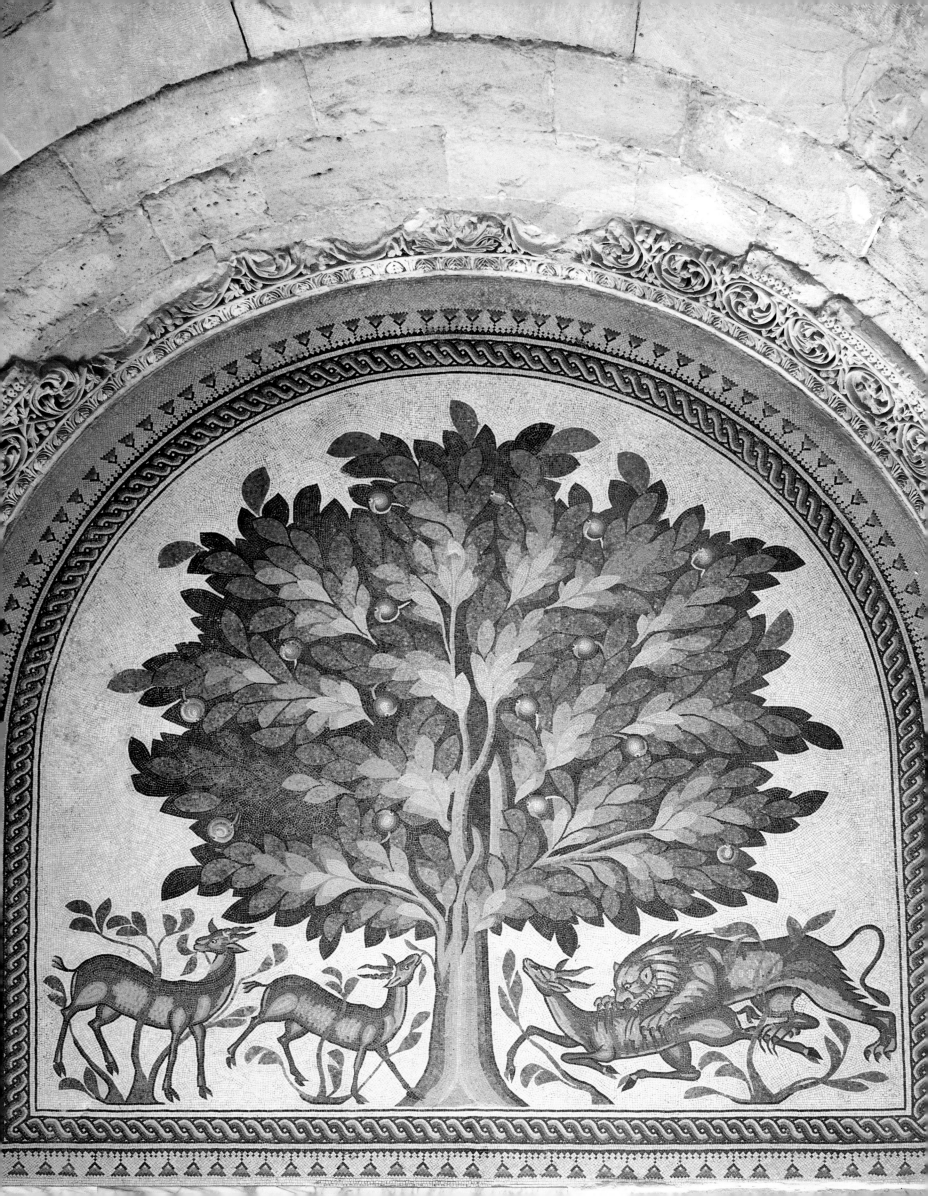

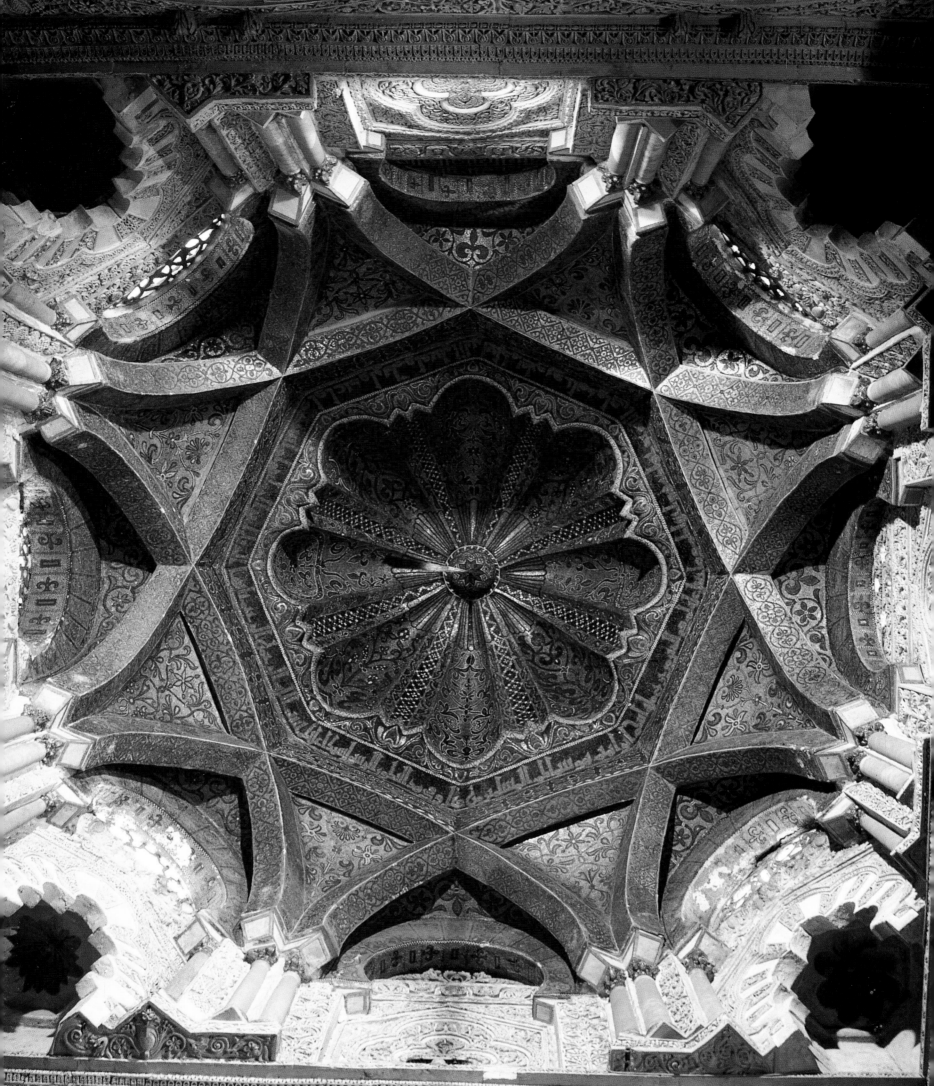

of a tree, for example, may be composed of alternating red and green lozenges and rectangles, recalling those in the crown of the Empress Theodora in the mosaic of the choir of San Vitale in Ravenna (6th century). Because the Umayyad caliph compelled his Byzantine craftsmen to eliminate all living creatures from their repertoire, they seem to have retained only the accessories: plants and jewels. On both faces of the octagonal portico and on the interior wall of the drum of the Dome of the Rock, a multitude of compositions appear, combining vases, chalices, diadems, bracelets, palms, foliated patterns of acanthus, bunches of grapes and stems bearing pomegranates and pine cones: all of these fantastic objects, which combine nature and precious metalwork, evoke a world far removed from reality. Another detail, however, adds to the composite nature of this decor. Among the jewels borrowed from high-ranking Byzantine figures, it is also possible to distinguish Iranian motifs such as the ancient emblem of Sasanian royalty, a pair of symmetrically spread wings.

In 706 when al-Walid succeeded 'Abd al-Malik, he began the construction of the Great Mosque of Damascus – in part to glorify his reign – and he too demanded the use of mosaic technique (*Ill. 97*). According to Arab historians, in order to achieve this ornamentation, he asked the Byzantine emperor to send him both craftsmen and glass cubes. All the walls of the prayer hall, the façades facing the courtyard and the interior walls of the galleries surrounding the courtyard were covered above the level of the marble casing with an uninterrupted cloak of mosaic. There every shade not only of green and blue, but also purple, yellow, red, black and white were intermingled with gleaming gold. Unfortunately, this magnificent decor, which many Islamic chroniclers admired, was largely destroyed by earthquake and fire. We can still get

100

an idea of its original state from various fragments, mostly situated in the courtyard. In the western gallery in particular a large panel has survived, seven metres high and thirty-four metres long, which establishes the fact that, although the technique is the same as that used in the Dome of the Rock, the methods of representation and the iconography are different.

Along the banks of a stream in the foreground are groves of majestic trees which give a rhythm to the landscape (*Ill. 96*). In this panorama, which is treated with a certain amount of realism, though lacking any suggestion of living creatures, appear a variety of buildings, realistic and fantastic, humble and costly: simple, rustic constructions perched on rocky escarpments and marvellous palaces ornamented with colonnades, pediments and vines.

Elements of Byzantine decor and traces of Classical or Christian Syrian architecture appear in the composition of this scenery. According to the geographer al-Muqaddasi, who described these mosaics at the end of the 10th century, they represent the principal cities of the world. Ibn Shakir, who wrote in the 14th century, even mentions a representation of the Ka'ba. If so, the mosaic is a symbolic representation of

101

99 In contrast to the figurative mosaics of Damascus, those which cover the cupola in front of the *mihrab* of the Great Mosque of Cordoba (961) are purely ornamental.

100, 101 Dispersed among luxuriant vegetation, the buildings in the mosaics of the Great Mosque of Damascus are sometimes fantastic and sometimes realistic. Some scholars have argued that the building which figures in the upper image is a representation of one of the hippodromes of Damascus.

the Umayyad conquests. There is, however, a more likely interpretation which suggests that we are confronted with an evocation of paradise: 'Blessed is He who, if He will, will assign thee better than (all) that – Gardens underneath which rivers flow – and will assign thee mansions.' (Qur'an, XXV, 10).

Although glass mosaic was used to create masterpieces in the first great monuments of Islam, it did not achieve a lasting place among Islamic ornamental techniques.

When the 'Abbasids seized power and moved the empire's political and cultural capital to Mesopotamia, mosaic,

which had remained a speciality of Byzantine artists, largely disappeared from Islamic architecture.

There is, however, a remarkable exception in the mosaic decoration of the Great Mosque of Cordoba, embellishing the arch of the *mihrab* as well as the wall surrounding it and the cupola above (*Ill. 99*). This part of a mosque has a particular symbolic value and is decorated with the utmost care. So here at Cordoba, gold dominates and presents a shimmering background for the plant-like motifs and epigraphic bands.

The Umayyad ruler al-Hakam in 961 ordered the decoration of the *mihrab* when the extension of the prayer hall was under way and the work was again carried out with Byzantine assistance. Al-Hakam asked the Byzantine emperor to send him craftsmen and mosaic cubes just as his ancestor, 'Abd al-Malik, had done before him. Compared to the mosaics in Jerusalem or Damascus, those in Cordoba seem to follow a new formal repertoire and to adhere to new plastic principles more specifically Islamic in content. The vegetal elements in particular have evolved into relatively abstract ornamental motifs, similar to those in the neighbouring stucco. The colour shading, which in earlier work had created an almost three-dimensional effect, was now replaced by an interplay of contrasted oppositions reflecting a more graphic perception of form.

Mosaic technique, which seems to have depended on Byzantine expertise, made one more brief appearance in Damascus in the Mamluk period thanks to the presence of Christian artists from Anatolia. It can be seen in buildings of the 13th and 14th centuries such as the Zahiriya *madrasa* (*Ills. 102, 104*) and the *türbe* of Amir Tankiz (*Ill. 103*) in a rather pale imitation of themes and motifs from the Great Mosque of Damascus and the Dome of the Rock.

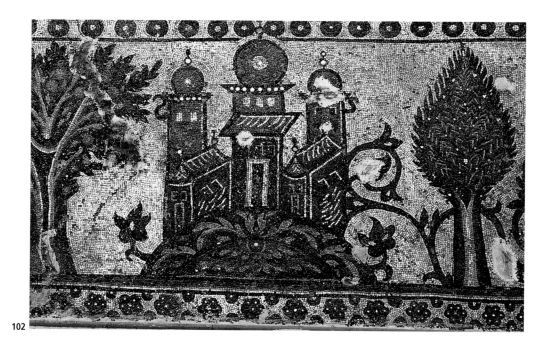

102

103

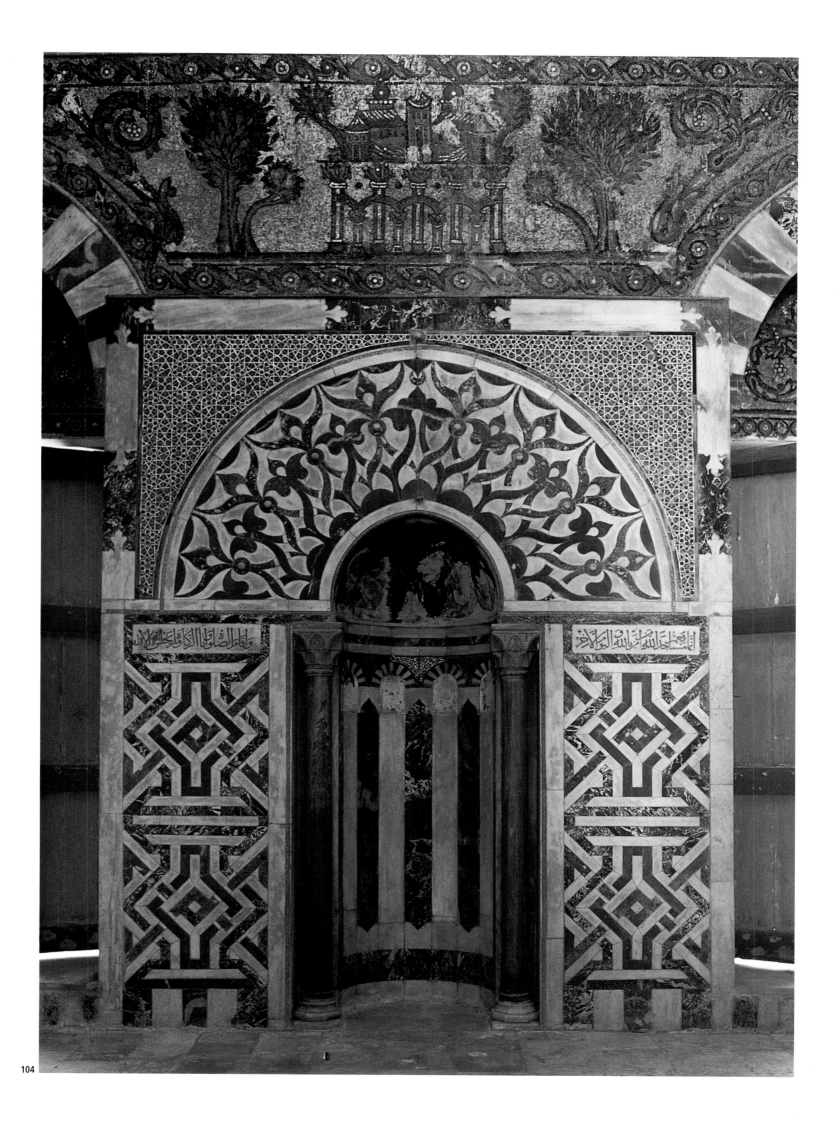

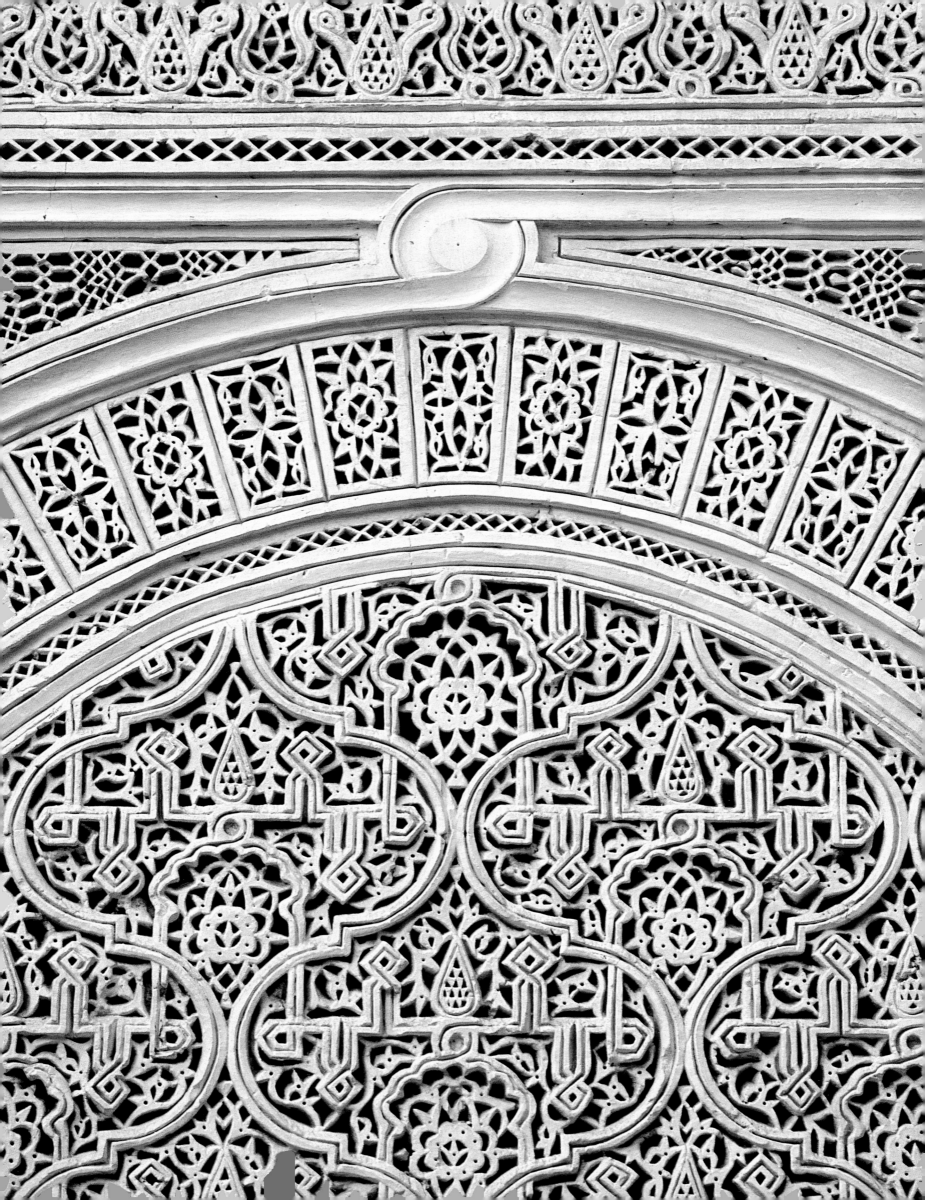

106

107

Stucco

105 A stucco panel in the Dar Lasram in
Tunis. The carving is carried out on three
planes, the first, corresponding to a division
of the surface into forms of tops, the
second, a series of pseudo-calligraphic
patterns and the third, finer leafy patterns.

106 Founded in 960, the Friday Mosque
of Na'in, east of Isfahan still has some of
its original stucco decoration. The niche
of the *mihrab* is notable for its decor of
vegetal motifs carved in strong relief.

107 Stucco from the Great Mosque of
Meknes (12th century). The pattern of
half-palmettes, disposed symmetrically
two by two, and inscribed in a grill of
lozenges is characteristic of the art
of Moroccan stucco masters.

A simple, plaster-based mural coating,
stucco is the most widespread method
of ornamentation in the Islamic world,
found everywhere from Central Asia and
India to North Africa and Spain. Several
reasons explain its success. One is the
relatively modest price of the materials
used. Stucco is usually produced from
gypsum, which can be found in
abundance in the Middle East, and it
does not require a high temperature to
be transformed into plaster, an important
consideration in countries where wood
is scarce. However, lime-based stucco
is also used and, though it is more
costly, it is better adapted to external
ornamentation because it is impermeable.

Another advantage of stucco is that
it is easily fashioned. It can be shaped,
moulded or, as is most usual, carved.
Finally, because it has no intrinsic form it
is adaptable to all architectural elements:
walls, pillars, vaults, etc., making it the

preferred material for masking the
often rough-hewn masonry of Islamic
buildings. Thanks to stucco, a wall of
crudely fashioned stone blocks, pisé, or
raw brick, for example in the Alhambra,
gives an impression of great luxury.

Being created from modest materials,
stucco owes this luxurious appearance
to the skill of the craftsman. Despite
variations in the details of production
techniques developed in different
regions and at different periods, or even
according to the wishes of the craftsman,
the basic operation remained broadly
the same: the preparation of the coating
mixture, its application, the tracing and
cutting of patterns and the methods
involved in the finishing touches.

Plaster, the basic material of stucco,
is obtained by the calcination of gypsum
or lime; but other materials also enter
into its composition to strengthen it
or give it an alabaster or marble-like

108

108 Dating from the 15th century, the
stucco *mihrab* of the Friday Mosque of
Varamin (1322–26) associates vegetal
arabesques with calligraphic motifs in
kufic script.

appearance. Glue can be added to the preparation, or even powdered marble or eggshell. Once it has been sifted and mixed with water, the preparation is stirred long enough to slow down the crystallization process. This means that the application of the coating and the sculpture work do not have to be hurried. As soon as the coating is ready, it is applied to the surface in several successive layers, then smoothed over in readiness for the sculptor's work.

In a method still used today in Morocco, the ornamental patterns can be traced directly with the help of a dry point, a ruler and a compass. But they are more often reproduced with stencilled paper, which the craftsman applies directly to the surface of the coating material and blots with charcoal powder. The blackened zones are then carved out. According to the choice of the craftsman, the cutting can be done downwards perpendicularly, or at an upward angle in order to take into account the view of a spectator standing below. After cutting the contours of the principal shapes, the craftsman begins whittling away given surface areas in order to create several planes, which will bring the effects of interlace into play or, for example, give a slight movement to a palmette. Lastly the finest details are added, those which often give ornamental stucco its lace-like aspect: the ribbing, hatching and perforation. Sometimes, however, the craftsman has recourse to a faster technique, which reproduces motifs by moulding the still-fresh stucco. But this technique produces a more mechanical style and the forms are slightly less distinct.

When the sculpting is completed, certain finishing touches add a given quality to the surface. By various methods used at different periods in different countries, a patina can be given to the stucco, for example, by applying marrow to produce a marble sheen, as

was done in Yemen. Or a plaster wash
can be added to the salient forms to
accentuate the contrasts between light
and shadow, or colours painted on,
or careful touches of gold applied.

Although Hellenistic art was familiar
with stucco technique, it was first used
to transform the surface appearance
of buildings in pre-Islamic Iran and
Mesopotamia, as can be seen in the
Sasanian palace of Ctesiphon near
Baghdad, dating from the 3rd and
4th centuries.

The adoption of this Iranian
ornamental technique by Islam
can be seen in the earliest Umayyad
buildings. At Qasr al-Hair al-Gharbi
and Khirbat al-Mafjar in particular,
the walls disappear under a blanket
of ornamentation from which stucco
figures sculpted in sharp relief
occasionally emerge. However, the first
classical examples of stucco art are those
at Samarra, the capital of the 'Abbasid
caliphs in the 9th century. The stuccos
of Samarra are divided by historians
into three styles. The first results from
carving work which hollows out the
plaster coating to create patterns of
vine leaves and clusters of grapes,
tightly entwined in geometrically
compartmentalizing forms – lozenges,
hexagons, rectangles, etc. The second
style seems to be an evolution of the first
towards a greater abstraction and tends
to interlock palmettes and stylized

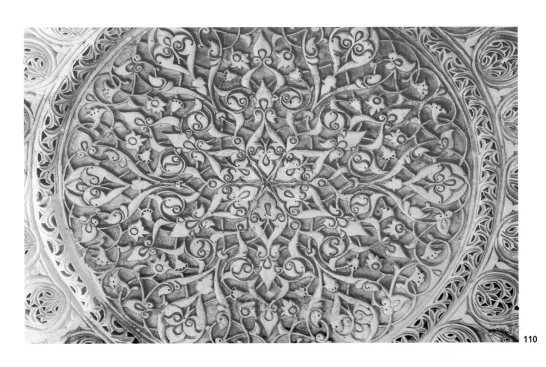

110

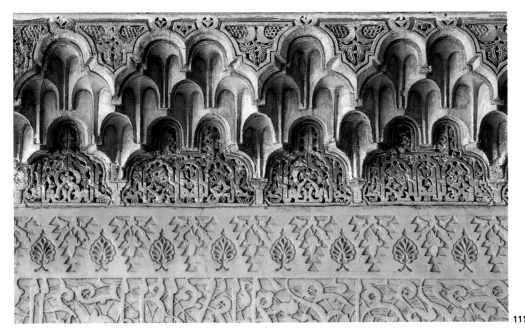

111

109

109 The stucco facing which covers
the pillars in the prayer hall of the Friday
Mosque of Na'in is similar in style to the
earlier stuccos at Samarra. Set tightly into
a network of pearled ribbon are patterns
of leaves and grapes.

110 Stucco medallion of the *iwan* of the
Qaimari *maristan* in Damascus (1248–58).

111 Detail of the ornamentation from
the Ben Yusuf *madrasa* in Marrakesh
(1564–65). Generally used as a mural
facing, stucco also makes it possible
to create cornices with *muqarnas*.

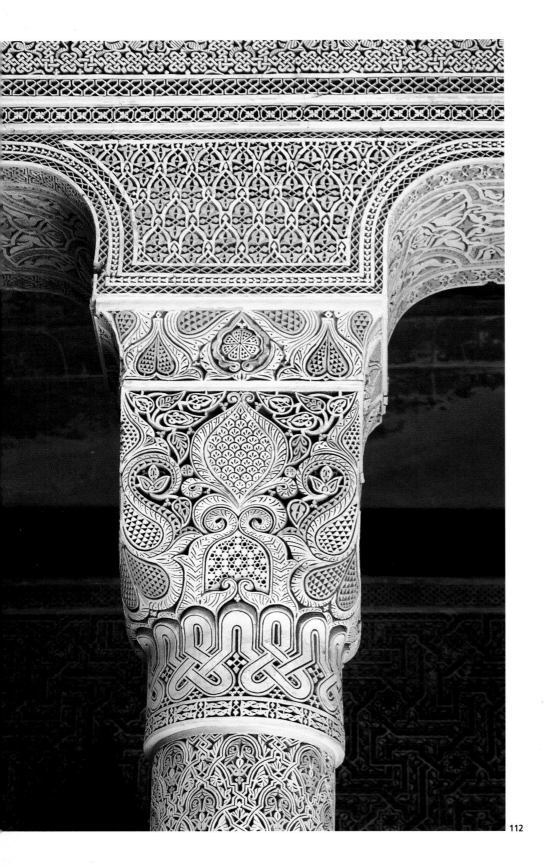

112

112 Detail of a carved stucco capital in the *kasbah* of Tlwat (19th century).

113 Detail from the intrados of the arches of the porticos opening onto the courtyard of the Ibn Tulun mosque in Cairo (876–79). Stucco sculpture is the main type of decoration in this mosque. Carried out in a technique of bevelled cutting which recalls the stuccos of Samarra, palmette patterns entirely fill the spaces left by a network of interlaced geometric forms.

flowers so tightly together that even the idea of a background disappears. The third style, known as the bevelled style, is totally abstract. It brings into play the repetition of curved symmetrical lines on the surface of the wall. While the first two Samarra styles clearly stem from an Iranian heritage, it is believed that the third might have originated in the art of the Central Asian steppes. Situated between Isfahan and Yazd, the small Friday Mosque of Na'in has preserved a series of stuccos dating back to the 10th century. The deeply carved ornamentation, which covers the pillars (*Ill. 109*) and the intrados of the arches (*Ill. 267*), is a direct descendant of the Samarra tradition, as can be seen in its repetitive compositions which group together several vegetal patterns in geometrical figures traced by a typically Sasanian ribbon of pearls. However, at Na'in, it is the *mihrab* which above all else holds the attention. It is surmounted by an arch made entirely of stucco, presenting a dense mass of vegetal forms, which, although far removed from any naturalistic intention, seem to overflow with organic life (*Ill. 106*). As opposed to the flat sculpture of the other stuccos nearby, the power of the form concentrated here in the *mihrab* is designed to give maximum focus to this highly symbolic element of the mosque. It is also the first of a long series of stucco *mihrab*s in Iran, perhaps the most famous of which is the *mihrab* in the Friday Mosque of Isfahan, built by the Ilkhan Oljeitu in 1314 (*Ills. 266, 268*).

In this masterpiece, stucco sculpture achieved its greatest perfection through the elegance of the forms and delicate contours and the spatial distribution of the various plastic elements – scrolls, vegetal arabesques, decorative ribbons, calligraphic texts, etc. – which are set in tiers on several planes.

From Samarra the stucco technique also spread westwards. It appeared first in Egypt, where it constitutes most of the

ornamentation of the Ibn Tulun mosque in Cairo (*Ill. 113*). Directly inspired by the Great Mosque of Samarra, stucco decorations of a high quality are sculpted with only a slight relief, harmonizing with the planes of the walls. From Cairo stucco technique spread to North Africa and Spain, where it was to find further fertile ground for expression.

The most remarkable examples of stucco in Morocco are found in the numerous *madrasa*s built during the 14th century by the Marinids in Fez, Marrakesh and Meknes (*Ill. 115*). Stucco covers most of the façades facing the courtyard, though the dados are embellished with mosaic tiles, more resistant than stucco to shocks and water damage. The upper walls are covered with a sculpted cedar facing. Placed between the polychromy of the tiles and the darker zone of wood, the pale ochre stucco is divided into rectangular panels. They produce a complex woven pattern on the wall and make use of the structure of the building by juxtaposing different

decorative panels like tapestries hung side by side, some with vegetal, others with geometric or calligraphic patterns of varying density.

In the architecture of Muslim Spain, the art of stucco attained new heights of elegance, refinement and technical virtuosity. The Alhambra, the final flourish of Islamic architecture on the Iberian peninsula, seems to be nothing but a palace of sculpted plaster, as the construction materials disappear everywhere behind finely wrought veils of stucco. The Court of the Lions is the best demonstration of the triumph of stucco decor over architectonic laws. Thus, the approximately 130 slender columns, which form a peristyle around the fountain, are no longer required to bear the weight of the arches. Their only function is to support the fine network of cut stucco openwork (*Ill. 27*). The decor no longer covers the wall, it replaces it. In other words, by this extreme use of stucco, the architecture itself has become an ornament.

114 Stucco panel from the Qurji mosque in Tripoli, Libya (early 19th century), combining several levels of graphics, from the strongly accentuated pattern of the arch down to the finest vegetal details.

115 The Bu 'Inaniya *madrasa* in Meknes (mid-14th century). In Marinid architecture, as in the Nasrid palaces of Granada, stucco is used not only to cover walls, but also to embellish the intrados of arches with delicate compositions of *muqarnas*.

116 Stucco *muqarnas* from the interior of the cupola over the tomb of Ibn al-Muqaddam in Damascus (late 12th century).

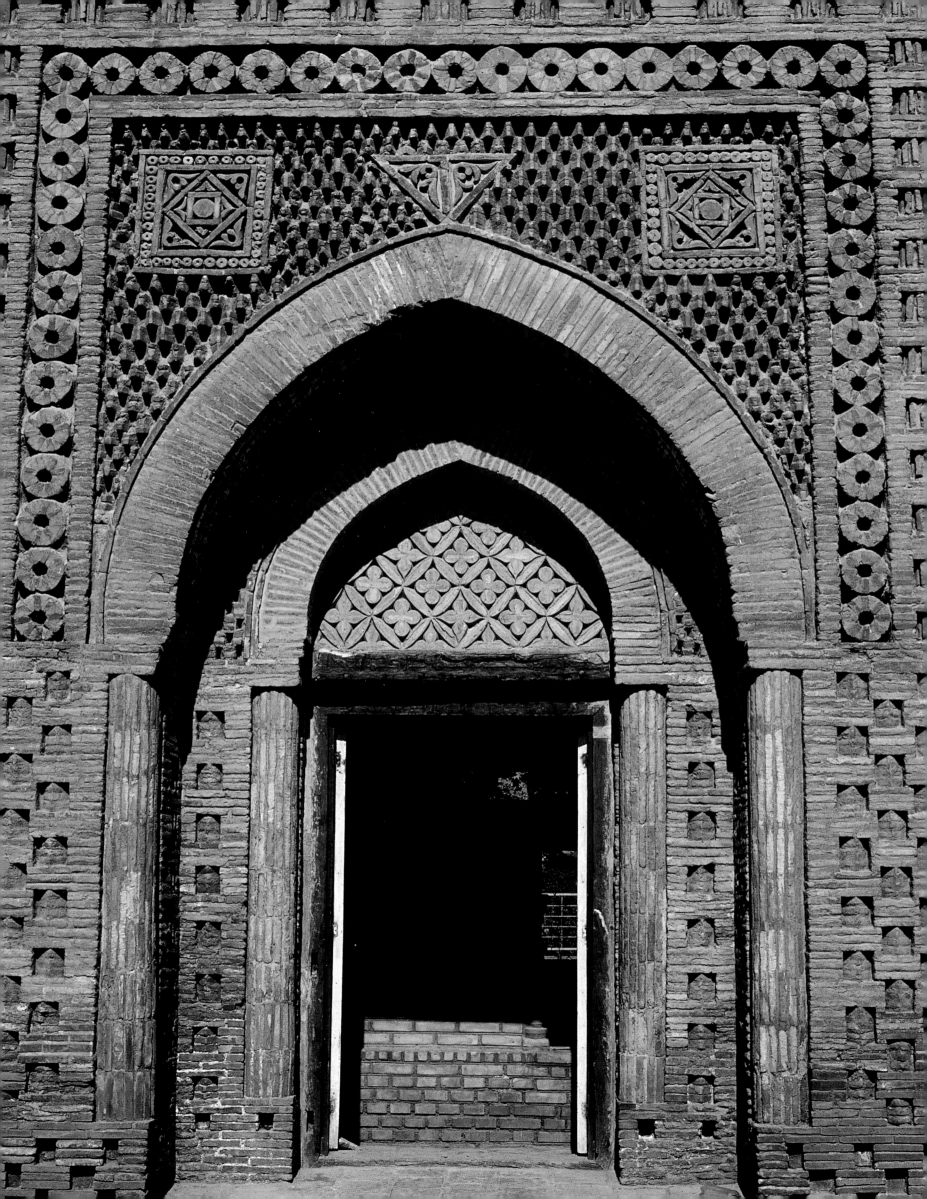

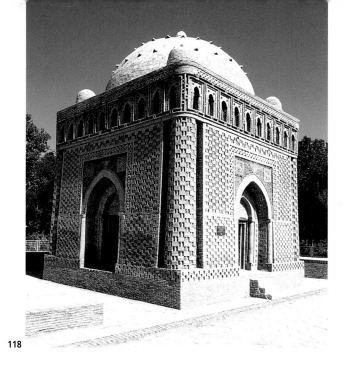

118 The Tomb of the Samanids, built in Bukhara at the end of the 10th century by Isma'il the Samanid, is the first Islamic edifice to exploit the decorative possibilities of brick. Its structure, a cubic volume surmounted by a dome with openings on all four sides, has been compared to that of Zoroastrian fire temples, the so-called *chahar taq*, 'four arches'.

Brick

117 The entrance to the Tomb of the Samanids is composed of two ogival arches inscribed one inside the other and framed by a rectangular frieze made up of a repetition of circles. All of the ornamentation is based on a technique of brick assemblage, except for a few sculpted terracotta panels such as those occupying the squinches.

Brick, the principal construction material in a vast region which includes Iran and Central Asia and stretches from the Indus valley to Mesopotamia, not only has thermic and antiseismic qualities, but also mechanical ones, which have a direct incidence on architectural forms. But its weak resistance to forces of tension makes the use of lintels impossible, and, especially in regions where wood is scarce, implies the use of the arch, the vault and the cupola in the construction of roofing. The fragility of brick thus lies at the origin of technical solutions which then, through the talents of the Iranian builders, acquired a major aesthetic dimension.

However, that brick gave birth to a specific ornamental art was mostly due to the fact that the fashioning, drying and firing techniques involved yielded a series of small elements of standardized dimensions. This formal characteristic of

brick offered the builder both a problem and its solution. If the repetitive use of such a small module over very large surfaces inevitably creates a disagreeable sensation of monotony, on the other hand brick lends itself to all sorts of manipulations which can disrupt that same monotony.

The oldest ornamental solutions encountered in Islamic brick buildings give a rhythm to the mural surface by placing elements in relief. By borrowing a model already in use on the façade of the Sasanian palace at Ctesiphon, Islamic builders were able to create an interplay of niches, blind arches and entablatures. These were produced by a simple layering of bricks in the assemblage of the wall at Ukhaidir (764–88) and the Baghdad Gate of Raqqa (772) in eastern Syria.

However, the most novel contribution appeared in Transoxiana in the 10th

119, 120 Details of the brick ornamentation of the Qal'a *madrasa* in Baghdad (mid-13th century). On the façade the bricks are either set back from the surface and disposed horizontally or pushed out and set vertically, producing a pattern in a delicate relief, underlined by squares of stamped bricks. The entry portal is framed by a sculpted brick mosaic combining vegetal and geometric forms.

121 The minaret of the Kalyan mosque in Bukhara (1127) offers a remarkable example of the geometrical variations obtained by the simple layering of brick. At the summit of the minaret, the roof and balcony from which the muezzin calls the faithful to prayer are supported by cornices with *muqarnas* also made of brick. Under the lower cornice runs a blue enamelled frieze.

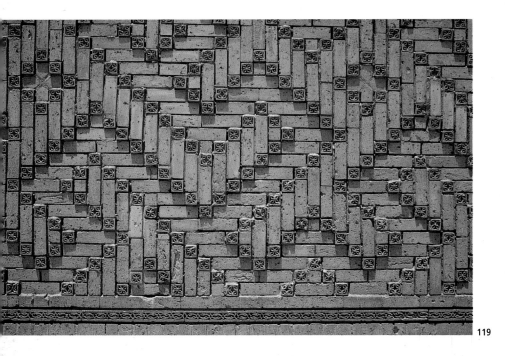

119

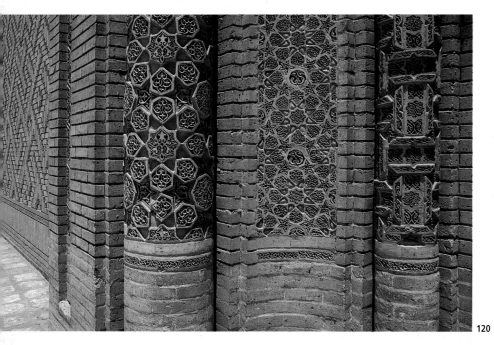

120

century on the Tomb of the Samanids at Bukhara (*Ills. 117, 118*). This cubic edifice, crowned by a cupola, is pierced by four doors and set at each corner with an engaged column and turret. By using a wealth of invention with no apparent antecedents, the builders achieved a perfect balance between the structural and the decorative functions of the brick. On the interior and exterior walls of the building almost every visible brick intervenes both as an element of construction and as part of a decorative pattern. By exploiting the contrast between the bricks jutting out of the wall and those set back in recess, the builders created a surface where shadow and light produced effects of warp and woof similar to those in weaving or basketry.

This technique, which is known as brick style, had considerable success under the Saljuqs in the 11th and 12th centuries and spread into the Subcontinent, where it is most notable in the mausoleums of Multan, as well as throughout Iran. In Afghanistan and in northern Iran it appears in all its splendour in a series of minarets, funerary towers and small mausoleums. On the minarets, for example, with their cylindrical or slightly conical shapes, the brick ornamentation forms superposed zones, each with a different pattern and a different type of relief, density and rhythm. These patterns were obtained by a skilful assemblage of standard bricks, but also by the insertion into the pattern of several cut or sculpted bricks.

What is fascinating in the art of brick assemblage is the perfect interaction between the construction technique and the ornamental patterns. The aim is not to reproduce a predetermined ornamental form by using a technique which is adapted to that purpose, but rather to set into play the ornamental possibilities of a technique not originally

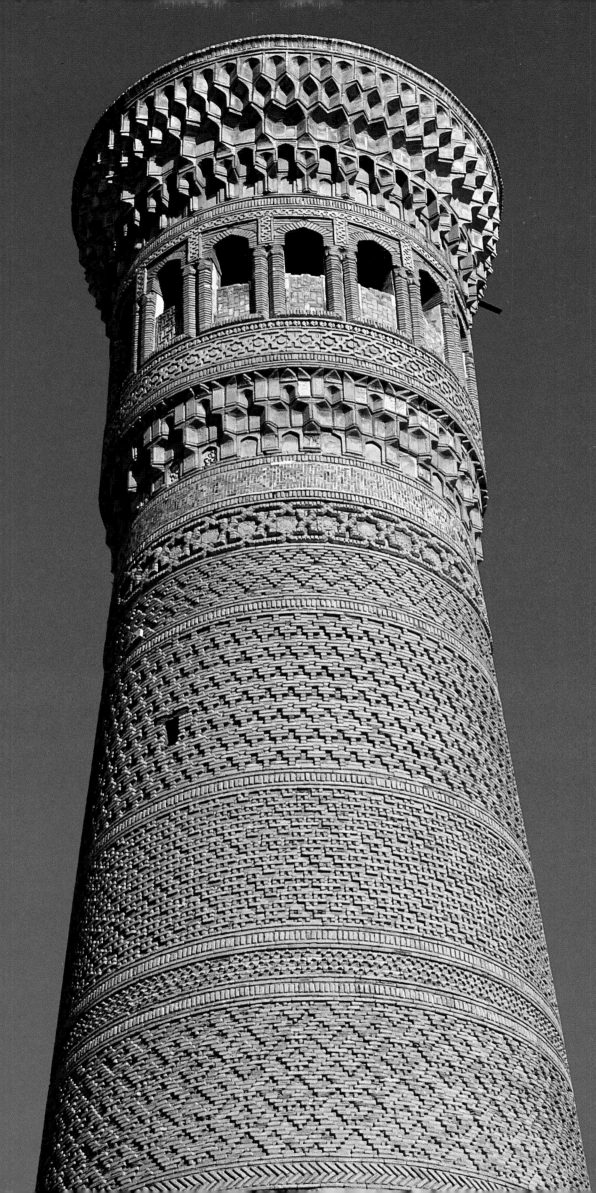

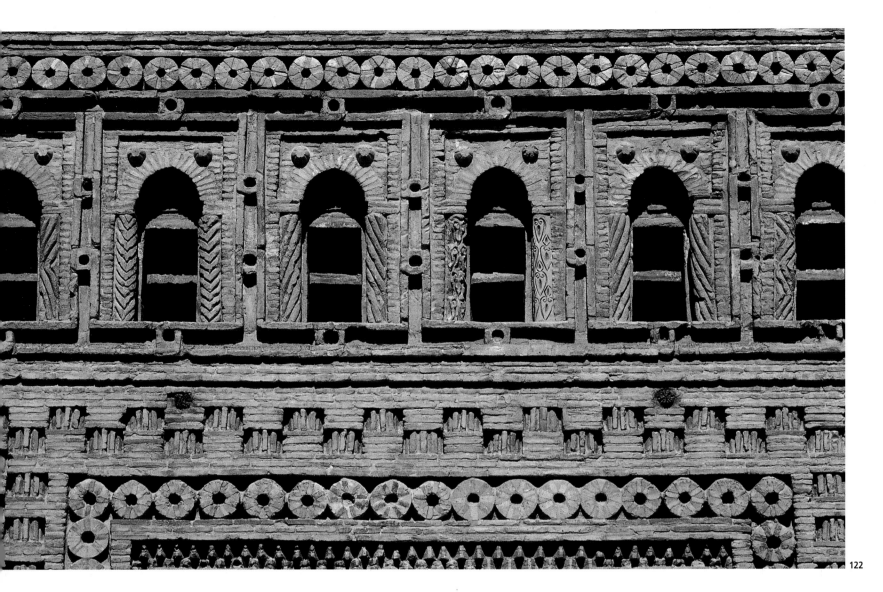

122

122 Detail of the arcature which
surmounts the façades of the
Tomb of the Samanids in Bukhara.

designed for this function. These
possibilities are directly determined by
two basic factors: the first is the serial
method of production and the second is
the principle of construction, according
to which the elements must be set in an
overlapping fashion so as to ensure the
cohesion of the whole. Produced in
series with an identical format, the bricks
become modular elements which allow
the builder to systematize his work, that
is, to regulate his actions according to
simple logical laws of combination.
The standard proportions of the bricks
employed – squared-off slabs whose
thickness is equal to one fourth of their
length – make it possible to refine and
further elaborate this combinatorial
logic. To do this, the craftsman simply
creates sub-modules by splitting the
bricks into halves or quarters. The
second technical factor – the necessary

overlapping disposition of elements in
the masonry – enables the production of
patterns which are never constrained but
instead always react with neighbouring
patterns and thus tend to dissolve into
an apparently endless framework.

A second characteristic of this brick
art, just as fascinating as the interaction
between technique and pattern, is its
absolute legibility. It is an art which
displays its resources and hides nothing.
If the spectator is seduced by the textural
appearance of the pattern, by the visual
effects of light and shadow animating
the façades of buildings or the shafts
of minarets, a closer examination will
reconstitute the repertoire of actions
which were used to obtain these effects,
a repertoire which is also a collection
of technico-mathematical formulas.

The simplest formula consists of
alternately laying the bricks horizontally

and vertically. This arrangement creates a chevron pattern evolving diagonally along the surface. Numerous combinations can be derived from this basic formula which, by using half and quarter bricks, for example, can produce uniform networks of diamond mesh. A second basic formula of this technique consists of exploiting the relief so as to integrate an impalpable but visually active element into the brick pattern: shadow. In order to do this, two similar procedures are used. Either specific bricks are deeply recessed into the wall or some bricks are set parallel to the surface and others are set at an angle of forty-five degrees. In the first case, a line of shadow appears in a staircase pattern, and in the second, a pointillist effect is produced.

In addition to these two basic formulas, which exploit the simple positioning of the bricks, other procedures can be used which necessitate a preliminary preparation of the material. The edges of the bricks can be re-cut either by making triangular indentations or by bevelling the corners. Thus sculpted, the brick can participate in new combinations, causing the surface structure to employ shadow as a sort of punctuation and to create zigzags, stars and various other forms generally used in the creation of narrow friezes. These different formulas or procedures constitute the basic principles which can be freely combined, according to the creative talent of the bricklayer exploiting them, to create an infinite number of patterns which, however, always adhere to the same logic of the combinatory rules of forms within a constant framework.

The Iranian master brickworkers, however, did not limit themselves to principles generated by the laws of construction. They used brick, not only as a formal element, but also as an artistic material in the creation of brick mosaic. Their technique, used in the ornamentation of Saljuq mausoleums and minarets like the Gunbad-i Qabud at Maragha (1197) and the Minaret of Mas'ud at Ghazna (12th century) (*Ill. 123*), is particularly adapted to the creation of ornamental panels and epigraphic bands. To create these bands, fragments of brick are cut according to predetermined geometric or calligraphic shapes. These are then assembled on the floor, facing downwards. Once the composition is finished, a layer of plaster is poured over it in order to create an element of facing which is then transferred to the actual building.

Finally, other interventions which can be seen on the buildings of Central Asia and Iran, offer even greater refinement: the inclusion of bricks bearing a stamped motif on their exposed faces, stuccoed and sculpted joints and fragments of terracotta covered with turquoise blue enamel, elements which were later to have considerable importance. This

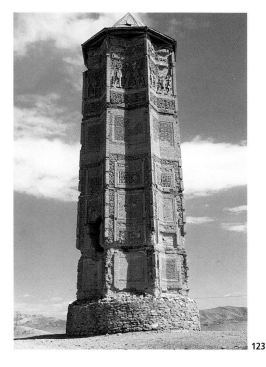

123

123 The Minaret of Mas'ud III in Ghazna, based on an eight-pointed star plan, is in fact only the base of a minaret whose upper part was cylindrical but has now disappeared. Its ornamentation consists of mosaic panels and sculpted brick.

124 Detail of the brickwork with inserted stamped bricks from the mausoleum of Chelebi Oghlu in Sultaniya (early 14th century).

125 Detail of the brickwork with inserted glazed bricks in the Blue Mosque in Tabriz (1465).

126 Detail of the brickwork on the Tomb of the Samanids in Bukhara. The bricks are set either parallel to the surface of the wall or at an oblique angle, producing a pattern which, probably intentionally, imitates basketry or weaving.

127 Drum supporting the dome of the tomb of Mulla Hasan Shirazi in Sultaniya, dating from the beginning of the 14th century. Patterns of brick in relief are replaced by a geometric and calligraphic decor obtained by juxtaposing rough and enamelled bricks in the masonry.

ornamental exploitation of brick is highly original and the principles employed to produce it, together with its visual effects, must be considered.

As far as the visual effects are concerned, when many brick masterpieces are seen in direct sunlight, they appear to be enclosed in a textile envelope. This is because the sunlight accentuates the graphic aspect of the design. They seem to be clothed in luxurious robes, at once recalling the Muslim aristocracy's pronounced taste for finely woven silk garments and for brocade and damask. This would appear to be more than a simple analogy because the Central Asian origin of this technique suggests that the bricklayers were inspired partly by the textile arts, and it is possible that the brick mausoleums could have been permanent replicas of traditional nomadic funerary tents.

At a more fundamental level, in seeking to understand the connections between this method of ornamentation and textiles, the technical principles at work must be considered. The art of brick assemblage is not just a simple imitation of textiles, but is based on procedures which display similarities to those used in weaving. Just as the weaver progressively brings out the patterns, line by line, by intersecting the warp and the woof at variable rhythms, so the builder constructs his mural design row by row, modifying the position of each of the elements. This relationship between the two types of ornamentation is probably at the origin of the Persian name given to the art of ornamental brickwork: *hazar baf* or 'thousand-weavings'.

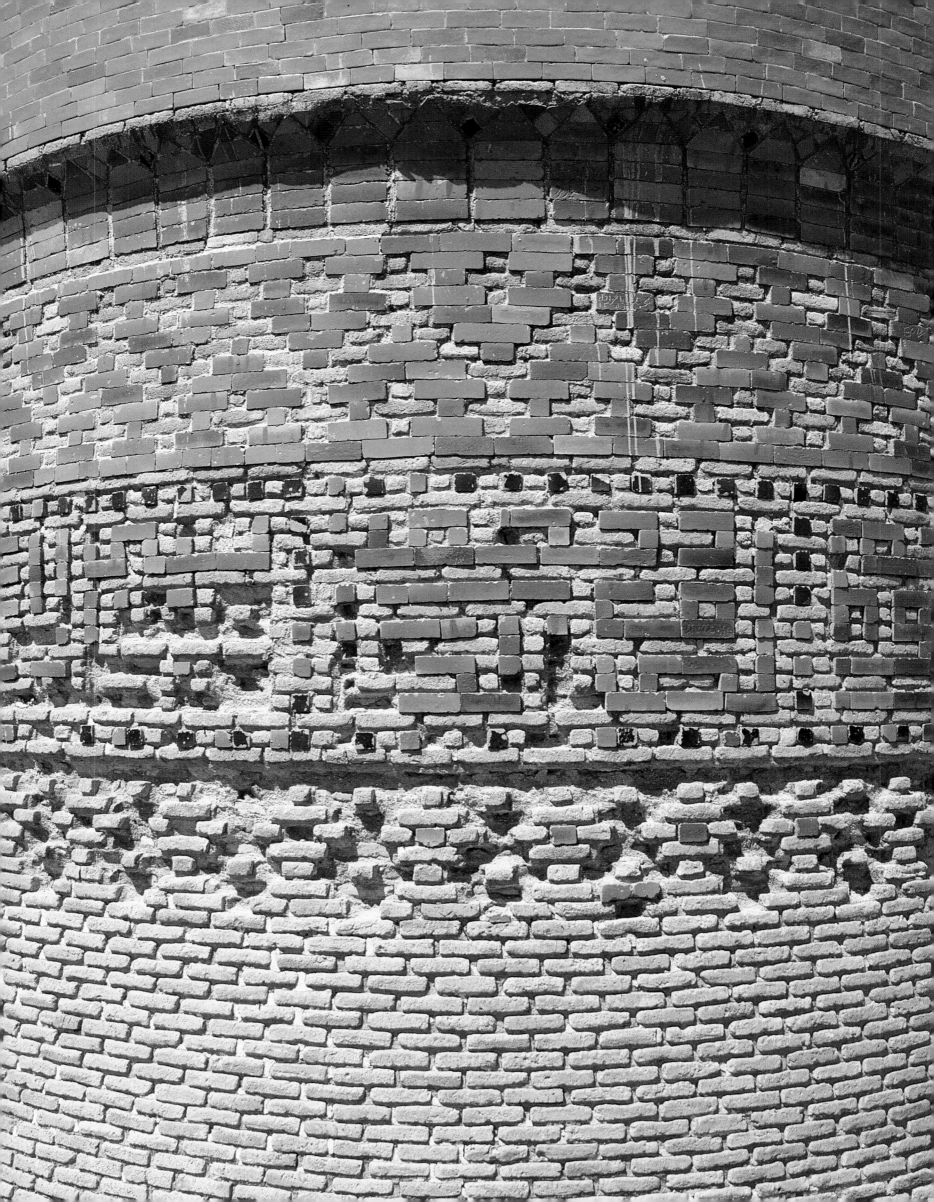

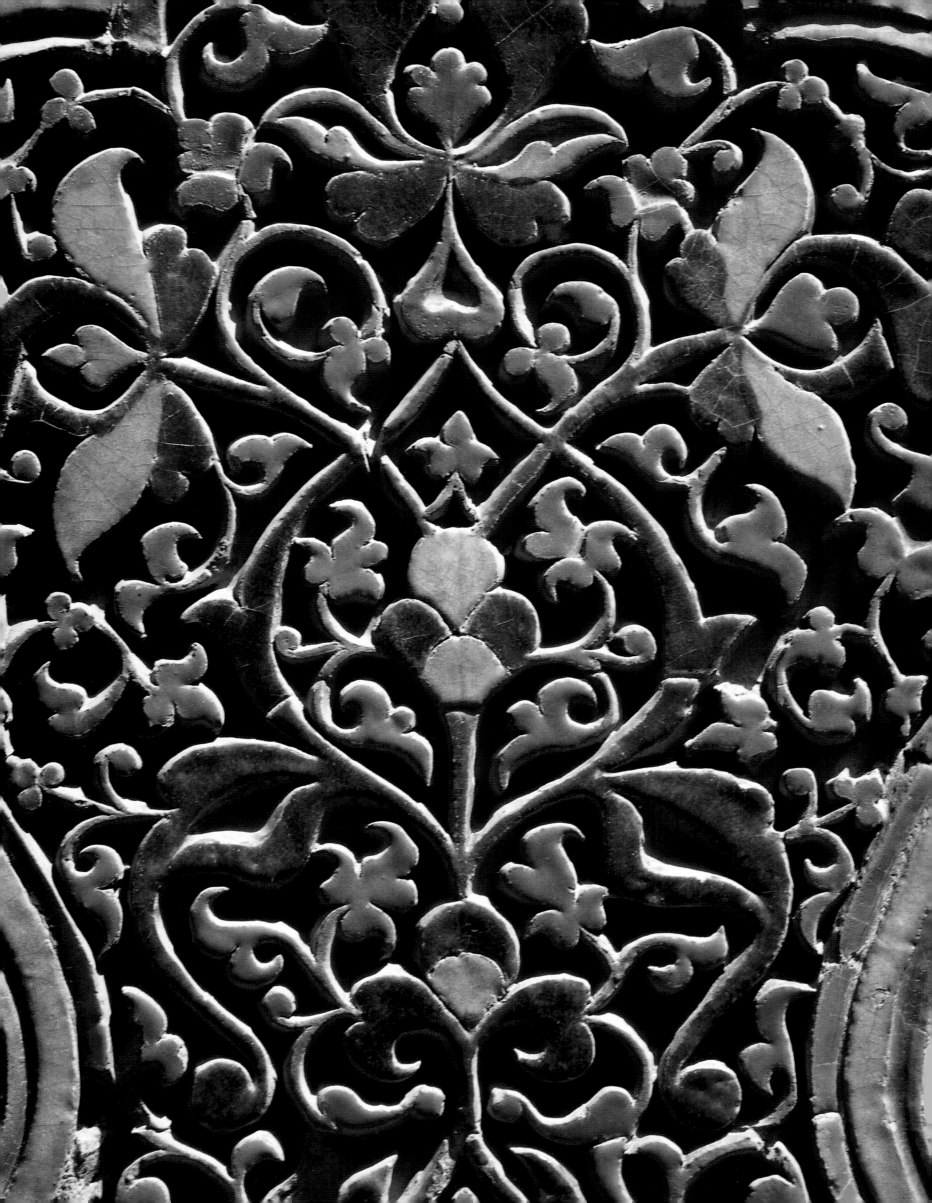

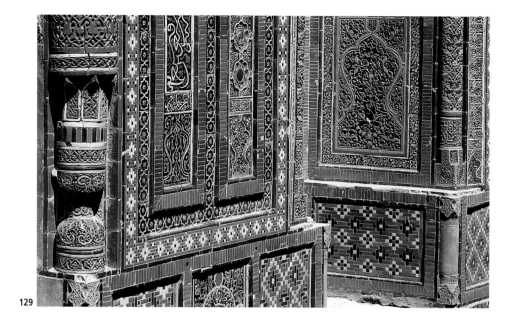

129

Ceramic

128 Among the ceramic techniques in the ornamentation of the mausoleum of Shad-i Mulk Aqa, the most elaborate and most spectacular is that of pierced glazed tile decor which combines delicate sculptures with the subtle transparencies of glazing.

At first limited to hints of azure blue appearing in the lattice of monochrome brick, the introduction of glazed brick into the ornamentation of various Saljuq buildings of the 11th and 12th centuries announced a revolution in the aesthetics of Islamic architecture. The polychrome finery, which soon covered most of the religious monuments of Central Asia, Iran and Pakistan, also spread to other regions such as Syria and Turkey. At the same time, although we cannot affirm a direct link between the two practices, mural ceramic art developed at the western extremity of the Islamic world in the Maghrib and Spain.

The development of ceramic facings constituted a rebirth of one of the most ancient ornamental traditions of the Near and Middle East. As early as the 3rd millennium BC, panels of blue-green enamelled frit decorated the tomb of Jezar at Saqqara. At the end of the 2nd millennium BC, polychromatic ceramic tiles were used at Susa. The Assyrians, and later the Babylonians, made use of enamelled brick to decorate their palaces. Later, under the Achaemenids, this technique was used to create the *Frieze of the Archers* (5th century BC). Although it declined during the Parthian and Sasanian periods, ceramic art found a place again in the architectural decor of Islam.

The use of enamel in Islamic architecture is found throughout the Iranian world. One of the first examples is the brick minaret of the Friday Mosque of Damghan (second half of the 11th century) whose summit is encircled with an epigraphic band brightened by delicate touches of pale blue. Several decades later these same turquoise elements were used at Maragha in Iran on the mausoleum of Gunbad-i Surkh (1147). They were also used on the

130 Hexagonal ceramic tile with an ewer design from the Tairuzi mosque in Damascus (early 15th century).

131 Glazed tile mosaic covering the intrados of the entry arch of the Green mausoleum in Bursa (1421).

Minaret of Jam in Afghanistan and the minaret of the Mosque of 'Ali at Isfahan. In all these examples fragments of terracotta covered with a glaze made of pulverized quartz and cobalt are included in the assemblage of rough brick. These accents of colour took on a progressive importance, so that enamelled bricks, sometimes displaying a decor in relief, made up geometrical friezes or traced the characters of an inscription.

In the Timurid period (1370–1506), this evolution led to vast labyrinthine compositions, which combined rough and enamelled brick and in which the educated eye can discern the names of Allah and Muhammad or various Qur'anic formulas. Another Timurid creation derived from enamelled brick can be seen in the panels of ceramic whose incised decor is covered in a turquoise and cobalt glaze. These were integrated, for example, into the sumptuous architectural ornamentation on the portal of the mausoleum of Shad-i Mulk Aqa in the Shah-i Zinda necropolis of Samarqand (*Ills. 128, 129*).

But the method of ornamentation which truly created the splendour of Central Asian and Iranian architecture is glazed tile mosaic. Perfected by the

Timurid master ceramicists of Samarqand, Herat and Tabriz, this technique, called in Persian *mu'arraq kari*, 'implanted work', is found in all the former imperial capitals of Iran, where it covered every visible part of the religious monuments, whether mosques or *Imamzada*s – tombs of the Shi'a Imams or their descendants and holy sites of popular piety.

Glazed tile mosaic, magnificently illustrated by the Darb-i Imam in Isfahan (15th century) or by the Blue Mosque of Tabriz (1453), is the product of an impressive number of operations which demanded the participation of highly skilled workers. First, monochrome enamelled tiles of various colours were prepared – navy blue, turquoise, emerald green, saffron yellow, white and black, with the occasional addition of brown and red – each one requiring a specific firing time in order to achieve its maximum beauty. Then came the cutting of the tiles according to a model furnished by the ornamentalist. For this the cutter used a kind of adze which had to be wielded with great delicacy in order to avoid chipping the enamel. Once cut, the edges were smoothed with a file and the pieces were fitted together face down. A layer of mortar was then poured over this precisely adjusted assemblage. Finally, when it had dried, it was transferred to the surface it was to decorate and it was fixed in place. The work demanded amazing skill, especially when one considers the complexity of the designs, usually vegetal motifs with delicate curves. This mosaic technique became even more difficult when the surface to be covered was the honeycombed interior

132 Glazed tile mosaic with a geometric and calligraphic decor from the Gök Medrese, or Blue *madrasa* in Tokat (18th century).

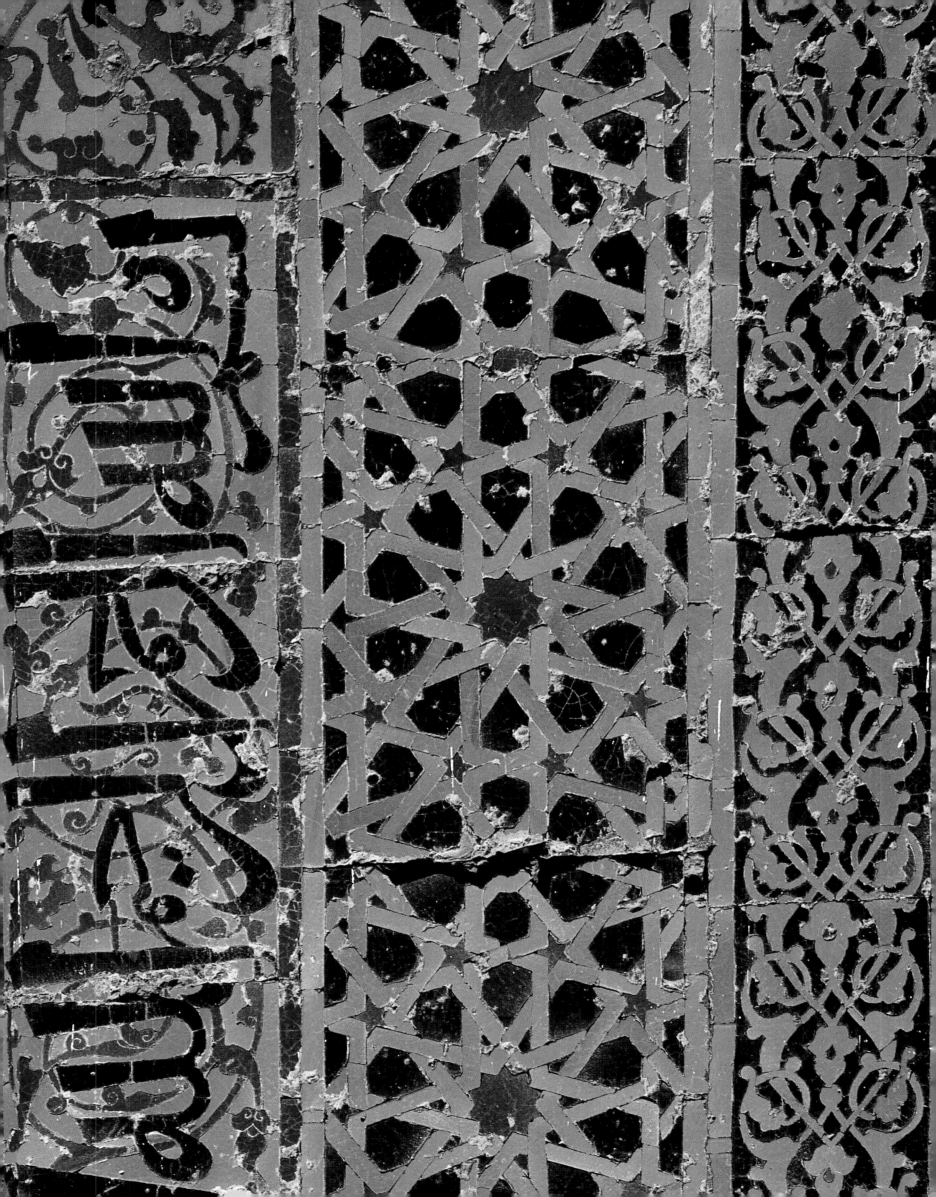

135 Polychromatic ceramic mural decoration from the 'Palais de l'Orient' in Tunis. Its graphic style, iconography and technique recall Persian ceramic panels of the Safavid period. (17th century).

133 Floral decor of the Shah Mosque in Isfahan (begun in 1611). More quickly produced than the traditional glazed tile mosaic, *haft rang* technique, in which patterns are painted directly on the clay tiles, was liberally used by Shah 'Abbas I for his major building works in Isfahan.

134 The blue and white 15th-century ceramic panels from the Topkapi Sarai in Istanbul display a new taste for naturalism. Amongst the vegetal decor of peonies and curved leaves (*saz*) can be found various species of bird.

of a *muqarnas* vault rather than the smooth flat surface of a wall.

Several variations of this technique were used for the facing of domes. In one variant, enamelled tiles were replaced by enamelled bricks, which offer more resistance to the degradation caused by rain and freezing temperatures. In another variant, the different pieces of the composition were set into position in concave cases corresponding to portions of the dome. Each one of the elements so produced was then hoisted up and fixed into place.

Alongside this evolution from enamelled brick to glazed tilework, there was another ornamental tradition whose origin is more properly linked to pottery – lustreware. Used in Baghdad and Samarra under the early 'Abbasids and probably introduced into Iran by Egyptian craftsmen after the fall of the Fatimids in 1171, this technique became the speciality of Kashan. The workshops of Kashan made two kinds of products designed for the ornamentation of secular and religious buildings: first, tiles in the form of stars, crosses or hexagons decorated with vegetal motifs or little animated scenes, and second, plaques of a larger format displaying inscriptions in relief and which were used in the composition of *mihrab*s.

This specialization in Kashan gave ceramic tiles their Persian name, *kashi*, a contraction of *kashani*, of Kashan. Another technique, *haft rang*, or 'seven-colour', was developed in Kashan. It consisted of painting polychromatic designs on tiles which were fired a second time *(Ill. 133)* and then used in architectural coverings. Because all colours were given the same firing time, *haft rang* could not hope to compete with the chromatic intensity of glazed tile mosaic. But in spite of its lesser quality, the Safavid shah 'Abbas made use of this technique, because it reduced the number of operations needed cover the immense surface areas of his building projects in Isfahan, particularly in the Shah Mosque, reserving the slower costlier glazed tile mosaic for those parts of the building judged to be the most important, such as the monumental entrance opening onto the *Maidan-i Shah*, the Royal Square.

The use of ceramics in architecture appeared in Anatolia at the same time as in Iran. In the 13th century under the Saljuqs glazed tile mosaics displaying a range of luminous colours, which included turquoise, cobalt blue, manganese violet and white, were the usual ornamentation for *mihrab*s *(Ill. 132)*. In the 15th century, a group of Persian ceramicists known as the Masters of Tabriz, developed a technique in Anatolia called *kashi haft rang*, magnificently illustrated in the blue, green and turquoise hexagonal tiles adorned with golden motifs which cover the interior walls of the Yeşil Cami, or Green mosque, in Iznik.

But the greatest innovation in this art was made by Ottoman ceramicists. Building on this Iranian contribution, they perfected a ceramic art towards the

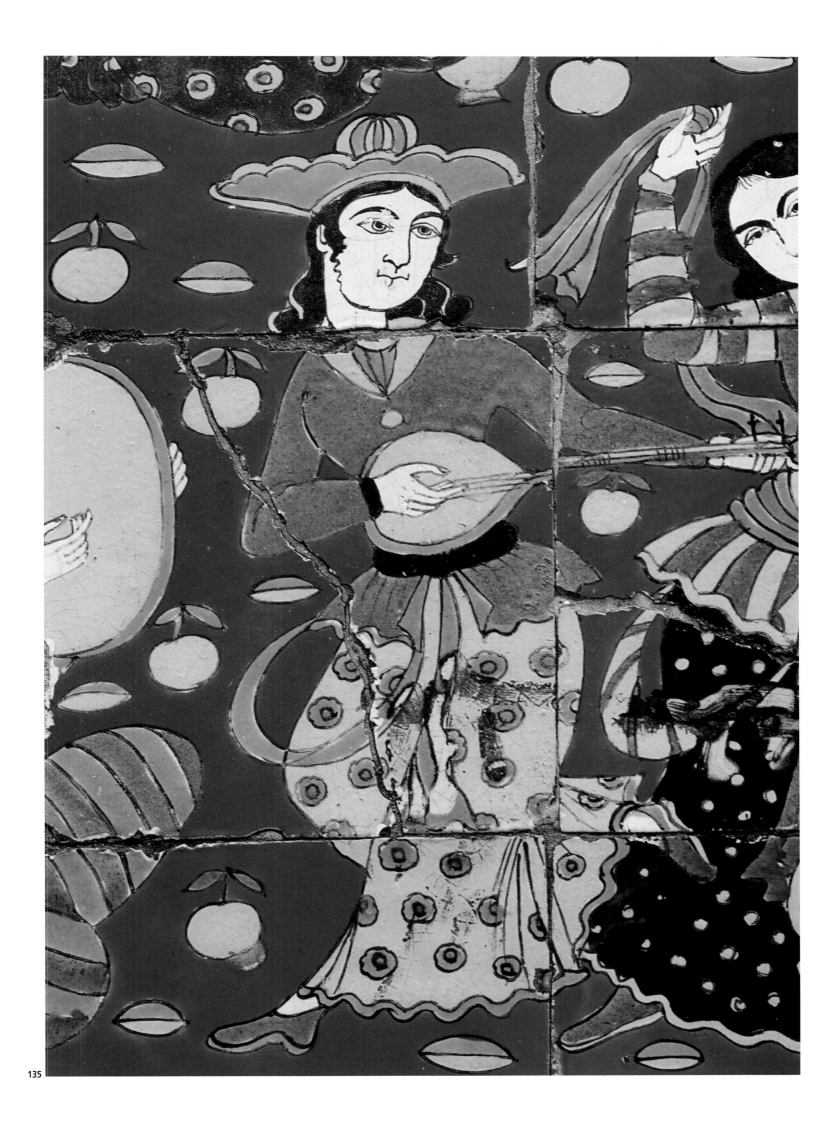

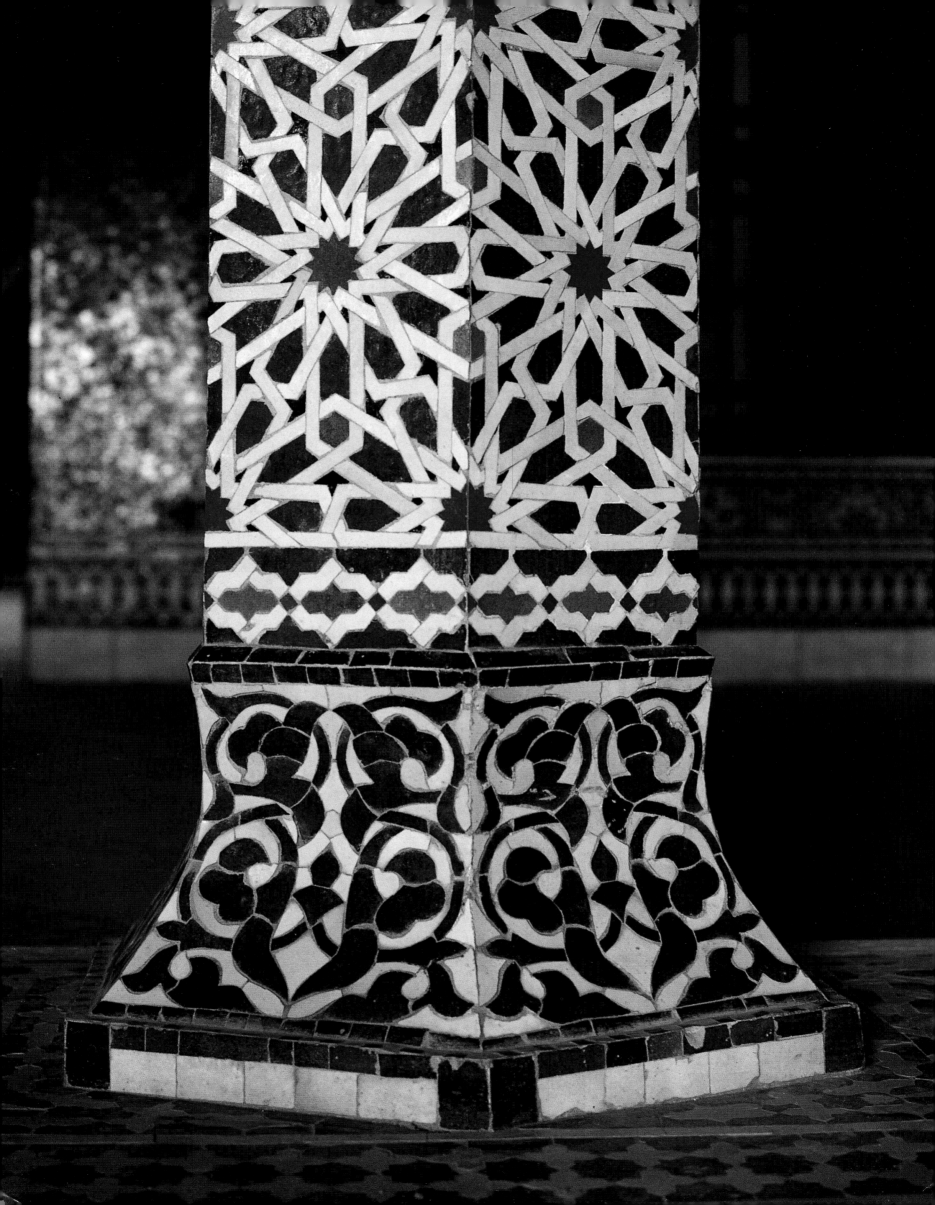

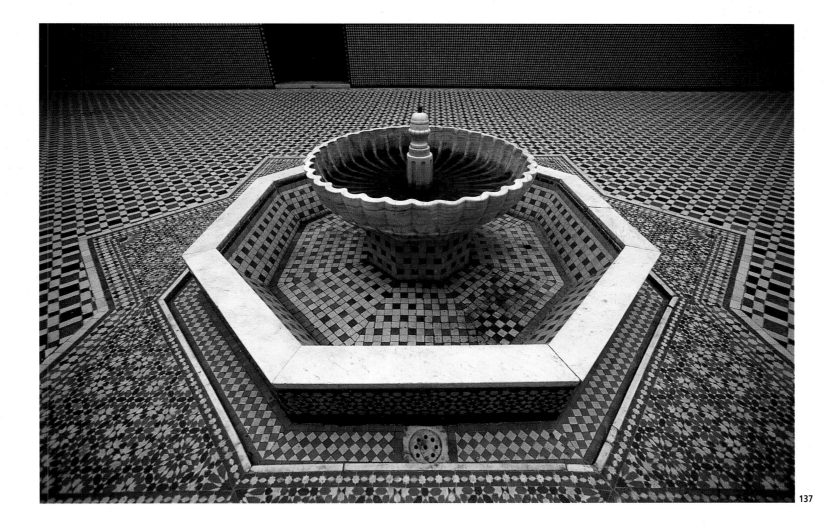

137

end of the 15th century in the workshops of Iznik, whose originality was partly due to the basic materials and chromatic range employed, but also to its patterns and graphic designs (*Ill. 134*). At first the ceramicists of Iznik imitated blue-and-white Ming porcelain. But towards the middle of the 16th century they adopted a new range of colours marked by softer hues such as pale green and mauve, but also by the increasing presence of a gleaming tomato red, which they obtained from clay rich in iron oxides, the so-called Armenian bole. As for the patterns which filled the ceramic facings of Iznik, which were created for use in mosques, palaces or tombs, they were frequently distinguished both by Chinese influence and by a new tendency towards naturalism in their motifs of flora and fauna.

In the 12th century and far from Iranian influence, the Maghrib and Spain also developed an ornamental technique which required the use of enamelled tiles known as *zellij*. Appearing in conjunction with stucco and sculpted or painted wood, *zellij* – which gave its name to the Spanish *azulejos* – occupied specific locations. It was essentially used to cover the dados on the interior walls in both religious and secular buildings.

The fabrication of *zellij* – the firing of monochromatic tiles, their cutting, assemblage, transfer, etc. – is exactly the same as the method used in Iran for glazed tile mosaic. But one difference distinguishes *zellij*. It conforms to a greater degree of systematization. Unlike its Iranian counterpart, it almost always displays geometrical patterns. Because it does not have to adapt to the fluid forms of ornamental vegetation, *zellij* technique can proceed according to mathematical principles. All the classical compositions are obtained by a skilful associative interplay based on a vast, but not unlimited, number of standard elements.

136 Pillar of the *kasbah* of Tlwat (19th century), covered with *zellij*. *Zellij* technique, an assemblage of elements cut from ceramic tiles, is similar to the technique of glazed tile mosaic used in Central Asia, Iran and Turkey. But here geometric interlace takes on a vigour which is specific to western Islamic art.

137 Fountain of the tomb of Mulai Isma'il in Meknes (18th century). Generally used to cover dados, *zellij* is also used in the Moroccan architectural tradition as a paving technique, and in particular to enhance the fountains placed in the centre of patios.

OTHER TECHNIQUES

BRONZE

138, 141 Door of the *zawiya* of Sultan Baibars II in Cairo (1310). In Egypt, the art of metalwork reached its apogee in the 14th century. It was used by the Mamluks to cover the doors of their religious monuments in richly worked bronze plaques, usually displaying a decoration with geometric interlace.

140 Door knocker from the principal door of the *bimaristan* of Nur al-Din in Damascus, built in 1154.

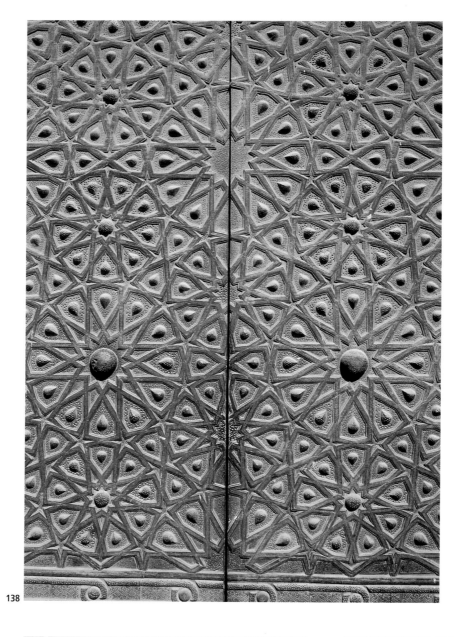

138

139

140

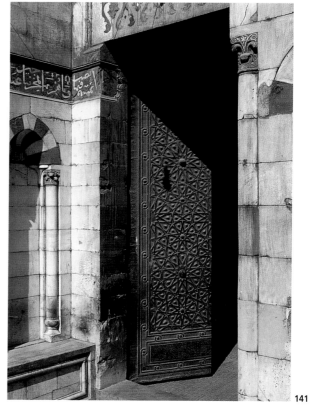

141

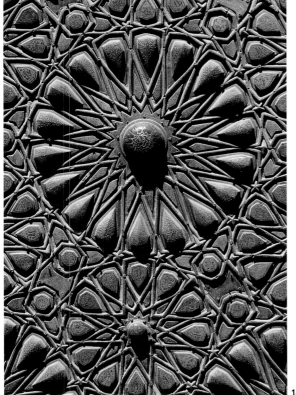

139, 142 Door of the *madrasa*-mosque of Sultan Barquq in Cairo (1384–86).

143 Grill of a public fountain in Istanbul (Ottoman period).

144 Detail of the geometric and calligraphic ornamentation on the door of the mosque of al-Mu'ayyad in Cairo (1415–20). This door, covered by magnificent sculpted bronze decoration, was originally created for the mosque of Sultan Hasan (1356–63), from which it was taken by Sultan al-Mu'ayyad.

142

143

144

WOOD

145 Detail from the *minbar* of the mausoleum of Qa'itbay in Cairo (1472–74). The *minbar*, or pulpit chair, situated to the right of the *mihrab*, is traditionally covered with wooden strapwork, sculpted or inlaid with ivory in which starry polygons are frequently found.

146 Roof in sculpted cedar which surmounts the portal of the al-Najjarin *funduq* in Fez (17th century).

147 Detail from the wooden *mihrab* dating from 1245 in the Halawiya mosque at Aleppo.

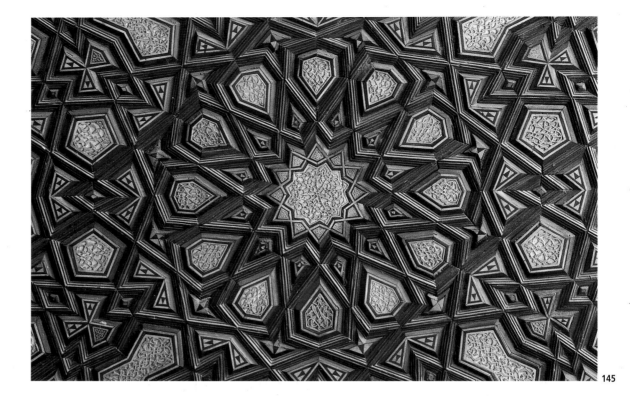

145

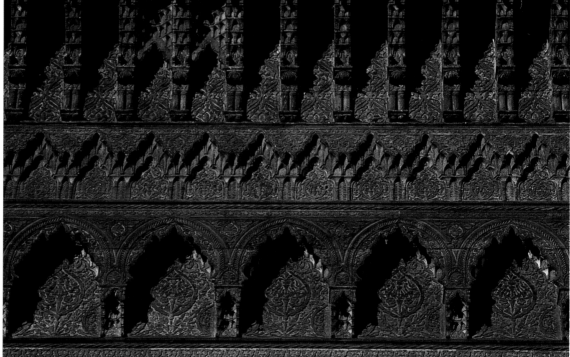

146

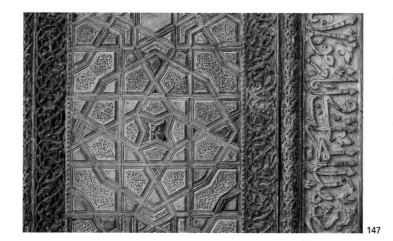

147

148 Detail of the marquetry work on the *minbar* of the *madrasa*–mosque of al-Ashraf Barsbay, built in 1432.

149 Sculpted wooden door of the Shir Dar *madrasa* in Samarqand (1619–36).

150 Sculpted wooden door of the Tahir Khan Nahar mausoleum made in Sitpur at the beginning of the 16th century.

151 Detail of a wooden grill and its sculpted frame which surmount the door of the mausoleum of Shah Rukn-i 'Alam in Multan (13th century). The patterns obtained by the assemblage of pieces of wood recall those produced by certain arrangements of brick.

148

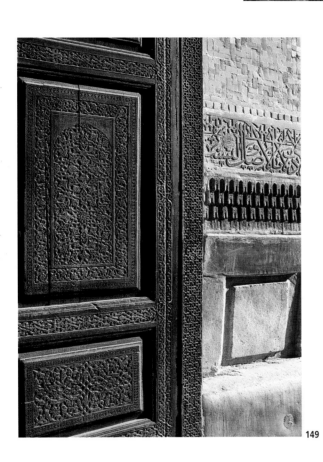

149

150

151

PAINTED WOOD

152 Ceiling of the music room in the 'Ali Qapu, an audience hall which looks onto the Royal Square of Isfahan (early 18th century). Created from wood and laquered stucco, the alveoli of this ceiling are pierced with openings in the shape of vases, pitchers and glasses. Apart from being decorative, it is believed that this was a system of acoustics for the hall.

153 Coffered ceiling of painted wood from the Dahda palace in Damascus (17th century). During the Ottoman period, the art of sculpted and painted wood developed in Syria and was used principally for the creation of sumptuous ceilings for reception rooms.

154 Wooden ceiling from the mosque of Amir Qijmas al-Ishaqi in Cairo (1480), painted with geometric interlace.

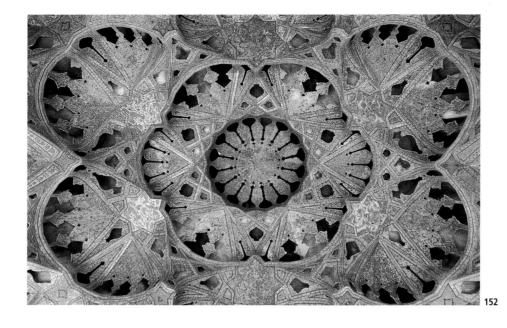

152

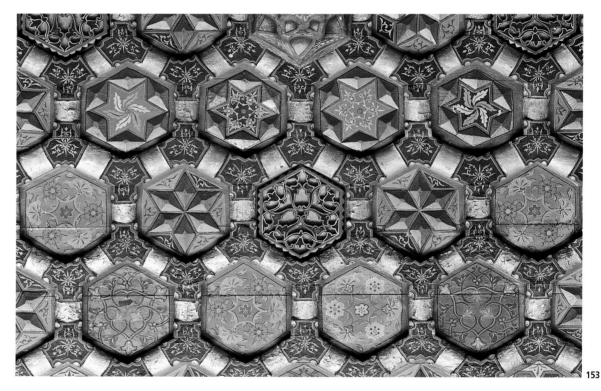

153

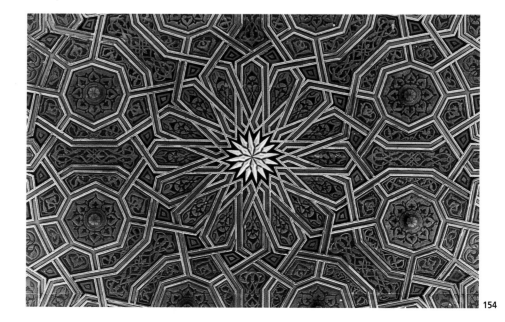

154

155

156

155 Sculpted, painted woodwork with star-like patterns on the ceiling of the house of Khalid al-'Azm in Damascus.

156 Detail from the painted door of the *kasbah* of Tlwat (19th century).

157 Stuccoed and painted wooden *muqarnas* from the Wazir Khan mosque in Lahore (1634).

158 Sculpted and painted wooden medallion representing snakes set the centre of the ceiling in the Ajiqbash house in Aleppo (18th century).

159 Interior of the Siba'i house in Damascus. The palaces and elegant residences built in Damascus and Aleppo during the Ottoman period exhibit an almost baroque taste for luxury. In them one can find the polychromy of building stone, marble-covered floors, sculpted or inlaid wood on the doors and painted woodwork on the ceilings.

157

158

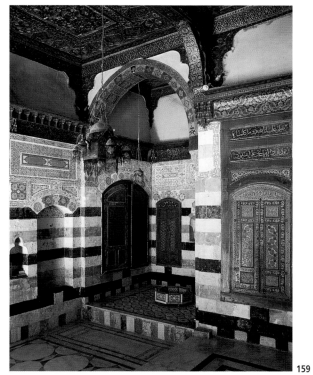

159

Ornamental Motifs

The Figure
Plant Forms
Geometry
Calligraphy

Additional Motifs
The Figure
Plant Forms
Geometry

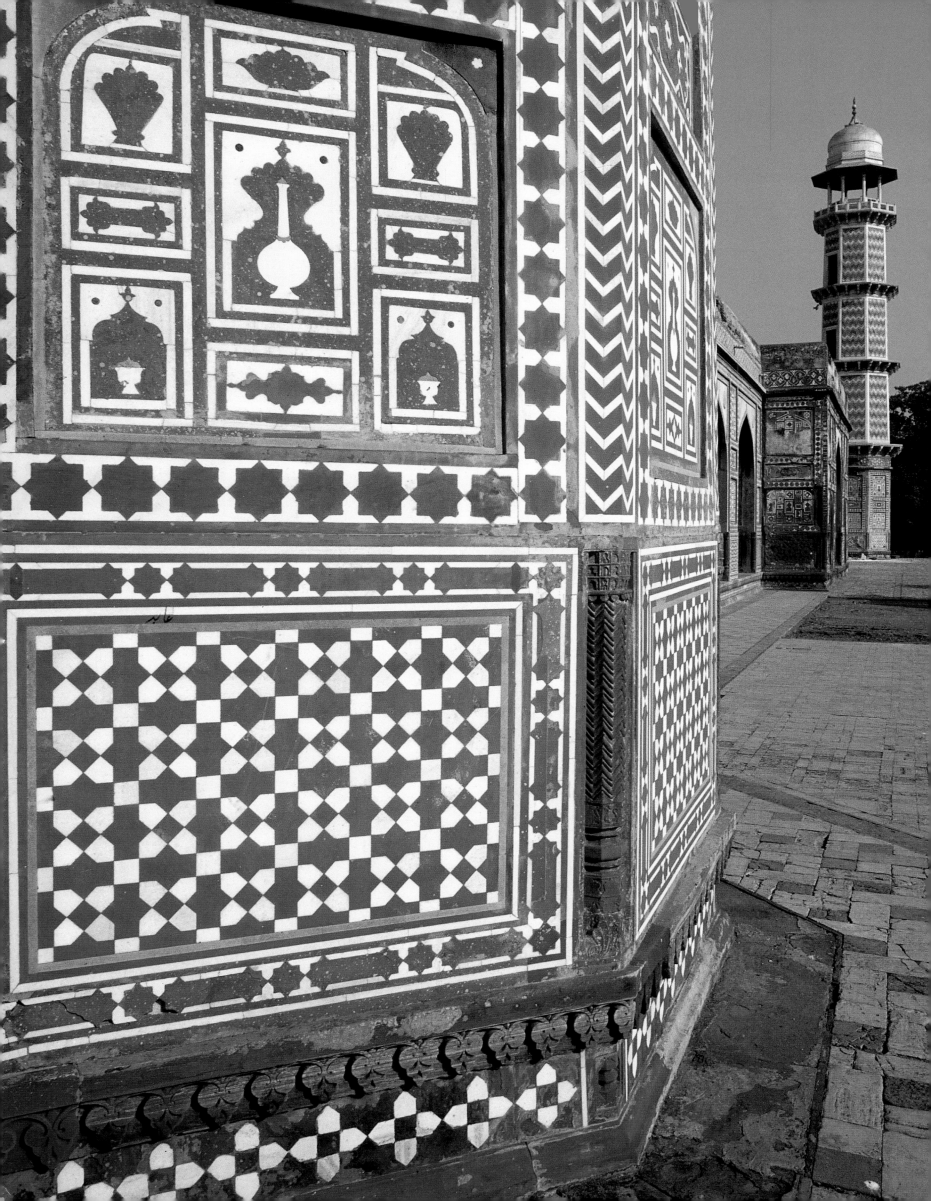

160 The mausoleum of
Jahangir, built in 1637
near Lahore, is covered with
marquetry in red sandstone
and white marble. Among the
geometric compositions can be
found several panels displaying
objects which recall courtly life,
such as flasks and glasses.

The nature of some ornamental techniques seems to induce particular types
of patterns. A perfect example is the assemblage of bricks in an overlapping
fashion which generates an infinite variety of geometric networks. In the
same way, the *zellij* of the Maghrib and Spain and the marble and sandstone
marquetry of Mughal edifices create compositions by the simple fact that
their elements are cut along a pattern of straight lines, in which a variety
of triangles, lozenges and polygons are articulated. Other materials, such as
wood, organized by an assemblage of lengths of moulding and small panels,
give rise to similar forms. In all cases the geometry engendered seems to be
the direct product of the technique used.

On the other hand, techniques can also be adapted to forms which are in
principle foreign to them. Glazed tile mosaics, such as those developed by
craftsmen in Central Asia and Iran and similar to *zellij* in their production
techniques, lent themselves to the curved forms of vegetation and the fluid
forms of cursive script produced by calligraphers. In the same way, the
technique of stereotomy used by Syrian builders was able to produce stone
hewn in the shape of a *fleur-de-lis*. This adaptability of a technique to meet
the requirements of forms it was not intended to produce is evidence of the
artist's virtuosity.

On still other occasions, a technique influenced the forms it borrowed
from other fields, adapting them to fit its proper logic. When calligraphy
was transferred to the art of the bricklayer, it took on an angular profile
that challenged the designs made by the calligrapher and his *qalam*, or pen.

The relationships between techniques and ornamental forms are thus
extremely diverse and changeable. However, one phenomenon is constant:
the ease with which Muslim ornamentalists were able to transfer design
systems from one technique to another. A given form, like the quadrangular
writing naturally produced by the assemblage of bricks, was sculpted at a

161 Detail from the floral
ornamentation made of marble
inlay in sandstone decorating
the principal portal of Akbar's
mausoleum at Sikandra near
Agra (1613).

162 Geometric network and
vegetal arabesques decorating
one of the portals of Akbar's
mausoleum.

161

162

later period into stone, and another form whose origins lay in the textile arts, was transposed into enamelled tile mosaic or stone. This repeated phenomenon of transfer operated not only in the narrow field of architectural ornamentation, but also created connections between many other forms of plastic expression: metalwork, pottery, fine woodwork, illumination, weaving, etc. It is partly this propensity of Islamic ornamental motifs to transgress techniques which explains the considerable success of stucco. Totally flexible, stucco can accommodate all motifs and all possible design systems.

The movement of ornamental forms from one technique to another is paralleled by another kind of movement in both space and time. Certain motifs not only passed freely across the frontiers of techniques, but also migrated with equal facility from one region of the Muslim world to another or perpetuated themselves sometimes with minimal variations down the centuries. For example, a window grill from the Great Mosque of Damascus is similar to its Cordoban equivalent created two centuries later, or to a stone open-work grill produced in the 16th century in Mughal India. This mobility of forms in space and time can be explained by the constant cultural and artistic exchanges in the Islamic world, by the movement either of artisans or of the objects which are the actual vehicles of ornamental systems. But another possible explanation brings the status of the artist into the equation. The artist did not work as an individual, giving free rein to his individuality, but as a member of a community of artists which accepted a common aesthetic. There are some rare exceptions to this rule, such as a ceramic panel from Bursa (*Ill. 163*) which has escaped recognized conventions and seems, in a strange way, to have more in

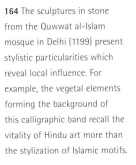

164 The sculptures in stone from the Quwwat al-Islam mosque in Delhi (1199) present stylistic particularities which reveal local influence. For example, the vegetal elements forming the background of this calligraphic band recall the vitality of Hindu art more than the stylization of Islamic motifs.

163 Although Islamic ornamentation is always based on rigorously constructed systems, this ceramic panel from the Green mausoleum at Bursa (1421) is disconcertingly unconventional.

163

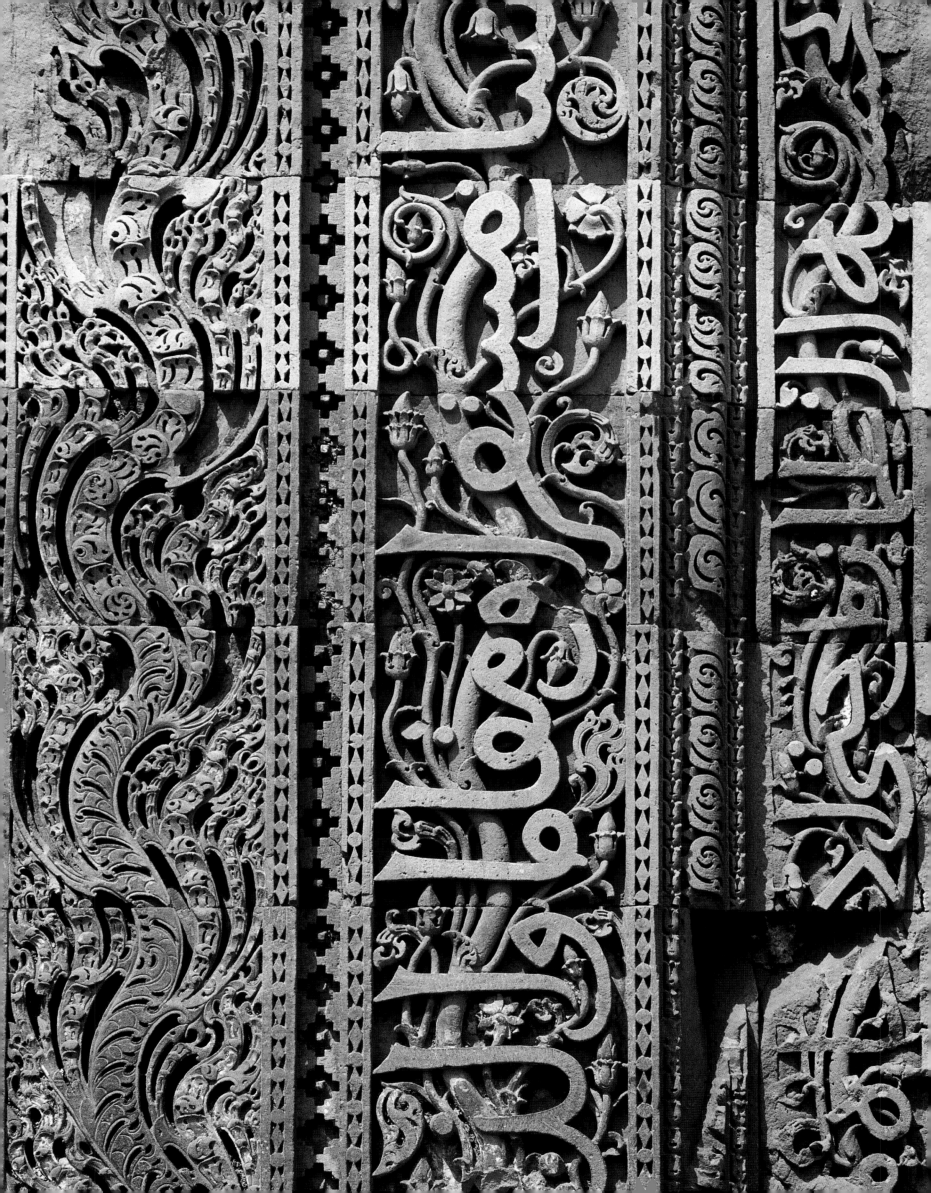

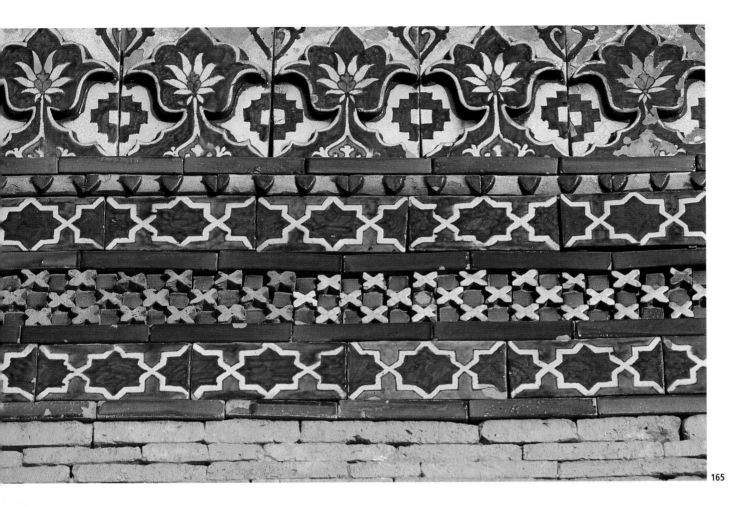

165

common with modern compositions by, for instance, Paul Klee. But
above all the technical specificities and all the regional or dynastic stylistic
variations of Islamic ornamentation, several major shared themes dominate
and thus can be called pan-Islamic since they act as unifying elements
in most Islamic architecture: plant forms, geometry and calligraphy.

In the earliest Umayyad monuments such as the Dome of the Rock,
the Great Mosque of Damascus, Khirbat al-Mafjar and Mshatta, decor
with a vegetal inspiration is seen as the direct extension of the pre-Islamic
arts of the Near East. The similarity is such that archaeologists have
occasionally hesitated to attribute a given building to the Islamic period.
The vegetal patterns sculpted into the stuccos of Khirbat al-Mafjar or
into the stone of Mshatta do not present any fundamental differences
from those decorating pre-Islamic Syrian monuments. Similarly, those
which appear on the mosaics of Jerusalem and Damascus can be
considered a local variant of Byzantine ornament.

Although its roots are found undeniably in pre-existing arts, the
specificity of Islamic vegetal ornament comes from the central role it
achieved. From a secondary decorative motif, limited to the embellishment
of a cornice or a capital, it became an artistic form in its own right,
covering large surfaces and utterly transforming the appearance of
buildings. At the same time, vegetal ornamentation was subject to stylistic
mutations which rapidly made it lose what was left of Greco-Roman
naturalism. In its place a highly formal stylization appeared, sometimes
pushed to the limits of abstraction. This mutation gave birth to what is
commonly called the arabesque or, in Arabic, *tawriq*. The success of vegetal

ornamentation – which reverted to more naturalistic forms at certain periods – must be understood as a function of Islamic thought and is linked to nature and, more precisely, to the garden.

Geometry, the second great theme of Islamic ornamentation, also has its origin in the arts of late Antiquity. But here again, what had only been a marginal decoration reserved for an occasional frieze, the design of a pavement mosaic or the decor of a coffered ceiling, was brought by Islamic architecture to an extreme of complexity and sophistication, playing upon the skilful partition of surfaces. This development of the geometric theme reflects advances in the mathematical sciences made in medieval Islam. Moreover, the frequency of the star pattern in geometrical decor appears to echo a heavenly world which functions as a counterpoint to the natural world represented by vegetal ornamentation.

The third theme, script, since it was used for ornamental purposes, owes nothing to the great artistic traditions which preceded Islam in the Near

166 Detail of the brick and ceramic ornamentation of the Tahir Khan Nahar mausoleum at Sitpur (early 16th century).

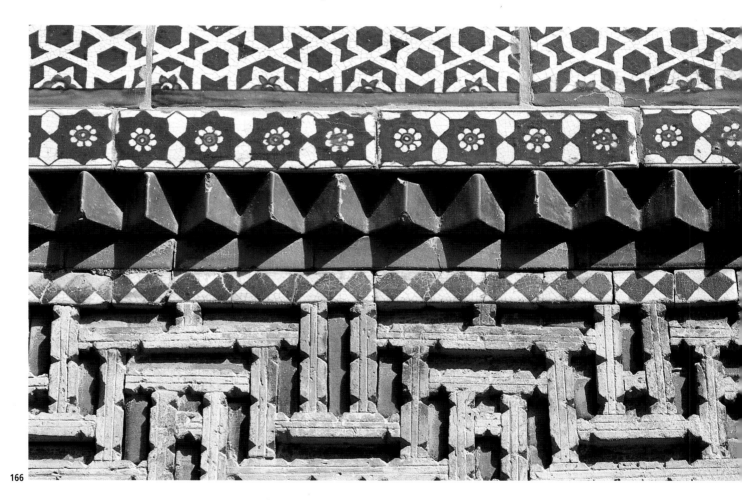

166

167

167 Detail of an epigraphic band from the minaret of Qa'itbay (second half of the 15th century) in the Great Mosque of Damascus.

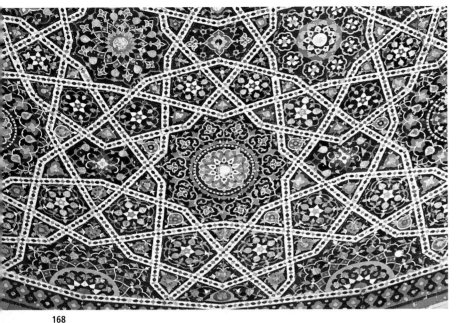

168

168 Interior cupola of the
mausoleum of Turabeg Khanum
(1330–70) in Kunya Urgench
(Turkmenistan). The decor of
glazed tile mosaic demonstrates
an extreme mathematical
refinement.

East. Calligraphic ornamentation
is a purely Islamic creation and
shares its origins with the Arabic
script. Derived from the Nabatean
script and introduced into the
Hijaz in western Arabia shortly
before the birth of Islam, the
Arabic script was highly esteemed
even in pre-Islamic Mecca since
it could preserve speech. It is said
that at the end of poetry contests
held during the seasonal fairs
in Mecca, the victors had their
poems transcribed and hung upon
the wall of the Ka'ba. The term
mu'allaqa, 'suspended', denoting
a genre of pre-Islamic poetry, retains a memory of this practice. But with
the spread of Islam the Arabic script became clearly associated with the
idea of the Divine Word.

Unlike geometric and vegetal ornamentation, whose symbolic meanings
can only be conjectured, ornamental epigraphy occupies a particular
position in that its way of expressing meaning is based on a convention
known to anyone who can read. The texts transcribed on monuments can
thus refer to historical facts — names of those who ordered the construction
of the building or the builders themselves, the date of construction or
restoration, etc. — or they can, as in the Alhambra, be poetry, but mostly
they consist of verses from the Qur'an, indicating the meaning or function
of the building or of a part of the building. Although the principal purpose
of writing is to transmit meaning, its use as a decorative element expanded
its role. The function of epigraphic ornamentation in Islamic architecture
is both to convey meaning and to make the Divine Word, and thus the
Divine Presence, visually manifest. For this function to be fulfilled it is
not necessary for the spectator to be able to read, he needs only to see.
This distance from the initial function of writing means that the letters,
because they are regarded as plastic forms endowed with sanctity, are used
in ornamental configurations which sometimes make them difficult, if not
impossible, to read. Thus, for example, a calligraphic band situated at the
summit of a minaret is designed rather to raise the profession of faith up
to heaven than to be legible to a potential reader.

These three major themes, which are almost always associated, create a
kind of visual polyphony in their simultaneous evocation of nature, the

169 Geometrical network of rough
and glazed bricks which are part of the
ornamentation of the mausoleum of Shah
Rukn-i 'Alam in Multan (13th century).

170 The façade of the tomb of Atgah Khan
in Delhi (1567) displays three adjoining
ornamental procedures. On the lower part,
the pattern is produced by a assemblage
of simple geometrical elements. In the
middle, sculpture reproduces the marks
of a calligrapher's *qalam*. In the upper
part, stone marquetry demonstrates
the principle of interlocking forms
with their counterforms.

169

171

abstract world of geometrical forms and the Divine Word. They have
sometimes been understood by art historians as the outcome of the Islamic
ban on imagery, that is, scenes with figurative representations. Thus
Muslim artists were thought to have searched for a more formal, licit
repertoire of pure ornamentation. This rather hasty interpretation, which
presupposes that art is in essence rooted in an impulse to represent living
creatures, is clearly the product of ethnocentrism and tends to belittle
the aesthetic meaning of such a choice. It is nonetheless true that these
ornamental themes, which constitute one of the major identifying
characteristics of Islamic architecture, appear as an alternative – whose
modalities need to be specified – to a figurative practice which did
in fact exist in Islam, and particularly in architectural decoration.

Jurists throughout Islamic history frequently expressed their suspicion of
images. Basing their views on an interpretation of various passages from the

172

172 Detail of a ceramic tile from
the Darwish Pasha mosque in
Damascus (1571). The chipped-off
bird's head is the result of a
hostile act against the figurative
representation of living creatures.

173 Detail from a ceramic panel
in the Qutaish mosque in Sidon,
(15th century). These ceramic tiles
are clearly related to the ones in
the Tairuzi mosque in Damascus
(Ill. 130) as well as those of the
Muradiye mosque in Edirne
(Ill. 197).

174 Circular calligraphic
composition integrated into
the ceramic decor of the Friday
Mosque of Yazd (1375).

173

174

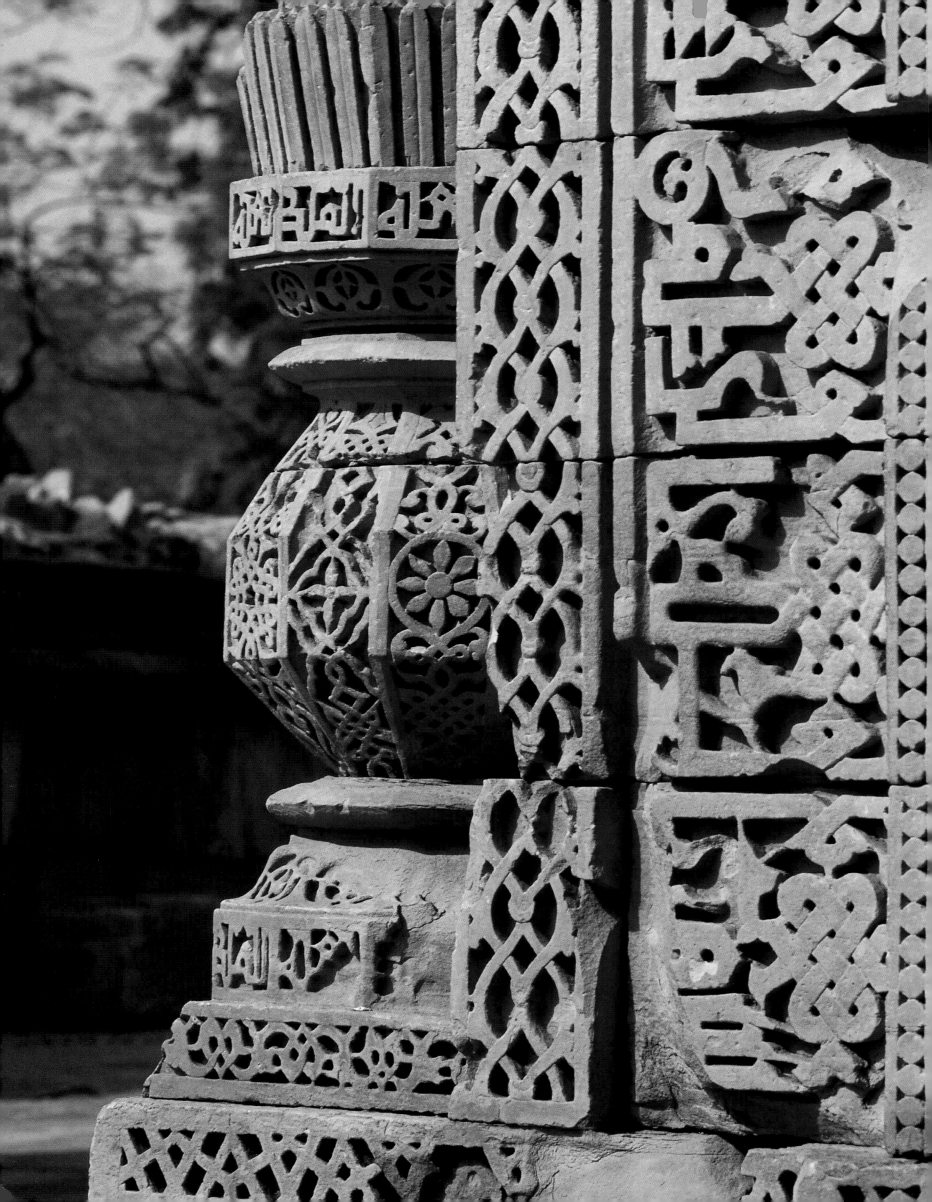

176

175 Detail of sculpted ornamentation from the extension added to the Quwwat al-Islam mosque in Delhi between 1210 and 1229. In the foreground on the right can be seen a plaited kufic inscription with markedly dense forms.

176 Small engaged baluster in the corner of one of the windows opening onto the mosque of 'Isa Khan Niyazi's tomb in Delhi (1545–47).

177 Sculpted lion medallion at the entrance to the Bait al-Din palace south-east of Beirut (early 19th century). The image of a lion has been often used since earliest times as an emblem of power to protect city gates, castles and palaces.

Qur'an and referring to certain *hadith* (sayings or acts of the Prophet), some doctors of law developed an argument which held that the figurative representation of living beings was contrary to the Divine Will and thus reprehensible. For these jurists, the act of reproducing the image of a being endowed with the breath of life is the same as counterfeiting the work of God's creation. That is why, as is said in one *hadith*, 'Angels will not enter into a house where there is a dog nor into one where there is an image.' It is quite likely that such dogmatic attitudes caused artists to abandon figurative art. However, this exegesis does not seem to have been followed with equal rigour in every region or at every period of Islamic history.

In fact, remains of Umayyad buildings reveal numerous examples of figurative ornamentation. This can be illustrated by the two pavement frescos in the palace of Qasr al-Hair al-Gharbi, one representing the Greek goddess Gaia and the other an archer on horseback in the purest Sasanian tradition (*Ill. 178*). The palace of Khirbat al-Mafjar contains the famous pavement mosaic of a lion attacking a gazelle under a tree, as well as some human figures modelled in stucco. However, the most elegant testimony to the existence of Umayyad figurative art is the impressive cycle of frescos which decorate the baths of the hunting lodge of Qusair 'Amra (*Ills. 179, 181*). There is other evidence from 'Abbasid and Ghaznavid remains: both Samarra and the palace complex of Lashkari Bazaar in southern Afghanistan have revealed fragments of frescos demonstrating the continuation of Persian and Turkish figurative traditions.

We could continue this enumeration by citing the fine wood panelling of Fatimid Egypt or the lustreware tiles of Baghdad or Samarra, but what is important is that all of these representations are found in princely residences, that is, in edifices which, unlike places of worship, had no religious significance. With time, however, the rejection of images became more widespread, at least in the Arab world, since an increase in figurative architectural ornamentation can be seen in Safavid Iran, Mughal India and Ottoman Turkey.

177

178 Fresco from the Umayyad palace of Qasr al-Hair al-Gharbi, situated near Palmyra (early 8th century). The linear style and iconography of this fresco, representing a horseman hunting with a bow and arrow, demonstrate the continuity of Sasanian art into the Umayyad period.

178

The Figure

In spite of condemnation by jurists, figurative art did exist in the Islamic world. It is best known in the illustration of manuscripts. But without being exceptional, the use of animal and, above all, human forms had only a marginal place in architecture and could not compete with other methods of ornamentation. Moreover, even though art historians can trace the links between different instances of figuration in Islamic architecture, these are usually relatively independent in terms of style, theme and function. Only in the 11th and 12th centuries did this kind of ornamentation present stylistic and iconographic constants throughout the Islamic world: an international courtly art evoking the pleasures of the palace, of music, dance and the hunt. However, even in this case, images only appear sporadically in the form of little scenes included in a vegetal scroll or contained within

the narrow limits of a ceramic tile.

For the rest – and it is probably as a consequence of the judicial attitude of Islam concerning images – figuration was only able to find its place in Islamic architecture under certain particular conditions, mostly induced by external cultural influence or surviving local custom. Nevertheless, the animated decorations that can be seen in the form of frescos, sculptures, mosaics or ceramics in architecture throughout the Islamic world merit our attention both by their plastic qualities and by the social, political, magical or religious meanings that they convey.

Figuration appeared most frequently in architecture when Islamic art first began evolving under the Umayyads. Whether it was to satisfy their inclination for images or more specifically to glorify their power, the Arab rulers used the figurative repertoire of Near Eastern

179 The frescos from Qusair 'Amra in Jordan (early 8th century) show a variety of styles and subjects. The winged figure, probably the work of a local artist, seems to be at the confluence of several artistic traditions including that of late Antiquity and that of Sasanian Mesopotamia. The gesture of the arm is surprisingly similar to that of the horseman's arm in the fresco at Qasr al-Hair al-Gharbi.

180 Bathing scene situated in the great hall of Qusair 'Amra. The naked female figure seems to be entering a low pool after having opened the curtain. The impression of a ritual is increased by the presence of the other figures watching her and by the strange gesture of the fingers on her right hand.

180

Greco-Roman tradition and imperial Christian or Sasanian iconography into the adornment of their palaces. The resulting impression is often one of an accumulation of themes whose exact meaning is difficult to determine, for example, the pavement mosaic or the modelled figures in the stuccos of Khirbat al-Mafjar. The pavement mosaic has been interpreted as an emblem of Umayyad power, but it is unclear whether the figures at Khirbat al-Mafjar had any symbolic value for those who ordered them to be made.

The most spectacular example of this accumulation of images can be found at Qusair 'Amra, about a hundred kilometres east of Amman. On the walls and the vaults of this building (composed of a basilical hall and three small rooms making up a Roman bath) can be found a juxtaposition of frescos whose iconographic styles betray their diverse origins and whose meaning is unclear. At the back of the apse, where the sovereign held his receptions, is the representation of an enthroned prince in a style which closely resembles Byzantine iconography of Christ. On the side wall, six hieratic figures make a gesture towards the prince. As is confirmed by the Greek and Arabic inscriptions above them, the interpretation of the scene is clear: it is the offering of tribute by the kings of the world to the caliph. However, around this scene and in the bathrooms, there are varied scenes which seem to be simply a haphazard collection and not a coherent cycle: an allegorical figure of Victory, hunting scenes, bathing scenes, buildings, grape-picking, animal figures, signs of the Zodiac, etc.

The styles of these frescos indicate their diverse aesthetic origins. The characters in the court scene have Byzantine proportions, the dynamism of the animals in the hunting scene recalls the animals decorating Sasanian silverwork and the bathers are treated

with a naturalism inherited from Roman art. Thus, the frescos of Qusair 'Amra appear as a sort of artistic booty whose fate Islam had not yet decided.

However, at Qasr al-Hair al-Gharbi, situated near Palmyra and built during the same period, there is a pavement fresco which had a lasting influence on Islamic courtly art. Under a double arcade framing two musicians is a figure of an archer on horseback hunting ibex (*Ill. 178*). This composition is a faithful replica of Sasanian imperial iconography although the crown, which in Sasanian art identifies the king, is replaced by a turban. This substitution neatly paraphrases both the appropriation of power by Islam and the adoption by the new rulers of the lifestyle of the vanquished kings.

Although the images in Islamic architectural ornamentation can serve to represent power, they can also imply heraldic or astrological symbolism, or totemic or magic beliefs. This may explain the presence of angels, eagles, lions, snakes, Zodiacal figures, dragons, griffins, sphinxes and sirens on certain

181

181 Figure of a woman with her arms held upwards, painted on the intrados of an arch in the great hall of Qusair 'Amra.

secular and military constructions, bridges or ramparts – notably those at Diyarbakr and Konya – but also on the façades of various religious buildings.

This taste for animal figures with symbolic value, particularly common in Saljuq architecture, is often attributed to the cultural traditions imported by the Türkmen populations who established themselves in Anatolia during the 11th century. According to some scholars, it is possible to identify borrowings from the animal art and magico-shamanic universe of the Steppes. However, these scenes and motifs, in which real animals and fantastic creatures mingle, may also derive from the ancient civilizations of the Near and Middle East.

The Great Mosque of Diyarbakr in eastern Anatolia, which dates back to the 12th century, offers an example of this type of ornamentation. On either side of the portal arch and under a calligraphic band, two identical images of a lion hunting down a bull are sculpted in stone, each mirroring the other (*Ill. 183*). Although modelled with a technique of bevelled sculpture which recalls Eurasian styles of animal depiction, this scene

appears to be a later version of a motif already present when Achaemenid palaces were built. Its origins could lie, according to Richard Ettinghausen, in an astronomical symbol representing the two constellations Taurus and Leo with the domination of the second over the first, thus symbolizing in the Assyrian and Achaemenid periods the most important day of the Zoroastrian calendar and the first day of the luna-solar year, or *Nauruz*. However, at the entrance of the Great Mosque this motif has become a symbol of power, explained in the adjacent inscriptions as a reference to the overthrow of local rulers at the end of the 12th century.

Deriving from an old stock of symbolic figures, this type of motif can have multiple meanings which often become intermingled and now are difficult to elucidate with precision. Some figures may have acquired a heraldic function such as the representation of the moon in feminine form which due to its astronomical symbolism became the emblem of the Atabeg of Mosul, Badr al-Din Lu'lu', Badr al-Din meaning 'the full moon of religion'. This might also be the function of the two-headed eagles on the Great Mosque of Divrighi (*Ill. 182*). But there are cases in which the talismanic function of images is very clear,

182

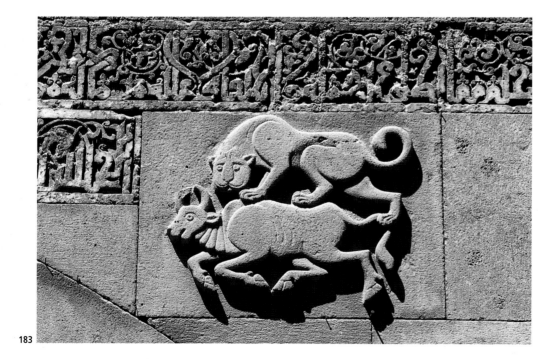

183

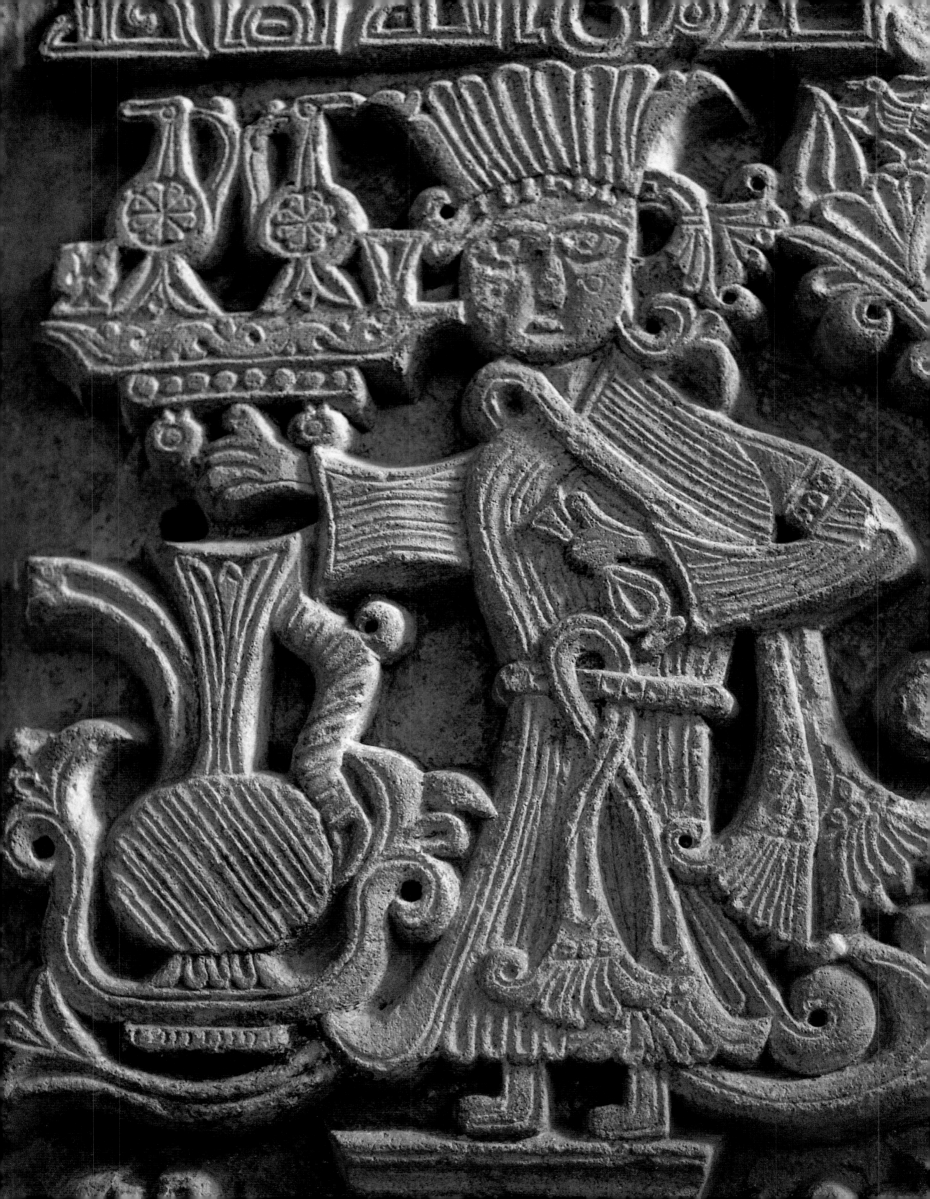

especially when these latter appear on the fortifications of cities and citadels.

The apotropaic function of the image was clearly illustrated at the beginning of the 13th century by the intertwined snakes framing the arch of the first gate of the citadel of Aleppo in northern Syria (Ill. 186). Like the relief of opposing dragons on the Talisman Gate of Baghdad (1221), now destroyed, the origins of this motif are found ultimately in Sumerian beliefs. These attributed to snakes the power to heal, to deflect the forces of evil and, generally speaking, to rout the enemy. Perhaps we should recognize an analogy in the intertwining of the snakes, since these twisting forms, which clearly have an ornamental function, also recall certain magical uses of the knot. Even quite recently in Egypt, people would occasionally hang a cord with several knots on the doors of their homes as an amulet. Other figures belonging particularly to the ornamental repertoire of Iran and Central Asia suggest meanings combining astrological symbolism, literary allusion and legend. They are often fantastic beings, hybrids of species such as the angel, the harpy and the siren. This mythical bestiary includes the Simurgh, a fabulous bird of Persian tradition similar to the phoenix. Although this type of motif is now most often seen on the small ceramic tiles displayed in museums around the world, it once contributed to monuments of an exceptional visual impact in Bukhara and Samarqand.

The portal of the *madrasa* of Nadir Diwan Bighi, built in Bukhara in 1622, for example, is decorated with an astonishing composition of glazed tile mosaics. On an ultramarine sky, covered with constellations of flowers, two symmetrical representations of the Simurgh confront each other, wings outspread, each with a lamb clutched in its talons. These mirror images turn towards a solar disc with a human face

situated at the apex of the *iwan*. These elements may have come from illustrations in manuscripts – *The Book of Kings* for the fabulous bird and some astrological work for the solar symbol – for there is no doubt the composition has mystical connotations. The Simurgh, which originated in Zoroastrian Iran and is a character in the mythical history of Iran, became, in the writings of Suhrawardi and Farid al-Din 'Attar in the 12th century, a symbol of access to mystical knowledge, personified here by the sun at its zenith.

In Samarqand the portal of the Shir Dar *madrasa*, completed in 1636, offers another composition mingling astrological iconography and mystical symbolism in a similar fashion (Ill. 185). Each one of the spandrels overhanging the arch bears the image of a feline animal chasing down a gazelle. Above the feline is placed a sun. This animal with the rising sun behind him ultimately became a symbol of Iran. However, the origins of the motif lay in astrological imagery and it probably symbolized not so much the geographical east as the mystical east of Persian Neoplatonic philosophy.

186

185 Detail from the glazed tile mosaic decor of the Shir Dar *madrasa* in Samarqand (1619–36) displaying, on either side of the *iwan* of the entry gate, a feline carrying the rising sun. This motif became a symbol of Iran.

186 Aside from their ornamental value, the intertwined snakes decorating the first door of the citadel of Aleppo (13th century) may have a magical protective function.

188

189

188 Ornamental frieze from the Wazir Khan mosque. The vegetal forms, leaves and flowers spread out from two superposed sinusoidal curves.

189 Detail of a floral pattern created in glazed tile mosaic which decorates the Shir Dar *madrasa* in Samarqand. (1619–36).

Plant Forms

187 Detail of the glazed tile mosaic decor in the Wazir Khan mosque in Lahore (1634). The stylized flower here displays a particularly elegant dynamism thanks to the addition of slender, curved leaves.

Vegetal ornament is not unique to Islam. Its multiple forms can be encountered in many artistic cultures and probably ultimately indicate a universal fertility dream. It is, however, in Islamic art that this type of ornamentation was given maximum attention. Virtually all ceramic panelling, sculpted stone and fashioned objects carry its imprint. This taste for vegetal patterns finds its most marked expression in the arabesque, a type of ornamentation which obeys several important plastic principles of style and composition.

Although some art historians deny it anything more than a decorative value, the omnipresence of plant life in Islamic ornamentation provokes speculation as to its function. It may be to translate, in a more or less implicit way, a view of nature specific to Islam, nourished by Qur'anic descriptions of 'the Garden of Felicity'.

Islamic vegetal ornamentation takes its basic vocabulary from Middle Eastern, Greco-Roman, Sasanian and Byzantine artistic traditions. The mosaics in Jerusalem and the sculptures of Khirbat al-Mafjar and Mshatta furnish a more or less complete repertoire of the antique motifs adopted by the Umayyads: acanthus leaves, vines, bunches of grapes, rosettes, palmettes, etc. In this ancient Near Eastern repertoire, the process of stylization had already largely begun. Islamic decorative artists continued along the same lines, gradually distancing themselves from the natural model.

Encircled by the spiral formed by their stems, the vine leaves sculpted on the stuccos of Samarra in the 9th century bear little resemblance to the plant itself. In the 11th century in Egypt and Iran a form with local variations predominated to which it would be difficult to attribute a botanical name: a trilobed palmette

195

195 Vegetal frieze in a sober style from the Taj Mahal.

196 Vegetal frieze decorating the Anup Talao, or 'inimitable pool', in Fatehpur Sikri (founded in 1573). While retaining the principle of unlimited development along a sinusoidal curve, the representation of the plant here tends toward naturalism. The elements, such as leaves and fruit, are treated in a descriptive way and the stem itself adopts more irregular forms.

through ceramic art (Ill. 193), indicating the influence of pottery in the evolution of taste. One can see on the enamel tile facings which panel the walls of Ottoman buildings the same patterns as those decorating the elegant tableware which was in great demand. They include the tulip, the carnation, the hyacinth and the wild rose, to which the rose and the peony were sometimes added. In this repertoire, no longer strictly ornamental but also botanical, appear long, narrow, curving and finely dentate leaves. All of these plants, some of which take their inspiration from Ming porcelain imported by the Ottomans, were generally treated so descriptively that their movements and curves convey the impression that they have just been picked. A picturesque detail such as a broken stem was often added to this naturalism, enhancing the elegance of the composition.

The amazing success of vegetal ornamentation in the Islamic world cannot be explained solely by restrictions on figural representation. During certain periods it is common to find animals included in decoration. This theme, which turns an architectural environment into a living space, should be understood as the expression of a sympathy for nature constantly present in Islamic

aesthetic sensitivity. It is a kind of nature which, not overrun and wild but mastered and cultivated, has become a garden. Thus, a permanent link exists between this architectural ornamentation and the tradition of the garden, maintained in the Iranian and Mesopotamian worlds since earliest Antiquity, and from there transmitted to all regions of Islam. It is an uninterrupted tradition which stretches from the hanging gardens of Babylon to the Shalimar gardens of the Mughals or the Generalife in Granada.

Throughout history the love of gardens was closely related not only to palatial architecture but also to religious thought. The garden, which, as an architectural reality, can be defined as a parcel of land surrounded by walls – that is the original meaning of the ancient Persian pairidaesa – has been conceived since its beginnings as the earthly reflection of Heaven. All Qur'anic descriptions of paradise reflect the Iranian idea of the celestial garden: 'a Garden of Delights', 'of Felicity', 'filled with foliage', where 'streams abound', 'a sublime garden whose fruits will be within reach' and where the pious 'will never know the taste of death'.

The relation between vegetal ornamentation and the theme of paradise is set out in certain buildings. Some Arab historians put this forward as the interpretation of the mosaics in the Great Mosque of Damascus and the Mosque of Medina. The same meaning is also conveyed by the Qur'anic verses placed at the entrance to the Taj Mahal. However, it is impossible – except perhaps in the case of the mosaics in Damascus which clearly resemble a landscape – to affirm that Islamic vegetal ornamentation offers images of paradise. It evokes rather than represents paradise. In other words it is a way of signifying, which is a matter of suggestion, not of denotation and gives all interpretive latitude to the beholder.

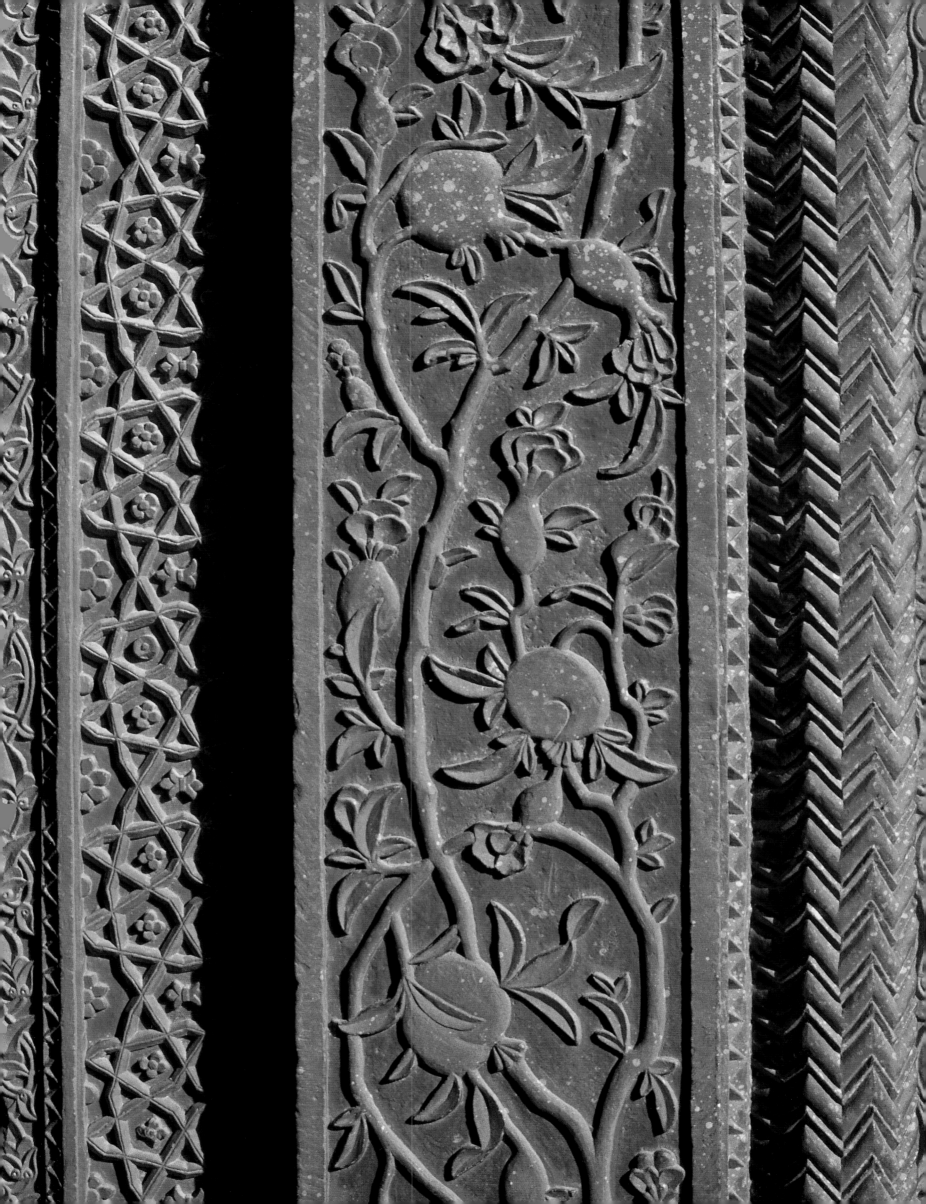

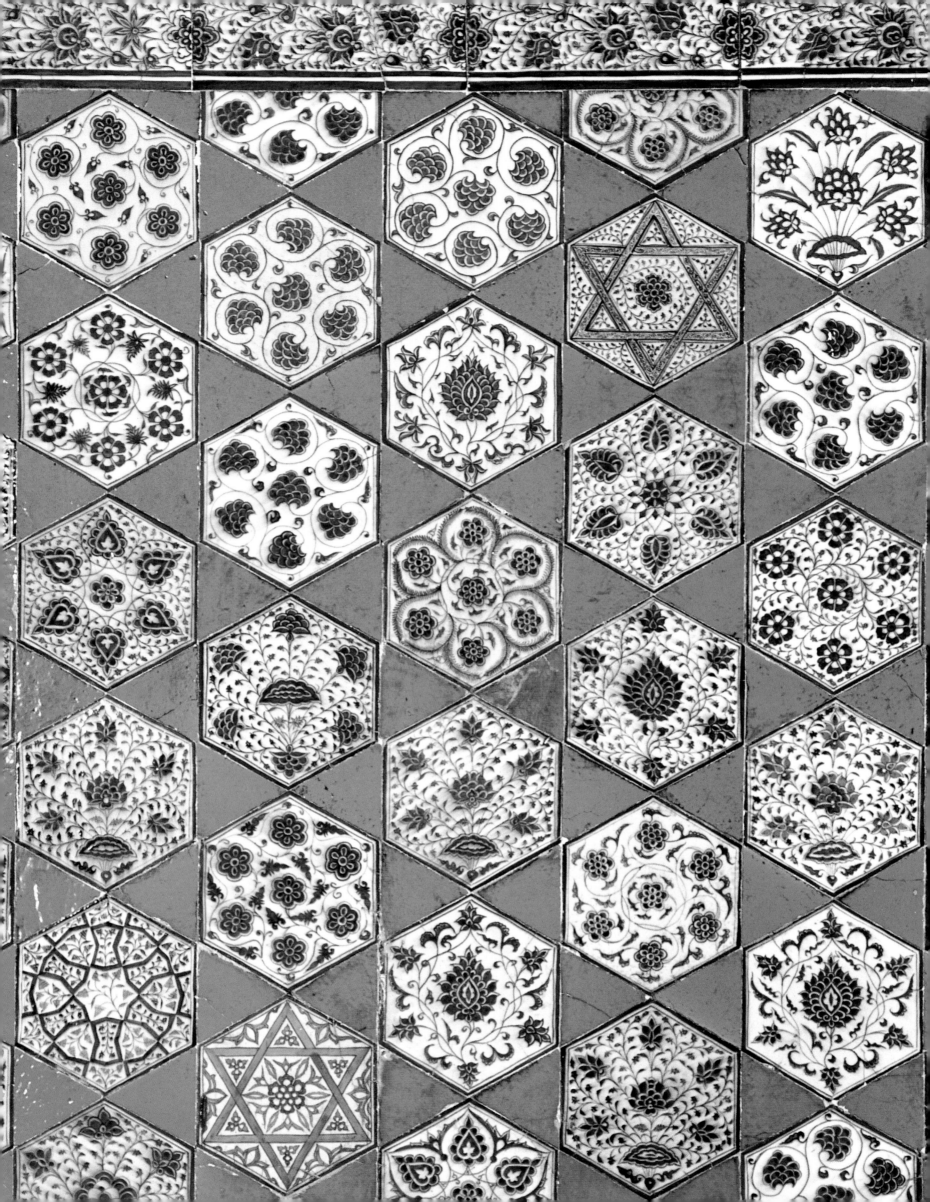

198

199

Geometry

197 Enamelled tile panel decorating the prayer hall of the small Muradiye mosque in Edirne (1435–36). Associated with the turquoise green triangles, hexagonal tiles with various vegetal motifs produce a network in which six-pointed stars appear.

198 Ceramic tiles from the mosque of Shaikh Abu 'l-Qasim in Yazd.

199 Ceramic tile from the Qutaish mosque in Sidon, (15th century). The pattern, which displays seven flowers inscribed in a hexagon, is almost a mirror copy of the tiles of the Muradiye mosque in Edirne *(Ill. 197)*.

In Islamic architectural decoration, geometry is just as important as vegetation. These two formal systems often work in counterpoint, either by their deployment on adjacent surfaces or when patterns inspired by natural forms find their way into geometric figures.

Even more than vegetation, geometry is used ornamentally to a degree unequalled anywhere else. The possibilities offered by the combination of mathematically defined forms fascinated Muslim artists. In different periods and in different regions of the Islamic world, the principles of elaboration, the schemas of composition and common patterns imposed themselves with increasing complexity, so that this radically abstract art became the aesthetic *lingua franca* of Islam. Even though it is possible to point to antecedents in the art of Late Antiquity or historical and regional variations,

geometrical ornamentation, more than any other type of ornamentation, lends itself to formal analysis. This fact does not, however, exclude debate as to its possible interpretations.

Geometric ornamentation is found in all the materials used in architecture – stone, brick, mosaic, marble facing, stucco, enamelled tiles, wood, etc. – but with a few of them it has a more intimate connection. For example, brick, due to its intrinsically geometric definition and the construction technique it requires, encourages variation in its placement so that varieties of chevron or staircase patterns can emerge from the wall's surface.

Nonetheless, the technique which is the most intimately linked to Islamic geometric ornamentation is undoubtedly that of ceramic tile facing. By means of this technique geometric ornamentation provided a solution to the relatively

simple mathematical problem of covering all of a plane surface using standardized elements. Rejecting the simplest answer which consists of juxtaposing square tiles, the ceramicists revelled in this mathematical game. They invented more skilful solutions which were also more aesthetically satisfying because they created varied patterns. One possibility consisted of assembling hexagons, a solution based on the natural prototype of the honeycomb. A richer variant, creating networks of six-pointed stars, was obtained by inserting small equilateral triangles between the hexagons (*Ill. 197*). Another solution, which was very popular with the

ceramicists of Baghdad and Kashan, was the interlocking pattern of two perfectly complementary modules: an eight-pointed star and a cross with triangular extremities (*Ill. 203*).

Diversifying their propositions, which were always based on the complementarity of complex geometrical forms, the ceramicists began to increase the number of elements that fitted into each other, so that it became difficult to distinguish between ceramic tile technique and *zellij*, and stone marquetry as displayed, for instance, in the mausoleum of I'timad al-Daula at Agra. Although the pieces were prefabricated in the first case and cut one by one in the second, the basic mathematical principle remains the same since it involves the geometrical partition of a surface according to mathematically defined forms.

The principle of the geometric partition of a surface raises two questions: one concerns configurations and the other refers to networks. These require not only mathematical logic but perceptual phenomena. Configurations in this context mean new figures created by the combination of basic geometrical figures. The simplest example is the star formed by placing an equilateral triangle on each side of a hexagon. More complex examples can be found in the *shamsa*s, 'suns', which spread their rays across *zellij* wall facings (*Ill. 202*). To clarify the legibility of these secondary figures, the rays of the sun, the artist could attribute a distinct colour to each element. On the other hand, he could confuse legibility by exploiting the simple alternation of light and dark shapes. This latter formula, characteristic of white marble and red sandstone in

200 Geometrical composition in tile mosaic decorating the principal *iwan* of the Friday Mosque of Isfahan. Probably dating from the end of the 15th century, this panel is a skillful composition around a ten-pointed star.

201 'Water collector' in the Great Mosque of Qairawan. Used to gather rain water to replenish the water tank, this is also a sculptural object produced according to geometrical rules.

200

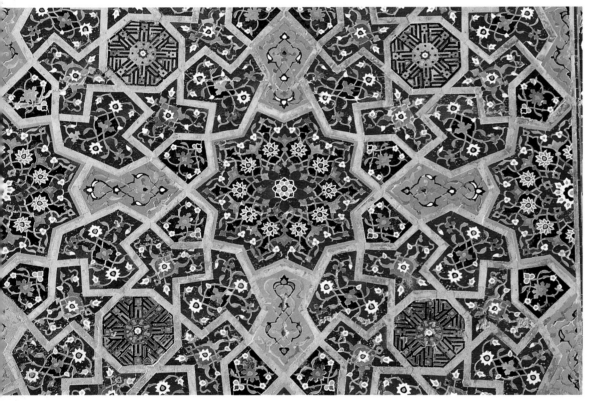

201

202 Decoration of the al-'Attarin *madrasa* in Fez (1323–25). The dado is covered with a geometric interlace made of *zellij* and bordered at eye level by a double calligraphic band of excised ceramic tiles and stucco.

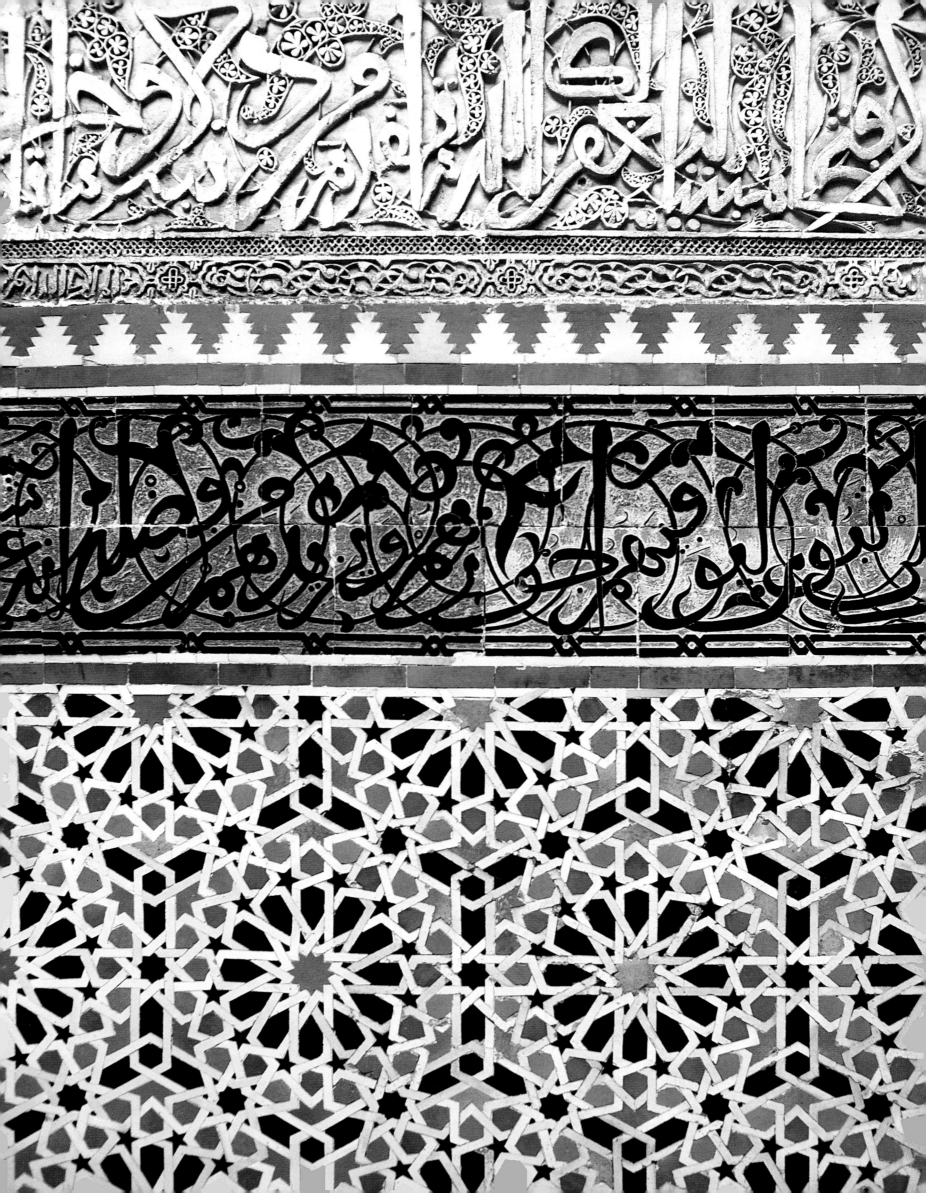

Mughal marquetry (*Ill. 205*), creates an optical phenomenon of vibration due to the fact that the eye constantly hesitates between light and dark elements. The design of the network is similar to that of configurations except that it is based on a linear perception of geometric compositions. The lines of partition are emphasized, creating more or less complex networks. These network patterns are particularly adapted to the creation of grills in sculpted stone, such as those in the Great Mosque of Damascus (*Ill. 323*). The most spectacular examples, however, are found in India, at the tomb of Salim Chishti in Fatehpur Sikri (*Ill. 207*).

Geometric interlace is the most remarkable ornamental system developed in Islamic art. It is based on the mathematical division of a surface. It associates a woven pattern with the reticular system of the geometric network. Although this type of ornamentation sometimes appears to be extremely complex, its creation requires no more than a ruler and a compass and can be paraphrased in three steps: the mathematical schema, the grill, and the weaving. The mathematical schema is a framework of straight lines generated by the division of an original circle into

equal segments. The number of segments is usually a multiple of four or six, thus causing either squares and octagons or hexagons and equilateral triangles to appear. When the lines of the mathematical schema cross at certain points, they form radiating centres which, connected between themselves, can be repeated infinitely. As for the grill, it is a second linear network obtained by doubling each of the axes of the mathematical schema. The effect is to multiply the fragmentation of the plane and to engender new geometrical figures. The third step is the weaving. It consists of threading a ribbon which jumps according to a rigorous programme from one line of the grill to another. It becomes interlaced with the portions of itself which it encounters, passing alternately above and below them. This weaving technique interconnects the geometrical figures like the mesh of a net. Some of the mesh, located at the radiating centres of the mathematical schema, takes on the form of star-shaped polygons.

This ornament, which is a pure product of the mind, owes its power of fascination to the deciphering which it requires. The work of weaving gives primacy to the line, which becomes a

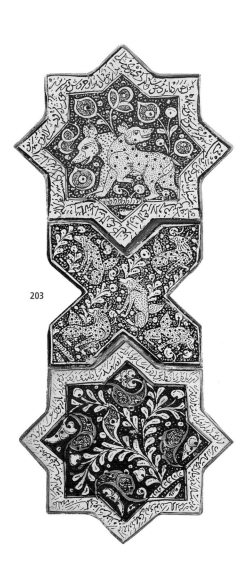

203

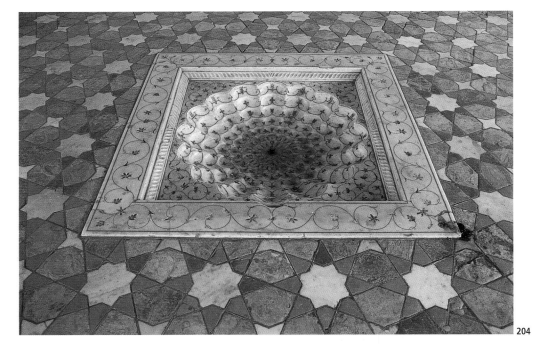

204

203 Ceramic tiles from the *Imamzada Ja'far* at Damghan (1267). Such ceramics, in the form of stars and crosses, were the speciality of the workshops of Kashan (Louvre, Paris).

204 Pool of the *diwan-i khass* in the Lahore Fort (1645).

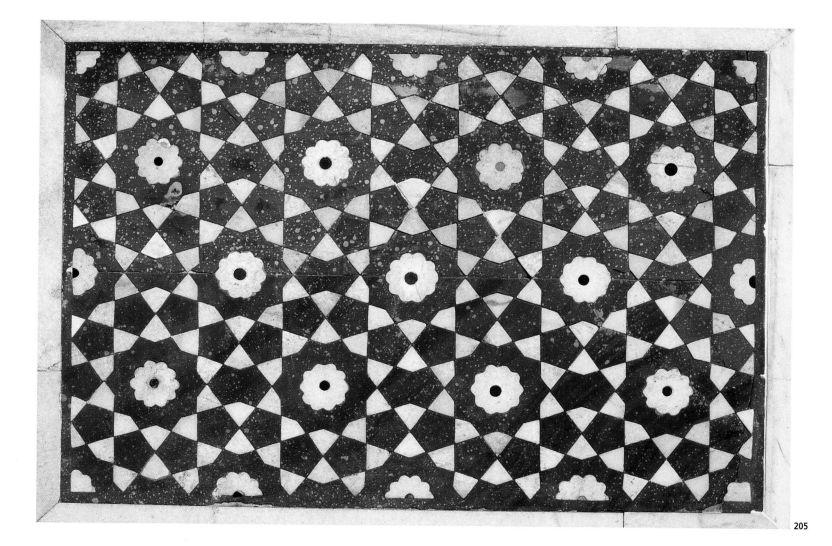

205

dynamic element constantly leading
the eye astray, as in a choreographic
arrangement where each figure works
in conjunction with the others, crossing
over, echoing and involving them: a
choreography with no end and no
horizon. However, these interpretative
characteristics are not confined to a
meandering gaze. When looking at
a pattern of geometric interlace the
spectator is always confronted with
two possibilities: either to follow the
movement of the line or to stop at the
starred polygons springing out here and
there. In other words, the geometric
interlace functions as an apparatus whose
object is to confound the gaze of the
beholder.

Furthermore, if the formal logic of
geometric interlace has the effect of
provoking the perpetual dissolution and
recomposition of shapes, it also possesses
the characteristic of recognizing neither
centre nor limit, and the ability to spread

out virtually forever. Thus, the spectator
who enters into the logic of the interlace
is enticed into mentally continuing
its development beyond the limits of
the decorated surface. In other words,
the geometric interlace possesses an
existence which goes beyond material
reality. It is, properly speaking, a
conceptual art.

What meaning might be given to
Islamic geometric ornamentation? It
is difficult to offer a clear and precise
response to this question because there
are interpenetrations of different levels
of meaning – aesthetic, philosophical
and symbolic. A certain number of
hypotheses can, nonetheless, be
suggested. It is obvious that this complex
art reflects developments in the
mathematical sciences. More precisely,
as Louis Massignon has suggested, the
perpetual transformation of shapes in
geometric interlace corresponds to the
specific development of mathematics in

205 Facing on the principal entry portal
of the mausoleum of I'timad al-Daula at
Agra (1628). An optical effect is created
by the contrast between the repetition
of the star pattern and the opposition
between red sandstone and white marble.

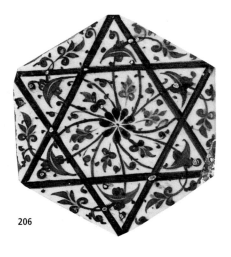

206 Six-pointed star inscribed in a ceramic tile in the Qutaish mosque at Sidon (15th century).

207 Pierced marble screen on the tomb of Salim Chishti at Fatehpur Sikri (late 16th century). Using geometrical patterns the sculptors of Mughal India developed the delicate art of *jali*, screens entirely cut from a fine plaque of marble.

206

the Islamic world. Going beyond the static Greek model, Islam invented the dynamic mathematical concept of trigonometry. Massignon argues that the new orientation derived from a philosophical conception of the world as an unstable agglomeration of atoms, a philosophical atomism, which could have been equivalent to a religious belief in the transience of the world as set against the permanence of God.

The fact remains, however, that the dynamism of the line and the phenomenon of fragmentation intervene upon perfect mathematical figures. These probably reflect the Islamic idea that geometry belongs to a superior truth, beyond the reach of earthly concerns. The exegesis by one of Islam's greatest authorities, al-Ghazali, of the Qur'anic *sura* entitled *The Bees*, specifies that the geometrical perfection of the honeycombs that bees create is a tribute to the Divine Intelligence from which they originated.

The omnipresence of starred polygons in this ornamentation tempts the spectator to imagine that they were intended to evoke the heavens or astral bodies. This interpretation seems to be confirmed by particular cases, such as the ceiling of the throne room in the Alhambra. In the form of a vault, the wooden ceiling bears a geometrical ornamentation in which seven levels of starred polygons appear, probably corresponding, as a recently discovered inscription suggests, to the seven celestial spheres which hold up the throne of God in Islamic cosmology.

All these interpretations are conjectural and cannot be generalized. It is more likely that geometric ornamentation was a plastic system without intrinsic significance, but whose semantic richness resides precisely in its ability to be open to multiple interpretations, according to the way it is used – to decorate a ceiling, a door, a *mihrab* or the frontispiece of a Qur'an.

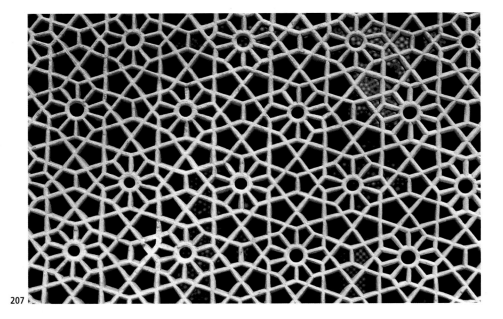

207

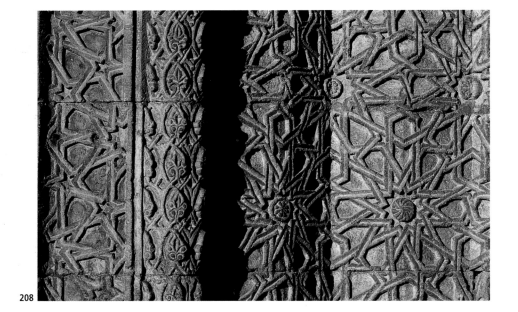

208

208 The geometric interlace sculpted in stone in the Saljuq buildings of Turkey, such as the Çifte Minareli in Erzurum (1253), produce the impression of a textile envelope.

209 Bronze door situated to the left of the *mihrab* in the *madrasa*–mosque of Sultan Hasan in Cairo (1356–63).

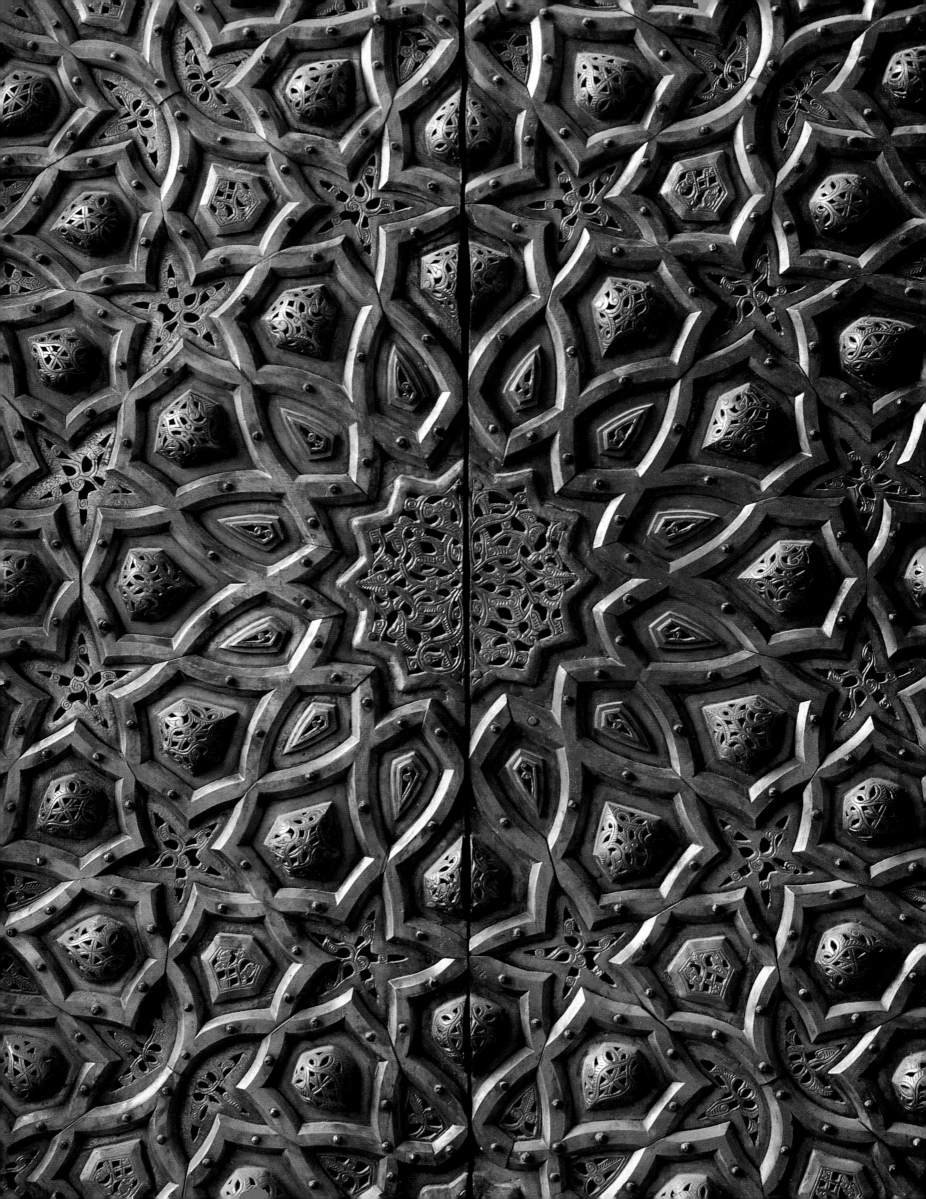

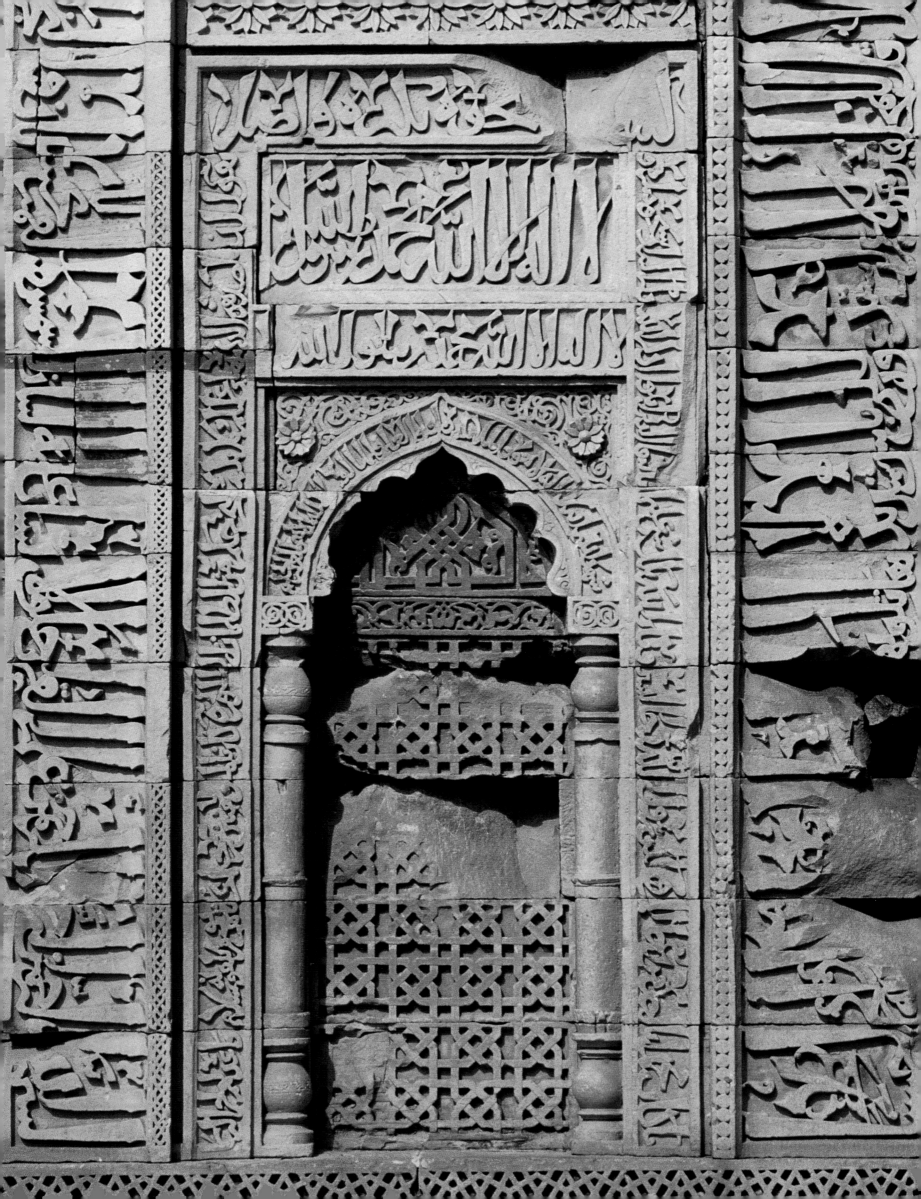

211 Inscription attributed to Malik Shah decorating the façade looking onto the courtyard of the Great Mosque of Diyarbakr (12th century). Executed in a beautiful plaited kufic script, the inscription records an event in the history of the city.

Calligraphy

210 *Mihrab* pattern carved into the stone facing of the Quwwat al-Islam mosque in Delhi (enlarged between 1210 and 1229) and framed by numerous calligraphic bands. Used for the first time in architectural ornamentation, the cursive style is characterized here by the long sabre-like strokes. The two inscriptions at the summit of the arch are the transcription of the *shahada*, the Muslim profession of faith.

Already present as a relatively unobtrusive element in Umayyad religious edifices, the written script rapidly attained a major ornamental role. In the 10th and 11th centuries it burgeoned out and became the visual element which contributed, more than any other, to uniting the varied architectural output of the Islamic world. A passion for the written script constitutes one of the fundamental traits of Islamic culture, something comparable to the Christian world's attachment to images. Calligraphy – *khatt* in Arabic – is the only art which enjoys universal acknowledgement and respect. Many treatises in Arabic, Persian and Turkish have been devoted to its study, retracing its history or fixing its technical and aesthetic guidelines. For Islam, the Arabic script is not a mere tool invented by human beings but a gift of God which finds its archetype in a celestial script.

The first thing which God created, known as the 'mother of writing', is identified by theologians as the Divine Attribute of the Logos. Even when the written script serves to transmit only human words, it still retains an aura of sacredness as writing.

The first example of the use of written script in Islamic architecture is the mosaic inscription which winds around the summit of the octagonal arcade in the Dome of the Rock. It presents an angular script with perfectly calibrated letters which follow each other on a rigorously horizontal path. In the neighbouring al-Aqsa mosque, in the Great Mosque of Damascus and at Medina, all three edifices built twenty years after the Dome, there appear identical epigraphic bands produced, according to Arab historians, from designs made by Khalij ibn Abi al-Sayyaj on the model of copies of the Qur'an

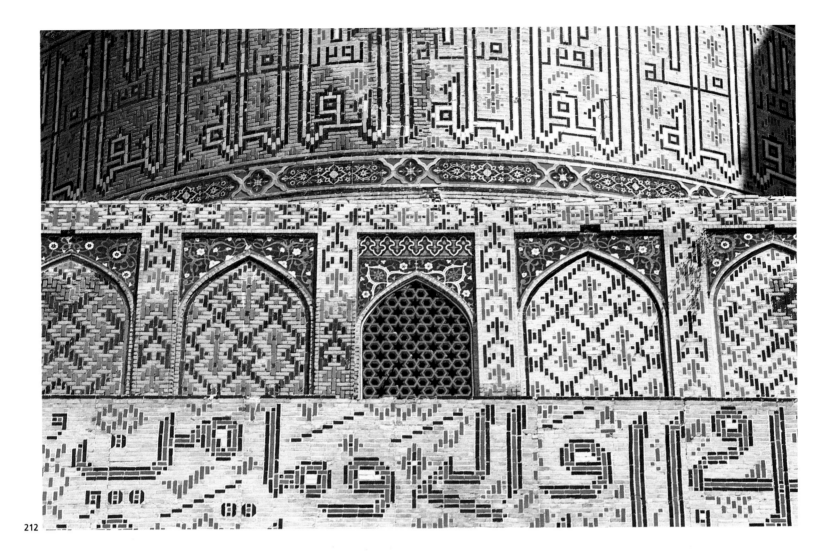

212

212 The exterior decoration of the Bibi Khanum mosque in Samarqand (1399–1404), entirely done in the technique of rough and glazed brick, combines geometrical patterns and kufic inscriptions. On the drum of the cupola, the pious formula is repeated: 'Only God endures'.

which he created for the caliph al-Walid. Although more rigid than the calligraphy in manuscripts, this first monumental script is directly related to it and has no obvious ornamental purpose. Its essential function is to convey a message. *Kufi*, 'kufic', the name given to this characteristically angular style, constitutes the basis of the first ornamental developments of Arabic script in architecture. In the 10th and 11th centuries works appeared, generally attributed to artists from eastern Iran, with various forms of kufic, called foliated or plaited, which incorporated elements into the strokes of the letters borrowed from vegetal or geometric ornamentation.

In foliated kufic the vacant spaces between the vertical strokes and the lower letters are first covered with arabesques, creating a dense background which invades the text. The letters themselves adopt vegetal forms: the

up and down strokes turn at right angles on the upper edge of the band and extend themselves into the patterns of demi-palmettes. Through association with the plant forms, the Arabic script appropriated their positive connotations. The sensation induced by following the line of this form of script seems similar to sap coursing through plants.

The introduction of the interlace pattern into kufic script also arises from the need to fill the empty spaces between letters. It can intervene at the level of the loops formed by the letters to reveal the graphic movement, but it mostly operates at the level of the strokes. These it ties together so closely that they sometimes appear, as in the Alhambra (*Ill. 30*), more like a carpet covered with geometric motifs than a text. These two ornamental variants of kufic are almost always associated with one another and they seem to take pleasure in confounding the limits

between the experience of reading and that of contemplation.

Of a completely different order, but also stemming from the rigid written form of primitive kufic script, the form known as mason's kufic, *'al-banna'i'* or quadrangular kufic, is a development which owes its unusual appearance to the encounter between the forms of the Arabic alphabet and the builder's technique (*Ills. 214, 218*). With this style of kufic, elaborated in Iran and in Central Asia about the 15th century, the inherent linearity of writing is abandoned and replaced by a general occupation of the surface, and the flow of the writing yields to the geometric form of brick. The letters break at right angles and squeeze themselves against each other, the words become interlocked and the text folds over itself. Like labyrinths these compositions, which alternate rough and glazed bricks on the walls of religious monuments in Samarqand, Bukhara and Isfahan, seem to want to lead the reader astray. But perhaps it is precisely in this subordination of meaning that their significance is found. It is possible that the intellectual pleasure procured from deciphering these enigmas corresponds, in the realm of aesthetic appreciation, to the quest for a hidden meaning which characterizes aspects of Iranian Islam.

On most monuments the various forms of kufic are found alongside other styles of script which owe their aesthetic qualities to their dynamic movement. The introduction of cursive calligraphic styles to architectural ornamentation in the 12th century is the consequence of a revolution in book production two centuries earlier. At the beginning of the 10th century Ibn Muqla, the 'Abbasid vizier, gave cursive writing, whose use had previously been limited to the administration, its patent of nobility. He perfected a new method called proportioned script – *khatt al-mansub*.

In this script the basic schema of each letter is derived from a standard circle, itself determined by the form taken by the letter *Alif*. From then on, cursive styles replaced traditional kufic in the work of copyists and from there entered the field of architectural ornamentation.

Cursive script first appeared in architectural ornamentation on the Qutb Minar in Delhi (*Ill. 210*). It emphasized the strokes, whose various sizes were greatly exaggerated and given a sabre-like profile, thus creating a dense rhythm above the lower letters which were concentrated together in tight loops. Generally though, monumental cursives are closer to the characteristic marks of the *qalam*, as can be seen in the beginning strokes with hooks, the full curved shapes alternating with slender forms and the final dynamic strokes (*Ill. 216*). This graphic quality of the line made it possible, as was pointed out in various treatises on calligraphy, not only to record the actual movement of the hand, but also to translate that of the voice and so to contribute to the legibility of the text.

213 Details of the inscriptions in both kufic and cursive script, made with enamelled bricks and ceramic tiles on the drum of one of the cupolas of the Shir Dar *madrasa* in Samarqand (1619–36).

214 Angular writing called *kufi banna'i*, or mason's kufic, decorating the *iwan* of the Tilla-kari *madrasa*-mosque in Samarqand (1659–60). The curves of the script, when subjected to the geometry of brick, are transformed into a labyrinth which only reveals the names of the first four caliphs to the skilled eye.

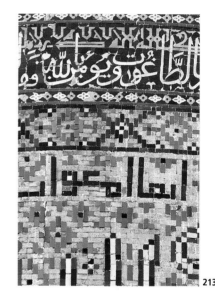

213

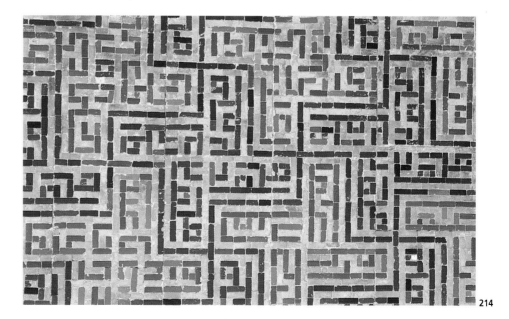

214

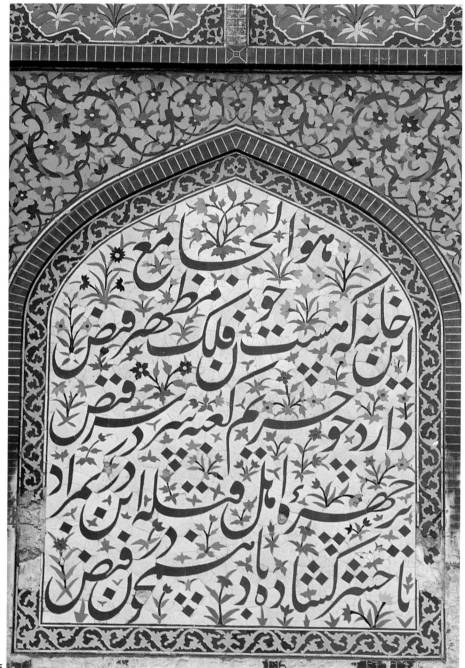

215

If even the earliest cursive styles, in contrast to ornamental kufic, aimed at an aesthetic which allowed for easier reading, they often adopted complex designs so as to distribute themselves equally over the surface. Thus, words or fragments of words could be shifted to different levels, requiring an intellectual effort on the part of the reader to reconstitute the semantic linearity of the phrase. This kind of disposition finds its most accomplished form in the compositions which spread, no longer across bands, but across rectangular or arch-shaped panels like those decorating the Wazir Khan mosque in Lahore *(Ill. 217)*.

This edifice also contains compositions employing a different calligraphic style. Here the underlying structure is no longer regulated by the repetition of verticals and horizontals, but tends to dissolve in a succession of diagonal movements stretching towards the left *(Ill. 215)*. Still used today to transcribe Persian texts, this new style, which bears the name *nasta'liq*, seems to show the same taste for the fragmenting of forms seen earlier in the tendency of the Persian arabesque to transform itself into a scattering of flowers. It can also be explained by the frequency in the Persian language of certain letters which are not attached to those following and therefore interrupt the graphic continuity. From a linguistic characteristic, Persian calligraphers were thus able to develop an aesthetic form.

The ornamental inscriptions found in Islamic architecture can be regarded as autonomous works, endowed both with unique plastic qualities and a specific meaning, but they can also be understood in the architectural context where they are expressed.

Their most immediate, perceptible function is to structure mural surfaces.

215 Calligraphic composition in the cursive Persian style (*nasta'liq*) on the Wazir Khan mosque in Lahore (1634).

216 Detail of a calligraphic band in glazed tile mosaic from the Friday Mosque of Isfahan.

217 Calligraphic composition in the cursive style (*naskhi*) from the Wazir Khan mosque in Lahore (1634).

216

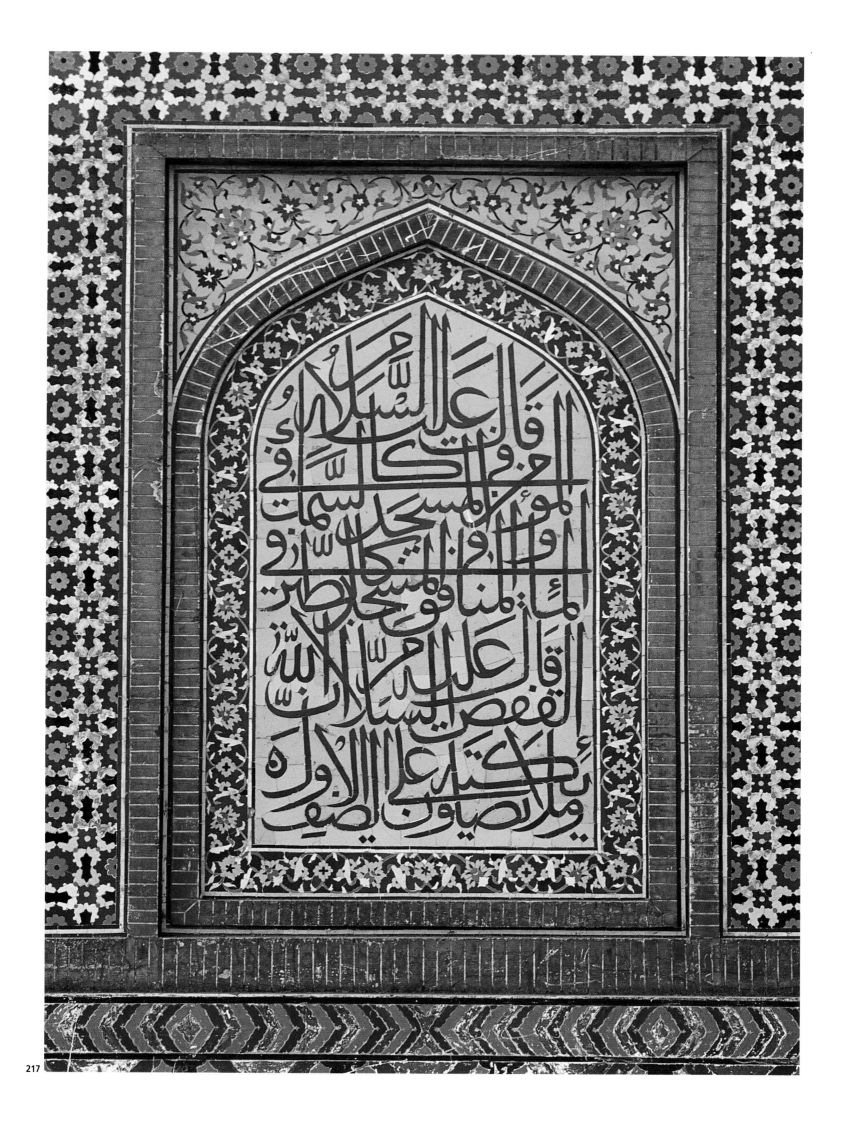

217

In the form of bands, for example, written script ensures the separation of two surfaces of a different nature. In Morocco and Spain such written script is traditionally situated at the junction between the *zellij* dados and the stucco facings. Elsewhere, it can emphasize the framework of a portal, encircle the base of a cupola or underline the curve of an arch. This use of epigraphic bands as a plastic link is general in Islamic architecture, and the portal of the Ince Minare in Konya offers the most spectacular example (*Ill. 220*). Here two large bands fit tightly around the arch of the door, intertwining above it and reaching up to the summit of the façade.

A second function of monumental inscription is to clarify the meaning of the edifice by way of its semantic content. Besides standard historical inscriptions giving construction dates or the names of those who ordered the construction, several cases can be found of a more poetic or religious nature. The majority of the sculpted calligraphies in the stuccos of the Alhambra reproduce verses by Ibn Zamrak singing the praises of the Alhambra palace itself, all the while adding symbolic resonance to the words. The poems seen on some Iranian mosques – such as the quatrain in a splendid quadrangular kufic script on the Friday Mosque of Isfahan (*Ill. 218*) – belong to mystical literature, thus further serving to make these

buildings places of meditation. However, the most frequently employed texts are passages of the Qur'an, chosen because they reflect the place they occupy. On a *mihrab*, for example, can be found the *Sura* of Light, on a minaret, the Call to Prayer, and on a mausoleum, yet another verse evoking paradise. But these inscriptions, with their religious content, can also have other functions as do the pious formulas inscribed in brick letters on walls, vaults and the shafts of Iranian minarets, which are a geometrical echo of the praises addressed by man to God, to Muhammad and to 'Ali (*Ill. 92*).

219 Detail of a funerary inscription from the Makli necropolis, near Thatta. So as to avoid leaving empty spaces between the strokes, the calligrapher was careful to place the letters on several levels even though this complicated the legibility of the text.

220 Detail of the inscription decorating the façade of the Ince Minare *madrasa* in Konya (1260–65).

219

220

218 Composition in quadrangular kufic on the northwest *iwan* of the Friday Mosque of Isfahan dating from the 17th century. The inscription reproduces the four verses of a mystical quatrain, as well as the signature of the artist in the central square.

ADDITIONAL MOTIFS

THE FIGURE

221, 222 Sculptures displaying birds and floral compositions decorating the Baradari, a white marble pavilion built in 1810 in the Huzuri Bagh gardens in Lahore.

223 Panel of glazed tilework from the Topkapi Sarai, dating from the 16th century and representing mythical animals from the Chinese repertoire of motifs.

224 Sculpture on the portal of the Yakutiye Medrese in Erzurum (1308) representing two confronted lions on either side of a palm tree.

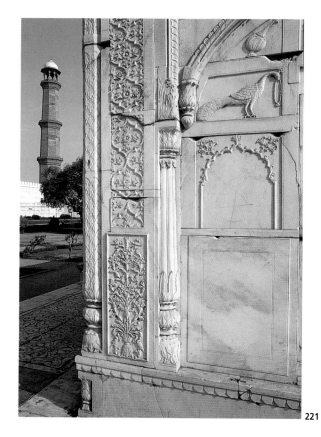

221

222

223

224

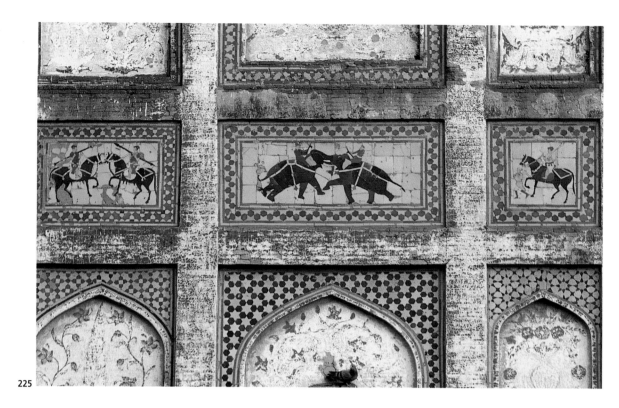

225

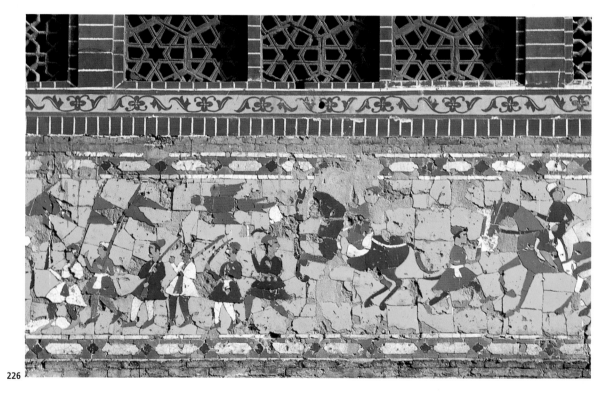

226

227

225, 226 The outer walls of the Lahore Fort, covered with glazed tile mosaic, were begun in 1624 by Jahanjir and completed in 1631 by Shah Jahan. Set among the various geometric and floral patterns, one can see many scenes recalling the pastimes of the Mughals: sports, spectacles, military parades and fights between elephants, camels and bulls.

227 Ceramic tile with animated decor from the Khan *hammam* in Kashan.

159

PLANT FORMS

228 Detail of the floral ornamentation in marble and sandstone from the Badshahi mosque in Lahore (1673–76). With a naturalism of extreme delicacy, this flower was created using a technique associating sculpture and inlay.

229, 231 Representation of plants and vases in glazed tile mosaic decorating the façade of the Wazir Khan mosque (1634).

230 Bas-relief from the guest house in the complex of the Taj Mahal. The naturalism of this representation goes so far as to include the mound of earth in which the plant is set, suggesting the inspiration of Western herbaria.

232 Detail from a ceramic tile of the Safavid period in the Friday Mosque of Isfahan.

228

229

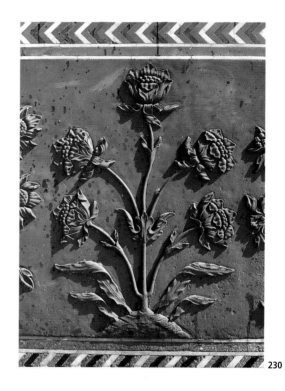

230

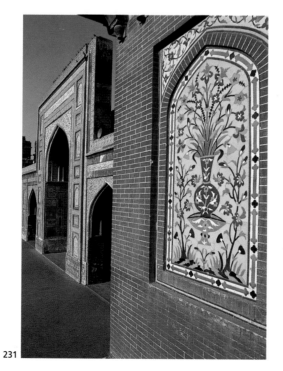

231

232

233

234

236

235

237

233 Detail from a ceramic panel in the Sinan Pasha mosque in Damascus (1586) representing a cluster of grapes.

234 Detail of the vegetal ornamentation in ceramic on the portal of the Blue Mosque in Tabriz (1465).

235 Ceramic tile facing from the Ottoman period (American Colony Hotel in Jerusalem, former residence of the Ottoman Pasha). An ancient symbol of immortality in the Middle East, the cypress plays an important role in Ottoman ceramic art. When associated with the *mihrab* motif, it takes on a mystical meaning.

236 Ceramic tiles from the Darwish Pasha mosque in Damascus (1571). The plant forms on these ceramics, such as the cypress and the cluster of grapes come directly from the pre-Islamic symbolic repertoire of the Middle East.

237 Detail of the glazed tiles decorating the walls of the Selimiye mosque in Edirne (1569–74). Peonies and carnations, along with tulips, roses and hyacinths are the flowers most often displayed on Ottoman ceramics.

GEOMETRY

238 Summit of one of the corner towers of the Amin Khan *madrasa* in Khiva (1851–52). The geometry is generated by the simple disposition of glazed green and white bricks.

239 Ceramic decor from the entry portal of the mausoleum of Shah Rukn-i 'Alam in Multan (13th century). The geometric network is produced by the superposition of dodecagons.

240 Ceramic decor from the Great Mosque built by Shah Jahan in Thatta (1647) based on the division of a circle into twelve equal parts.

241 *Zellij* decor in the Sa'adian tombs in Marrakesh (late 16th century) based on the division of a circle into sixteen equal parts. These radiating motifs are called *shamsa*s, 'suns', by Moroccan artists.

238

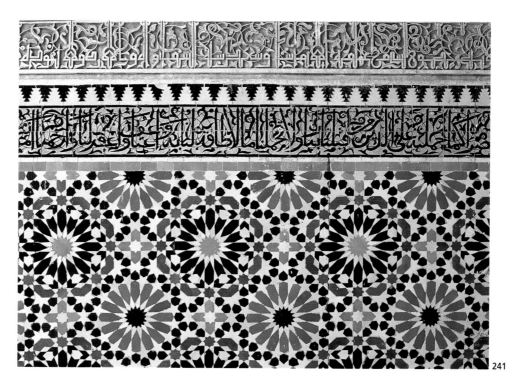

239

240

241

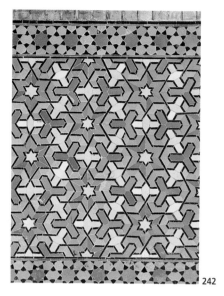

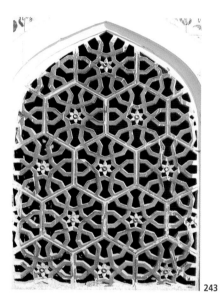

242

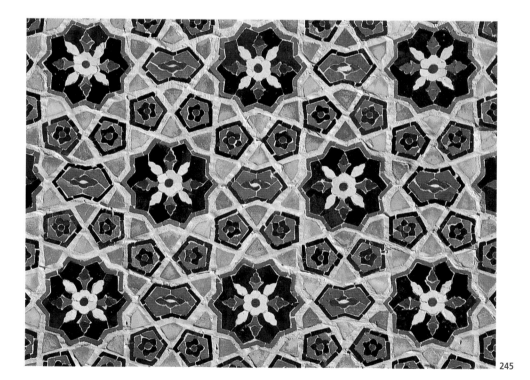

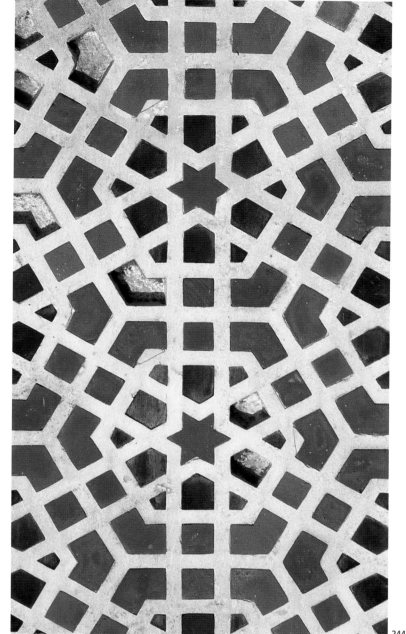

243

244

242 Ceramic facing from the Madar-i Shah *madrasa* in Isfahan (1704–14). The fragments of ceramic are fitted together like pieces of a puzzle.

243 Window grill composed of hexagonal, hollowed-out ceramic tiles from the mausoleum of Shams-i Tabrizi in Multan (built in 1329 and almost entirely rebuilt in 1779).

244 Detail of a grill displaying a pattern of stars and hexagons from the mosque of the Old Fort (*Purana Qil'a Masjid*) in Delhi (1541).

245 Detail of the ceramic facing covering the principal façade of the mausoleum of Zangi Ata in Tashkent (late 14th century).

245

163

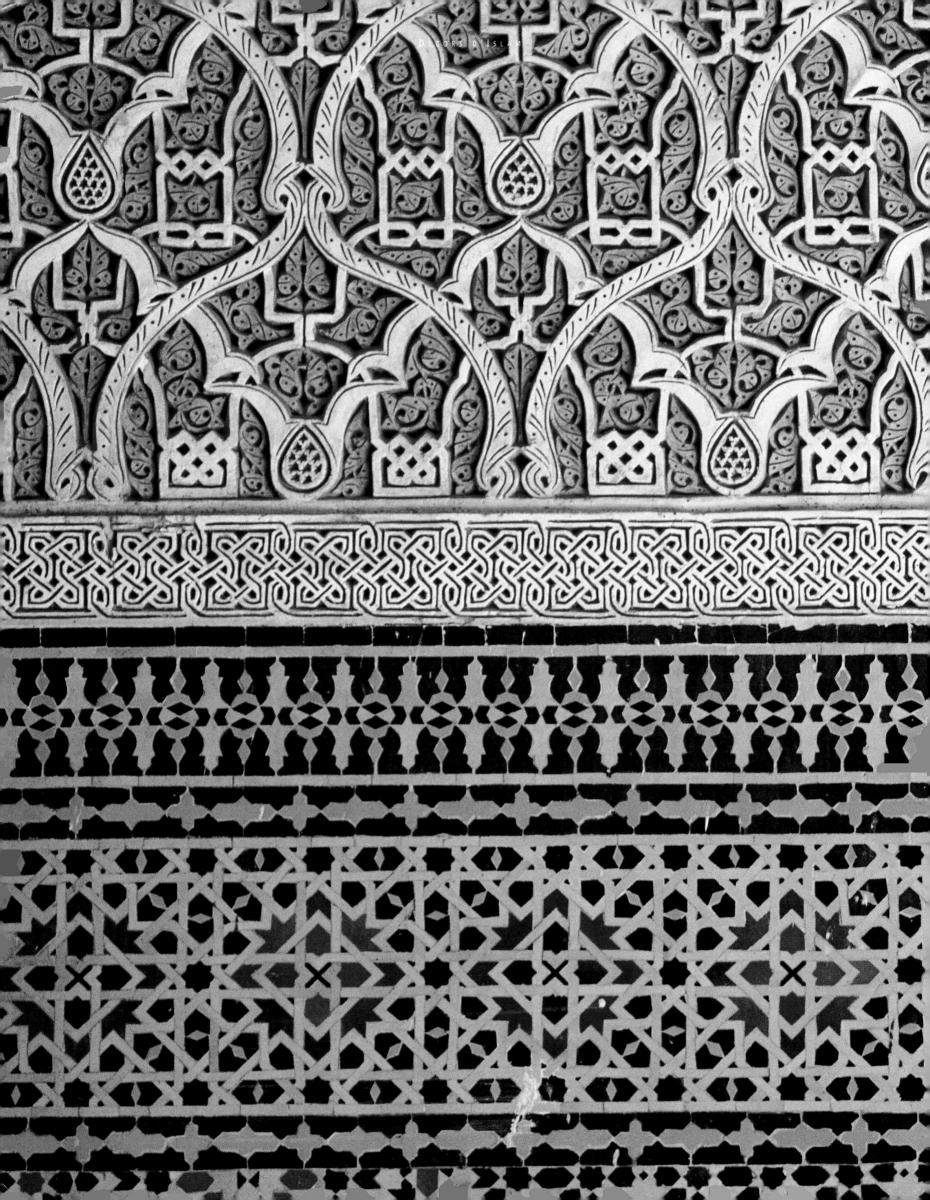

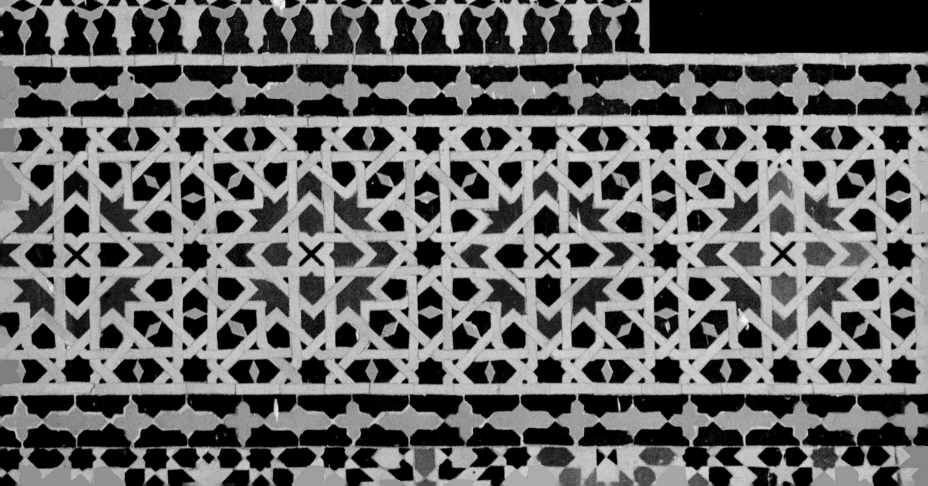

A Surface Art

The Logic of
Textures
The Articulation
of Surfaces
Supporting Forms and
Supported Forms
Aesthetics of the Veil

Architectural Space
Arches
Cupolas
Columns and Capitals
Patterns of Light

Preceding pages

Zellij and stucco decor in the *kasbah* of Tlwat (19th century).

246 Panel of glazed tiles in the Darwish Pasha mosque, Damascus (1571). The arch, from the summit of which a lamp hangs, is a representation of a *mihrab*. The two dark shapes are shoes indicating the threshold of a sacred space.

Islamic ornamentation, like Islamic architecture itself, presents a great variety. By placing emphasis on this variety, some writers have tended to question the term 'Islamic art', arguing that there is no Islamic art but only the arts of Islam. However, common characteristics appear in all the ornamentation used in Islamic architecture, especially those characteristics derived from certain techniques and dominant themes. These themes, which help to give buildings all over the Islamic world their familiar stamp, constitute a formal vocabulary, by means of which the different Muslim peoples can recognize themselves as members of a single community transcending all frontiers. The Arabic script is therefore the most powerful element in this vocabulary, since every Muslim, whether he knows how to read or not, immediately recognizes in it the sign of Islam *par excellence*. But above and beyond the materials or themes it employs, architectural ornamentation also presents more general characteristics which deserve attention.

One of these characteristics is the limited place it gives to symbols, especially religious ones. Except for the script, which is a unique case because of its linguistic nature, the formal repertoire of Islamic architectural ornamentation has almost no visual elements about which there is general agreement as to the meaning. For a plastic form to function as a symbol, it should be able to be used in isolation, containing a meaning within its own boundaries and without any additions, like, for example, the Christian cross. The fact is that Islamic ornamentation is distinguished, in part, by the scarcity of images and also by a tendency to meld both figurative and abstract motifs into a graphic continuum with no inherent limits. Of course, some cases seem to be exceptions to this rule, such as the animal figures clearly visible on the façades of certain buildings, which are filled with astral, magical or political symbolism, or the motif of the tree, in

247 The inscription over the door of the tomb of Nur al-Din Sentimur in Tokat (1314) is a Qur'anic formula traditionally used in epitaphs as a reminder that every soul will experience death: *kullu nafsin dha'iqatu 'l-mawti* (Sura III, 185).

247

248 Framed by two engaged columns and panelled with vertical bands of marble, the *mihrab* of the al-Firdaus *madrasa* in Aleppo (1235) is surmounted by a vigorous interlace done in marble marquetry of different colours.

which can be recognized the Tree of Life. However, the significance of these images generally remains mobile, closer to evocation than to the enunciation of an unequivocal message.

The motif of the arch offers an interesting example of this fluctuation of meaning. It acquires an almost symbolic status when it appears as a *mihrab*, containing the image of a mosque lamp (*Ill. 246*), a reference to the *Sura* of Light, where it is said that the light of God is 'as a niche wherein is a lamp'. But it can also be part of the general decoration of a building as a simple motif chosen for its form. In this case it is possible to question whether the aesthetic appreciation bestowed upon the form of the arch is totally unrelated to the religious value of the *mihrab*. It is also possible to speculate about the ambiguous relationships which exist between this ornamental arch and the real arches of the building it decorates.

Besides its meaning, which usually remains astonishingly mobile if not volatile, another dominant characteristic of Islamic ornamentation is the frequent use of certain more specifically plastic choices. Even in the first centuries of Islam there was a marked taste for effects of texture which has continued, in various forms and in various materials, throughout its history. There was also a great exploitation of rhythmic repetition and of the principle of variation starting from the same graphical schema. On a larger scale, we can also observe the constant use of ornamentation to articulate mural surfaces. In most buildings, this articulation of surfaces, which plays upon the juxtaposition of panels and the continuity of bands, seems to enjoy producing ambiguous relationships between the ornamental facing and the underlying architectonic structure.

The frequency in Islamic architecture of interference between ornamentation and principles of construction should also be noted. The arch stones of Mamluk *mihrab*s, thanks to their skilfully hewn and interlocked forms, are often transformed into a decoration of interlace (*Ills. 248, 250*). In the same way, when considering the porticos of the Court of the Lions in the Alhambra, it is difficult to say where construction ends and ornamentation begins. The most spectacular examples of this phenomenon, however, are encountered in ribbed *muqarnas* cupolas. These develop systems of crossed arches or honeycombed corbelled constructions which, going beyond or even contradicting their initial architectonic functions, reproduce three-dimensional geometric decors.

One final essential characteristic of Islamic ornamentation is the degree of importance given to it by Islamic builders, even when the first Umayyad

249 Decor of brick and enamelled tiles from the mausoleum of Shah Rukn-i 'Alam in Multan (13th century) imitating a wooden grill.

250 Detail from the façade of the Jaqmaqiya *madrasa* in Damascus (1421) combining *muqarnas* of sculpted stone and an interlace done in marble marquetry.

249

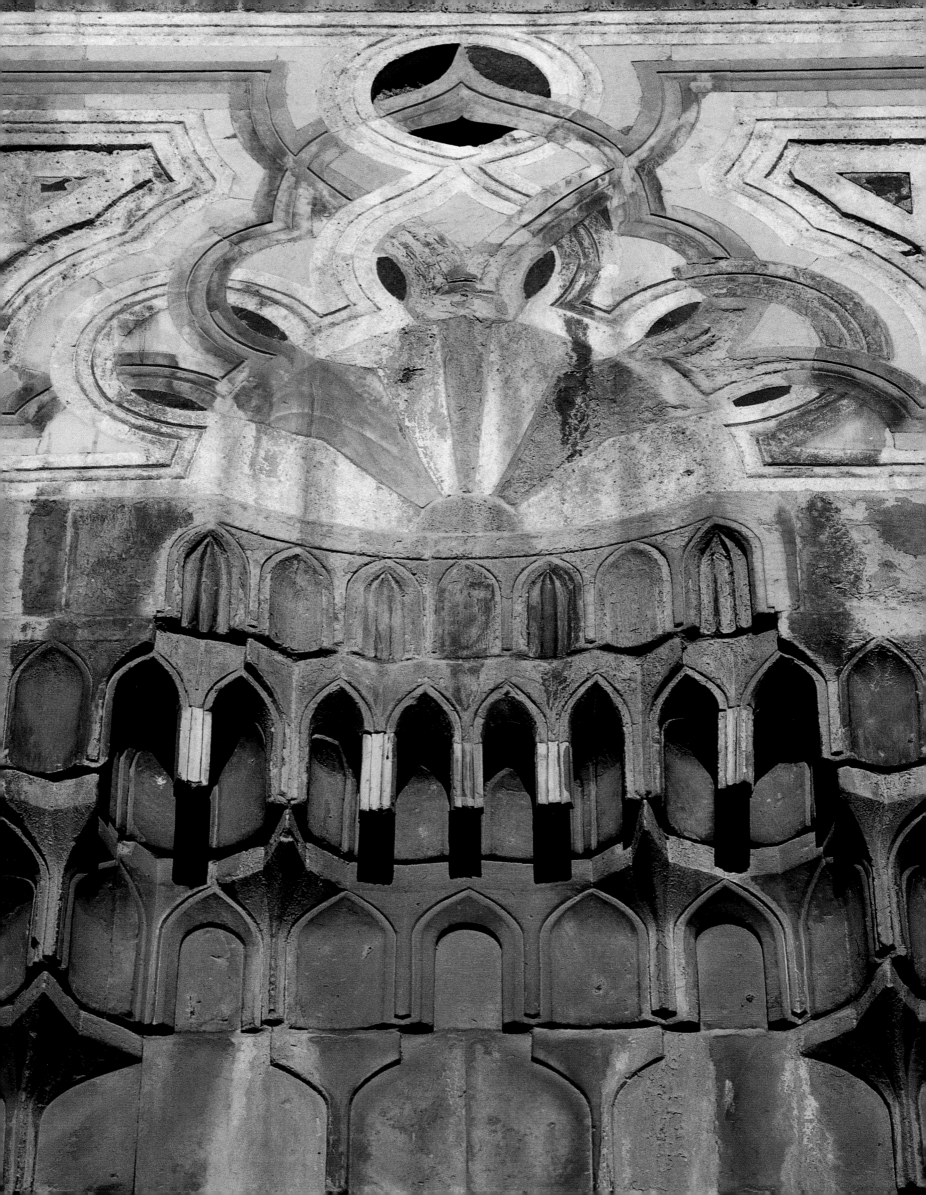

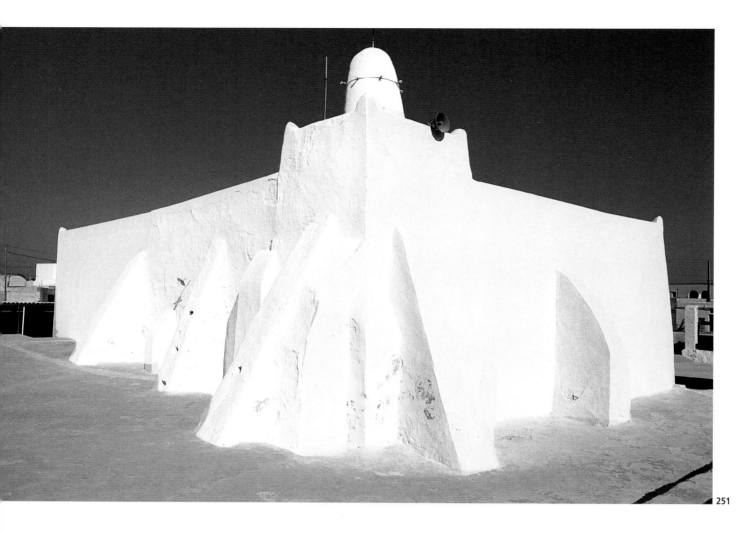

251 Entirely whitewashed, the Umm al-Turkiya mosque of al-May on the island of Jerba (16th century) reflects the religious beliefs of Kharijism, an Islamic sect which values simplicity and rejects the luxury of ornamentation.

251

buildings were erected and in spite of the tradition that primitive Islam was hostile to the embellishment of religious edifices. A *hadith* recounts that the Prophet was supposed to have asked his companions who were constructing a place of worship to avoid any ornamentation which might distract the faithful, because 'God does not order us to cover stone or brick.' This attitude was taken up by jurists like Khalil ibn Ishaq, who lived in the 14th century and who went so far as to declare the decoration of the wall of the *qibla* unlawful. Testimony to this primitive austerity can be found in the religious buildings constructed on the island of Jerba in Tunisia or in the Mzab in Algeria by the Kharijites, a Muslim community who have sometimes been called 'the puritans of Islam'. Everywhere else, as soon as a need to express prestige was felt, ornamentation triumphed on religious and public monuments alike.

Two points which have often held the attention of commentators on Islamic art are its tendency towards the generalized use of ornamentation and its plastic characteristics. They have favoured different explanations and interpretations, depending on their methodological orientation or their philosophical and religious viewpoint.

Some of the pioneers of Orientalism, who necessarily had access to only a limited amount of material, readily attributed these dominant traits of

252 The Great Mosque of Say'un,
Yemen.

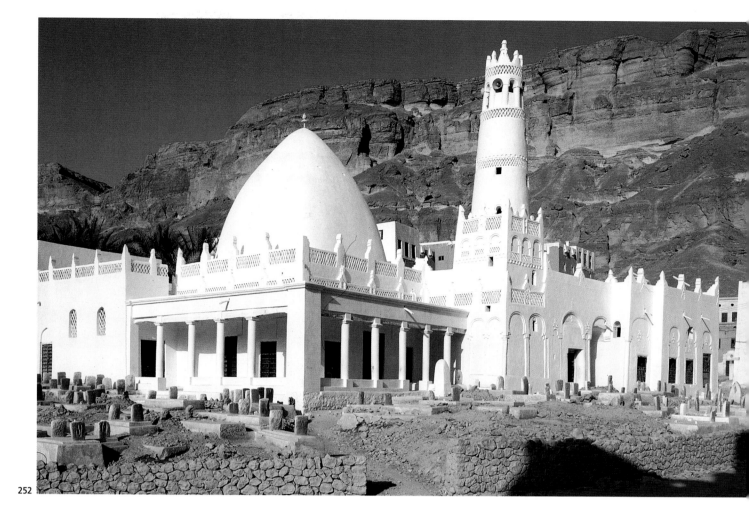

252

Islamic art to the 'genius' of the peoples of Islam. It was generally believed
that each nationality had a specific artistic genius which was reflected
in their productions. Thus, one spoke of the German genius or the Greek
genius. But in the case of Islam, which grouped together populations
of very different origins, this explanation had to be qualified. Although
the fact that the sources of Islamic art lay in Antiquity was emphasized,
its evolution and stylistic variations were explained by the historical
or geographical predominance of one people or another: Arabs, Moors,
Turks, Persians, and so on. According to this argument, the most permanent
characteristics of Islamic art were attributed to the Arab core from which
Islam itself had sprung. Sometimes the term 'race' was used, which seemed
to confirm the idea of an atavistic predisposition for a particular artistic
form. According to this interpretation, Islamic art was the product of a
Semitic mentality characterized by a fascination for abstract contemplation,
a tendency towards mysticism and a taste, often judged excessive, for
ornamentation. The artistic forms developed in the Iranian world, on
the other hand, reflected an Indo-European spirit, more inclined to explore
the reality of the natural world. Although the term 'race' was eventually
replaced by 'mentality' or 'the psychology of peoples', the dangers of such
views are obvious.

253 Buildings in Sana'a', the capital of Yemen. Vernacular Yemeni architecture is distinguished by the height of the buildings, which can be up to seven storeys tall, and even more by its ornamentation, using geometric patterns painted in lime on brick walls. Over the windows of the reception rooms, fitted with wooden shutters, are stucco window grills set with plaques of alabaster or coloured glass.

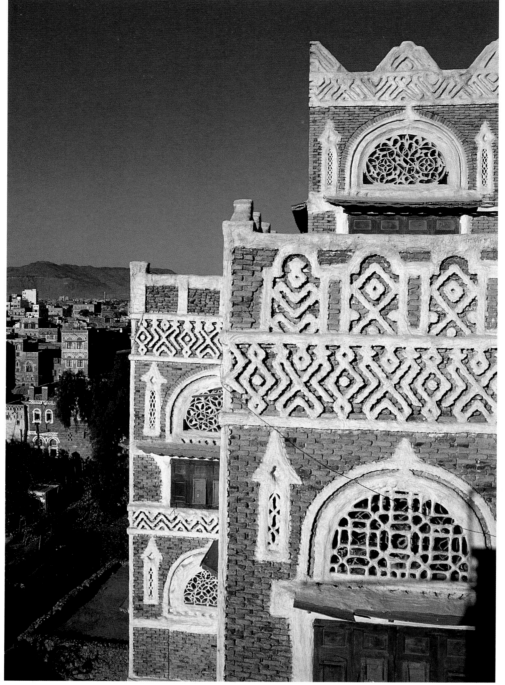

253

Specialists of the following generation prudently distanced themselves from such explanations and refused to make what they considered to be hasty generalizations. They preferred instead to devote themselves to the careful study of specific cases so as to contribute to the sum of knowledge about the various arts of Islam. Even though this scientific rigour led them to give more importance to historical or regional characteristics, the problem of the stylistic kinship between the products of different Islamic arts continued to be posed. The explanations which they offered were generally historical or sociological. The common plastic characteristics in the art of the Islamic world could be explained by the transmission of an artistic heritage, by a phenomenon of diffusion aided by the fact that artists and craftsmen moved from place to place and by a principle of stylistic evolution. These explanations, in conformity with a concept of art history which avoids aesthetic questions, were carefully limited to a description of tangible or documented facts.

254 Detail from a tomb in the Chowkandi necropolis east of Karachi which dates from the 13th to the 16th centuries. The ornamentation of the surfaces is achieved by sculpture work which, with the help of light and shadow, creates geometric motifs where the square, the chevron and the cross dominate.

254

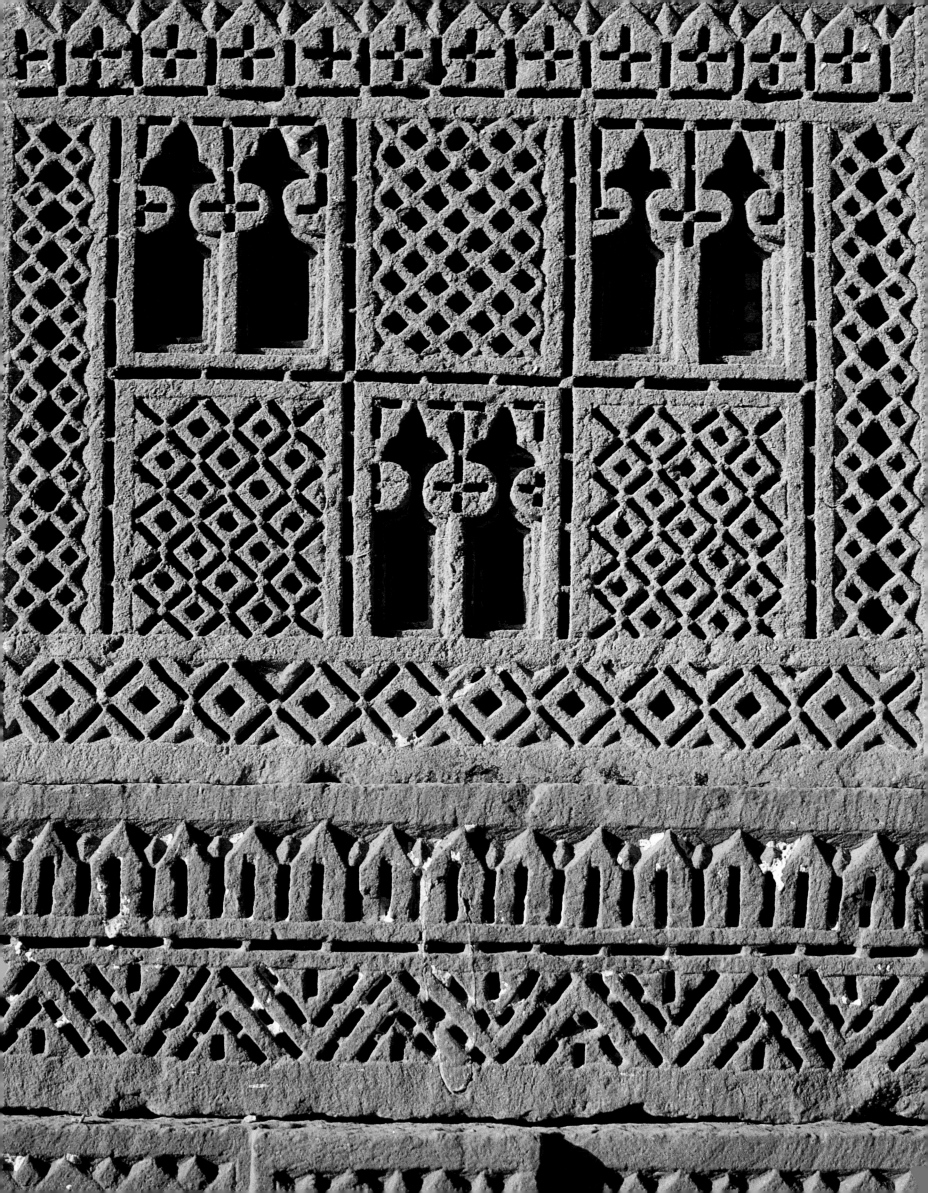

Unlike these historians of Islamic art, other writers have seen in the aesthetic choices of this art not so much the consequences of history as the expression of a type of thought. In many cases, this kind of explanation gives a decisive role to Islam not merely as a social system but as a religious system, sometimes going to a mystical extreme which interprets the feeling of unity produced by Islamic ornamental art as the manifestation of Divine Unity.

These three attitudes, which emphasize ethnic, historical or religious factors, all contain elements which may help to clarify the bases of Islamic ornamental aesthetics, although some risk over-interpreting or taking ideological shortcuts. Together, however, they can participate in discussing the question of ornamental aesthetics in the wider context of Islamic culture. Culture, here, should be understood as those intellectual and material aspects which characterize a given society and make of it a coherent totality in relation to other societies, although, in the particular case of Islam, a relative diversity should be taken into account. These multiple constituent aspects of a culture are as varied as its institutions, its diverse social practices, different artistic expressions and philosophical and religious systems. In Islamic culture, it is clear that the essential unifying element is the religion itself. It is therefore legitimate to think that the general model for understanding the world established by Islam has

256 Ornamentation detail from the façade of the Gök Medrese, or Blue *madrasa*, in Sivas (1271). This example of stone sculpture, a great speciality of Saljuq builders, brings together three types of patterning from the Islamic decorative repertoire: plant forms, geometry and calligraphy.

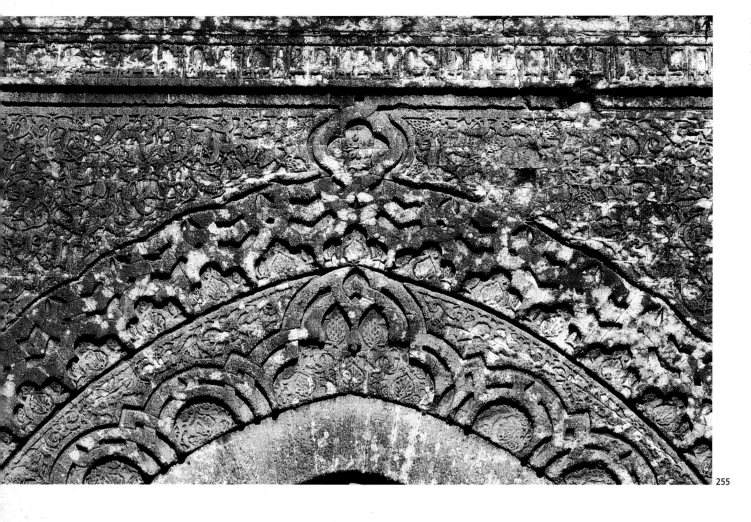

255

255 Detail of a sculpted frieze framing the arch of the portal of the Marinid necropolis at Shalla near Rabat (1310–39).

256

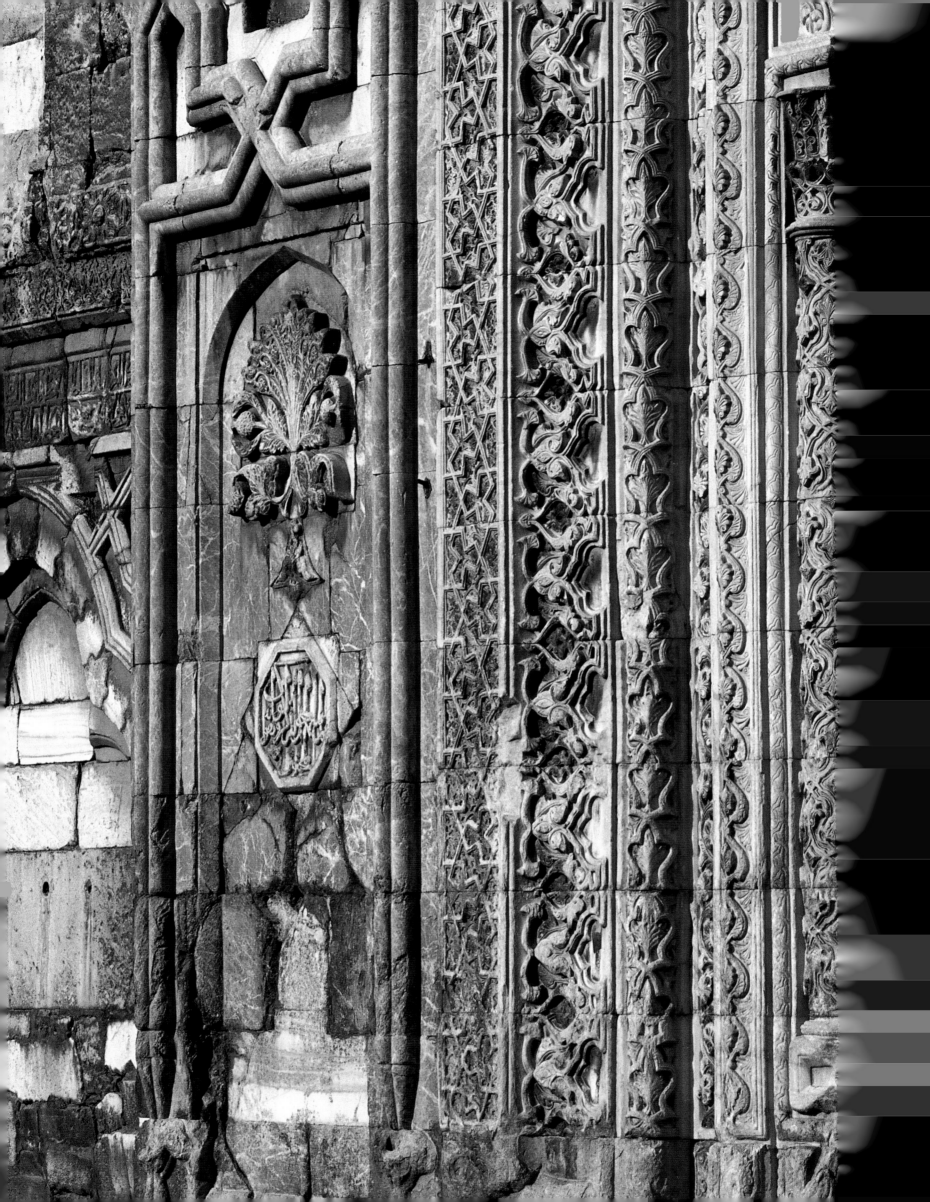

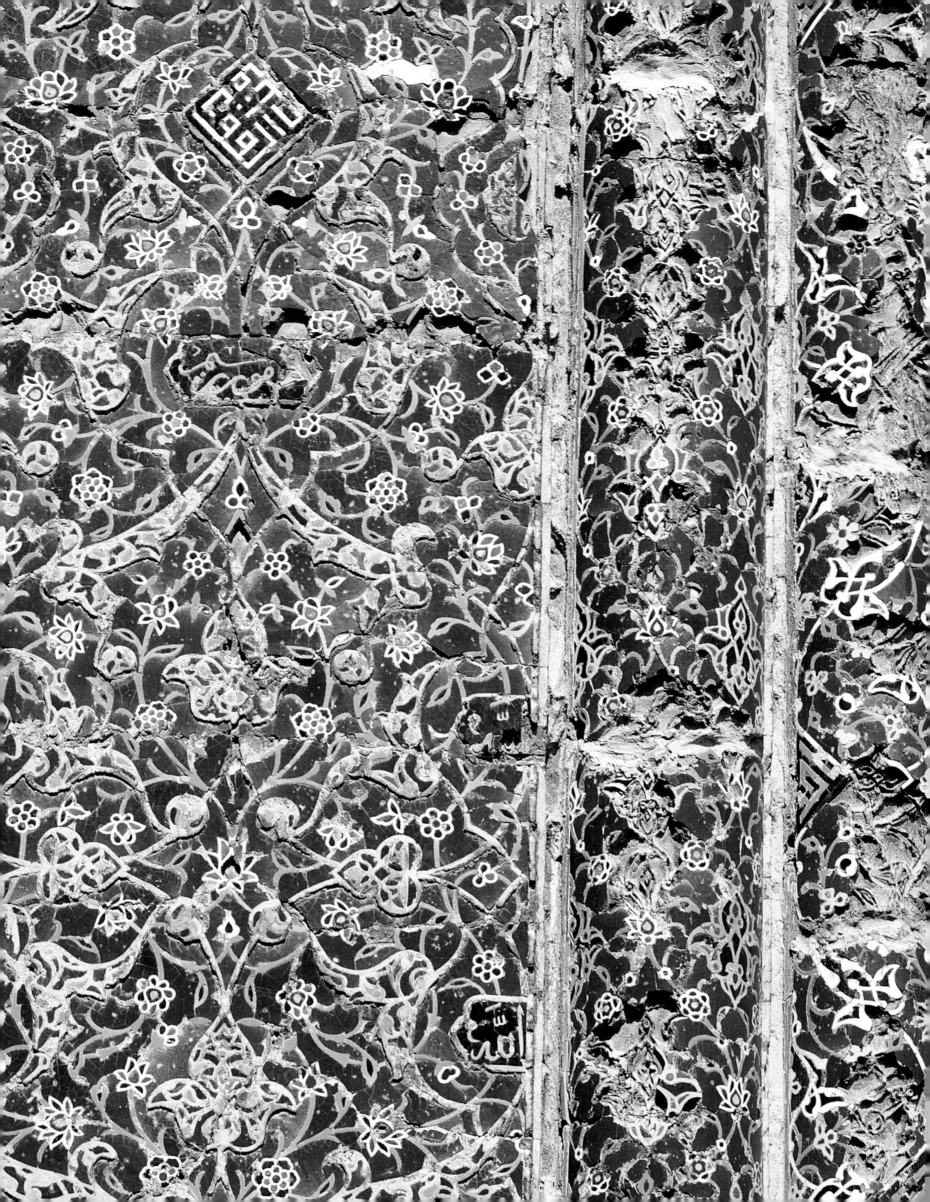

257 The Blue Mosque of
Tabriz (1465) owes its name
to the ceramic cladding with
a turquoise blue background
which completely covers it.

influenced the other components of Islamic culture and that the ornamental facing of surfaces, a dominant characteristic of Islamic art, constitutes its plastic expression.

What is this model for understanding the world propagated by Islam in all the countries where it took root? It can be paraphrased roughly as follows: the world in which we live is no more than a transitory abode to which the believer should not become attached. Indeed Islamic ornamentation, rather than maintaining the illusion of the permanence of the world by duplicating its deceptive appearance, works only to beautify the environment in which we live. The forms of ornamentation, which spread themselves out over buildings and other objects with no edges or fixed limits, as well as their repetitive graphic textures encourage the spectator's gaze to glide over the surface of things.

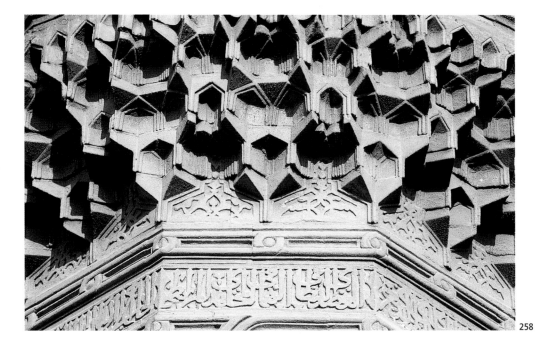

258

258 Details of the corbelled structure supporting the balcony of the minaret in the Azbak al-Yusufi mosque in Cairo (1495). Specific to Islamic architecture, the *muqarnas* system produces a geometrical fragmentation of volumes.

259 Window grill of sculpted stone openwork in the Rani Sipri mosque in Ahmadabad (1514).

260 Ornamentation detail from the western portal of the Great Mosque of Divrighi (1228–29) exploiting the principle of interlocking forms which excludes any notion of a background.

259

260

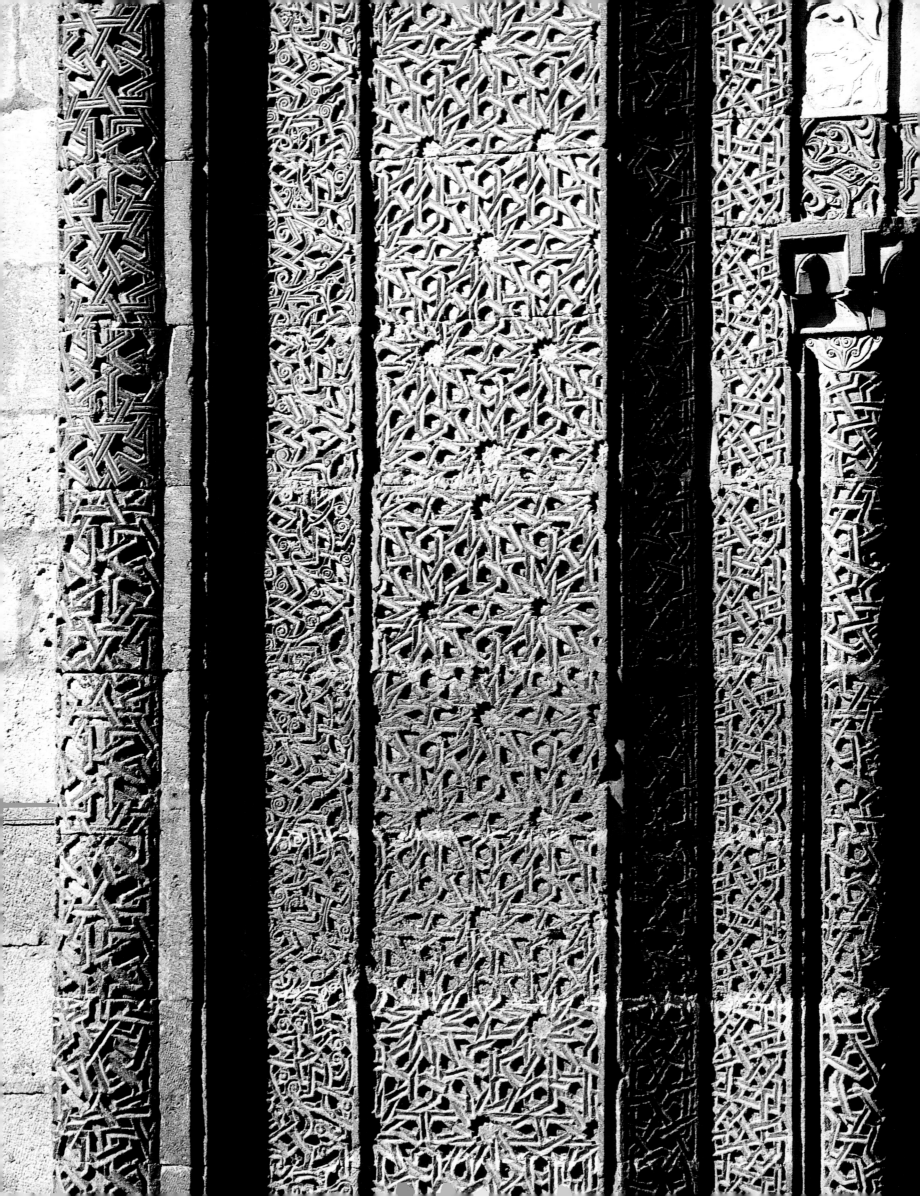

262

The Logic of Textures

Although the themes of architectural ornamentation can be easily isolated, the same is not true of the plastic principles which unite them. It is immediately apparent that vegetal, geometric and calligraphic patterns all share a graphic logic of line and rhythm, density, variation and repetition, at least in their most usual forms. All these plastic aspects, however, are so intimately linked to each other that it seems almost impossible to perceive them separately.

What term, then, could be used to define the plastic principles of Islamic ornamentation? One expression often employed is *horror vacui*. In all his productions the Muslim artist is said to demonstrate an overwhelming need to cover the surface. While this view can lead to interesting interpretative hypotheses, there is another more descriptive term, which sums up more immediately the

dominant characteristic of Islamic ornamentation, namely texture.

When contemplating a work of Islamic architecture whether it be in Spain, Morocco, Iraq, Iran or India, the same visual experience frequently occurs: the perception one has of the building undergoes a transformation as one draws closer. From a global vision of the building, its spaces and its large architectural masses, one enters into the graphic universe of ornamentation. The transition between the view of the whole and the view of the parts operates not only through the general structuration of the ornamentation but also through a progressive perception of its texture. Appearing at first as zones of variable intensity which articulate the mural surfaces, these textures slowly reveal their intrinsic rhythms, their *tempi*, and finally their patterns. Particularly evident in ornamentation which exploits the

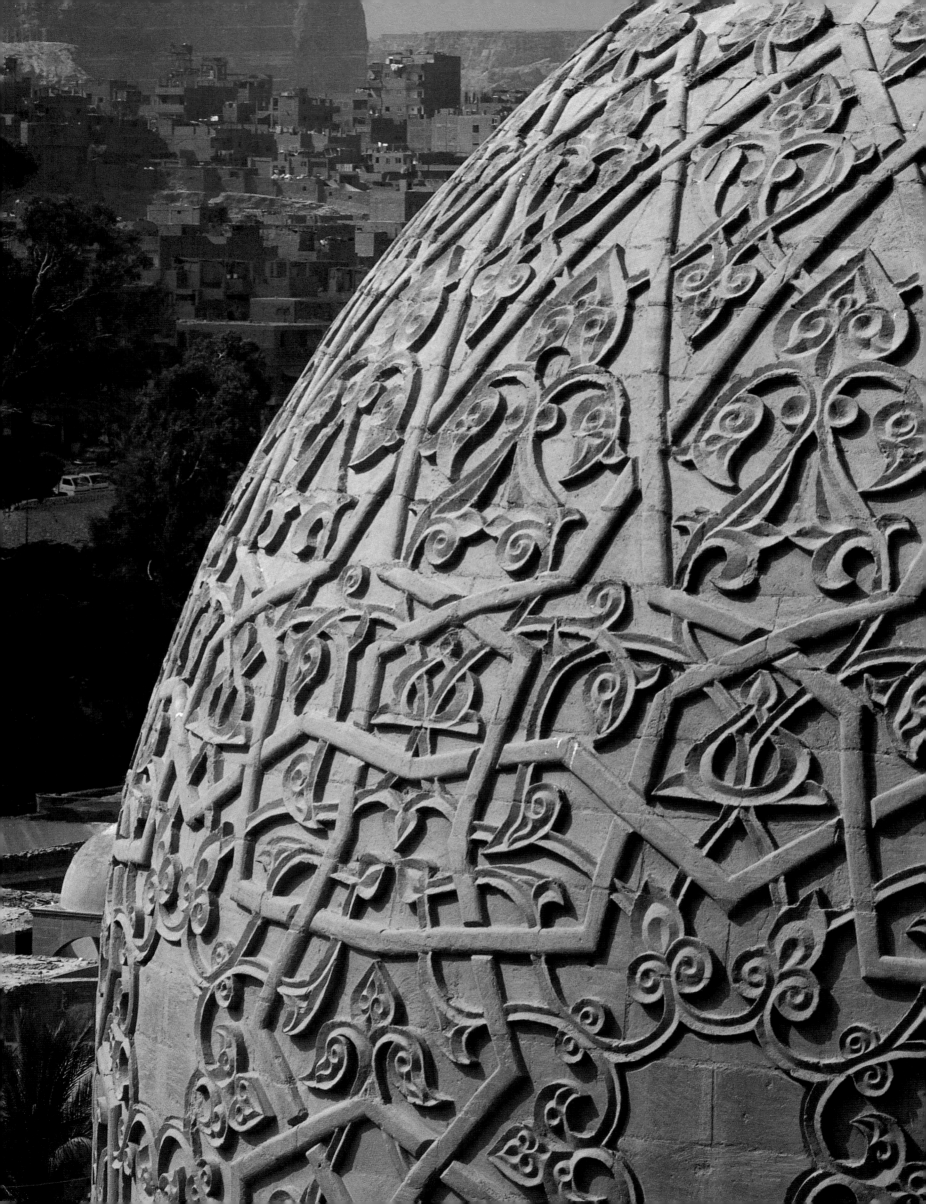

263 Cupola of the mausoleum of Qa'itbay Cairo (1472–74). Richly sculpted with a complicated network of polygons superposed over a network of vegetal arabesques, this work could be likened to an object of fine metalwork.

effects of shadow and light, such as stucco, sculpted stone or wood, or the assemblage of bricks in a wall, this phenomenon also appears in a slightly different form in ceramic facings, where the rhythmic shimmering of colours precedes the identification of finer forms.

These remarks might concern nothing more than the simple phenomenology of perception, if the apparent delight of Muslim artists in deliberately multiplying the levels of texture were not also taken into account. The simplest procedure consists of juxtaposing different densities which can be perceived at different distances. This desire to manipulate the phenomena of perception is demonstrated even more by a procedure which could be called the multi-layering of textures, of which the stuccos in the Friday Mosque of Na'in (Ill. 267) or in the mosque of Ibn Tulun (Ill. 113) provide very clear examples. The object of this procedure is to differentiate in one ensemble bold textural elements which can be seen from afar, others of a medium density which become perceptible as one approaches, and still others so delicate that they only appear close up. These multi-levelled textures, which are almost a constant in stucco art, are frequently used in calligraphic ornamentation and in the system of geometric interlace. In the first case, the strong rhythm of the calligraphic text appears upon a background of lighter density scrolls. In the second case, it is the network of interlace itself which constitutes a first level of texture, whereas the fine decor, which occupies the vacant spaces, appears as a second level.

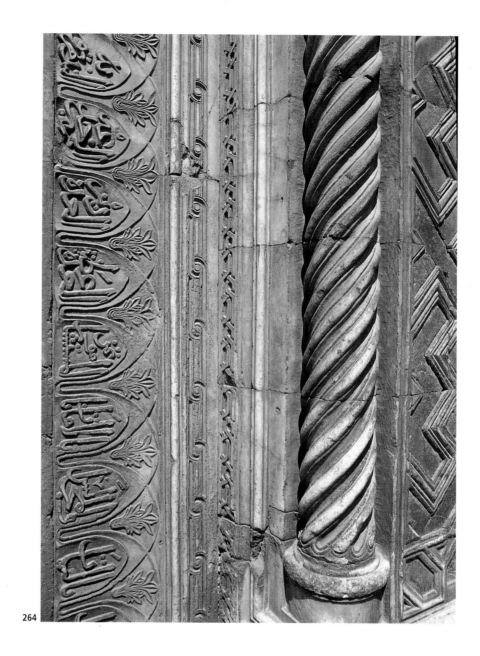

264

265

264 Detail from the sculpture on the portal of the Büyük Qaratai Medrese in Konya (1251).

265 Detail of the *muqarnas* in stone of the portal of the Çifte Minare Medrese in Sivas (1271–72).

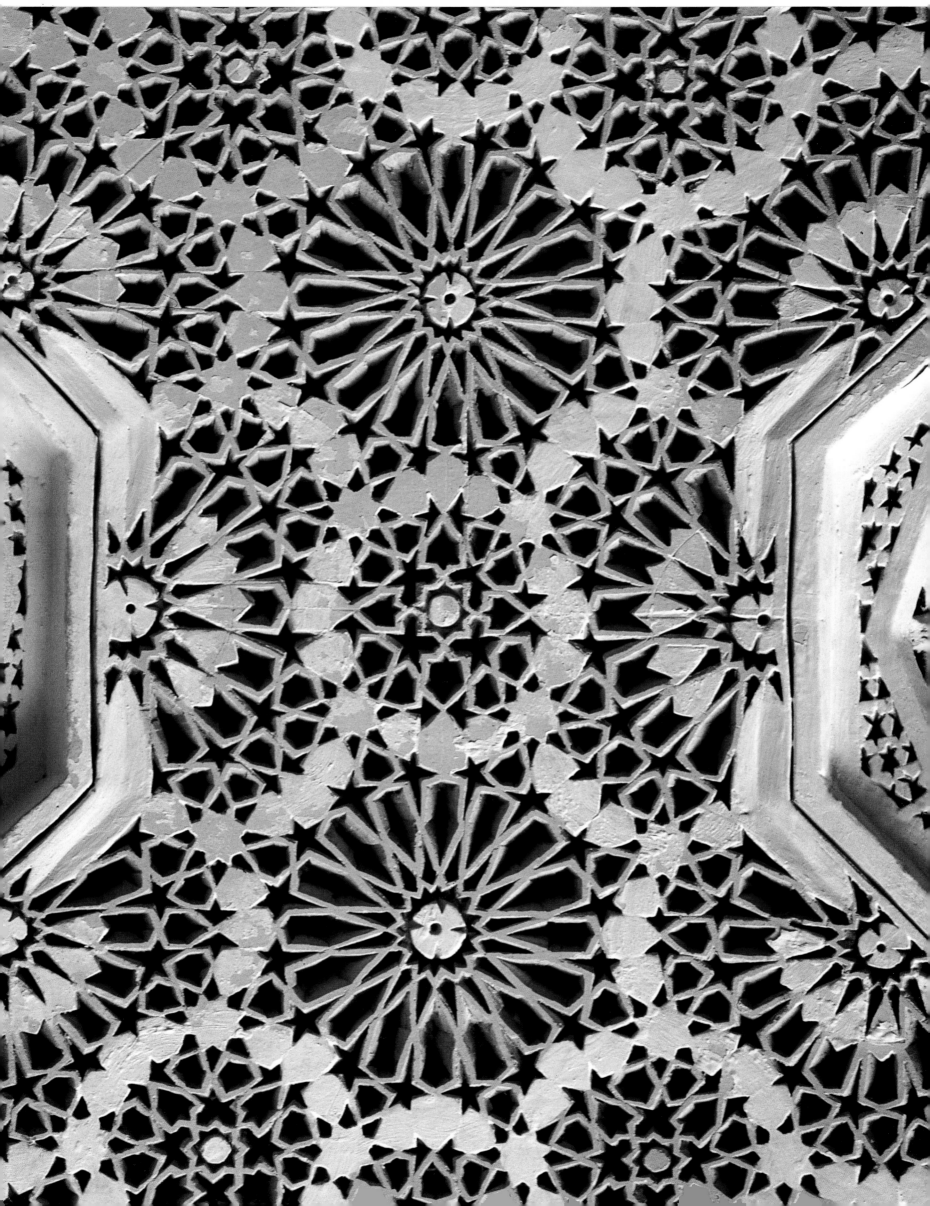

means, which make it possible to activate each section of the visible surface, share the property of eliminating the background as a neutral plane on which forms and figures might stand out.

Most often the background is simply eliminated by saturation. The empty space between the various graphic elements is reduced to such a degree that it no longer looks like a negative form, but merely appears residually in several minute interstices. Particularly evident in the sculpture technique of carving out, it is this phenomenon, found in the earliest Umayyad architectural ornamentation, as at Mshatta or Khirbat al-Mafjar, which often gives Islamic architectural ornamentation a lace-like aspect.

The stuccos of Samarra display two further developments in methods of eliminating the notion of background. One is accomplished by interlinking patterns, generally vegetal ones, without leaving any space between them. The second is achieved by animating the totality of the wall surface, using a system of decoration known as the bevelled style. In the latter case the lines, whose involutions retain a certain plant-like appearance, no longer act as a contour isolating the figures against a background, but instead isolate similar zones. Taking on the aspect of a groove with rounded sides that merge gradually into the original surface plane, these lines transmit an identical plastic quality to the zones they separate.

In a similar way, although based not on curves but on straight lines, certain principles of the geometrical partition of surfaces – particularly frequent in the techniques of the ceramicist – also make it possible to eliminate the notion of

background. The idea is to assemble complementary forms, such as the eight-pointed star and the cross with triangular extremities. According to this principle each portion of the surface has the value of a figure. A similar process consists of combining a series of identical forms, which have the geometric quality, according to the direction they are given, of being able to become perfectly interlinked with each other (*Ill. 260*). More specific, and yet exploiting the same principles of the complementarity of forms, are the compositions of quadrangular kufic script in which the labyrinth created by the line of script finds its plastic counterform in the space separating the convolutions. In these cases the complementarity of forms is generally accompanied by an opposition between two colours or two values – black and white, marble and sandstone, rough and glazed brick, etc. – whose function is to disturb the relationship between form and background.

Through the effects of textural saturation, interlinking of forms and visual ambiguity, Islamic ornamentation seems to distance itself from what could be called the aesthetics of the figure. The rare exceptions to this general principle can be found in both the Saljuq architecture of Anatolia and that of Mughal India, where figures of heraldic animals or images of naturalistic plants can be seen standing out on a uniform background. Perhaps this almost unanimous rejection of the figure reflects certain orientations of Islamic religion and philosophy, which claim that the forms which make up the visible world have only a relative autonomy. Thus, the forms of Islamic ornamentation, deprived of a background which would enhance their status as figures, cannot claim any sort of independence and are nothing more than the product of modulations of the plastic surface.

270 Detail of the stucco decor created on two planes in the Mustansiriya *madrasa* in Baghdad (1233).

271 Stucco decor above the calligraphic band made of excised *zellij* on the al-Najjarin *funduq* in Fez (late 17th century).

270

271

269 Detail from the stucco decor of the *kasbah* of Tlwat (19th century). This deeply carved geometrical network lets a second network appear, formed by the links which were not hollowed out.

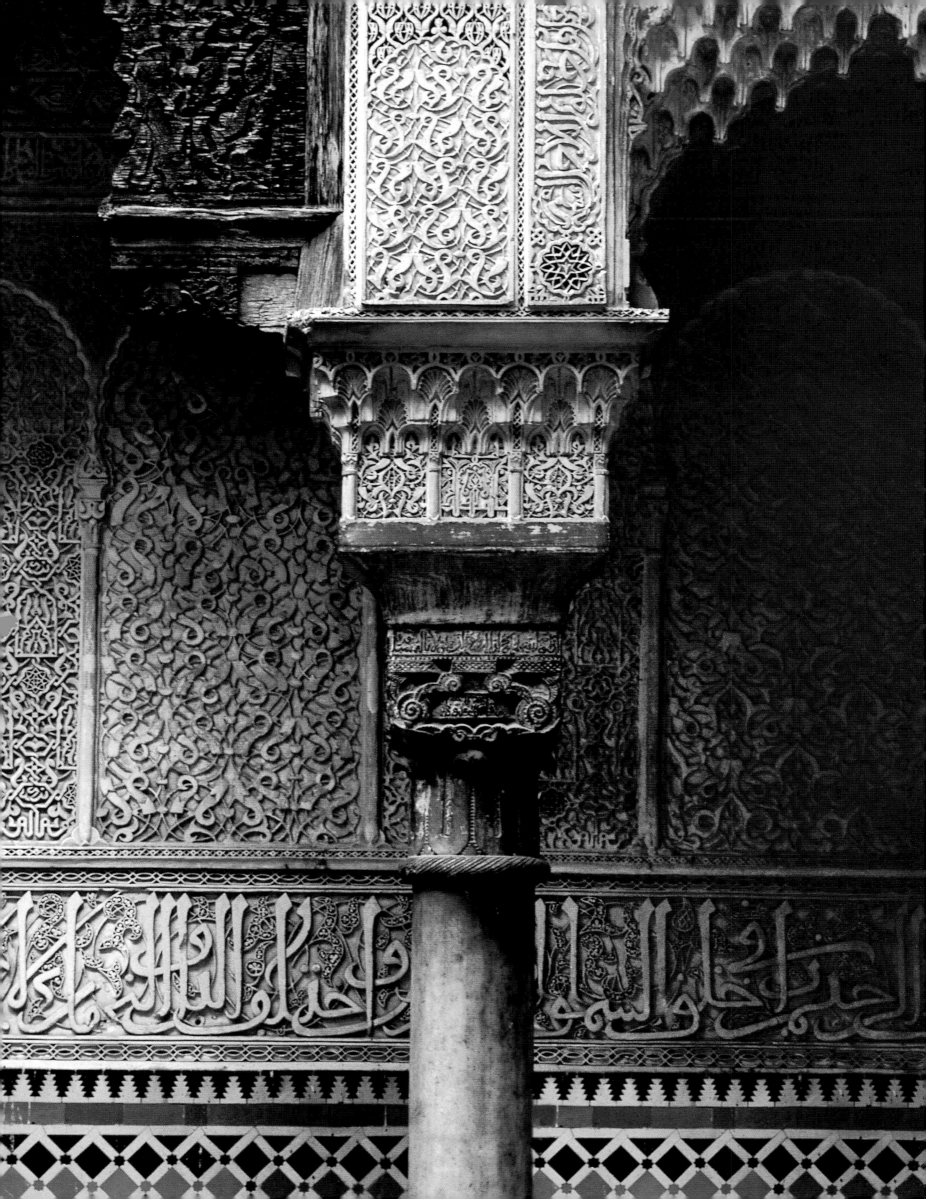

273

273 System of sculpted bands framing
the door of the Gök Medrese, or the
Blue *madrasa*, in Tokat (13th century).

The Articulation
of Surfaces

272 Architectural detail in the al-'Attarin
madrasa in Fez (1323–25). Whereas
ornament in Western architecture is
generally limited to indicating places
where forces are exerted, in Islamic
architecture, and particularly in Marinid
works, it tends to cover surfaces with
a multitude of panels and bands.

Through its frequent use of facing
techniques – stone, stucco, ceramics –
or techniques of shallow relief sculpture,
Islamic architectural ornamentation
appears, above all, as surface work. But
the entire surface of a building cannot
be covered by one continuous, uniform
ornamental pattern, because a taste for
variety and variation must also be
satisfied.

Therefore, before the surface of a
wall receives any ornamentation, it is
subdivided according to a system based
essentially on two elements: the panel
and the band. These two elements
of Islamic ornamental syntax interact
in such a way as to make the plastic
articulation of the wall possible. Where
the panels function as discontinuous
elements, the bands serve as links
guaranteeing the cohesion of the whole.

Just as Islamic ornamental vocabulary
is an identifying mark of Islamic

buildings, this ornamental syntax gives
them their particular character, a mixture
of clarity and ambiguity: clarity of the
ornamental structure and ambiguity of
the relationship between this ornamental
structure and the underlying
architectonic structure.

As is the case in most of the artistic
language of Islam, the ornamental
articulation of panels and bands, which
can be found in almost all periods and
regions of Islam, is not an invention
which sprang *ex nihilo* from the work
of Islamic builders. It is the development,
at a new level of expression, of principles
already employed by several earlier
architectural traditions of the Near East.

A division of the mural surface into
clearly circumscribed rectangular panels
was used in Umayyad constructions in,
for example, the marble facings of the
Dome of the Rock, the Great Mosque
of Damascus and the stuccos of Qasr

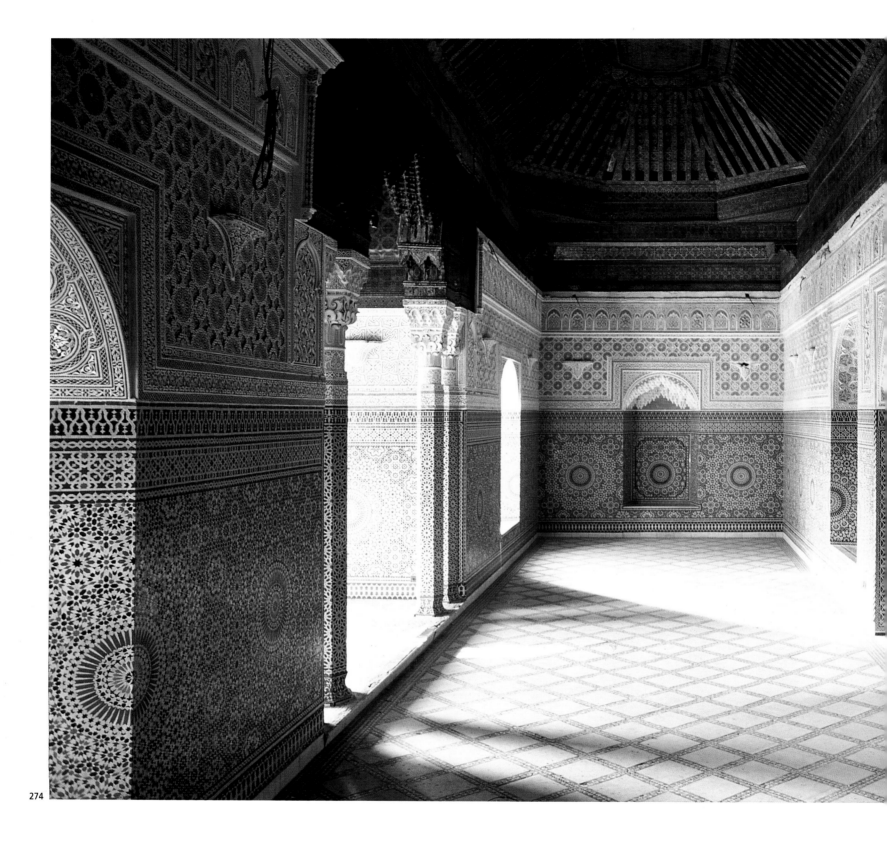

274

274 *Harim* of the *kasbah* of Tlwat. The technique of covering mural surfaces with *zellij* on the dados and stucco for the upper walls is used systematically in Moroccan architecture. Situated at eye level, the dividing line between the two zones produces a visual effect which seems to increase the space.

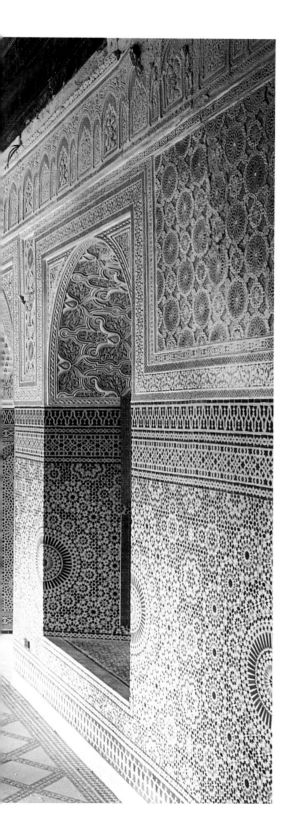

al-Hair al-Gharbi. This technique has several sources. The first is the ornamental techniques of Byzantium, and the second the Sasanian tradition of stucco. In both cases, the subdivision into panels makes it possible to counteract the monotony of large surfaces by endowing the wall with an overall structure in which various ornamental patterns find their place. Another possible origin of Islamic ornamentation using juxtaposed panels is to be found in the architectural tradition of Iran. In the Sasanian constructions at Ctesiphon, as was already the case in Achaemenid palaces, series of panels were arranged slightly recessed from the bare wall with no other function than to disrupt the uniformity of the surfaces.

The second element which plays a role in Islamic ornamental articulation is the band, a large projecting band or a thin ribbon, which is a Near Eastern descendant of the friezes, mouldings and cornices of Classical architecture. In Islamic buildings, however, as was already the case in the Christian architecture of Syria, the ornamental band no longer serves to make the real articulations of the construction visible. Its role is rather to create purely plastic links, which can visually unite the different parts of the façade. This linear element, with a weak or non-existent relief, can spread out horizontally or may turn through ninety degrees and assume a vertical direction. It can follow the curve of an arch or, as is frequently the case in Egypt, Syria and Anatolia, it can become interlaced with another band. Calligraphic bands readily lend themselves to this function of visual connection. The direction of the script

275 Detail of the portico enclosing the courtyard of the Bu 'Inaniya *madrasa* in Fez (1350–55). This decor juxtaposes surfaces made of different materials and patterns: *zellij*, excised *zellij*, stucco, wooden screens and sculpted beams.

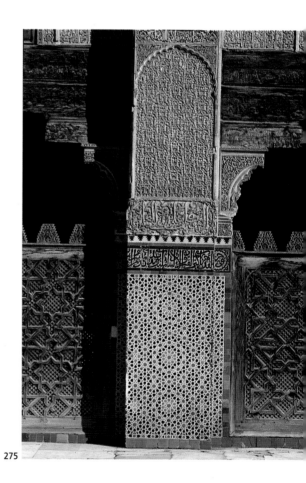

275

guides the reader's gaze along the surface of the building and is thus able to unite the different parts.

Finally, there is a particular use of the band which clearly responds to the desire to stabilize the dynamic form of the arch by inscribing it in a rectangular framework. An arch thus contained by a band has always been popular in Islamic architecture. It is this motif – used in the composition of the *mihrab* and reproduced on prayer carpets – which gives many ornamental panels their architectural aspect and also furnishes the façades of Persian and Mughal buildings with their major structural schema.

But although these organizational elements of the ornamental surface – panels, bands and inscribed arches – intervene almost universally in Islamic architecture, they influence the spectator's perception of buildings most effectively in Morocco and Iran.

The Bu ʻInaniya *madrasa* in Fez, constructed by the Marinids in the middle of the 14th century, is an excellent example of this phenomenon.

The general composition of each one of the façades facing the courtyard is dominated by a monumental door. Around this are eight smaller openings on two levels. The wall surfaces are fragmented into a multitude of panels which form autonomous units and display all kinds of materials, patterns, textures, densities and colours. One can see surfaces of *zellij*, scraped tiles, sculpted wood, pierced wood, dark and light zones, which are matt or shiny, coloured or plain. There are plant, geometric and calligraphic motifs and networks with a more or less concentrated pattern. At first the spectator's gaze is dazzled by such variety. Moving the eyes backwards and forwards creates an illusion in which each panel seems to detach itself from the wall and to float as if suspended in space. But longer observation reveals a progressively strengthening, rigorous order in this optical instability, which allows for multiple interpretations, with the eyes making their way across a pattern of horizontal and vertical axes.

Although the proportions of the façades facing the central courtyard of the Shah Mosque in Isfahan are more imposing, they present certain structural analogies with those of the Bu ʻInaniya *madrasa*. However, in the former case the use of panels and bands makes it easier to apprehend the building. The dominant motif in this ensemble of perfect geometric clarity is that of the arch inscribed in a rectangle. The subdivision into panels is particularly noticeable on either side of the *iwan*, where squares and rectangles are superposed in slight recess, with each rectangle containing the form of an arch (*Ill. 36*). It would, however, be just as easy to consider each unit, formed by a real arch and circumscribed by its

276 General view of the courtyard of the al-ʻAttarin *madrasa* in Fez (1323–25).

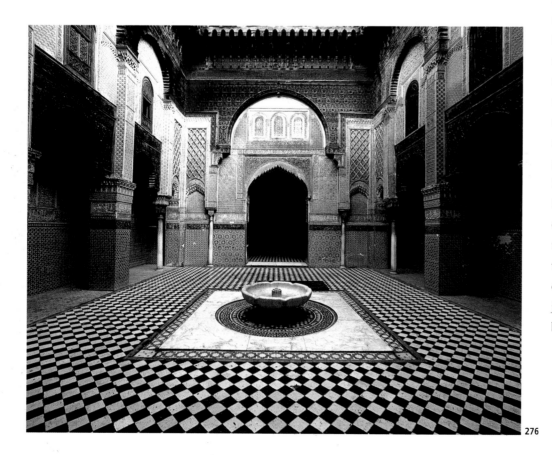

276

277 System of polychromatic bands sculpted with vegetal, geometrical and calligraphic motifs which frames a portal of the ʻAlaʼi Darwaza in Delhi.

27

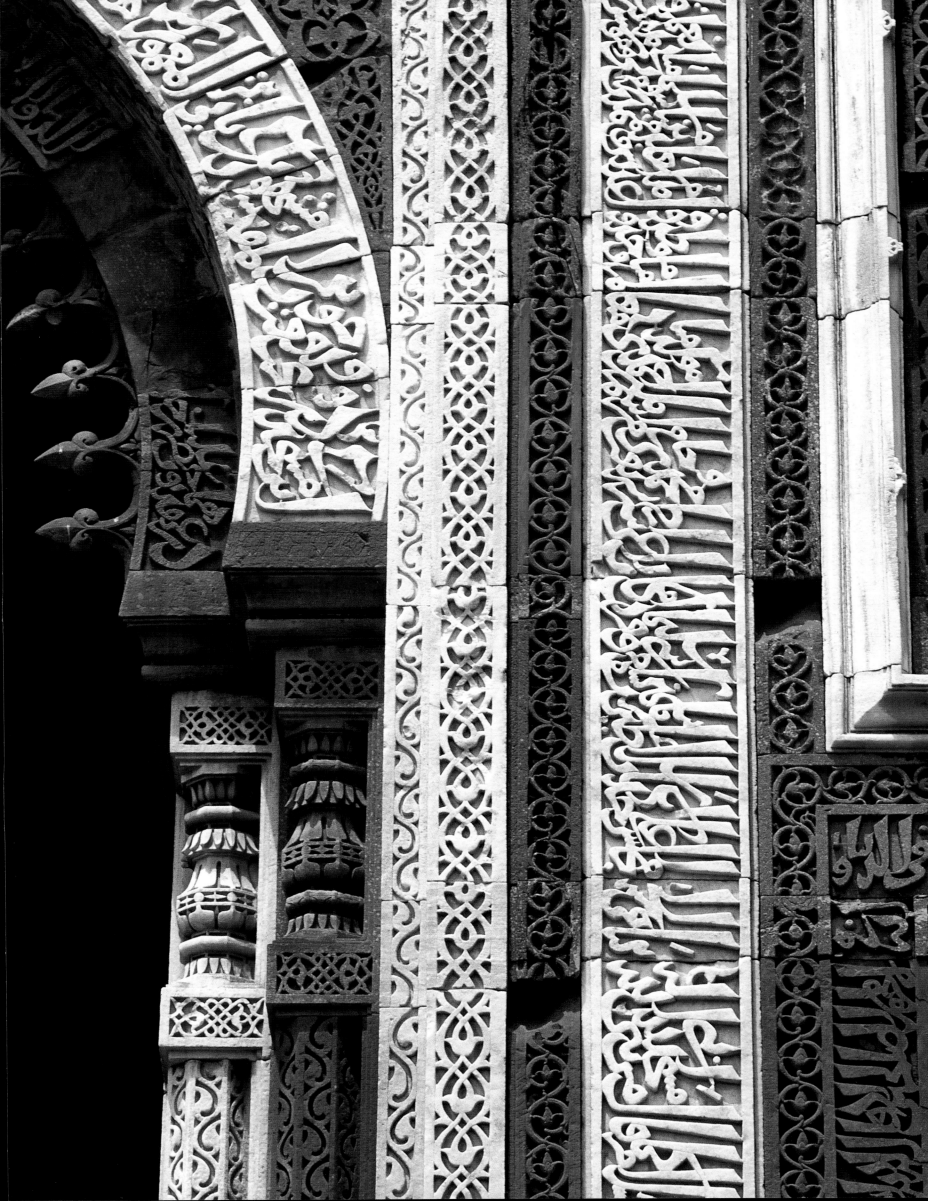

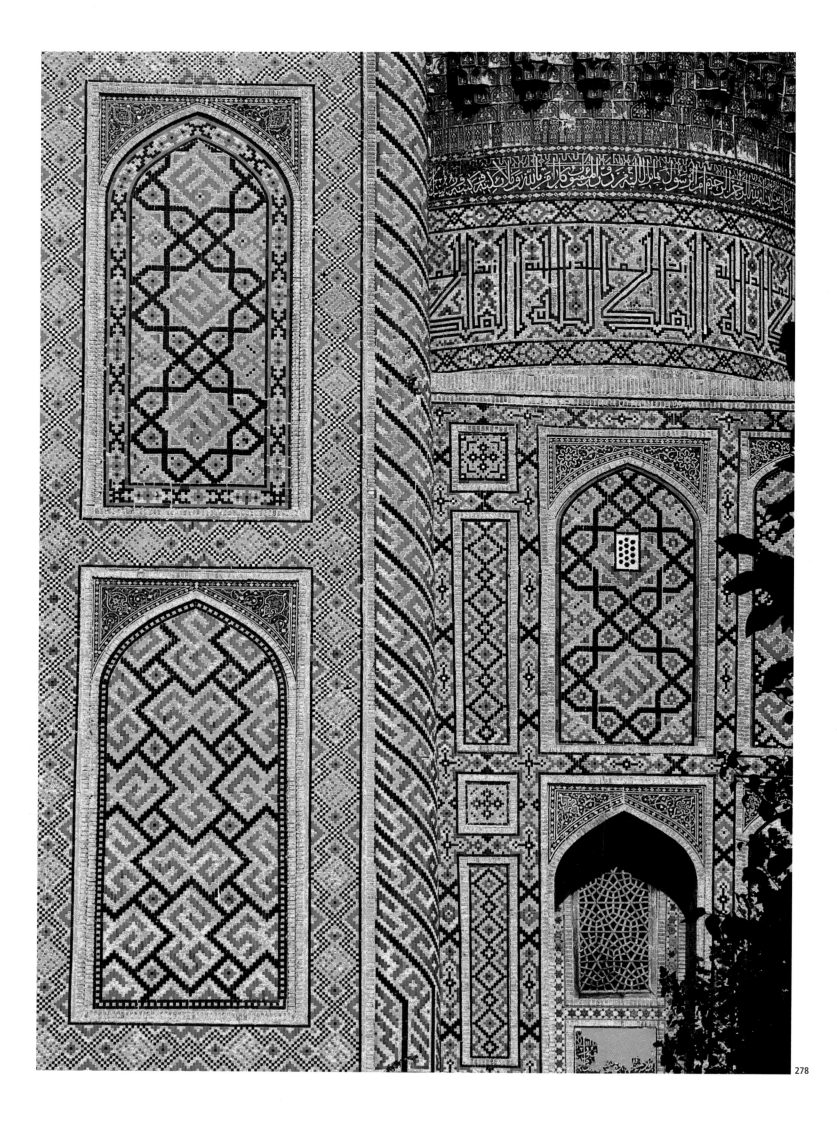

rectangular frame, as a panel, or alternatively, to see panels in the actual *iwan*s themselves, since the arch is so tightly fitted into the rectangular façade. It is clear that in such buildings, as is shown by certain effects of transition between the real and depicted arches, the global conception of the façade is based on an ornamental procedure of subdivision into panels. In the bands, which give the set of façades their orthogonal structure, it should be noted that the treatment of the verticals and the horizontals is identical. Since the vertical and horizontal axes correspond respectively to the supporting and supported elements, the use of identical bands for all of them has the effect of obliterating their architectonic value. Like Persian miniatures, Iranian architecture would seem to be the result of manipulating two-dimensional ornamental planes, rather than the product of a composition of architectural volumes.

The difference between these two types of ornamentation is considerable. The formal complexity and the abundance of materials in Marinid ornament can be opposed to the geometric clarity and the technical unity of Safavid decor. It seems that, while western Islam delighted in exploiting both visual and tactile perceptive effects, Iran opted for a more intellectual approach to ornamentation. However, they share a common characteristic, proved to be of primary importance, and found in the great majority of buildings in Islam, namely that ornamentation with a propensity

to cover surfaces in their entirety radically transforms a building. Islamic ornamentation does not usually try to express the constructive logic of a building. Even if it maintains undeniable relations with the architectural structure, it aims to produce an image of the building reduced to its surface effects.

Although it is important to avoid generalizations which might be considered mistaken – for exceptions do exist – it is clear that Islamic ornamentation operates to hide rather than reveal the forces which are at work in the construction. In Western architecture, ornamentation tries to bring out the organic character of the construction by emphasizing the places where forces are exerted – capitals, keystones, pilasters, cornices, etc. – and by pointedly distinguishing the vertical supporting elements from the horizontal supported elements. However, Islamic architectural ornamentation tends to blur the frontiers between the structural and non-structural. As a result the building seems to ignore the laws of gravity, either because the architectonic forces disappear beneath a superficial ensemble of panels and bands or because the forces lose their dynamic aspect and stiffen into an abstract form.

This ornamental enfolding of the architectural object seems to fulfil both a need to hide its corporeity and a desire to endow it with an appearance which places it beyond material circumstances. Just like the figurative forms which were developed in Islam, this ornamentation appears to participate in the aesthetics of transfiguration.

279

279 Façade in the courtyard of the Ben Yusuf *madrasa* at Marrakesh (1564–65).

278 Exterior walls of the Shir Dar *madrasa* in Samarqand (1619–36). The ornamentation done in rough and enamelled brick is made up of panels separated by bands. Among the various geometrical patterns can be found pious formulas written in quadrangular kufic script.

280 Detail of the *muqarnas* vault on
the portal of the Qaimari *maristan* in
Damascus (1248–58). The concave forms
which make up the vault are derived from
a bidimensional geometrical schema.

Supporting Forms
and Supported Forms

Even though ornamentation appears
to be simply a garment clothing the
building, it is actually an integral part
of the architectural conception. The
edifice cannot be considered separately
from this dominant ornamental aesthetic
factor and, because of this, we can
observe the influence exerted by
ornamental principles on the elaboration
of the architectural forms themselves.

This interaction between the structural
and the ornamental, which constitutes
one of the most characteristic aesthetic
orientations of Islamic architecture,
appears in a very particular manner
in those elements of construction, like
the arch and the cupola, which have an
architectonic function. These two forms,
which are basic elements of Islamic
architectural vocabulary, propose
specifically Islamic solutions in which
technical and plastic issues are intimately
intertwined. The types of arches

developed by Muslim builders –
horseshoe, polylobed, scalloped,
intersecting, etc. – reflect a constant
lack of interest in the visual expression
of physical forces. It is, however, in
the systems used in cupolas that the
submission of architectonic laws to
ornamental logic appears with most
originality.

The cupola is an architectural form
which poses a technical problem: how
can the transition between a square base
and a hemispheric dome be achieved?
The traditions of Antiquity offered two
solutions: squinches or angle niches
and pendentives or spherical triangles.
Of these two, Byzantine architecture
chose the second. Islamic architecture,
however, quickly rejected the pendentive
and, on the basis of the squinch,
developed the system of the angle or
corner arch, to which it added systems of
its own: ribs and *muqarnas*. Attempts have

281 Architectural detail from the
mausoleum of Baha al-Din Halim in
Uch Sharif (15th century). The transition
between the octagonal base of the building
and the circular cupola is accomplished
by the use of flat-backed angle niches.

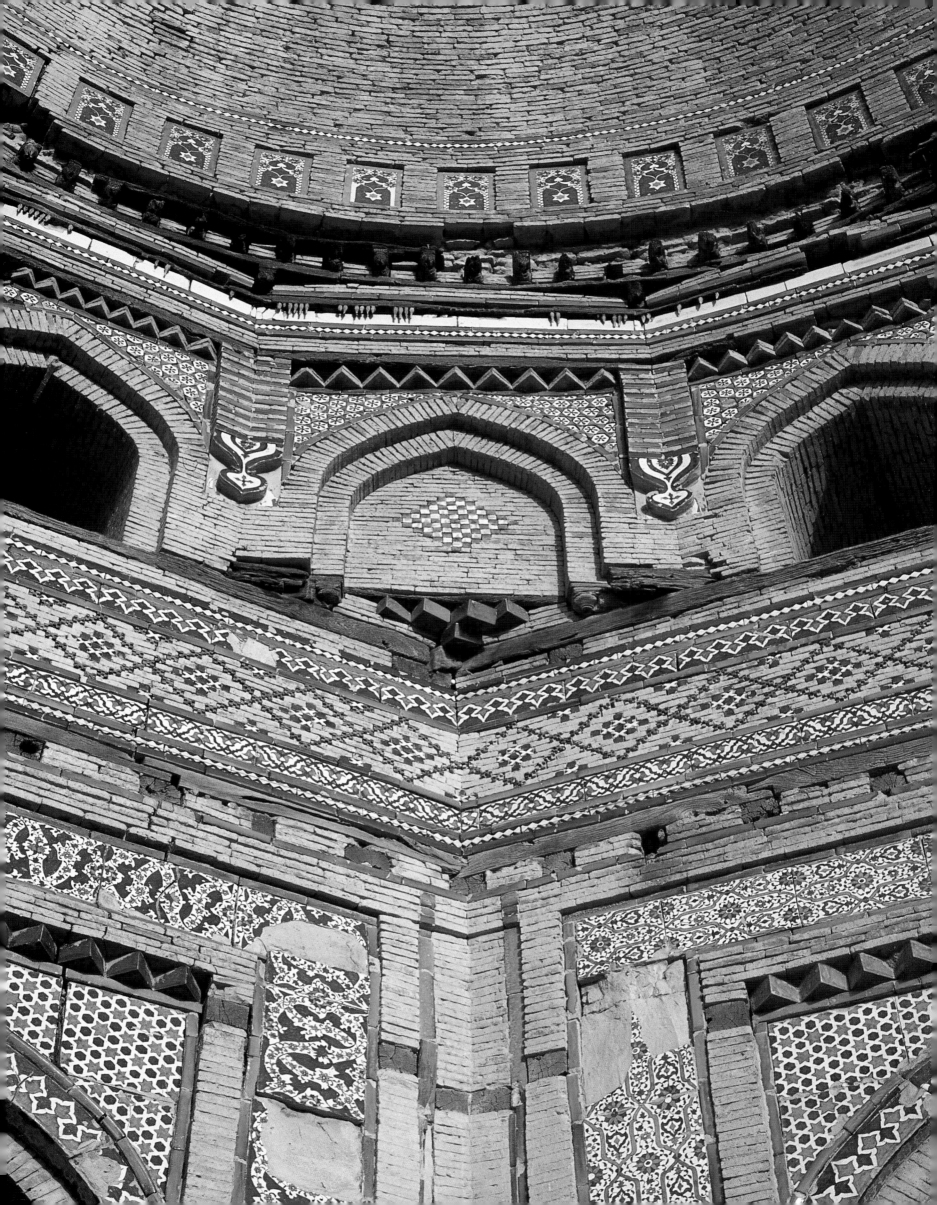

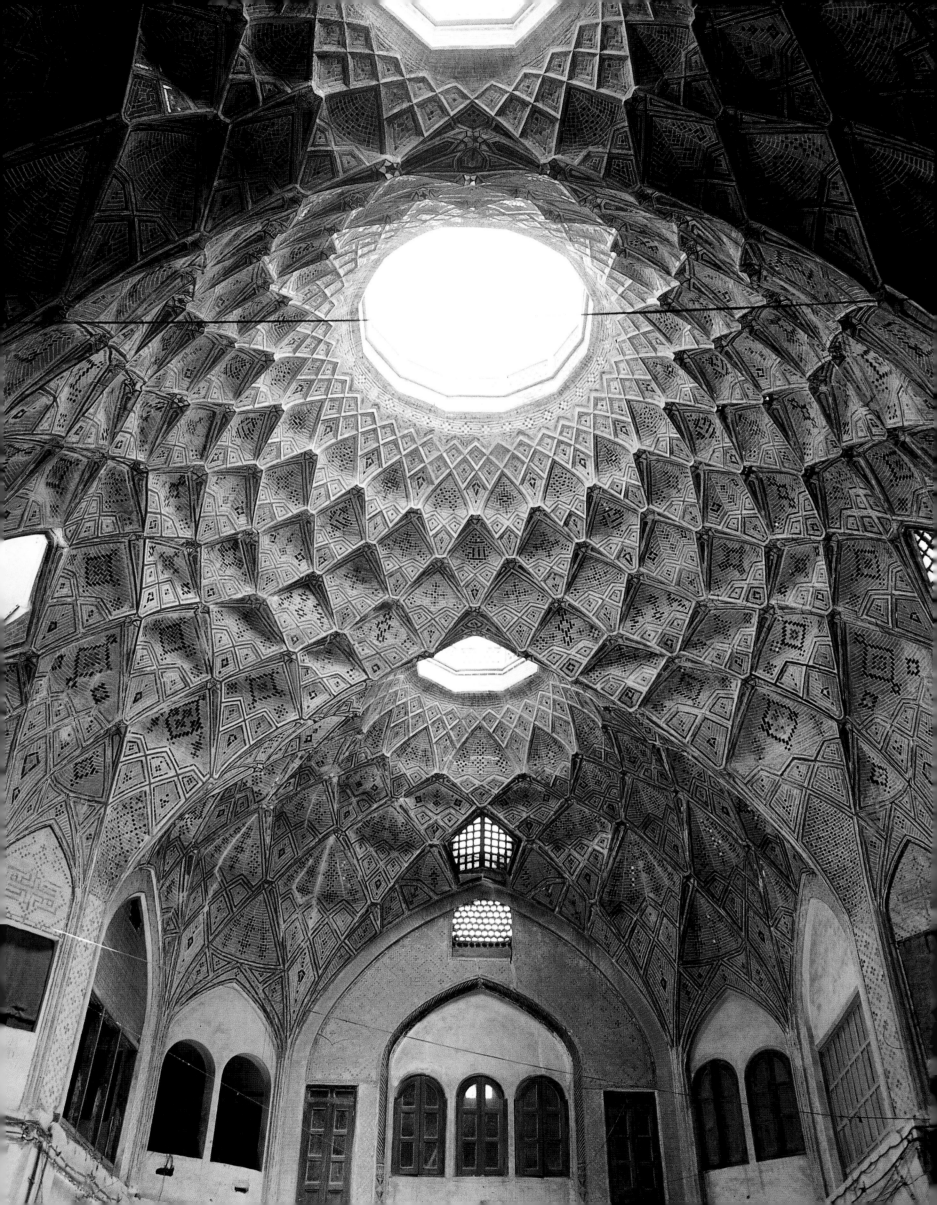

been made to clarify the origins and historical interactions of these different technical solutions, but their aesthetic implications are equally interesting.

The cupola placed on pendentives was not entirely unknown to Islamic architecture, since it was used briefly during the Umayyad period at Khirbat al-Mafjar as well as at Qusair 'Amra. However, it was rapidly abandoned and replaced, first by a system of squinches and then by corner arches, probably the result of aesthetic choice. Indeed, whereas the pendentive accentuates the unity of the volume of a covered room by prolonging the concavity of the cupola into the corners of the walls, the system of squinches, which implies diagonal arches cutting across the corners of the base square, integrates the cupola into a bidimensional geometrical order. The transition between the square base and the circle of the cupola requires a series of leaps between three contrasted geometric forms: the square, the octagon and the circle. This option, taken up by Muslim builders, can be seen as an aesthetic choice in favour of abstract geometric figures instead of organic spaces. It should also be noted that the reappearance of the pendentive in Islamic art was due to the influence of a Christian building, the basilica of Hagia Sophia, which served as a source of inspiration for the architect Sinan.

Ribbed cupolas, which appeared in 966 in the Great Mosque of Cordoba (Ill. 99) and then multiplied into ever more complex forms, subject architectonics even more strongly to ornamental dictates. The principle is to have the vault resting upon a series of semicircular arches spanning the space to be covered. Although this system responds perfectly to technical necessities, as it constitutes a kind of framework, it nonetheless goes beyond simple functionalism. The disposition of arches in relation to each other is dictated by a logic which reveals

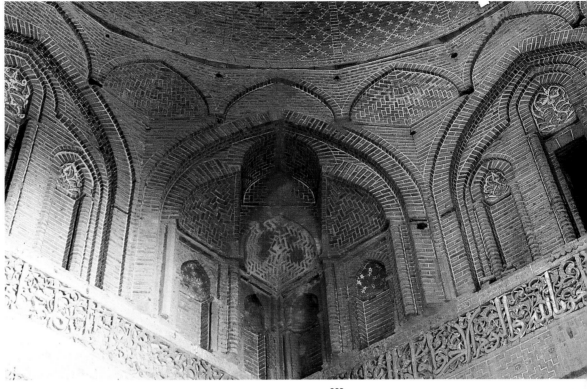

283

an essentially ornamental approach to the problem. Though this type of construction has been compared to medieval Western architecture, here the ribs do not try to channel the living forces of the building as in Gothic architecture. They are the three-dimensional development of a planar abstraction, whose geometric truth precedes any material realization. Thus, the ribs of the cupola in the *mihrab* at Cordoba are the product of a combinatory system of intersecting squares inscribed in a circle, a motif which occupies a central place in Islamic geometric ornamentation.

However, it is the cupolas with *muqarnas* which exemplify the most original encounter between constructive and ornamental principles. First appearing in the 11th century and generally believed to originate in eastern Iran, the *muqarnas* system found enduring popularity in different forms throughout the Muslim world. Originating with the multiplication of angle niches at several levels, the *muqarnas* consist of superposed corbel constructions of prismatic alveoli clinging to an arch form. They can be made of brick, stone, stucco, wood or

282 Vaults in the Kashan bazaar (19th century). The geometric network with its lozenge organization is derived from the *muqarnas* system and bears a striking similarity to contemporary geodesic architecture.

283 Architectural detail from the prayer hall of the Friday Mosque of Ardistan (1133–34). The transition between the square base and the circular cupola is achieved by squinches made up of corner arches opening onto the complex vaulting. Some scholars believe that this architectural solution is the origin of the *muqarnas*.

Overleaf
284 Ceramic covered *muqarnas* vault from the Nasr al-Mulk mosque in Shiraz (19th century).

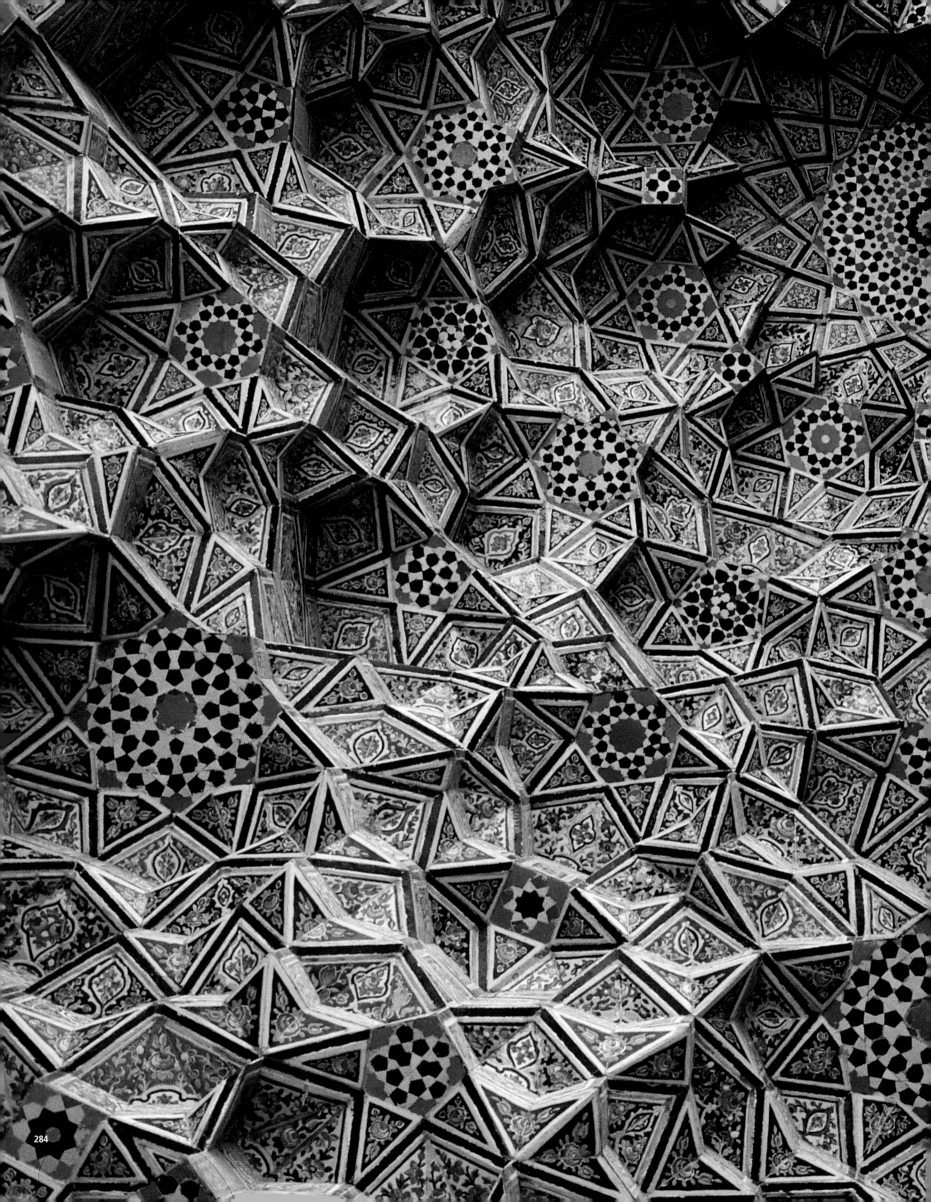

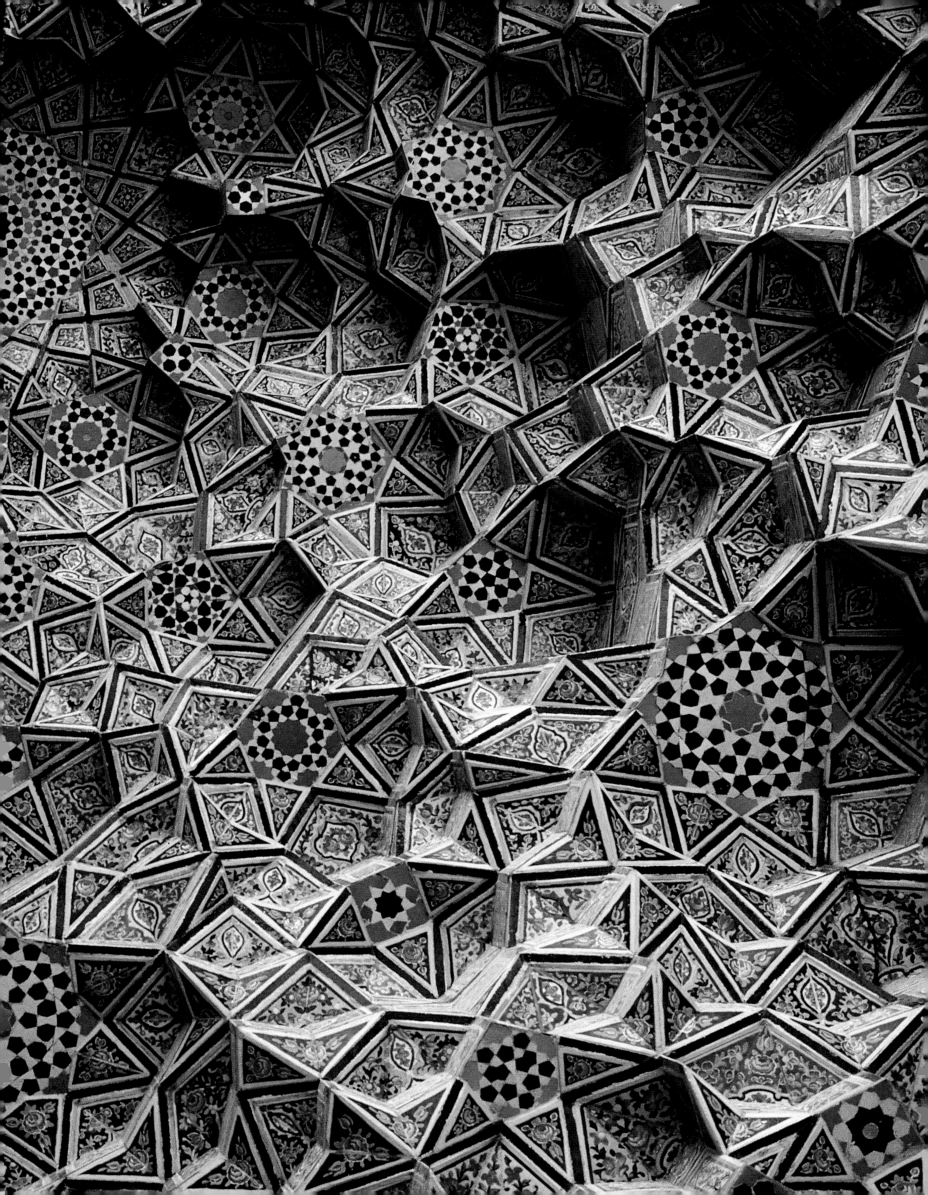

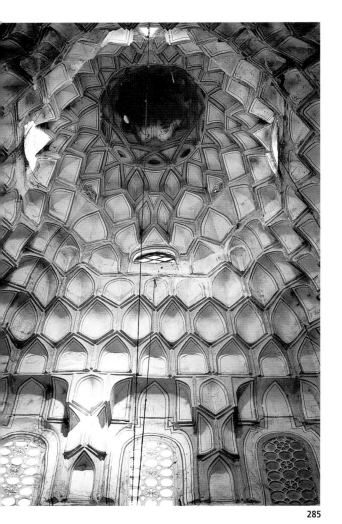

285

285 *Muqarnas* vault from the tomb of Nur al-Din in Damascus (1172). The multiplication of alveoli makes it possible to pass, almost imperceptibly, from the square base to the intermediate octagon and thence to the circle of the small cupola. Some writers argue that this architectural form reflects an atomistic philosophical outlook.

plaster covered in glazed tilework, depending on the region or period in which they are created. They can also, as in Ottoman architecture, be deeply carved and endowed with pendants, which explains why they are called stalactites. However, in contrast, they can appear like a taut network of facets, as in Iranian architecture of the Safavid period. Their function is not only to embellish cupolas, but also to cover the semi-domes of *iwan*s and portals. They can be grafted onto the corbels of a cornice or they can beautify the intrados of an arch, as in the architecture of Spain and the Maghrib.

The most singular feature of this system of forms is the relationship which it establishes between structural and ornamental values. Although it stemmed from a system whose function was to support the cupola, and though it continued to borrow its basic forms from the supporting structure of the arch, it quickly transformed these functional elements into purely ornamental ones. From supporting forms, the *muqarnas* became supported forms in the strict sense of the word because, with the exception of stone *muqarnas*, which were directly sculpted in the mass, they were usually suspended like a false ceiling by a series of fasteners hooked onto the real vault, which thus remains hidden.

Evoking constructive principles, while at the same time reversing their laws, the system of *muqarnas* is thus a three-dimensional ornamentation. But more precisely, it appears upon analysis to be a system which gives volume to a bidimensional ornamental schema, according to a complex but perfectly clear process. All *muqarnas* vaults, whatever their type, were produced from a two-dimensional working drawing, which, like compositions of geometric interlace, was based on

the rotation of regular polygons inside a circle. It is this planimetric geometry, projected into three-dimensional space, which is reconstituted when the spectator stands directly beneath the centre of the composition (*Ill. 284*).

Suspended overhead and covering an architectural element which is traditionally viewed as a metaphor for the celestial canopy, these cascades of *muqarnas* may have held a particular significance in certain circumstances, when symbolizing the rotating skies of Islamic cosmology. This is probably the case when cupolas with *muqarnas* cover mausoleums like that of Nur al-Din (1172) in Damascus (*Ill. 285*). It is certainly true of the cupolas in the Hall of the Two Sisters and the Hall of the Abencerrajes in the Alhambra – undoubtedly the most spectacular examples of *muqarnas* vaults – since the verses of Ibn Zamrak inscribed on the walls say so explicitly.

Although cupolas with *muqarnas* have in certain cases been endowed with more or less explicit cosmological symbolic values, it would be a mistake to extend these values to all the *muqarnas* in Islamic architecture. As is the case of bidimensional geometric ornamentation, it is a formal system which lends itself to symbolism, rather than adhering to it in an absolute way. On the other hand, besides these occasional symbolic meanings, there are other meanings, of an aesthetic nature, which may have a more general value. Given its continued popularity in all Islamic countries from the 11th century onwards, it is legitimate to think that the system of *muqarnas* reflects certain cultural, philosophical and religious attitudes concerning form, matter and space.

The most remarkable characteristic of *muqarnas* vaults is the way they avoid any expression of architectonic forces.

Rather than disclose the forces which
are really at work in the construction,
they offer the image of a structure
obeying geometrical laws similar to
those of crystallography. It is an aesthetic
choice which tends to ignore terrestrial,
physical – it is tempting to say sub-lunar
– realities in favour of a purely
conceptual, formal universe. Such an
attitude probably reflects Islam's lack
of interest in the representation of the
world. In Islam the role of art is not, as
in classical Western culture, to imitate
nature, but to transform or even
sublimate it.

However, if the exact science of
mathematics constitutes an alternative
to naturalism, it is another aspect
of *muqarnas* vaults, namely their
fragmentation of volumes, which grasps
the attention. The idea of unitary volume
is rejected and so the cupola no longer
constitutes a global physical entity as,
for example, in Byzantine architecture,
but instead is divided into a virtually
unlimited number of fragments. The
concept of an autonomous whole is
replaced by the idea of an assemblage
of small units whose coherence depends
on laws of interrelationship. This
fragmentation of space presents clear
analogies with the atomist theories
professed by Islamic philosophers and
theologians, for whom the universe, just
like matter, time and space, could not
possibly be an eternal immutable reality
like the Aristotelian cosmos, but instead
a collection of atoms held together by
Divine Will.

Just as Panofsky spoke of the
structures of Gothic architecture
translating the structures of scholastic
thought, it may be said that the
fragmentation of volumes created
by the *muqarnas* can be seen as the
architectural representation of an
Islamic concept of the universe.

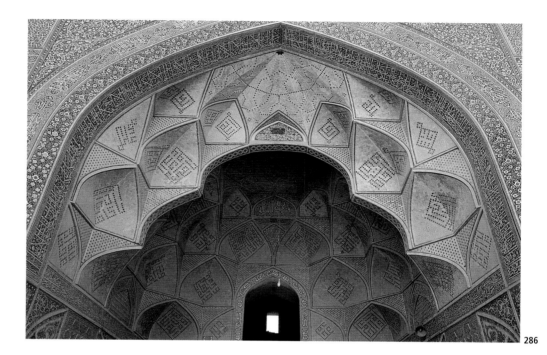

286

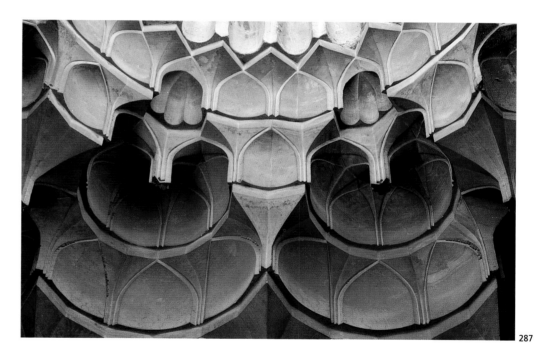

287

286 *Muqarnas* vault from the principal
iwan of the Friday Mosque of Isfahan
(10th–11th centuries).

287 *Muqarnas* vault from the portal
of the Jaqmaqiya *madrasa* in Damascus
(1421). The formal evolution of the
muqarnas during the Mamluk period,
particularly with the introduction of
pendants, causes them to move away
from their structural function and to
assume an essentially decorative role.

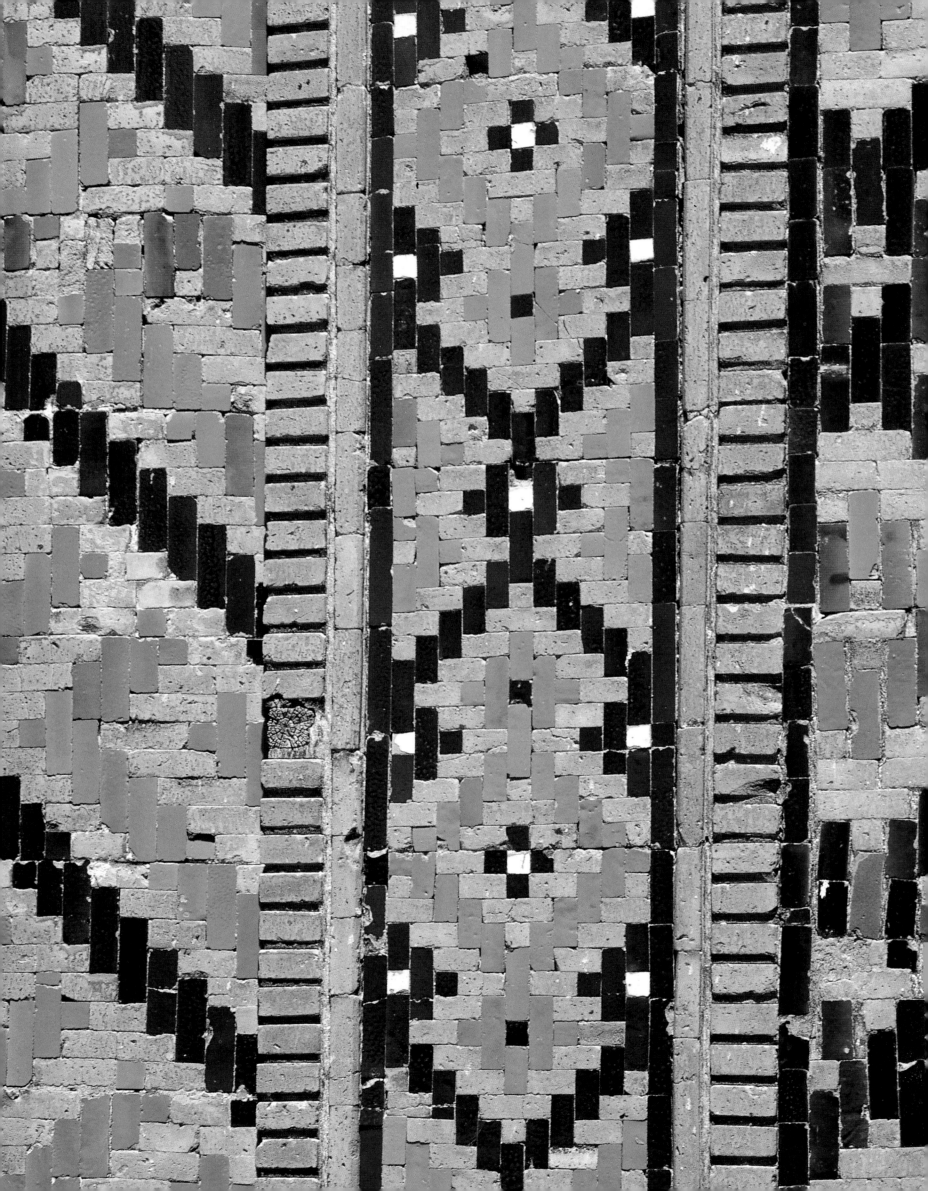

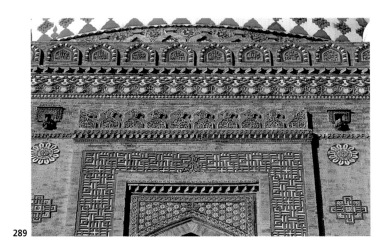

289 Detail of the exterior ornamentation
of the mausoleum of Shah Rukn-i 'Alam
in Multan (13th century).

289

Aesthetics
of the Veil

288 Detail of the brickwork covering
the façades of the Shir Dar *madrasa*
in Samarqand (1636). The ornamental
patterns, produced by the assemblage
of rough and glazed bricks, are similar to
those in woven carpets which are obtained
by the interweaving of warp and woof.

In every attempt to describe Islamic
ornamentation, the terms which naturally
and insistently impose themselves
refer back to the vocabulary of textiles.
We may speak of weaving, textile work,
interlace or net with reference to certain
patterns, of groundwork or texture
to characterize certain surface effects.
We may speak of lace to evoke carving
in stucco or stone. It is also said that
this ornamentation covers buildings
like a wall-hanging, clothes them like a
garment and hides structures like a veil.

Are these formulas only descriptive
figures of speech or do they touch
upon the deeper aesthetic significance
of Islamic ornamentation? Whatever
the answer, they have their equivalents
in Arabic and Farsi. The historian
al-Maqrizi compares epigraphic bands
on the façades of buildings to *tiraz* – the
woven decorative bands which gave their
name to ceremonial robes – and the term

hazar baf, or 'thousand-weavings', was
given to patterns obtained from the
interplay of bricks in Iranian architecture.

The textile metaphors so frequent
in references to Islamic architectural
ornamentation refer to some of its
visual effects. Like threads in weaving,
which cross the warp and the woof,
this ornamentation inhabits a two-
dimensional world. Whatever its
volumetric characteristics, a building
is seen in terms of its external envelope.
On closer examination, this envelope,
by its fragmentation into small,
rectangular panels and by the abrupt
changes of patterns, seems to be made
up of a juxtaposition of wall-hangings
or carpets. An impression of flexibility
dominates, as if, far from emphasizing
the weight of the different construction
elements, the ornamental surface were
suspended upon an underlying structure.
This dissociation between the

203

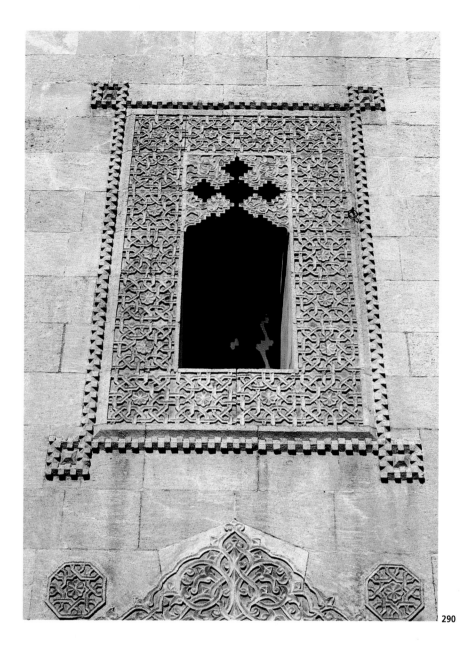

290

290 Window of the Ghazala house
in Aleppo, where the window frame is
treated like a carpet and no distinction
is made between the lintel, the stiles
and the ledge. The arch, as well,
becomes a simple cut pattern.

architectural support and its
ornamentation has sometimes been
likened to the architectural principles
of nomadic tents. Islamic architecture
may have used this cloaking decor to
perpetuate, even in the heart of the
city, the remembered pleasure of the
unique flexibility of nomadic life.

Another common characteristic
of Islamic ornamentation, which
accentuates its textile aspect, is the
tactile quality conferred on it by certain
techniques. Sculpture work, in particular,
plays with oppositions of shadow and
light by minutely carving the surfaces,
rather than by making the volumes
prominent. It endows an apparently
supple texture on hard materials like
stone, wood or stucco, which appears
to absorb light in the same way as cloth
does.

This sensation of fabric is often
further accentuated by effects
of the groundwork, due either to the
production technique, in the brick
assemblage called *hazar baf*, or to the
constant importance given to the line.

The most striking formal kinship
between Islamic ornamentation and
textiles lies in the logic of interlace.
Like the threads which weave over and
under each other to form a fabric, the
lines of Islamic ornamentation, whether
vegetal, geometric or calligraphic, make
use of over–under dynamics to guarantee
the cohesion of the plastic plane.
Throughout the Islamic world this taste
for interlace and braiding is so strong

291

291 Detail from the ceramic facing
on the Tashkaul palace in Khiva (1831–41).

292 Sculpted decor from the minaret
of the funerary *madrasa* of al-Nasr
Muhammad ibn Qala'un in Cairo
(1296–1304). The plastic elements which
make up the stucco decor – bands, stripes,
panels, medallions, etc. – are identical to
those found in the art of carpet-making.

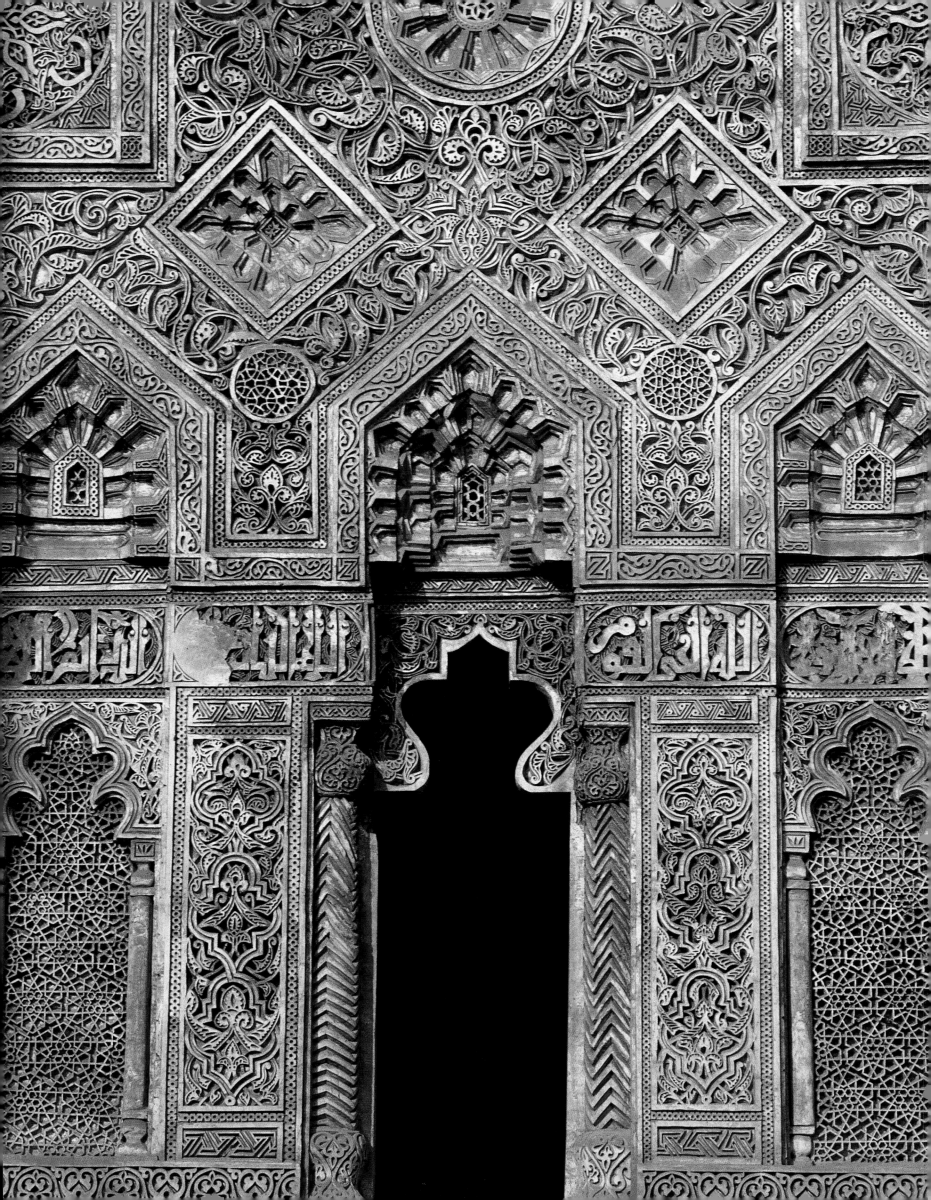

that it even penetrates the building structure itself. The plaited arches of the Great Mosque of Cordoba (*Ill. 293*) or those of the Aljaferia palace at Zaragoza seem to owe their rather affected elegance more to curtain trimmings than to masonry.

While the textile character of Islamic ornamentation is often metaphorical, there are numerous cases where the reference to textile models is perfectly explicit. The metaphor finds its basis in the deliberate intentions of ornamentalists, who either tried to imitate textiles faithfully or, more frequently, to transpose textile patterns and compositions into the diverse ornamental techniques at their disposal.

The most ancient examples of textile imitation appear in the earliest Islamic art, for example in the Umayyad floor mosaics which, bordered with fringe motifs, were obvious representations of carpets. In the 13th century the *türbe*s, or Saljuq funeral towers on a circular plan in Anatolia and Iran, furnished another interesting example. These could be interpreted as solid representations of the tradition of Central Asian funerary tents. Thus, the tower of Radkan in eastern Iran is a circular brick building whose walls imitate not only weaving motifs, but also vertical folds formed by the weight of hanging fabrics; so, at the base of the conical roof, that is at the place corresponding to the seam, there is scalloped trimming decorated with tassels.

Without going so far in the imitation of technical details, the ceramic mosaic

293 *Mihrab* of the Great Mosque of Cordoba (962). The interlaced arches which frame the zone of the *mihrab* express an essentially decorative conception of architectural forms.

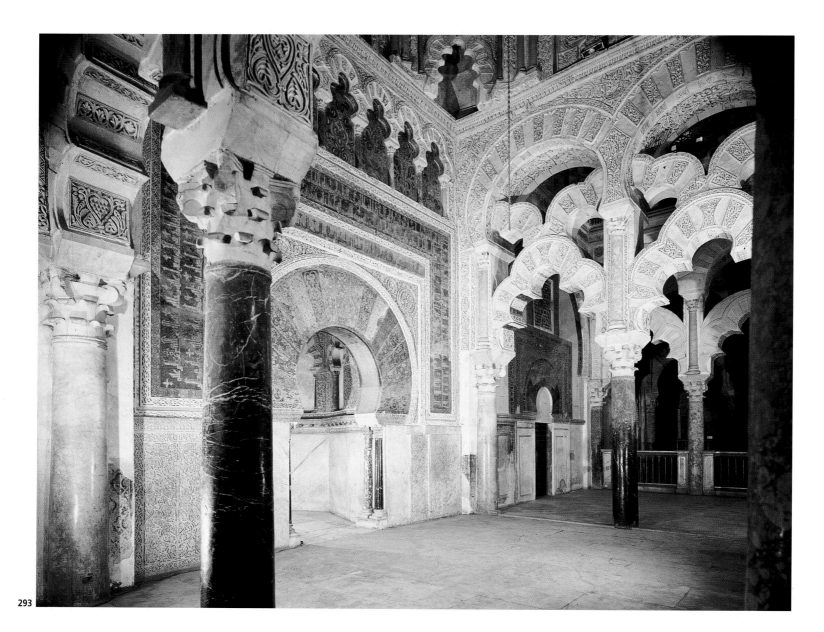

293

facings which cover Iranian monuments derived inspiration for patterns and compositions from contemporary carpets. Although this phenomenon already existed during the Timurid period, it is even more prominent in the buildings erected by the Safavid emperor Shah 'Abbas in Isfahan. There, the royal carpet workshops seem to have given their cartoons directly to the mosaic makers, as can be seen in the two ceramic panels framing the entrance to the Shah Mosque. It can be suggested that the larger dimensions of ornamental panels in Safavid architecture reflect the enlarged format of carpets from this period.

More or less universal in the Islamic world, this principle of transferring textile models to the techniques of architectural ornamentation was a regular feature of Mughal architecture. Thus, the inlaid marble floor of I'timad al-Daula's tomb in Agra exactly copies Mughal carpets and certain sculpted stone grills decorating the windows of the Lahore Fort resemble embroidered veils (*Ill. 297*).

Whether Islamic architectural ornamentation suggests an imitation of textiles, borrows their formal repertoires, or merely contents itself with transcribing technical procedures or visual effects, it reveals the special attraction for fabrics in Islamic culture. Although this ornamentation should be understood in relation to certain textile techniques linked to the architectural context, it also touches on other aspects of textiles such as clothing.

There is a tendency in the study of Islamic architecture to consider monuments in their present state. But the study of written texts and manuscript illustrations makes it plain that the architectural environment gave a primary function to all kinds of textiles: curtains, wall hangings, carpets, sofas, cushions, etc. Arab, Persian and Mughal miniatures show that floors were covered with carpets, walls often hung with tapestries

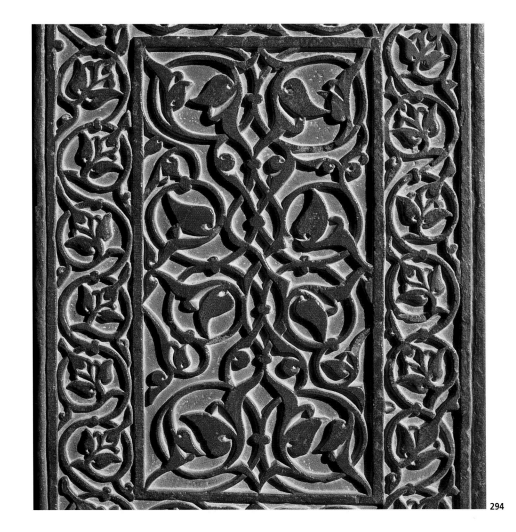

294

295

294 Ornamental sculpture from the palace of Rajah Birbal at Fatehpur Sikri (1573–80).

295 Detail from the stucco decor of the *mihrab* of the Fulus mosque in the Midan district of Damascus (11th century).

and arcades fitted out with curtains. Through the use of these mobile accessories, the usually undifferentiated space of Islamic architecture could be modulated to meet particular needs. Even today in Islamic countries, when there is a celebration, a curtain is often hung to separate the women from the men. One of the most specific examples of these uses of textiles linked to architecture concerns the ritual of the *hijab*, or veil, behind which the caliph held his audiences.

If fabrics made it possible to modify spaces temporarily, and, on certain occasions, took on precise symbolic values, they were more commonly used as a sign of wealth. An account of the reception of a Byzantine delegation at the Caliphal palace in Baghdad in 917 states that the buildings were covered with 38,000 curtains and 22,000 carpets. Such shows of luxury – there are also similar descriptions of receptions at the Fatimid court in Cairo – have their equivalents in clothing. We know that a robe of honour was the ultimate princely gift and also that, like the minting of coins,

the production of fine fabrics was usually a state monopoly.

This constant obsession with fabric sheds light on many formal aspects of architectural ornamentation, so much so that ornamentation seems to be participating in the 'textile mentality' which Lisa Golombeck has named as a characteristic trait of Islamic culture. One could go further and suggest that the pre-eminence of the textile model in ornamental methods also sets into play the equally important concept of the veil.

If the first image evoked by the Arab term *al-hijab* is the piece of cloth behind which many Muslim women hide their faces, it also has a wider meaning, one which is an essential concept of Islamic religious and philosophical thought. The *hijab* is that which separates not only the female from the male, but also the private from the public, the interior from the exterior and the invisible from the visible. All of these oppositions are summarized in religious terminology by the terms *al-batin*, 'the hidden' and *al-zahir*, 'the revealed'. Attributing a fundamental symbolic function to the act of seeing, the Islamic concept of the veil implies that the world in which we live, and which we perceive thanks to our sense of vision, is only appearance: 'Thou wast heedless of this; now have we removed thy veil, and sharp is thy sight this day!' (Qur'an, L, 22)

Is it not possible therefore to say that Islamic architectural ornamentation, since it takes pleasure in adorning buildings with draperies of stucco or cloaks of ceramic, embodies the aesthetics of the veil?

296 Openwork marble screen on the tomb of Muhammad Ghaus in Gwalior (16th century). These carved stone grills, or *jali*, are a speciality of Mughal architecture. They filter the light from outside like a muslin curtain.

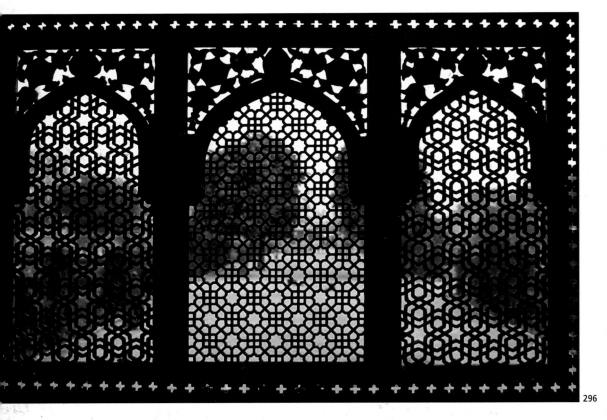

296

297 Openwork marble screen or *jali*, from the apartments of Shah Jahan in the Lahore Fort (1645). In the background can be seen the *diwan-i khass*, or private audience hall, also fitted with openwork screens looking out on the river.

ARCHITECTURAL SPACE

ARCHES

298 *Mihrab* of the Friday Mosque of
Tinmal in the High Atlas mountains,
Morocco (1153–54). The horseshoe arch,
common in western Islamic architecture,
is a slightly overhanging broken arch
with de-centered intrados and extrados.

299 Palace of Rajah Birbal at Fatehpur
Sikri (1573–80). Although it has the
general aspect of a scalloped arch,
the motif surmounting this opening
is, in fact, a transposition into stone of
a structure used in wood construction.

300 The lateral portico the Great Mosque
built by Shah Jahan in Thatta (1647)
is made up of a succession of cupolas
separated from each other by sober
pointed brick arches.

301 Summit of the sculpted brick portal
arch of the Mirjaniya *madrasa* in Baghdad
(second half of the 14th century).

302 The graceful pattern of an arch
framing the fountain situated at the
entrance of the Bait al-Din palace,
south-east of Beirut (early 19th century),
is produced by simply joining together
two construction stones with scalloped
extremities.

298

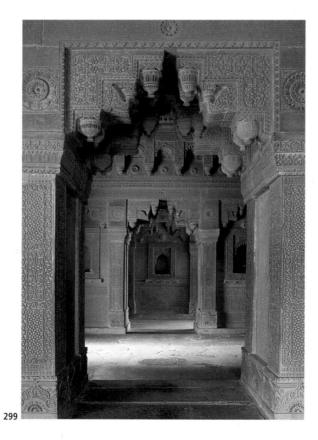

299

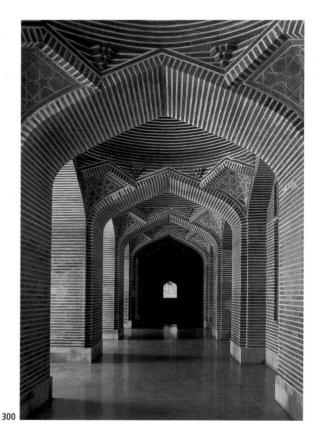

300

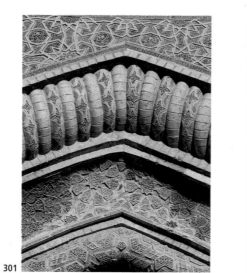

301

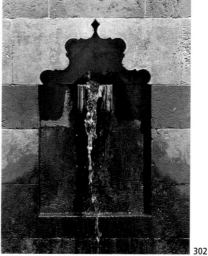

302

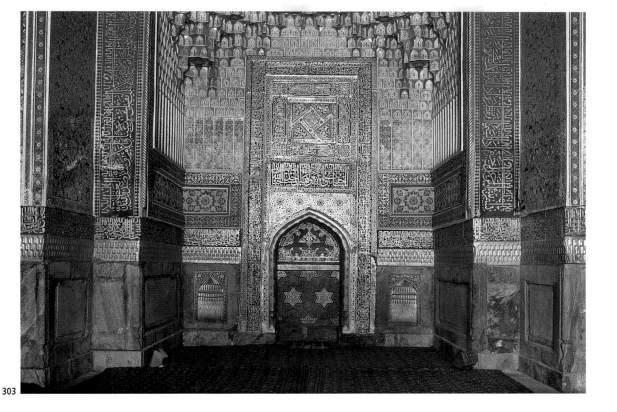

303

304

305

303 *Mihrab* of the Tilla-kari
madrasa-mosque in Samarqand
(1659–60). A symbolic door indicating
the direction of prayer, the arch of the
mihrab is the place in a mosque where
a wealth of ornamentation is concentrated.

304 The crowning glory of the portal in
the Buruciye Medrese in Sivas (1271–72).
Muqarnas sculpted in stone dominate
Saljuq portals with a triangular profile
that does not apply the principle
of vaulting, but makes use of a
technique of corbel construction.

305 Door opening onto the courtyard
of the mausoleum of Mulai Isma'il
(18th century) in Meknes. The curvature
of the horseshoe arches of western Muslim
architecture is obtained by the combination
of the arcs of a circle whose centres are
situated at mathematically determined
points.

CUPOLAS

306 Dome of the tomb of Sitt Zubaida in Baghdad (13th century). Resting on an octagonal base, the vault rises up in a succession of *muqarnas*, which form a sixteen-pointed star above the transition zone, and which are pierced with oculi allowing daylight to enter the room.

307 Cupola with *muqarnas* from the shrine of 'Abd al-Samad in Natanz (1307).

308 The cupola of the Tairuzi *hammam* in Damascus (15th century), supported by a cornice of *muqarnas*, is pierced with small openings covered over with sheets of glass which allow daylight to enter.

309 Vaulting from the entrance hall of the mosque of al-Mu'ayyad in Cairo (1415–20).

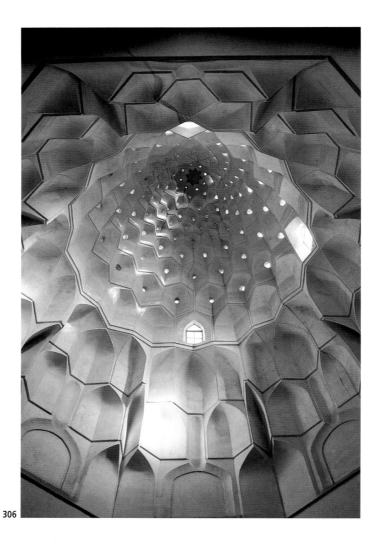

306

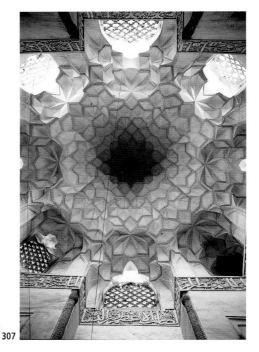

307

309

308

310

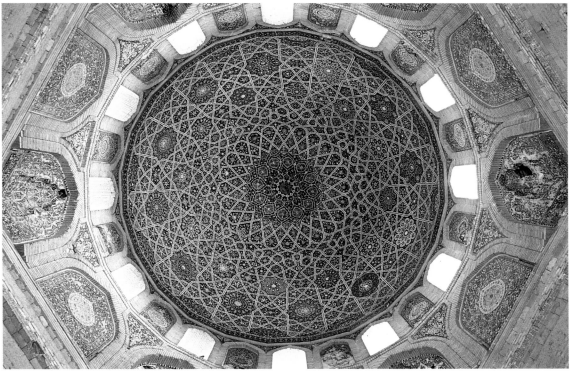

311

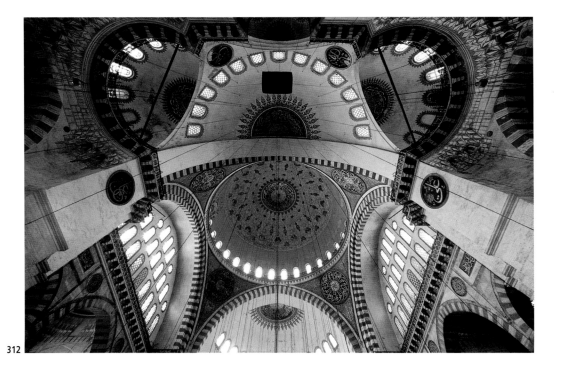

312

310 Vault of the Tabriz bazaar. The art of constructing cupolas in Iran was not limited to religious architecture but can be found in bazaars, used for commerce and the manufacture of goods.

311 The cupola of the mausoleum of Turabeg Khanum in Kunya Urgench (1330–70) is considered by some scholars to be one of the most beautiful in the Islamic world. Its ceramic decor prolongs the geometry of the basal hexagon by an interlace based on dividing the circular dome into twelve parts.

312 The dome of the Süleymaniye mosque in Istanbul, inspired by that of Hagia Sophia and created by Sinan, is fifty-four metres high. It is carried by four large arches, flanked by two tympana pierced with numerous windows and buttressed by two half-domes. The space thus produced is remarkable both for its luminosity and for its vastness. (1550–56).

GLOSSARY

arabesque ornamental system made up of stylized vegetal forms with a rhythmic movement (see *tawriq*)

arcade architectural unit formed by a succession of arches

artesonado Spanish term for an ornamented panelled ceiling; a work of traditional craftsmanship

azulejos Spanish word for mural ceramics deriving from the Arabic word *zellij*

baradari 'twelve-pillared'; a Mughal term for a summer house or rectangular pavilion with a tripartite arcade on each of its sides

bimaristan a hospital (see *maristan*)

caliph title given to the leader of the Muslim community, in Arabic *khalifa*, successor or deputy of Muhammad

caravanserai lodgings for merchants where business was conducted (see *funduq*)

chahar bagh a walled garden divided into four by canals or walkways

chahar taq 'four arches'; a domed structure with four arched entrances based on the plan of the Zoroastrian fire temple

chhatri a small kiosk surmounted by a cupola, found in India

claustra window gratings

diwan-i khass private audience hall

drum circular wall supporting a cupola

extrados exterior portion of an arch or a vault

Friday Mosque the main mosque of a city or district, used for communal prayers on a Friday

funduq lodgings for merchants and a depot for merchandise where business was conducted (see **caravanserai**)

guldasta small structure with a pyramidal roof placed on top of the western *iwan* of Iranian mosques from which the *imam* addresses the faithful in the central courtyard

gunbad a mausoleum in the form of a tower, found in Iran and Turkey (see *türbe*)

hadith an account of an act or saying of the Prophet Muhammad and one of the principal sources of Islamic law

haft rang 'seven-colour'; a ceramic technique in which the pattern is painted with several colours before firing

hammam bath, bathhouse

harim private or family apartments of a house or palace

hasht bihisht 'eight paradises'; a pavilion on an octagonal plan

hazar baf 'thousand-weavings'; latticed brickwork

hijab veil or covering

hijra flight of the Prophet Muhammad from Mecca to Medina in AD 622; beginning of the Muslim era

hypostyle having a roof supported by multiple columns, a type of mosque

imam prayer leader; among the Shi'ites *Imam* designates the successors of Muhammad via his son-in-law and cousin, 'Ali

Imamzada shrine of a Shi'ite saint

interlace ornamental system based on the intertwining of straight or curved lines to form geometric patterns

intrados interior, concave surface of an arch or a vault

iwan a monumental vaulted room open on one of its sides, a traditional element of Iranian architecture

jali a perforated marble screen with an ornamental design, found in India

Ka'ba cubic monument situated in Mecca which is the focus of Islam

kasbah word for a citadel used in the Maghrib (see *qasr*)

Kharijism Muslim sect characterized by its moral and religious strictness

khatt Arabic word meaning line or trace, designating the art of calligraphy

kufi literally, from the town of Kufa in Iraq; an angular calligraphic style which took on various ornamental forms, kufic

kufi banna'i type of *kufi* with quadrangular forms created in brick

madina city

madrasa college for theology and law; in medieval times subjects also included literature, Arabic grammar and the sciences

Maghrib the west of the Islamic world roughly comprising Morocco, Algeria and Tunisia

maidan public open area, a plaza, often used for ceremonies and sports

maristan a hospital (see **bimaristan**)

martyrium a type of Byzantine mausoleum enclosing the tomb of a martyr

mihrab niche in the *qibla* wall of the mosque indicating the direction of prayer, that is, of Mecca

minaret tower attached to a mosque from the top of which the muezzin calls the faithful to prayer

minbar monumental chair situated to the right of the *mihrab* in the Great Mosques, from which the *imam* delivers the Friday sermon

Mi'raj ascension of the Prophet Muhammad through the seven heavens after the nocturnal voyage referred to in the Qur'an

mu'allaqa 'suspended'; a form of pre-Islamic poetry

mu'arraq kari 'implanted work'; Persian term for glazed tile mosaic

muezzin man who calls the faithful to prayer from the top of the minaret

muqarnas 'stalactite'; architectural decorative motifs in alveoli, made up of niches and portions of niches

naskhi cursive calligraphic style

nasta'liq flowing horizontal calligraphic style with pronounced downward oblique strokes invented in Iran in the 15th century

Nauruz Iranian New Year

ornamentalist artist specializing in the conception and the creation of decorative motifs

pendentive curvilinear triangle, of which there are four, which make it possible to pass from a square plan to a circular plan and which support the cupola

pietra dura technique of coloured stone inlay in marble

qadi judge in Islam for civil law

qal'a citadel

qalam pen fashioned from a segment of reed

qasr term used in eastern Islamic countries to designate the citadel (see **kasbah**)

qibla the direction of prayer

Qur'an the Islamic book of revelation, God's Word as revealed to Muhammad

Reconquista Christian conquest of Islamic regions in the Iberian peninsula

saz long supple dentated leaf used in Ottoman art in the 16th century

shah Persian word for king

shahada profession of faith affirming the unity of God and the prophetic mission of Muhammad

Shi'ism the minority branch of Islam that regards 'Ali and his descendants as the rightful successors to Muhammad and the true leaders of Islam (hence Shi'ite)

shish mahal Mughal term for room or rooms decorated in mirror mosaic

Simurgh fabulous bird from Iranian mythology, sometimes with mystical significance

spandrel area just inside or outside of an arch

squinch an arch or a system of arches placed at the internal corners of a square structure so as to accommodate a dome; it permits the passage from a quadrangular basal plan to the circular plan of the cupola

Sunnism orthodox majority in Islam (see **Shi'ism**)

sura a chapter of the Qur'an

tawriq ornamentation using leaves and vegetal elements as its basis; vegetal arabesque

tesserae small cubes of mosaic made of stone or glass

tiraz precious cloth produced by the caliphal workshops under the 'Abbasids and the Fatimids; a robe of honour; a decorative cloth band embroidered with calligraphy; an epigraphic frieze on the façade of a monument

türbe a funerary monument on a circular or octagonal plan with a conical roof in Turkey (see **gunbad**)

zawiya a centre for Islamic mystics and their followers, sometimes associated with a shrine or mausoleum

zellij term used in the Maghrib to designate the ornamental technique of glazed tile mosaic (see **azulejos**)

Dates throughout the book are given according to the Christian calendar.
The date in the Muslim calendar, which is based on a lunar year, is reckoned from the beginning of the year of Muhammad's migration from Mecca to Medina (the hijra; hence Anno Hegirae, or AH), equivalent to 16 July 622 in the Christian calendar (AD).

The following formulas may be used to calculate one date from the other:
Year AH × 0·97 + 621·6 = Year AD (thus, AH 487 = AD 1094)
Year AD − 621·6 ÷ 0·97 = Year AH (thus, AD 1549 = AH 956)

BIBLIOGRAPHY

Al-Andalus, The Art of Islamic Spain,
The Metropolitan Museum of Art, New York, 1992

Almagro, Martin, et al., Qusayr 'Amra, résidencia
y baños omeyos en el desierto de Jordania,
Instituto Hispano-Arabe de cultura, Madrid, 1975

Arabesques et jardins de paradis, Réunion
des musées nationaux, Paris, 1989

Barrucand, Marianne and Achim Bednorz,
L'architecture maure en Andalousie, Taschen,
Paris, 1992

Barry, Michael, Colour and Symbolism in Islamic
Architecture: Eight Centuries of the Tile-Maker's
Art, photographs by Roland and Sabrina Michaud,
Thames & Hudson, London, 1996

Bloom, Jonathan M., 'On the Transmission of Designs
in Early Islamic Architecture', Muqarnas, 10, 1993,
21–28

Bloom, Jonathan M., et al., The Minbar from the
Kutubiyya Mosque, The Metropolitan Museum of Art,
New York, Ediciones El Viso, Madrid, [Rabat] Ministry
of Cultural Affairs, Kingdom of Morocco, c. 1998

Brisch, Klaus, 'Observations on the Iconography
of the Mosaics in the Great Mosque of Damascus'
in Content and Context of Visual Arts in the Islamic
World: Papers from a Colloquium in Memory of
Richard Ettinghausen, Institute of Fine Arts,
New York University (ed. Priscilla P. Soucek), The
Pennsylvania State University Press, University Park
and London, 1988, 13–23

Burckhardt, Titus, The Art of Islam: Language and
Meaning, World of Islam Festival, London, 1976

Chuvin, Pierre, Les arts d'Asie centrale,
Citadelles & Mazenod, Paris, 1999

Clévenot, Dominique, Une esthétique du voile. Essai
sur l'art arabo-islamique, L'Harmattan, Paris, 1994

Clévenot, Dominique, L'art islamique, Scala, Paris,
1997

Creswell, Keppel A. D., revised by James W. Allen,
A Short Account of Early Muslim Architecture,
Ashgate, Aldershot, 1989

Degeorge, Gérard, Syrie. Art, histoire, architecture,
Hermann, Paris, 1983

Degeorge, Gérard, Damas des Ottomans
à nos jours, L'Harmattan, Paris, 1994

Degeorge, Gérard, Damas, des origines
aux Mamelouks, L'Harmattan, Paris, 1999

Ecochard, Michel, Filiation des monuments grecs,
byzantins et islamiques. Une question de géométrie,
Librairie orientaliste Paul Geuthner, Paris, 1977

Ettinghausen, Richard and Willy Hartner,
'The Conquering Lion, the Life Cycle of a
Symbol', Oriens, 17, 1964, 161–71

Ettinghausen, Richard and Oleg Grabar, The Art and
Architecture of Islam, 650–1250, Penguin Books Ltd,
New York and Harmondsworth, 1987, paperback ed.,
New Haven, Conn. and London, 1992

Ettinghausen, Richard, 'Interaction and Integration
in Islamic Art' in Islamic Art and Archaeology:
Collected Papers (ed. Miriam Rosen-Ayalon),
Gebr. Mann Verlag, Berlin, 1984, 51–87

Ettinghausen, Richard, 'The Taming of the Horror
Vacui in Islamic art' in Islamic Art and Archaeology:
Collected Papers (ed. Miriam Rosen-Ayalon), Gebr.
Mann Verlag, Berlin, 1984, 1305–9

Golombeck, Lisa, 'The Draped Universe of Islam'
in Content and Context of Visual Arts in the
Islamic World: Papers from a Colloquium in
Memory of Richard Ettinghausen, Institute
of Fine Arts, New York University (ed. Priscilla
P. Soucek), The Pennsylvania State University Press,
University Park and London, 1988, 25–38

Golvin, Lucien, Essai sur l'architecture religieuse
musulmane, Klincksieck, Paris, 1970

Grabar, Oleg, Islamic Architecture and its Decoration,
AD 800–1500, Faber and Faber, London, 1964

Grabar, Oleg, The Formation of Islamic Art, Yale
University Press, New Haven and London, 1973

Grabar, Oleg, The Mediation of Ornament,
Princeton University Press, Princeton, 1992

Grabar, Oleg and Saïd Nuseibeh, The Dome
of the Rock, Thames & Hudson, London, 1996

Hedgecoe, John and Salma Samar Damluji, Zillij:
the Art of Moroccan Ceramics, Garnet Publishing
Limited, London, 1992

Hillenbrand, Robert, Islamic Art and Architecture,
Thames & Hudson, London, 1999

Hillenbrand, Robert, Islamic Architecture: Form,
Function and Meaning, University of Edinburgh,
Edinburgh, 1994

Hoag, John D., Islamic Architecture, Berger-Levrault,
Paris, 1982

Irwin, Robert, Islamic Art: Art, Architecture and
the Literary World, Laurence King, London, 1997

Koch, Ebba, Mughal Architecture: An Outline
of its History and Development (1526–1858),
Prestel, Munich, 1991

Massignon, Louis, 'Les méthodes de réalisation
artistiques des peuples de l'Islam' in Opera
Minora, textes recueillis par Y. Moubarac,
3 vols, Presses Universitaires de France, Paris,
969, vol. 3, 9–24

Michell, George (ed.), Architecture of the
Islamic World, Thames & Hudson, London, 1995

Nasr, Seyyed Hossein, Islamic Art and Spirituality,
State University of New York Press, New York, 1987

Okada, Amina, Taj Mahal, Imprimerie Nationale,
Paris, 1998

Otto-Dorn, Katharina, L'art de l'Islam, Albin Michel,
Paris, 1967

Paccard, André (trans. Mary Guggenheim), Traditional
Islamic Craft in Moroccan Architecture, 2 vols,
Edition Atelier 74, Saint-Jorioz, 1979

Papadopoulo, Alexandre (trans. Robert E. Wolf), Islam
and Muslim Art, Thames & Hudson, London, 1980

Stierlin, Henri, Ispahan: image du paradis, Sigma,
Geneva, 1976

Stierlin, Henri and Anne Stierlin, Alhambra,
Imprimerie Nationale, Paris, 1991

Stern, Henri, Les mosaïques de la Grande Mosquée
de Cordoue, Walter de Gruyter & Co., Berlin, 1976

Tabbaa, Yasser, 'The Muqarnas Dome: Its Origin and
Meaning', Muqarnas, 3, 1985, 61–74

Vogt-Göknil, Ulya, Mosquées, Chêne, Paris, 1975

INDEX OF THE MONUMENTS

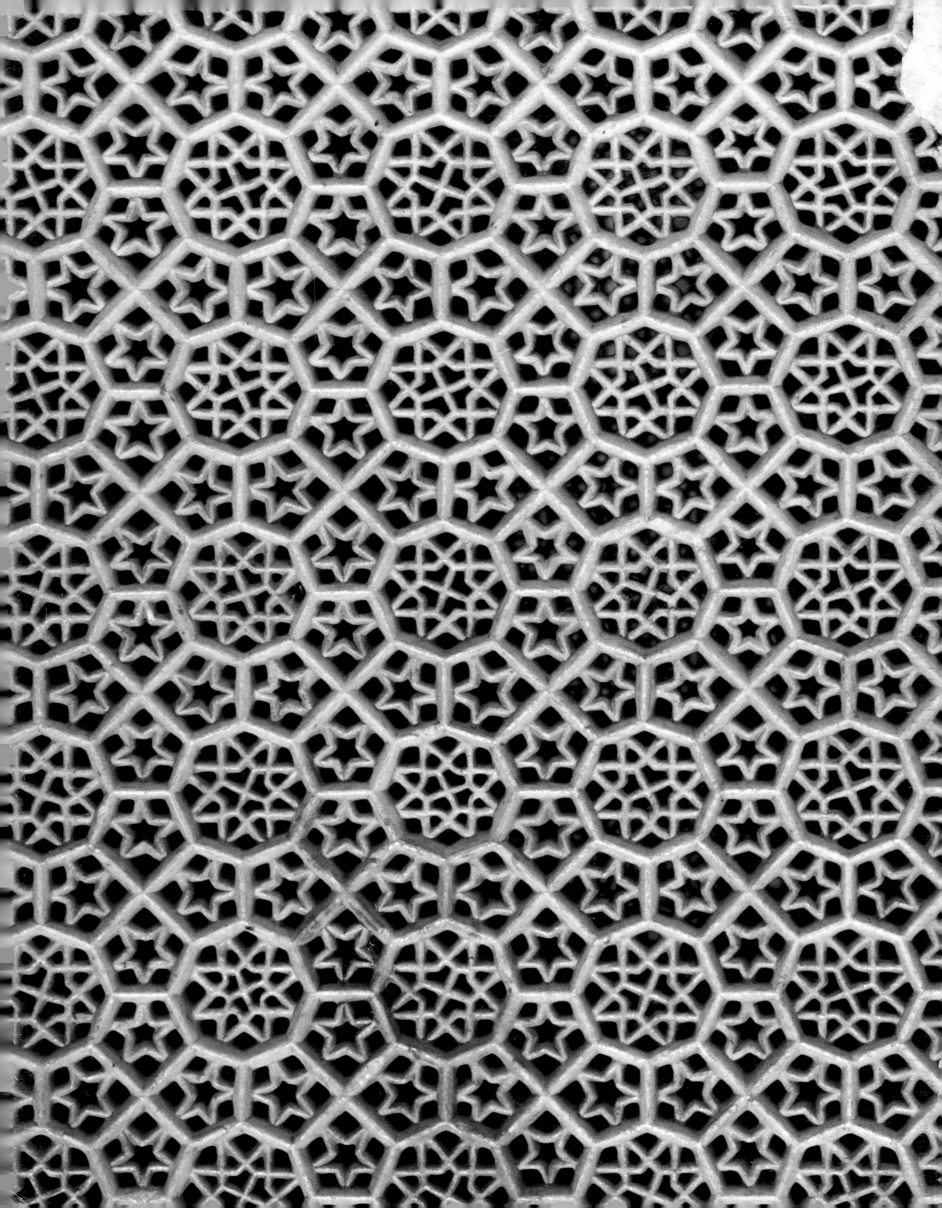